Massively Multiplayer Game Development

Massively Multiplayer Game Development

Edited by Thor Alexander

CHARLES RIVER MEDIA, INC.

Hingham, Massachusetts

Publisher: Jenifer Niles
Production: Publishers' Design and Production Services, Inc.
Cover Design: The Printed Image
Cover Image: Dale Homburg

CHARLES RIVER MEDIA, INC.
10 Downer Avenue
Hingham, Massachusetts 02043
781-740-0400
781-740-8816 (FAX)
info@charlesriver.com
www.charlesriver.com

This book is printed on acid-free paper.

Thor Alexander. *Massively Multiplayer Game Development*.
ISBN: 1-58450-243-6

Library of Congress Cataloging-in-Publication Data

Alexander, Thor, 1968-
 Massively multiplayer game development / Thor Alexander.
 p. cm.
 ISBN 1-58450-243-6
 1. Computer games—Programming. I. Title.

QA76.76.C672A428 2003
794.8'1526—dc21

 2002154761

Printed in the United States of America
03 7 6 5 4 3 2 First Edition

CHARLES RIVER MEDIA titles are available for site license or bulk purchase by institutions, user groups, corporations, etc. For additional information, please contact the Special Sales Department at 781-740-0400.

CONTENTS

ACKNOWLEDGMENTS

First off, I would like to extend my deepest appreciation to the contributors whose hard work made this book possible. I would also like to single out *Dale Homburg* for the cover artwork as well as super-contributors *John Olsen, Matt Walker, Mark Brockington, Artie Rogers* and *Jay Lee* for going that extra mile and submitting eleventh-hour replacement articles.

Second, I would also like to extend a very special thank you to the following people who have personally encouraged or inspired me throughout my life to chase down my dreams and fulfill them: *Jimmy Monson, Marcia Prescott, Diane Pavlik, Steve Lindquist, Gary Moore, Andy Anderson, Jodie Norton, Scott Thomson, Tony Rocco Castellani, Phil Bailey, Lauren Winters, Debbie Schneider, John Rooney, Missy Henrickson, Kelly DeCook, Mark* and *Kelly Cussans, Andy and Sara Lynch, Buck* and *Dawn Andrews, Ryan Stoddard, Scott Wescott, Dan "Neller" Heller, Dmo Betts,* the *Aiello* brothers, *Eddie Hamaty, Carl "SSCGBB" Jacobs, Anne Bowers, Scot Barnes, Jose Cayao Jr., Reza Beha, Phil Dawdy, Melanie Rogers, Howard Jones,* and last but far from least, *Aimee Noel Vladic.*

Next, I would like to thank all of the great and talented people that I have had the pleasure of working with over the years in this wacky business that we call the *game industry,* especially *Rick Hall, Gordon Walton, Jeff Anderson, Richard Garriott, Drew Markham, Greg Goodrich, Mal Blackwell, Alex Mayberry, Corky Lehmkuhl, Max Yoshikawa, Starr Long* and the *UO2* Team.

Finally, I would like to thank *Steve Rabin* and *Dante Treglia* for getting me started writing in their books, *AI Game Programming Wisdom* and *Game Programming Gems 3,* respectively, and last but not least, *über*-publisher *Jenifer Niles* for all of her help and support in making this book happen.

FOREWORD

Richard Garriott ("Lord British")

Oh, the computer games industry! Who would have thought that something so fun could turn into a major industry traded on international stock exchanges? Those of us who have been there from the beginning are amazed. Here is something that started as a hobby because we liked games and we liked computers, and now it is a full-fledged, competitive, high-end, high-dollar industry! What's more, books and magazines on game development are being published, movies based on game fiction and back story are being made, and universities are teeming with bright-eyed programmer and artist types who only dream of doing what we've been doing for 20 years—making games.

How lucky I am; I have been able to see a small subculture merge into mainstream pop culture, from the inside. Who would have thought it would go this far? I must say the computer games industry has far surpassed my original predictions. Sometimes people forget that it wasn't always high-polish, cutting-edge technology with stiff competition and pools of experienced artists, designers, and programmers. With the current popularity of computer games, and with massively multiplayer online games in particular, it is easy to forget where it all started.

A Short History

With the advent of personal computers (PCs) in the late 1970s, people began to create computer games—including multiplayer games. However, it took quite a while for online multiplayer computer games to be thought of as commercially viable products that were worthy of state-of-the-art technology. It took nearly 20 years, in fact.

When I first started creating games in the 1970s, I wrote them on a Teletype machine. Not many people remember these machines; they punched holes in a strip of paper tape, which was then fed to the computer. There were no graphics, per se; rather, textual characters were placed in rows and patterns to simulate graphics. There was a small group of people who were exposed to these early games, namely hard-core gamers and true computer enthusiasts. Soon, the technology improved, and computer games began to both look better and be more playable. The electronic games business grew along with the PC business. As PCs became better, more popular, and more affordable, so did computer games.

When cheap modems appeared on the computer products market, things started to change. The addition of the modem to the personal computing front gave rise to the text-based multiplayer game. The computer games business was just about to blossom.

Then came the Internet.

BOOM!

The Birth of Massively Multiplayer Games

When services like AOL became very popular in the early 1990s, online games became slightly more sophisticated, but they were still primitive by our standards. AOL enabled thousands of players to play games together; however, these were generally either text-based games or games with low-tech graphics. While this was not very impressive compared to current standards, and while the gaming products were technologically inferior to other commercial software products at the time, online gaming had established a hard-core following. Processor speed, graphics technology, sound technology, and storage devices all continued to get bigger, better, faster, and cheaper. By the mid-1990s my cohorts and I were in the process of making the first successful high-end, Massively Multiplayer Online Role-Playing Game (MMORPG) in the world, *Ultima Online* (*UO*).

Since then we've seen newer, better, and more successful MMORPGs released. Why? Because they are fun, people like them. We are seeing more and more people move toward Massively Multiplayer (MMP) games. The Internet provides gamers with something other types of computer games can't—the ability to socialize. Not only can you play with friends in your own town, you can also meet people across countries and oceans through MMP games. It is really pretty amazing, if you think about it.

As computer game developers, it is our responsibility to keep audiences interested and to keep the games coming. Doing that means not only providing innovative ideas and responsibly generating content, but it also presents some challenges that each developer and each development studio needs to deal with on a daily basis.

Development Issues

While there are many issues and challenges in the development cycle of an MMP game, one that must always take precedence over other issues is the importance of robust code and the ability to implement it. This means a lot of things; it means that your code should be engineered, not hacked. It means that code should contain enough comments to ease supportability and expandability. It means game features should be carefully documented so that future team members will understand *what the game is*. And it should be as 'bug free' as possible.

When defining coding and development standards, keep in mind that while there is no way any large piece of code can have zero errors, an MMP must have considerably higher standards than a traditional offline game. If one of the hundreds of thou-

sands of players manages to crash the servers, they will cause the game to fail for all players on the system. Plus, as the game has new features added, the code will move in memory, and will often manifest new ways to fail that had lain dormant in the code before.

Creative Challenges

Another huge challenge in the world of massively multiplayer games is how to make the best game ever. I believe that the right mixture of single-player aspects and multiplayer aspects in one MMP will result in one hell of a game.

We must respect single-player games; they are very popular for a reason. In these games, the best part is that everything about that game is designed to make the individual feel like the 'savior of the world.' The good part is that you are blissfully unaware that everyone else that owns this game is also the 'savior of the world.' The bad part is that you can't share the fun. You can't play with your friends.

In the current generation of MMP games, the reverse is true: you can take your friends adventuring with you, but not everyone can believe they are 'the' one person who saves the world. So, statistically speaking, most individuals playing MMP games are average—not everyone can feel special or can claim that they, individually, saved the world. People who like the process of the struggle over the glory of solving or conquering can really enjoy these games, but those who want to feel special and become saviors could have difficulty staying interested.

So the design challenge remains: how do you design for the best of solo play and the best of MMP play when each game type's key benefits are contrary to the other? We at NCsoft Corporation believe we have one answer to this question, and I look forward to other innovations as well.

Making MMP Games Look and Act
Like Single-Player Products

A key item that developers should keep in mind is the technical demands we make of our target market. It is much more difficult to get started in MMP games than in single-player games. In console games, you simply put in the disk and play. PC games require users to put in the disk, install, and then play. But MMP games require a whole series of events before you can get to the fun: put in the disk, install, create an account, learn what you are doing and why, learn to interact with others, and *then* play.

These steps of installing and playing multiplayer games can be so tedious and annoying that they turn people off. Great care must be taken with the User Interface (UI), the install programs, and the tutorials to ensure that players do not get bored or frustrated. So far, this is an area that has been largely ignored.

Another technical demand that represents an interesting challenge to MMP developers is the graphical representation of the game. Frequently, MMP games have

inferior graphics and interfaces compared to single-player games. This could be because we must overcome so many other development challenges to make an MMP work. As a result, MMP games are historically not as graphically rich as console or single-player PC games.

No one has developed an elegant, user-friendly interface . . . yet, especially in a state-of-the-art graphical environment. I hope to see a breakthrough in this area by the next generation of MMP games. In fact, I challenge developers to do it!

Looking Forward

There are many things to consider when developing multiplayer games. With each passing day we have even more challenges—internationalization, ratings, technological developments, and the like. As this industry grows, the number of challenges will grow exponentially. However, the base concerns for developers should always be how to make a great, innovative game, while making it stable, supportable, expandable, and easy to use.

To date, there has been a single pattern in MMP development. We have appeared to stick to a similar theory from studio to studio, company to company, developer to developer: create large, virtual worlds in which to play. I would like to see this industry take that one step further. We have come so far in the past 20 years; I know there are other types of massively multiplayer games that can yield success beyond the standard fantasy sword-and-sorcery or science fiction genre. And I'm counting on *you*, the industry's current and future MMP developers, to show the global game community innovation and masterful implementation of other virtual worlds!

ABOUT THE BOOK

Thor Alexander, Hard Coded Games

thor@hardcodedgames.com

Welcome to *Massively Multiplayer Game Development!* This book is a comprehensive and insightful anthology of articles from the developers of the most successful and anticipated MMP games, including *Ultima Online, Neverwinter Nights, The Sims Online, Toontown Online, Star Wars Galaxies,* and more. Within these pages you will find a wealth of unique and rare knowledge acquired in the trenches of MMP and online game development by some of the online game industry's best and brightest developers.

Intended Audience—Not Just for Programmers!

Although patterned after the successful *Game Programming Gems* series, also published by Charles River Media, Inc., this book strives to appeal to a wider audience. While programmers will find a multitude of technical 'gems' within these pages, designers and producers will also find many sections quite readable and informative, without all of the technical terminology found in most programming books. Customer support representatives will find articles in several sections that will prove to be an invaluable resource of knowledge that they would be hard pressed to find elsewhere. See the Preface Table for pointers to articles that may prove to be the most relevant to you.

Preface Table Chapters and Their Intended Audience

Section	Designers	Programmers	Producers	Customer Support Representatives
MMP Design Techniques	X		X	X
MMP Architecture	X	X		
Server-Side Development		X	X	
Client-Side Development		X		
Database Techniques	X	X	X	X
Game Systems	X	X		X

Section Overviews

The quick overviews below will help you navigate the sections in this book and find the articles that are the most interesting to you.

Section I: MMP Design Techniques

This first section provides 'big-picture' design process insights and is well suited for designers and producers. It includes an excellent review of the lessons learned by the *Toontown Online* team for making online games for the mass market. It also contains *Star Wars Galaxies* designer Ben Hanson's article on game balance techniques specifically for MMP games. This section wraps up with a review of online customer support pitfalls from former *Ultima Online* lead designer Paul Sage.

Section II: MMP Architecture

This section features extensive coverage on applying object-oriented and *Extreme Programming* practices to build robust MMP frameworks and architectures. While geared toward programmers, it is also intended for the designer who wants to know how things fit together in an MMP. Example articles include an overview of using the open-source *Twisted* framework by creator Glyph Lefkowitz, and Matt Walker's pertinent article on "Unit Testing for MMP Games."

Section III: Server-Side Development

This section covers the server side of online development, including server-lord Jason Beardsley's essay on the pros and cons of *seamless servers*, an excellent overview of server development and maintenance by *The Sims Online* lead developer Bill Dalton, a cutting-edge article on bringing MMP games to wireless devices by David Fox, and Jay Lee's must-read article on the "Considerations for Movement and Physics in MMP Games."

Section IV: Client-Side Development

Movement prediction is a major challenge to most MMP developers, and we take it on with complementary articles from Bioware's Mark Brockington and X-Box Live's Jay Patterson. Character customization is a core feature of many online games, and NCsoft's Todd Hayes has that covered with his article on "Texture-Based 3D Character Customization." This section wraps up with John Olsen's outstanding article on the "Unique Challenges of Console MMP Games."

Section V: Database Techniques

Database programming and administration is a black art that very few developers in the game industry have mastered. To help change that, this section includes two articles from database guru Jay Lee. The first is a neophyte's introduction to database fundamentals that is suitable reading for all developers, including designers and

producers. The second article provides exceptional coverage of how and how not to use a database for online games.

Section VI: Game Systems

This final section addresses designing the core game systems that power MMP games. Highlights include Artie Rogers' inspiring article on "Life in a Social Economy" as well as Mark Brockington's first-rate article on "Hatred, Forgiveness and Surrender in *Neverwinter Nights*."

How to Read This Book

There are a few suggested ways to read this book:

- Hunt-n-peck: Skip through and read what you find interesting.
- Cover-to-cover: This could take a while, so keep your bookmark handy.
- At the keyboard: The 'in front of the computer' approach.

Hunt-n-Peck

This is the recommended method. Most of the articles are meant to be bite-size and able to be digested in one sitting. Their self-contained nature allows them to be read out of order without regard for the articles that preceded them.

Cover-to-Cover

Anthology works such as this are not written by a single author, and the individual articles are meant to be complete in themselves if read in a stand-alone fashion. However, all of the articles share common subject matter and have an interconnected focus. The sections and the articles within them are laid out in a manner that lends itself to being read in order if so desired.

At the Keyboard

ON THE CD

Many of these articles include embedded code samples that can be typed in and run on your computer. Whenever possible, the source code is provided on the accompanying CD-ROM to save the reader the trouble of typing them in by hand. Be sure to consult the "About the CD-ROM" appendix at the end of this book for important details before diving it.

The "Big" Idea

Information wants to be free! Ideas are easy. It is the *execution* of those ideas that produces great games. By sharing this knowledge with you, the reader, it is the express wish of this author that this book will help foster an atmosphere of collaboration and cooperation between MMP and online game developers.

ABOUT THE COVER IMAGE

Dale Homburg, NCsoft

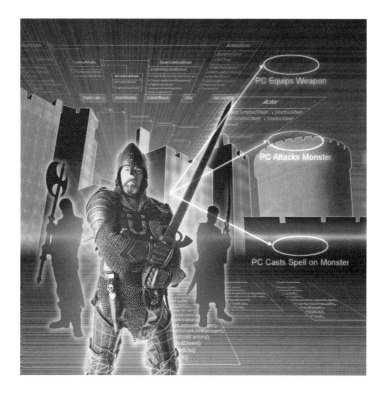

The cover image is an abstract representation of the process of creating an immersive world from individual elements of code and art. Instead of a scene showing what a player would likely see in-game, this image is like an x-ray of a screenshot. It demonstrates the many hidden elements that must be brought into the correct balance in order to create a believable virtual world.

About the Artist

Dale Homburg started making art for computer games in 1987 at the age of 14. He has created artwork for numerous games, including *Harpoon, Air Warrior, Ultima Online*, and *Ultima Online 2*. He lives in Austin with his wife, Erin, where he enjoys kayaking and hiking in the beautiful Texas hill country. As well as working for *NCsoft*, creating 3D art for upcoming titles, Dale also creates lighted sculptures in mixed media and found objects.

CONTRIBUTOR BIOS

Thor Alexander, Hard Coded Games

thor@hardcodedgames.com

Thor Alexander has spent the past decade working to bring believable autonomous characters to the game industry. In 2001 he founded Hard Coded Games in Austin, Texas, to bring state-of-the-art AI and machine learning to online games. Previously, he has held senior AI programming and design positions with Electronic Arts, Microsoft, and Xatrix Entertainment, as well as being a founding member of Asgard Interactive and CEO of Harbinger Technologies, Inc. Thor is the inventor of the hyperSim autonomous character system as well as GoCap (Game Observation Capture), a machine-learning process used to train AI characters by watching how real people play games. Thor's published works include contributions to the books *AI Programming Wisdom* and *Game Programming Gems 3* (Charles River Media, Inc.). Thor is also the editor and driving force behind the book you hold in your hands, *Massively Multiplayer Game Development*.

Jason Asbarh, Asbarh.com

jason@asbahr.com

Jason Asbarh's MMP background includes a senior engineering role on *Ultima Online 2* at Origin Systems. He recently consulted for BigSky Interactive, developing the Python-based scripting and AI system of *SpongeBob Squarepants*, which shipped on the Sony Playstation 2 and Nintendo Gamecube. Before that, he developed one of the first PC-based virtual actors for Compaq, crafted virtual building walkthroughs for architects, and created educational arcade games for the Houston Museum of Health and Medical Science. Jason is currently building open-source simulation systems for PC, console, and arcade platforms.

Jason Beardsley, NCsoft Corporation

jbeardsley@ncaustin.com

Jason has been writing network and server code for online multiplayer games since 1996. He has computer science degrees from MIT and Binghamton University. Currently, Jason is employed by NCsoft Corporation and is working on a next-generation online title.

Mark Brockington, BioWare Corp.

markb@bioware.com

Mark Brockington is a lead research scientist at BioWare Corp., where he has worked for the past five years. Mark worked as the lead AI and networking programmer on Neverwinter Nights. Mark also worked on the multiplayer code for the Baldur's Gate series of games. Mark received his doctorate from the University of Alberta in 1997.

Mark wishes to thank Yahn Bernier, Mark Darrah, Scott Greig, Sophia Smith, and Preston Watamaniuk for their comments and help on early drafts of his articles.

William Dalton, Maxis

bdalton@maxis.com

Bill Dalton began working on MMP games at Kesmai in1995 after his brief stint in academia as an astronomy teacher at the University of Virginia. After working on several seminal online games at Kesmai, including most of the *Air Warrior* franchise, he moved on to Origin Systems in Austin, Texas, as the lead programmer for *Ultima Online*. Bill's odyssey continued to Walnut Creek, California, where he is currently *The Sims Online* lead server engineer.

Bill would like to thank his beautiful wife Genny, for her unending patience and support.

David Fox, Next Game

davidfox@ureach.com

David Fox works for Next Game, creating Web and wireless multiplayer games of skill. He is the author of several best-selling books about Internet technologies, and his writing frequently appears in publications on such as Developer.com, Gamasutra.com, and Salon.com. David has presented topics in Java gaming at the Sun Microsystem JavaOne conference for the past several years.

Tom Gambill, NCsoft Corporation

tgambill@ncaustin.com

Tom Gambill was swept into the MMP world by Kesmai in 1995, where he began work on several sequels to *Air Warrior*, one of the first commercial MMP games. After completing *Air Warrior for Windows, Air Warrior II*, and *Air Warrior III*, he moved on to work on the graphics engine for *Ultima Online 2*. After that, he was tasked with creating an advanced graphics engine for NCsoft Corporation's Austin, Texas, division. Currently, when he's not on a plane between the Seoul and U.S. offices, he is working on several original MMP games that will be released soon in Asia and the U.S.

Mike Goslin, Walt Disney Imagineering VR Studio

mike.goslin@disney.com

Mike Goslin has done a bit of everything in his seven years at the VR Studio, from programming and game design to pitching big ideas and pure research. Mike has worked on a variety of projects, including theme-park attractions, location-based entertainment, and most recently *Toontown Online*, an MMP designed for kids of all ages.

Ben Hanson, Sony Online Entertainment

bhanson@soe.sony.com

Ben Hanson has been involved in the development of MMP games since 1992—a time when 2400-bps modem connections were considered fast and subscription rates of $6 per hour were considered cheap. He has worked on numerous online games, including some of the early commercial successes like *GemStone III* and *DragonRealms*. Ben is now with Sony Online Entertainment in Austin, Texas, hard at work on *Star Wars Galaxies*.

Todd Hayes, NCsoft Corporation

thayes@ncaustin.com

Todd Hayes has done 3D graphics programming for games for six years on titles such as *Ultima IX: Ascension*. Prior to games, he worked on projects like the Video Toaster and Lightwave 3D. He currently lives in Austin, Texas, with his wife, Patricia, where he is working at NCsoft Corporation on Richard Garriott's *Tabula Rasa* project.

Christian Lange, Origin Systems

clange@origin.ea.com

Christian Lange has spent 12 years as a senior and lead programmer for everything from government contracting to creating MMP games. He has a diverse skill set in several areas of game development with primary knowledge in database server programming. Now into his fourth MMP game, he continues to work on server infrastructures designed to support hundreds of thousands of players. It's a lot of challenging work, but the fans make it all worthwhile. He would like to give thanks to all the fans out there that make this job so much fun.

Jay Lee, NCsoft Corporation

gunner10@austin.rr.com

Jay Lee came into the game industry after a 10-year career with EDS, serving clients such as General Motors, Exxon, and Sprint in their information-technology needs. He started as a programmer with Sierra and contributed to titles such as *Gabriel Knight 2*, *Betrayal at Antara*, Colliers Encyclopedia, and *Swat 2*. He entered the world of online multiplayer games when he joined Origin Systems, working as the database programmer and scripting lead on *Ultima Online 2*. In his current assignment, Jay serves as technical lead and database programmer for an online title for NCsoft Corporation in Austin, Texas.

Jay is grateful to his Savior, Jesus Christ, for the gift of life and the provision of his wonderful wife, Jenni, and three special girls: Shaney, Shannon, and Shawna.

Glyph Lefkowitz, Twisted Matrix Labs

glyph@twistedmatrix.com

Glyph Lefkowitz is the Twisted Matrix Labs project leader. His MMP game experience includes work on *Ultima Online 2*. Glyph is an independent consultant, helping organizations develop and deploy Twisted and other open-source solutions on departmental to worldwide scales. In spearheading the Twisted project, Glyph leads a team of 19 developers and manages all parts of the development process, from high-level design to remote object protocol and low-level event loop programming.

Paul McInnes, Micro Forte

paulmc@syd.microforte.com.au

Paul McInnes is a social anthropologist and gamer with a long-standing professional interest in online communities. He has been working in the game industry since 1998. He was lead world builder on *Fallout: Tactics*, producer and designer on *Hot Wheels Bash Arena*, and is currently the lead designer for *Citizen Zero* at Micro Forte.

He would like to thank Brit, for her endless patience and support.

John M. Olsen, Microsoft Corporation

infix@xmission.com

John M. Olsen started working on graphics software of various sorts long before graduating from the University of Utah in 1989, and is now working for Microsoft developing tools used internally for creating both Xbox and PC game titles. He has contributed to the *Game Programming Gems* series (Charles River Media, Inc.), and has spoken at the Game Developers Conference. His interests include autonomous AI, stereographic image production, networking, and the organization and analysis of data.

John would like to particularly thank Jay Barnson and Bryan Brown for kicking around more game ideas and features than could possibly be numbered.

Sean O'Neil, Contract Developer for Maxis

s_p_oneil@hotmail.com

Sean O'Neil received a B.S. degree in computer science from Georgia Tech in 1995. Since then, he has worked full time for a telecommunications software company based in Atlanta, Georgia, which is where he currently lives with his wife and two children. Sean started working on his fractal-based planetary engine in his spare time in 2000. He published his first online article on GamaSutra.com in 2001. A developer at Maxis saw the article, and now Sean has a part-time contract for Maxis in addition to his full-time job.

Sean would like to thank everyone at Maxis for giving him the opportunity to get this far, and for being very generous in allowing him to publish much of the work he has done for them. They really are a great group of people to work for. Last but not least, Sean would like to thank his wife, Terri. Although she has the occasional urge to throw his computer through the window, she hasn't actually done it yet, and overall, she's been a very good sport about all the late-night work.

Javier F. Otaegui, Sabarasa Entertainment

javier@sabarasa.com

Javier F. Otaegui is project leader for Sabarasa Entertainment, an Argentine game-development studio based in Buenos Aires. He's been creating games since 1996, when he started *Malvinas 2032*, a local success. Nowadays, he is leading out-sourced projects for American customers and developing a commercial MMP game for his local audience.

Jay Patterson, Microsoft Corporation

jaypat@centurytel.net

Jay Patterson got his B.S. in computer science from Gonzaga University in 1988. He got into games in 1997 when he took over lead programming on an MMP game called *Castle Infinity*. After a brief stint with Web-based fantasy sports, he followed his multiplayer Zen master, Rick Lambright, to Cavedog. There he worked on The Boneyards for *Total Annihilation*, a game service designed to enhance and give more persistent context to peer-to-peer Internet play. Then, not wanting to be left out, he had his dot.com year, leading the technical design of an MMP, 4X space RTS, and helping build an online game download service. Currently, he's back where he started at Microsoft, this time working on Xbox Live instead of LAN Manager. Jay can't wait for console multiplaying to grow a huge player base.

Jay wishes to thank Rick Lambright for showing him the light, Pete Isensee and Bruce Dawson for their encouragement to stay in it, and the late Judy Johnson for the confidence to do so. Most importantly, he'd like to thank his family (Paula, Jimmy, Amy, Kelly, and Becky) for helping him remember how much more there is to life than work.

Patricia Pizer, MMP Design Specialist

ppizer@earthlink.net

Patricia Pizer's debut in the game industry was at Infocom in 1988, making games back when you didn't even need graphics. Most recently, she was the lead designer and then creative director of *Asheron's Call 2* at Turbine Entertainment Software. Currently, Patricia consults for several large publishers as an MMP design specialist and works with other game designers to examine some of the most pertinent design issues today. She is a founder and advisory board member of the Boston Area Game Developers' Network, and she serves on the board of directors of Zform, developers of game software for the visually impaired. Mostly, though, she just likes to play games.

Patricia wishes to thank Michael Steele, cheerleader, editor, and director of online operations for Ubisoft, North America, and an all-around terrific guy.

Sean Riley, NCsoft Corporation

srileyX@ncaustin.com

Sean Riley has been in the game industry since 1997, before which he worked on database server technology and multitiered server architectures for Web services. His shipped multiplayer titles include the first-person shooter, *Vigilance* and the massively multiplayer *10Six* from Sega.com. He also put in a stint at Origin Systems. He is currently a developer at NCsoft Corporation in Austin, Texas, working on a next-generation online title and participating in open source development.

Artie Rogers, Inevitable Entertainment

awrogers@texas.net

Artie 'BEAST' Rogers has been working on design and support for commercial MMP, PC, and console games since 1995. His most-recent MMP project was as a designer for *Ultima Online 2*. Artie is currently working as a designer for Inevitable Entertainment on *The Hobbit*, a console game that will be published by Sierra.

Paul Sage, NCsoft Corporation

psage@ncaustin.com

Paul Sage began his career in the game industry as a support technician for Origin and Electronic Arts. He moved on to a QA position, working on games such as *Crusader* and *Wing Commander IV*, eventually becoming a QA lead. Later, he began testing *Ultima Online*, moved to the support staff upon launch, and eventually supervised the GM department. From there, he went into a design position on *Ultima Online* to eventually become the lead designer during a period of growth from 175,000 players to 240,000 players. He has been involved as a professional in MMP games for six years and is an avid gamer. In 2000, Paul went to work on *Tabula Rasa* for NCsoft Corporation.

Derek Sanderson, Westwood Studios

gamedesigner@aol.com

Derek 'Windfeather' Sanderson has been designing commercial MMP games since 1995, and his designs and code exist in five live titles. His most recent project was *Earth & Beyond*, a space-based MMP developed by Westwood Studios for Electronic Arts. Derek is now a senior designer at Micro-Forte, a MMP developer based in Sydney, Australia, and may be contacted via email at *gamedesigner@aol.com*.

Derek wishes to thank Emily Jacobson, good friend, ruthless editor, and program manager for the games community on America Online, for her assistance in preparing this article.

Jesse Schell, Carnegie Mellon University

jns@cs.cmu.edu

Jesse Schell is a professor of entertainment technology at Carnegie Mellon, specializing in game design. Formerly, he was creative director of the Walt Disney Imagineering VR Studio, where his job was to invent the future of interactive entertainment for the Walt Disney Company. Jesse worked and played there for seven years as designer, programmer, and manager on several projects for Disney theme parks and DisneyQuest (Disney's chain of VR entertainment centers). His most recent work at Disney involves the design of family-friendly massively multiplayer worlds, such as Disney's *Toontown Online*. He came to the CMU Entertainment Technology Center to impart real-world experience and to build exciting new things. He has a B.S. in computer science from Rensselaer, and an M.S. degree from Carnegie Mellon. In a previous existence, he was writer, director, performer, juggler, comedian, and circus artist for both Freihofer's Mime Circus and the Juggler's Guild.

Jesse wishes to thank everyone who helped bring *Toontown* to life, sticking by it even when it looked like the Cogs might win.

Joe Shochet, Walt Disney Imagineering VR Studio

Joe.Shochet@disney.com

Joe Shochet is currently lead game designer and programmer on Disney's *Toontown Online* at the Walt Disney Imagineering VR Studio. Before working in the MMP genre, he helped design and build award-winning, location-based virtual-reality attractions for DisneyQuest and Disney theme parks.

Matthew Walker, NCsoft Corporation

mwalker@softhome.net

Matt Walker has been programming client-server applications since 1994. He has developed commercial software for NCR, BellSouth, and Lexis-Nexis. He began his career in game development with Origin Systems in 1999. Unbelievably, it seemed they wanted someone with software engineering skills even more than they wanted experienced game programmers. He now works for NCsoft Corporation on the *Tabula Rasa* MMP project and has vowed never to take another real job. He has developed server game code in Python and C++, implementing diverse systems, such as inventory, object manipulation, crafting, collision-detection and walkable surfaces, scripting environments, scriptable game building blocks, event registration and dispatching, and miscellaneous tools. His technical philosophy emphasizes an engineered approach, utilizing a variety of methods, including use cases, UML (Unified Modeling Language), and unit testing. He has a Bachelor's degree in finance from the University of Texas and has completed work on a Master's degree in computer science at the University of Dayton, which has most likely reached its extent of completion, as writing games in Austin is a much cooler way of life than coding Web applications in Dayton.

MMP DESIGN TECHNIQUES

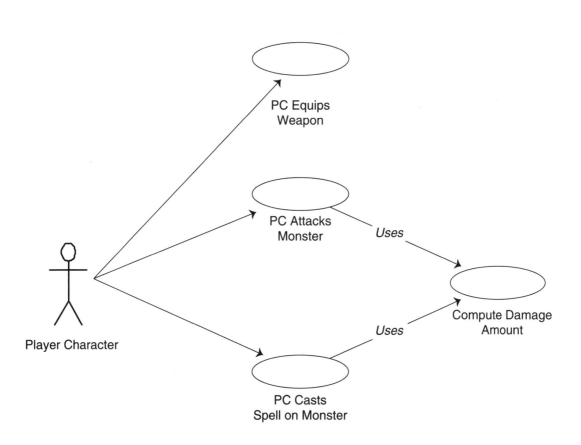

1.1

TOONTOWN ONLINE: BUILDING MASSIVELY MULTIPLAYER GAMES FOR THE MASSES

Mike Goslin, Joe Shochet, and Jesse Schell, Disney

Mike.Goslin@disney.com, Joe.Shochet@disney.com, Jns@cs.cmu.edu

oontown Online is a Massively Multiplayer (MMP) online game designed for kids. Players create their own cartoon character and join up with thousands of players to save Toontown from the 'Cogs', an invading army of business robots that are transforming the colorful streets of Toontown into row upon row of dull, gray office buildings. Toons battle the Cogs by pelting them with cream pies, squirting them with seltzer bottles, and dropping anvils on their heads.

The challenge of *Toontown Online* was to build an MMP for a mass audience. What follows is a description of some of the specific problems that were faced while attempting to build an MMP with broad appeal. The problems fall into two major categories: game design and social considerations. The final section of this article describes the concept of RPG-lite, a role-playing style of gameplay that has been simplified to appeal to a broad audience, as a good solution to many game design problems. Similarly, the social problems can be addressed by simplifying the typical community elements of MMP design.

Game Design Problems

Problem: Parents Have to Be Sold on the Product Too

Unlike an ordinary video game for kids, where parents have virtually no involvement after the game has been chosen and purchased, MMP games for kids have several features that require continuous parental involvement. Parents purchasing an MMP have to:

- Pay up-front costs. This part of buying an MMP is the most like buying a traditional video game. With an MMP, however, it is just the beginning.
- Pay for an ISP (Internet Service Provider). No ISP, no MMP.
- Pay continuing MMP subscription costs. Kids generally do not have credit cards. If your MMP is going to have continuing subscription costs, parents will have to foot the bill for this on an ongoing basis.
- Accept that the kids will be using the Internet frequently. In many homes with just a single phone line and a dial-up ISP, Internet usage is occasional and is done in short bursts. When buying an online MMP for their kids, parents have to accept that the kids may be tying up the phone line whenever they are playing the game.
- Feel that the MMP is a safe environment. Many parents have significant (and justified) concerns about letting their children use the Internet. Parents have to go to the trouble of learning enough about your MMP so that they can feel comfortable that it is safe.
- Feel that the MMP is a worthwhile investment. Parents have to learn enough about your MMP to feel that it is of good entertainment value.

This is a lot to ask from parents both in terms of time and money. In order to get them to go along with the purchase, a good strategy is to make an MMP that the parents can enjoy right along with the kids! Here are some strategies we used to do just that.

Make a Game Simple Enough That Both Kids and Adults Can Enjoy It
Kids need simple games, and many parents need even simpler ones. By focusing on simplicity, you stand a good chance of creating something both kids and adults can enjoy.

Leverage a Trusted Name
The Disney™ name, for example, communicates to parents that the world is a safe, high-quality environment. (More about safety will be covered in the Social Problems section.)

Enable Parents and Kids to Share a Character
We intentionally designed the gameplay 'punishments' in *Toontown* to be as painless as possible. A player never loses anything that can not be regained with a little bit of patience. An unintended side effect of this is that two players can share a character and never have to worry that the other player is going to 'mess up' the character. This means that a parent and child can have the rewarding experience of taking turns and building a character together.

Use Stories and Themes That Work on Multiple Levels

Toontown, of course, has many comedic elements. One of the goals for *Toontown* was to capture the feel of 1940s-era cartoons, which could be enjoyed by adults and children alike. This required jokes and situations that could be appreciated on multiple levels. We tried to put in a lot of slapstick humor for the kids, and also office humor that adults could appreciate. There was initial concern about including jokes that might go over the heads of younger kids, but we found that inserting grown-up humor has multiple benefits. It keeps adults interested and amused, it facilitates communication between kids and adults (the kids want to be in the jokes, too; so they ask their parents), and it makes the kids feel like they are being treated as adults, rather than being patronized.

Many Hardcore MMP Gamers Have Kids

Pity the hardcore MMP gamer who has a family: he loves playing his game, but he cannot share this hobby with the rest of the family due to violent content, complexity, or the large time investment that is required. If you can give this person a game he likes and that he can confidently share with his kids and spouse, he will become a huge advocate for your game.

Problem: Conflict Is Essential, Yet Violence Is Forbidden

Creating an MMP for the mass audience (and for families in particular) has some special challenges. While it is nice to imagine a happy game world where all the players just walk around beautifying their environment and doing nice things for each other, the truth is that to create an interesting world, some kind of conflict is required. The challenge is to make the conflict meaningful and important to players, but not so intense that it turns away crucial segments of your audience, such as parents or girls. We found several ways to approach this problem.

PVP? Forget About It!

By far, the game element most likely to cause bad feelings in your subscriber base is player-versus-player combat. We chose not to include it at all, since it goes against the feelings of cooperation and teamwork that we wanted Toontown citizens to enjoy. If you must include this kind of gameplay, you would be wise to make sure it is only for advanced players who participate by choice.

Work vs. Play

Since we decided that the characters of Toontown, the Toons, would not be in conflict with each other, we needed someone with which they *could* be in conflict. Realizing that we wanted Toontown to be a fun place to play, a natural enemy would

be someone who wanted to work all the time. We came up with the story of the Cogs, an army of business robots that want to take over Toontown and turn it into office buildings. It was an important distinction that the Cogs' main goal is to eliminate the Toon buildings, not necessarily the Toons themselves. This story creates a conflict that requires the players to band together in order to save their town.

Cartoon Battles

Instead of the standard attacks that many games feature, we opted for a theme of traditional cartoon practical jokes, such as letting Toons throw cream pies, squirt seltzer bottles, toss banana peels, and drop flowerpots on their enemies. The Cogs fight back with office-related humor, such as red tape, bouncing checks, and squirting fountain pens. This gave us a very unique battle system that has all the strategy of a traditional RPG battle, but with none of the realistic violence that can be a turn-off for the mass market. Figure 1.1.1 shows an example of Toontown's cartoonist combat in action.

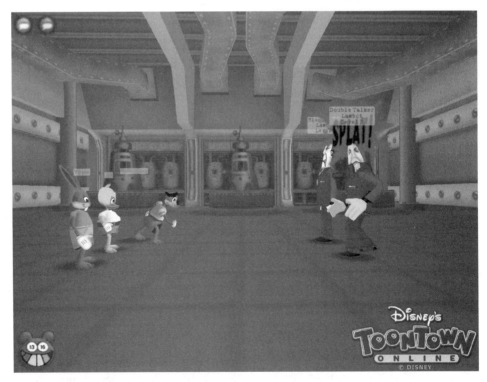

FIGURE 1.1.1 *Toontown features cartoon battles with robot enemies.* © 2002. Reprinted with permission from the Walt Disney Company.

Robot Enemies

It is something of a cliché, but it is true. Destroying imaginary robots is less violent than destroying imaginary life forms. We made sure to make it very clear through visual and sound effects that when an enemy was defeated, it was a robot and not a living creature.

Life Meter? No, Laff Meter!

Traditional RPGs use a 'life meter' or number of 'hit points' to communicate how close to death your character is. These did not seem like very good metaphors for *Toontown*, so we created the 'laff meter,' which tells how happy your Toon is. Too many hits from a Cog makes your Toon sad, and when the laff meter reaches zero, your Toon is too sad to keep fighting, and is sent to a nearby playground to cheer up. This is really a rather subtle change to the traditional life meter system, but it really helps take the violent edge off of the combat.

Fight Enemies for the Right Reasons

Many games let players take 'treasures' from defeated enemies. We generally avoided this in *Toontown*, because it is one thing to defeat an opponent to prevent him from taking over your town, and it is altogether a different thing to defeat him so that you can take his possessions. There were exceptions to this, such as cases where defeating a Cog lets you reclaim an item that was stolen from another Toon.

Teamwork, Not Lone Vigilantism

Letting the players team up in small groups against opponents enables them to feel more justified than when fighting alone. In addition to protecting yourself, you are fighting to protect the others on your team.

Problem: Too Many Choices Can Overwhelm the Player

A traditional MMP game lets the player create their characters and then just puts them out into the game world. It is then up to the player to discover what they need to do next. Casual gamers are often frustrated by this lack of structure. Since these same players are often unwilling to read a lengthy manual, the best approach is to build an instructional structure into the game itself.

Tutorial

A much better solution is to gradually lead the player into the depths of the game, starting out very simply, with very few choices, and gradually offering more choices to the

player as they learn their way through the game. *Toontown* features an integrated tutorial and quest system that gradually transitions the player through the following steps:

1. Single player, noninteractive tutorial
2. Simple tasks that must be completed as part of the single-player tutorial
3. Introduction to multiplayer features through an interactive tutorial
4. Exposure to the multiplayer world, while performing simple tasks
5. Simple multiplayer tasks (making friends)
6. A series of gradually more-complex game tasks selected by the player and completed in the order that the player prefers

For most players, the tutorial will be their first taste of the game, and a designer only gets one chance to make a good first impression. Be sure to schedule enough time to design the tutorial wrong a few times, because you will. Weaving the tutorial into the game is a difficult design challenge, but it is well worth the extra effort of design, implementation, and play-testing that it takes.

Quests

In *Toontown*, we decided to give the player a series of explicitly stated quests throughout the course of the game so that there would not be any question about what the player was supposed to do. We even provide a 'quest page' that clearly shows current quests, quest requirements, and current progress. To personalize the experience for each player, though, we implemented a tiered quest pool system, so that each player can choose from randomly selected quests. When the player has finished enough quests in one tier, they graduate to the next tier, which features more-difficult quests. As the player advances, they are allowed to work on multiple quests simultaneously.

While long-term goals (e.g., drive the Cogs out of Toontown) provide good context for the player, it is the series of short-term quests (e.g., bring this bread to the baker, defeat three pencil-pusher Cogs) that make the game addictive. However, climbing the same quest ladder all the time can grow tedious, so we found it useful to have more than one way to progress in the game. In addition to the quest system, which gives out many of the progress rewards, such as improved laff meters and larger jellybean jars, there are other ladders, such as a separate ladder for experience gained in battle. The battle ladder is completely separate from the quest system and gives out a different set of rewards (new types of gags). There is also a 'fishing ladder' that helps players recover lost laff meter points. Although players will often find themselves climbing more than one ladder simultaneously, the ability to shift focus from one ladder of achievement to another helps keep the game interesting and gives it variety and depth.

Problem: The Audience Is Impatient for the Fun to Begin

Hardcore gamers will put up with a lot in order to play a game. Casual gamers want to start enjoying their game right away. The quest system described above helps lead players toward the fun elements of the game, but *Toontown* also tries to inject fun into some of the more-mandatory aspects of an MMP.

The Download

While *Toontown* is downloading, instead of asking the player to stare at a load bar, we created a simple Flash movie and game for players to enjoy while they are waiting for the initial download to finish. This was also a good chance to introduce some of the game elements and back-story.

Create-A-Toon

Designing your avatar is an amusing game of mix and match. Even picking a name (in some MMP games, a frustrating experience involving multiple, rejected names) is fun due to the 'funny-name generator' that suggests all kinds of crazy Toon names.

Teleporting

The act of teleporting is necessary to get around quickly. *Toontown* makes the act whimsical by using 'portable holes.' Toons pull a portable hole out of their pockets, jump in, and pop out another hole at their destination, as shown in Figure 1.1.2.

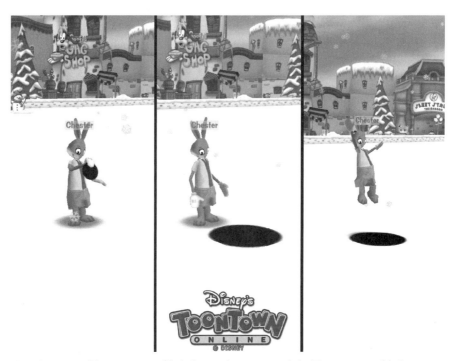

FIGURE 1.1.2 *Toons use portable holes to teleport around the Toontown world.* © 2002. Reprinted with permission from the Walt Disney Company.

Problem: The Mass Audience Is Afraid to Fail, Especially in Public!

Casual gamers are discouraged rather than challenged by early defeat. In an MMP where strangers are watching you, failing is all the more humiliating. We used several strategies to overcome the fear of failure and to build the player's confidence.

Guarantee Victory

The *Toontown* tutorial initially leads players through a rigged battle that is impossible to lose. This shows the player what to expect later on and helps build confidence. Players find it easier to engage in the same activity later in a more public environment.

Watch Me First

One of the features of our turn-based combat system is that a player can walk up to and observe other battles going on without having to fight in the battles themselves. This helps the more timid players know what to expect in more advanced battles. We found that younger players especially are afraid of getting into a battle when they are not sure how battles work. Watching someone else do it first really helps to build their confidence. This is the same strategy often used by arcade gamers; they observe others playing before dropping in their own quarters.

Emphasize Teamwork

For many casual gamers, the idea of head-to-head competition is threatening, stressful, and unappealing. They prefer to cooperate. In *Toontown*, we worked hard to put in game systems that allow players to team up in useful ways, and we only put in a few ways that players compete with each other directly.

Newbies and Experts Play Together

Include valid ways for newbies and experienced players to play together to their mutual benefit. This encourages socialization between them, which builds the confidence of the newbies and gives them something attainable to aspire to. Many expert players enjoy the process of guiding newbies into the mysteries of the game, so facilitating this kind of gameplay really has multiple benefits. Our minigame system was designed so that players of any levels could play together and still benefit from it. There are also elements of this in the battle system. In a group battle, the Cogs will tend to attack the more experienced players in the group, which gives the newbies some protection.

Problem: The Mass Audience Can Be Overwhelmed by Complexity

Most RPGs and MMP games are very complex. The paradigms and techniques of traditional RPGs are very effective. We have found it useful to modify and adapt them to make them simpler for the mass market. Here are some good ways to do this.

Avoid Numerical Stats

Numerical stats break the player's immersion in the game and are less-easily grasped by most players than graphical representations of numerical data. Sometimes, of course, numbers are the only good answer; but use them as a last resort.

Redundancy Is OK, OK?

Redundancy is good when it clarifies things for the player. For instance, our laff meter shows numerical data for how many laff points a player has in the eyes of the meter, and the number of teeth in the meter show the same data but in a graphical format. This lets the player quickly determine the approximate health of his character at a glance; and by looking more closely, he can find out the exact state of his health.

Inventory Should Be Finite

Many games show the inventory of items as an open-ended list that it is up to the player to sort and manage. It often means a lot of scrolling around to find what you want. We decided we would only have a fixed number of possible battle items, so we arranged them on a single screen grid with a grid square allocated for each item type, as shown in Figure 1.1.3. It is less work to manage and makes it easy for the player to see what items he has, since a specific type of gag is always in the same place.

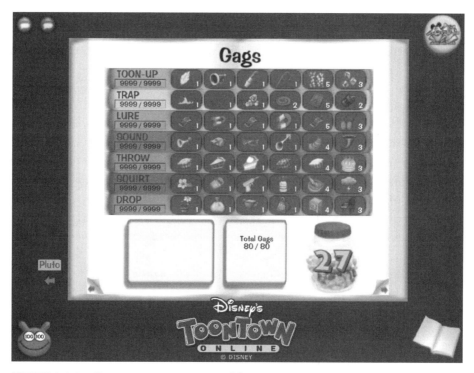

FIGURE 1.1.3 *Inventory items are arranged for easy management in Toontown.* © 2002. Reprinted with permission from the Walt Disney Company.

Merge and Unify

We took the inventory grid system one step further: we used it to unify the combat, purchasing, inventory management, and experience interfaces—since all of them operated on the same set of items. As a result, players need only learn slight variations of a single interface rather than four unique interfaces.

Avoid Weird Keystrokes

The mass audience has never played the PC game *Quake*. They do not know what 'strafing' is. If you must use keyboard controls, make them as simple as you can. If they are much more complicated than the controls for *Tetris*, you should try harder to simplify them.

Use the Familiar

When you have to introduce a new kind of interface, try hard to make it look like something the players have seen before. The *Toontown* logon screen resembles a Web page, because people are used to logging onto Web pages. The avatar control resembles that of a 3D platform game, because *Toontown* shares many features with a 3D platform game. The *Toontown* friends list resembles an instant-messaging buddy list, because many people are already familiar with that kind of interface.

Hide What You Can

Toontown players are not required to know which server they are playing on or even what a server is. We let the computer pick a server for you, and we automatically log you back onto the same server each time you play. Players may choose to use the server-switching interface to switch to new servers, but players who do not care what server they are on never need to know about switching.

Exploring Should Be Fun

The game world should be designed so that people can find their way around easily. Finding your way around a badly designed game is not fun for the mass audience. In *Toontown*, we removed loops (intersections that let players accidentally go back the way they came) from the streets, because loops just confused people. We also avoided putting in dead ends whenever possible, because it is no fun to have to turn around and go back the way you came. If players need to make maps to find their ways through your world, your space is poorly designed.

Do Not Oversimplify

Some complexity is necessary for a deep game with many hours of gameplay. Make the complexity gradual. Your game should abide by the old *Othello* slogan: "A minute to learn, a lifetime to master." Show the complexity too early, and the players will be

overwhelmed. Save it for later, when they are able to appreciate it. In *Toontown*, the battle system is very complex indeed, but most of the complexity is either hidden, waiting for the players to discover it, or it is not exposed to the players until they have reached a certain experience level.

Problem: The Audience Often Plays Only for Short Stretches

Kids today are busy. They have homework, soccer practice, favorite TV shows, and early bedtimes. Adults are even busier! The mass audience often does not have three or four hours at a stretch to play your game—they very often only have 20 or 30 minutes. In many MMP games, this is barely enough time to log on and find another player to play with before you have to log out. We used several techniques to engineer our game in such a way that players would be able to have a useful play session even if they only played for 20 minutes.

Explicit Goals Save Time

By giving the players very clear goals with our quest system, and by reminding them of the goals through our quest page, players spend less time wandering around trying to figure out what they are supposed to do and less time trying to remember what they were doing last time. Instead, they can focus right away on a clearly specified goal.

Measurable Progress Allows for Short Sessions

By giving the players a yardstick for their progress, they can get a sense of accomplishment for just completing a small action. The quest page shows not just which quests have been completed, but your current progress on each particular quest. For example, say you are currently on a quest to defeat five Lawbots. The quest page indicates you have defeated three out of five Lawbots. Defeating the fourth one will feel like a significant accomplishment because it will change the display on the quest page.

Well-Defined Activities Help Time Management

When players know how long a certain type of activity will take, they can manage their entertainment experience a little better, because it is easier to pack multiple activities into a constrained time period. In *Toontown*, we tried to have activities that took different amounts of time so that players could play differently, depending on how much time they had. Some examples:

- **Fishing:** One-minute activity or more
- **Minigames:** Two-minute activity or more
- **Street Battle:** Three- to five-minute activity

- **Item Delivery:** Three- to five-minute activity
- **Building Battle:** Ten-minute activity

Find Friends Fast

One way MMP players waste a lot of time is in trying to find their online friends. In *Toontown*, we provide a friends list that shows which of your friends are online right now. Furthermore, we give you the ability to teleport to them! This way, you can get right to having fun with your friends.

Exit Anytime

In some MMP games, if you log off in a dangerous area, you will find yourself back there the next time you log on—or even worse, your character hangs around, susceptible to attack for a minute or two after you have logged off! As a result, players must allot 5 or 10 minutes to get back to a safe location before logging off. In *Toontown*, you can log off at almost any time, and your avatar leaves the world immediately. Next time you log on, your avatar will appear in the nearest playground, and his safety is ensured.

Social Problems

One of the challenges with developing a massively multiplayer game is that designing, building, and balancing the core gameplay is only half the work. As a developer, you must be concerned with the 'whole product,' including chatting, grouping, Internet safety, Children's Online Privacy Protection Act (COPPA) compliance, and social metagaming. Because you are inviting players into your product, the problems that you allow players to create become your problems. The mass market has a low tolerance for these social nuisances. When a gamer is already outside of their comfort zone by playing a game online, one or two small social problems could mean the difference between renewing and canceling their subscription.

Problem: Audiences Have a Low Tolerance for 'Griefing'

Griefing is the act of repeatedly annoying other players solely for the sake of degenerating the integrity of the game world, even when it gives the griefer no personal gain in the game. We designed every system in *Toontown Online* to minimize the effects of griefing. Some specific examples follow.

Name Filter

The most common form of griefing we experienced during beta testing took the form of trying to fool the name filter. Every Toon's name had to pass through an extremely

rigorous automatic filter. No automatic filter is perfect however. The filter allowed names that were bad words in foreign languages, spelled backwards, spooncrisms, phonetic spellings, and others. A small percentage of players made a game out of trying to fool the name filter until the game masters caught them and renamed them. When caught with a bad name, the Toons were renamed a very drab Cog-like name, such as "Toon45782" or "Toon20034." We eventually came to the conclusion that no completely automated name filter would be able meet our needs, and now we have humans in the loop.

Pushing Toons

Another form of griefing we found was that players literally pushed other Toons around in the game. If you leave your Toon inactive for a few minutes, the Toon falls asleep. While asleep, the game is still running physics and collisions calculations on your local client, which means other Toons are able to slightly nudge you. With practice, 15 minutes, and a friend or two, you can actually push a sleeping Toon out of a safe area, onto the street, and into a battle that they will surely lose if left unattended. Since this form of griefing is easily prevented by not leaving Toons unattended, we decided this grief was not as bad as making Toons unpushable, which would result in the ability to chain multiple Toons together to completely block access to doors or other important game features.

Problem: Audiences Have a Low Tolerance for Real-Life Social Problems

In *Toontown*, we chose not to implement any stealing, hoarding, player-versus-player battling, or true commerce systems. We decided not to have any intrinsic race or class differentiation. We decided early in the design to keep the focus on fun, and always remember we were building a game, not a simulation of real life. As a result, players do not suffer any permanent damage to their Toons while playing the game. This enables parents and kids to share accounts without worrying that one or the other will be robbed, give away valuable items, lose status, or otherwise set back their account.

Problem: Parents Are Nervous about Their Kids Being on the Internet

When making an online game for the mass market, special consideration must be given to online safety. Since the ability to communicate with other players in an online game is a large part of why people play, a safe form of communication had to be found in order to make the game successful. We felt it was unsafe to allow open chat between all players; but it was equally unacceptable to completely block chat altogether. Instead, we developed several systems that facilitate safe chatting among players.

Menu-Based Chat

We developed a menu-based chat system that uses canned phrases to communicate between players. This works well on many levels. Menu-based chat is safe because you cannot divulge personal information. Players that are slow typists can communicate quickly without spelling, punctuation, or capitalization worries. Menu-based chat eliminates the acronyms, slang, and jargon that make MMP games intimidating to new players. We also made the menu dynamically update based on your progress through the quest system. Because the majority of chat phrases on the menu are positive and friendly in nature, strangers tend to be quite friendly people in Toontown. This phenomenon is supported by cognitive dissonance research that shows that attitudes are indeed affected by behavior. In fact, merely making statements contrary to your attitude can produce actual changes in attitude.

Password-Protected Chat

Menu-based chat can be quite limiting when a player wants to chat with somebody in the game that they know in real life. To facilitate this exception to the no-open-chat rule, we implemented the 'secret friends' system. This allows players to generate a password that can be given to a real-life relative, neighbor, or friend. Once the friend enters the password, the game enables a chat channel that only the two friends see. Because there is no way to swap passwords in the game, we ensure that everyone using the system has met outside the game. We also take extra precautions by only allowing passwords to be used once (i.e., one password per new secret friend), invalidating them 48 hours after issuance if they have not been used, and capping the number of secret friends any single player can have.

Problem: Gameplay and Social Features Are Often at Odds

The primary reason players return over the long-term is for the social experience. This means that the social features are at the same or even higher priority than the game features. With this in mind, we tried hard never to let a game feature block a social feature; but if it did, it was for a strategic reason.

Never Block Friends

At almost every point in the game, you can chat with friends around you or send a message to a distant friend. You can also teleport to a friend you have made in the game at any time, with the exception of special battles where we trap the player to increase the risk factor.

Social Interfaces

We tried to make all our interfaces 'group-friendly.' While choosing an attack in battle or purchasing inventory, you can see the interactions, status, and chat windows of all members in your group. We made every state of your character (e.g., fishing, checking your inventory, or sleeping) a distributed state so that all other players see exactly what you are doing. We implemented in-world, cartoon-style word balloons. These prevent players from having to divert their attention away from the game world in order to read a chat log. Reading a chat log while trying to play a game is as annoying to the mass audience as reading subtitles while watching a movie.

Cooperative Minigames

At first, we tried to strike a balance between competitive and cooperative minigames. We assumed that the natural greediness of players would ensure a proper competitive atmosphere; and often it does. What we did not realize, however, was that when *groups* play minigames together, the primary goal is not for a single player to get as many points (jellybeans) as possible, but rather for the entire group to fill their pockets. Competitive games degenerate into passive turn-taking so that each player can win, getting the most points possible, one at a time. Therefore, in a four-player group, each player can be assured that after playing four minigames and taking turns winning, the group will be full of jellybeans. Cooperative minigames do not suffer this pitfall, since cooperation is consistent with the shared goal of earning jellybeans. After we learned this, we strived to integrate cooperative elements into the minigames whenever possible.

Problem: Many Children and New Players Are Initially Shy

By nature, many children are shy, and adults new to an MMP do not fully know what to expect or what is expected of them. Being vested in the community, however, is the most addictive part of an MMP. To help bridge the gap from new player to full-fledged member of the online society, we designed in some important social features.

Lightweight Grouping

Easy grouping with other players lowers the barriers to initiating relationships. We decided not to have explicit, rigid grouping in the game, but instead opted for a model where anyone could effortlessly team up for a short time for a specific task. To do this, we made grouping an implicit part of the layout of the world. For instance, there are four player slots on the minigame trolley and battle systems. Playing a minigame or joining a battle with a stranger is as simple as hopping on the same trolley or walking up to the same battle. No verbal communication or preplanning is required.

Ice Breakers

We all learned from summer camp and youth church groups that ice breakers help stimulate the conversations that spark friendships. In *Toontown*, activities such as minigames, fishing, and Cog battles are all designed to help break the ice.

Shared Conflict

Nothing binds players together like a shared conflict. The quest system gives out quests that tend to have overlapping goals with other players in the same region. Because of this, while wandering the streets, a player is likely to find other players with the same or similar quest goals. Since the nature of the battle system encourages multiplayer cooperation, it is very easy to bond with other players while fighting the common enemy.

Friends List

To keep track of friends over the long term, we developed an integrated in-game friends list. Using the friends list, you can see which friends are online, where they are, teleport to them, and send them chat messages.

Conclusion

The primary design goal of a mass-market MMP is to keep people playing the game long enough to become invested in their avatars and establish ties to the online community. The traditional RPG model is very good at rewarding players for investing in their avatars and can support extremely long-playing game designs. Unfortunately, many examples of this genre are intentionally difficult to master and expose as much complexity to the player as possible in order to appeal to a hard-core gamer audience. If complexity is initially hidden from the player and the difficulty level is sufficiently low at the start, an RPG-lite model can be used effectively to develop a mass-market MMP.

RPG-lite principles can be applied to all aspects of game design. The guiding philosophy should be to never let the RPG framework get in the way of a player having fun. What follows are a few rules of thumb regarding the application of RPG-lite principles.

- **Let the excitement begin right away.** The mass audience does not possess the same level of patience as the hard-core gamer, so the first 15 minutes of gameplay must be rewarding and fun. In *Toontown Online*, one of the most exciting experiences is fighting a battle, and the tutorial leads players into an initial battle within minutes. This initial battle is impossible to lose and will hopefully embolden the player to join other battles once he or she has progressed beyond the tutorial.

- **Avoid forcing a player to make uninformed choices.** Typical RPG designs make players choose, for example, between being a wizard or a knight or a thief. This choice affects the abilities and limitations that the player will encounter later on in the game. Hard-core gamers typically have preconceived notions about the implications of being a wizard as opposed to being a knight, but the mass audience lacks this intuition and will be frustrated when they later discover that they should have chosen a different vocation. *Toontown Online* avoids this problem by separating game abilities from the initial character choice. Whether you choose to be a dog, cat, or duck, your abilities will be determined later by how you play the game.

- **Gameplay should dictate geography, not the other way around.** The mass audience needs direction about what activities are available in different physical spaces. If you want players to congregate, put in a clearing or a visible landmark. In *Toontown Online*, a dock on the shoreline indicates that a pond is fishable.

- **Play sessions can and should be short.** The mass audience is not generally willing to spend three straight hours to accomplish a game goal, so break tasks into subtasks and allow measurable progress in smaller increments. Players can accomplish meaningful objectives in *Toontown Online* in as few as 15 minutes.

- **Allow and encourage players to be spectators.** The community features of an MMP can also be modified to appeal to a broad audience. MMP players can learn tactics by watching others, so the community can effectively train itself to play the game better. The mass audience is often intimidated by new modes of gameplay when they first encounter them, so give them the opportunity to observe others. In *Toontown Online*, most of the battles happen in the middle of the street, in front of everyone.

- **Teamwork is often more rewarding than individual accomplishments.** The long-term goal of an MMP is to strengthen the bonds between players, so gameplay should encourage cooperation whenever possible. Nearly every activity in *Toontown Online* is designed for a group of players; and when they cooperate, players are rewarded with point bonuses and other strategic benefits.

Building an MMP for the masses can be both challenging and rewarding. It is important to never forget who your players are and to keep the RPG-lite design principles in mind. The result is a game with staying power and broad appeal.

1.2

EVERYBODY NEEDS SOMEBODY: PRACTICAL ADVICE FOR ENCOURAGING COOPERATIVE PLAY IN ONLINE VIRTUAL WORLDS

Derek Sanderson, Westwood Studios

gamedesigner@aol.com

Over the past several years, the idea that 'building community' is a key goal for a successful Massively Multiplayer (MMP) game has become generally accepted wisdom. While strict, statistical data supporting this claim is somewhat sketchy, there are three reasonable, commonsense arguments for encouraging cooperative play.

The first argument is that cooperative play reduces system overhead. Requiring your customers to share game resources increases the number of simultaneous players a single game server can handle, lowering hardware costs per customer, and thereby improving your bottom line. For example, if your expected server load is a maximum of 3,000 simultaneous players, and each can safely fight one evil monster alone, your game servers must be capable of handling the AI routines, collision, and various other tasks for 3,000 simultaneous beasts (the actual number might vary according to your game design, of course). Increase the number of players required to defeat an enemy to three, and you now must provide only 1,000 simultaneous bad guys.

The second argument is that cooperative play modes increase your game's content variability, lengthening the time line in which players consume all available precreated content and reducing the likelihood of boredom. In other words, make a game in which players have the tools to make their own fun, and they will run out of things to do much more slowly. The longer they stay, the more subscription revenue they generate, and the more friends and family they bring to your world to share in their fun.

Argument number three is that cooperative play creates barriers to subscription cancellation by allowing players to form social bonds that they are reluctant to break. While it is true that players' in-game social bonds eventually migrate outside the game, if their online identity is closely tied to social relevance within your game, they

will be loathe to relinquish that identity. Players who quit playing an MMP may retain their friends, but they often fear losing their status in the online society.

The arguments above are vastly simplified and do not apply equally to all MMP game types, but for the purposes of this article, they will be accepted as true; the intent here is not to create a theoretical work so much as to offer practical advice for the budding MMP developer. Most of the discussion will focus on the 'classic' MMP model in which players control a virtual representation of themselves and play in a virtual environment that models the geography of an imaginary world. However, a careful reader will note that the design strategies offered here may be applied to any sort of situation where cooperation between multiple players is desired.

Cooperative Play Will Not Happen Unless Your Customers Perceive It as Necessary

MMP design teams frequently quibble over how much cooperative play to include in their games, and the arguments become especially heated when the issue of whether to force interactive play is discussed. Half of the team (generally the extroverted half) wants to create a game in which cooperative play is predominant, while the remainder of the team (the introverts) are supportive of cooperative play, but want to ensure that a 'solo' experience is viable. Unfortunately, these goals are ultimately incompatible if the aim is to create a game that can be played in exactly the same way regardless of whether one is playing alone or with others. All other factors being equal, when you weigh the effort and annoyance required for interplayer cooperation against the effort required for singly completing a challenge, solo play invariably triumphs. If you want your customers to cooperate with each other in any given activity, you must make it vastly more profitable and fun than playing alone.

Do not, however, make the mistake of removing all single-player opportunities from your game. Internet games, even more than in the real world, are populated by introverts; and introverts desire activities that they can enjoy alone—until they are ready to interact with others. An MMP that contains unrelenting cooperative play will quickly tire your introverted customers and engender the sense that advancing in your world is more work than play, and cause them to migrate toward competing products where they can feel effective without being forced into heavy social interaction. In an environment that demands high subscription numbers to scale against equally high fixed costs, having gameplay that constantly requires socialization can be fatal to a product.

You might think the above statements contradictory; how does one balance a game's challenges to support cooperative play while still maintaining a viable single-player environment? The answer is a simple one: rather than attempting to

make every aspect of gameplay equally accessible to solo or cooperative play, create instead a variety of activities—some oriented toward playing alone, others oriented toward interplayer cooperation—all of which ultimately serve a cooperative, social environment.

Ultima Online (*UO*) is an excellent example of this idea in practice. Many of the game's activities, especially its crafting model, are essentially solo enterprises. For example, players may assume the roles of miners, lumberjacks, alchemists, cooks, and other professions whose primary activity is the gathering of resources and production of adventuring goods. These activities do not require cooperation from others to accomplish, and a player who wishes to chop trees or brew potions alone may generally do so without fear of harm. The *UO* crafting system is an introvert's paradise.

The cooperative aspect of these activities comes from the game-world market they serve. *UO* players have an ongoing need for potions, armor, and other adventuring goods. Because such items are of superior quality when crafted by a master player craftsman, *UO* craftsmen supply a steady stream of their goods to adventuring characters. This is cooperative play, even if not colocated play; in fact, the transactions in which cash is exchanged for goods often happen when the two trading players are not online at the same time! Instead, the selling player places his goods on a computer-controlled, Non-Player Character (NPC) merchant who stands outside the selling player's house and acts as a sort of vending machine for the craftsman's customers. This level of interaction is perfect for the more-introverted, solo-oriented player; he is able to fill a distinct, important role in the game's society without being forced to haggle over his goods in person.

Role Playing Is King: Cooperative Challenges Are Most Effective When Players Have Specialist Roles to Fulfill

Providing distinct roles for your players is vital to your game's success, for MMP games are not popular simply because they are social places in which one can adventure in the proximity of other people. Very few people would pay a monthly fee simply for the right to chat with a bunch of polygons. Rather, the core reason that MMP games are popular is that they allow players to achieve time-compressed success. People play MMP games because these games allow them to achieve success with much less effort than would be required in the real world; the ability to become strong, rich, powerful, famous, knowledgeable, sexy, or whatever else the player desires with a few hundred hours' effort is psychologically very attractive.

The basic concept is easy enough to grasp—but take care; different personality types have vastly different definitions of success, and you assume at your peril that your players' likes and dislikes parallel yours. Statements such as "The players don't

like X" ("The players don't like PvP" being one of the more common of these phrases) are dangerous obstacles to successful game design. If you are in the habit of making such statements, you should stop. "The players" do not exist.

Some of your potential players feel successful when their characters are wealthy. Some are more interested in perfecting their avatars through accumulating skills or levels. Some crave fame, and still others desire nothing more than a sense of being needed by others. There are as many definitions of success in MMP games as there are in the real world, and to attract the widest possible audience, you must create a variety of means through which your players can achieve in-game importance. The best way to do this is to provide distinct roles for your players to assume, each of which fulfills a basic, personality-driven need, and which must directly assist other players in fulfilling their needs.

In an MMP, who your players are—their relevance as people—is defined by the abilities given to them by the game. In *EverQuest*, a monk with the Feign Death skill is a 'puller,' someone who can trick a monster into leaving the safety of its pack so that it can be slaughtered by the monk's adventuring partners. Wizards are 'nukers,' characters who can do vast amounts of damage from a distance. In many fantasy MMP games, priests are 'rezzers,' players who can bring incapacitated characters back to life. These examples make it easy to see the relevance players give to the roles each character plays; players define their roles by what they do.

Providing Roles: Predefined vs. Ability-Defined Models

There are many ways to provide roles for your players, but over the years, two ways have become most prevalent. First among these is the classic 'character class' model, used by generations of games, from the venerable *Dungeons and Dragons* to *Diablo* to today's popular MMP games, such as *EverQuest* and *Dark Age of Camelot*. Character class games provide precreated templates that delineate a character's role in the world and give players a road map for their character's future progress: start as an acolyte, become a priest, and then a high priest. Begin as an apprentice, and end as a master wizard. Squire to knight, ensign to admiral—the character class model is a powerful tool for attaching players to their online avatars at an early point in the game; it allows them to differentiate themselves immediately from other players and gives their activities an early sense of purpose.

In my most recent project, *Earth & Beyond*, we used a class model for our character development and added several features to reinforce the player's perception that the role being assumed made them valuable to other players. During the character-creation process, for example, a voice-over describes the character classes in detail, pointing out three to four key abilities available to each class. Furthermore, in the first two hours of

the game, every character is given a series of missions that require the use of their key skills, illustrating how the skills are useful inside the game context. These two systems, used together, serve to alert players early in their game careers that their chosen character definitions would be necessary elements in the *Earth & Beyond* society.

A second popular role-providing model is often called the 'skill-based' model. It is one in which the character is not defined by a precreated template, but rather by what the character can do. Under the skill-based model, the player obtains skills and abilities through game mechanics, and the role he plays in society is based upon the abilities he has been able to master. *Ultima Online* is a classic example of a 'skill-based' system; every character may learn to master any skill, and those skills that a character is best at are the skills he has practiced the most. Chop trees, for example, and the player masters lumberjacking; fight monsters with a sword, and the player becomes similarly skilled with bladed weapons.

The skill-based model is popular with the 'core' gaming market because it offers the most flexibility in creating one's alter ego; however, it is risky in that it is more of an 'expert' system than the class-based model and can prove daunting to customers who have not played an MMP before. Tell a new player he is a healer, and he can probably guess what his role in the world will be; thrust him into the world, and he will likely attempt to fulfill the role, even if incorrectly at first. On the other hand, if you give a new player no class to play, but instead present him with First Aid and White Magic skills, he may eventually figure out how to become a healer, but his early play experience will more likely be similar to that of Robinson Crusoe—he will be lost in a strange land with some rudimentary tools, casting about for something to do. If you use a skill-based model, you are well advised to provide your players with instruction and suggestions that teach them what they can do with their skills.

Providing Challenges for Your Roles

Once you have chosen your basic character-advancement mechanic and the types of roles you will provide, your next task is to design your content in such a way that it constantly supports and reinforces those roles. Every challenge in your game should require a combination of unique player abilities to locate and overcome.

When creating these challenges, avoid designing situations where a single role has the only means to accomplish a task; similarly, do not design your roles such that they are useful in too narrow a context. Instead, design challenges that allow roles to combine into different strategies, and create roles that are useful in multiple contexts. This will help you avoid gridlocks in your game, situations in which players cannot have fun because they either do not have players present with the necessary skills or because their roles in the play session are too narrow and rote to be meaningful.

For example, if your game has locked doors that must be opened to allow access to game-critical areas, and the only way to open a door is to have a locksmith present, there will be times when a group of players will not have a locksmith with them. Therefore, they are unable to continue their play session. This will generate customer service calls from frustrated players; so rather than allowing a single role to restrict player access to the special areas, it is better to assign one role as the primary access provider and assign secondary roles to other characters who can open the doors at much greater expense. Such a secondary role could be a demolitions expert, for example, who can grant access to the area beyond the door at the expense of attracting nearby guards who come to investigate the explosion.

Our locksmith would be quite boring if he were only able to open locked doors, wouldn't he? If this were his only role in the game, it would be an example of the second mistake: scoping roles too narrowly. He would be an essential part of other players' experiences, but repeated completion of a rote task—even if that task is sorely needed by his fellow players—would get old quickly, and you would find your play session had few locksmiths. To avoid this situation, creating a more widely defined role would be the wise course. Defined more broadly—say, as a tinker—your locksmith could also provide access to locked chests full of treasure, create traps players could use to ensnare enemies, craft mechanical weapons, and serve as a backup blacksmith for emergency repairs to armor and weapons.

Maintaining Role Integrity

When broadening your roles, however, take care to maintain the integrity of each character's place in the world. If you introduce game elements that obviate the need for any given role, your customers who play that role will have no motivation for staying in the game. This mistake commonly occurs in a 'live' environment after an MMP has shipped. In an effort to provide fresh content for their players, a development team will create new abilities, game systems, or items that duplicate the core abilities of a given role. Such role-ability duplication is extremely hazardous, for it dilutes the sense of importance felt by the players of that profession.

Returning to our locksmith example: let us say your game is a classic 'fantasy medieval' type where players go on adventuring expeditions and return with locked chests full of treasure. A game of this nature will typically have some sort of 'rogue' or 'thief' playing a locksmith-type role. One of the core abilities of that character will be to open locked objects for other players. As mentioned previously, if there is no other way to open their chests, players who need the specific services of a rogue/thief will complain when no rogue/thief is available.

Eager to please their customers, a development team might take a short-term view of the problem and provide some sort of lock-opening device that can be easily

obtained and used by any player. Although this provides instant gratification to the players who want their locked objects opened, it is a dangerous solution, for the distinct role of the rogue/thief has been emasculated, eliminating the feeling of importance rogue characters once had of providing a unique service to their fellow players. Instead of providing an overly easy means of opening their own chests, a better solution might be some sort of interface for finding a rogue who is willing to perform the service.

There are exceptions to the 'do not dilute' rule. For example, if a character role provides a key service that is essential to completion of the game, it is unwise to make that character role the sole source of that service. A common example here is the concept of character 'death.' Death in MMP games is used to pace challenges and rewards by making it too risky and therefore undesirable to attempt challenges that are far in excess of the player's skills. However, players will push the absolute limits of safety in order to gain large rewards, and the inevitable result is a steady supply of 'dead' characters.

A dead character must be revived before they can return to their normal gameplay. If the only way to be revived were to find another player with the skill and desire to assist the dead player, there will be times when a player is unable to continue his game because he is unable to find another player to assist him. This situation is frustrating in the extreme; at best, it will result in a customer service call and demands that the game staff perform the necessary ritual themselves; and at worst, it will mean a cancelled account.

The best course of action here is to make a player-independent game mechanic that is available to characters, so they can continue their gameplay without being at the mercy of others. However, the mechanic should be a much less ideal means of solving the problem than the player-assist solution, balanced such that the obvious choice is always to find another player, but with a default choice available for those who do not wish to wait.

In *Ultima Online*, for example, a dead player can become a ghost, wandering a deathly gray landscape in search of a computer-controlled healer who can revive him. The cost here is the time involved in finding the healer, which can be quite significant in more-remote areas of the game. A wise party of *UO* adventurers will therefore bring an accomplished healer with them on a dungeon-delving expedition.

Help Your Players to Find Each Other

In the 'real' world, if we want a taxi, we generally look for a yellow car and wave frantically to get its attention. If we are stranded on a freeway with a cracked radiator and no cell phone, we look for the distinctive emergency lights of a policeman. In a restaurant, we look for uniformed waiters. All of these professions, and many others, serve distinct roles in our society; they are uniformed in order to make finding and recognizing them an efficient process.

A wise MMP designer will find ways to bring this efficiency into his game. If all of your characters have access to the same models, clothing, and equipment, and there is no game-defined way to differentiate them by role, players can spend inordinate amounts of time seeking others who can provide the services they need.

The game *Asheron's Call* is an example of a skill-based MMP with no ready-made identifiers for player professions; the game has three races, but no division of roles by race or other markers by which players are readily identifiable as having particular skills. As a result, it is common to see wounded characters standing in the middle of a crowded area, begging for anyone with healing magic or a healing kit to give them aid. (To be fair to the designers of *Asheron's Call*, nothing short of stealing their keyboard would prevent some players from standing in busy locations, screaming for attention—but the inability to recognize players with key skills does exacerbate the problem.)

EverQuest is an example of the other extreme. Character roles are restricted by player race, with one or two 'best choices' available for each role. Furthermore, at the highest levels of gameplay, there are fairly narrow options for the 'best equipment' available to each role, leading the most-capable players in any given role to bear a close resemblance to each other. Although not the best means of enforcing recognizable roles, similarity of avatar appearance is one way to make it possible.

Sight recognition, however, is not the only way to help players find the characters whose skills they need. Geography is another common tool used to encourage player interaction; the trick here is to create locations that serve a common player need, encouraging players to congregate in that specific place. Probably the most common example, which is present in nearly every MMP, is the idea of a 'bank' where players can access a form of storage other than the bodies of their own avatars. Other popular devices include trading centers filled with goods to buy or important nexuses through which players must travel, such as city gates, bridges, or crossroads. My favorite example, however, comes from the game *GemStone III*.

The geography-based socialization system of *GemStone III* is its network of 'nodes,' recognizable locations that promote faster healing and magic-power recovery rates, as well as other benefits useful to all of the game's character types. The benefits are so powerful, in fact, that it is rare to discover players resting in places other than a node, making them the major social centers in the game. Buying, selling, healing, chatting—it all takes place at the nodes.

Geographical proximity is not your only means of allowing players to find each other, however. It is also wise to provide your players with interfaces that allow them to locate characters with whom they wish to interact. The most common and simple of these interfaces is a /who chat-line command to list online players, perhaps with some information about their location and abilities. Even more advanced are GUI (Graphical User Interface) based systems, such as the interface in *Dark Age of Camelot*

that allows players who are looking for an adventuring group to flag themselves as available, and adventuring groups can search for available players whose skills meet their specified requirements. For example, if an adventuring group in *Dark Age of Camelot* is looking for a 'shaman' character type, they can use the GUI to filter for this character type when performing a search.

Helping Your Players Communicate

Your players now have roles and cooperative challenges, and you have made it easy for them to find each other. Your next challenge is to provide them with the tools to manage their interactions, so they can spend their time playing rather than fighting with the game mechanics.

Your first priority is to make communication easy. Though this should always be one of your initial and primary design goals (and merits an entire book of its own), you should pay special attention to providing effective communication methods for players who are attempting to overcome cooperative game challenges.

This will be dictated in part by the dynamics of your particular game. For example, if your game requires split-second tactical decision-making by small groups of players, you should consider some sort of interface through which players may issue short commands in order to coordinate their actions. If your game is more strategic in nature, you may want to provide a more-persistent means of communication that allows players who enter the game at different times coordinate their collective strategy.

Communication is not simply about speaking. The *Ultima Online* merchant system is a form of communication: players may place game-controlled merchant characters outside their homes to sell goods. By placing the merchant, the player is saying, "I have goods for sale—come look!" Another nonverbal mode of communication is the enabling of a flag on a character, which other players may see, that advertises a game state or a desire; in *Earth & Beyond*, for example, we allow incapacitated players to toggle a 'rescue beacon' when their ship is disabled, making the ship visible on radar from anywhere in the sector. The message communicated here is, "I am in need of rescue!"

Your second priority should be to ensure that players who play together are able to maintain their game session with little aggravation. Nothing is more frustrating than forming an adventuring group in an MMP, only to spend half the time searching for group members whose temporary burp in their Internet connections has caused them to lose sight of their fellow adventurers. Although leader-follower systems were easy to implement in text-based MUDs (Multiuser Dungeons), they have yet to be fully realized in graphical MMPs.

Conclusion

In fact, many common designs in today's MMP games are based on faulty assumptions from the pregraphical MUD days, and in the coming months and years, it is my hope that we will see a wave of innovation as we designers rethink our most basic assumptions about creating multiplayer environments. Cooperative play will undoubtedly remain king, however, and the extent to which you engender it will largely determine the longevity of your particular game. Designer beware, however—cooperation is easy to implement, but difficult to implement correctly, so make it an early design focus and test your assumptions throughout the development cycle. Best of luck, and see you in the game!

1.3

GAME BALANCE FOR MASSIVELY MULTIPLAYER GAMES

Ben Hanson, Sony Online Entertainment

bhanson@soe.sony.com

The Massively Multiplayer (MMP) environment poses a unique set of challenges to game balance. Unlike single-player games that normally provide 40 to 50 hours of entertainment, MMP games typically extend play time to hundreds or even thousands of hours. Therefore, game balance must account for this exceedingly long lifetime. Furthermore, the communal nature of online games allows for rapid communication and exploitation of balance weaknesses. If there is a best weapon or best technique, the player base will quickly determine it. Because the action of one player is capable of affecting others, significant imbalances adversely affect the entire community by allowing people to take advantage of these weaknesses or rendering players incapable of competing with those that do exploit weaknesses.

This article proposes methods of game balance that take into account the added complications introduced with the MMP environment. The methods begin the balancing process at the early stages of development, extend them through beta testing, and continue even after the project has been launched.

Establishing a Baseline for Game Values

Although it is virtually impossible to establish any lasting game values early in the development cycle, it is still possible to begin the process of balancing. This may be accomplished by establishing a baseline for the numbers.

To do this, it is best to begin with a system that is core to the project. In many MMP games, the ideal system to start with is combat. Establishing baseline values for combat works well because even before it is designed and implemented, its fundamental purpose is known (damage and destroy the target). In turn, it is easy to postulate certain values (such as damage and attack speed) that have a high probability of being utilized. Table 1.3.1 shows a sample of how establishing a baseline might work

Table 1.3.1 Baseline Values for Weapons

Weapon	Damage	To-Hit	Speed
Axe	18	−20	10
Club	15	15	13
Dagger	6	40	35
Maul	37	−40	6

for combat in a fantasy MMP game. In this example, weapons are defined by three basic variables: Damage, To-Hit, and Speed. Naturally, as the design for combat becomes fully realized, these variables may change or be augmented by others. Even so, this can be a powerful balancing exercise.

It is important to keep in mind that the numbers, themselves, are not the focus. Instead, the focus is on their relationships with each other. Referring to Table 1.3.1, a damage range of 6 to 37 has been established, with the dagger and the maul representing those extremes. While this range will most likely not be the final one, it sets up a useful precedent: the dagger has the lowest damage and the maul has the highest. When the actual range is altered as the combat system comes online, this precedent can be maintained. If play-testing later determines that the damage of a dagger works better at 20, then the baseline values enable the designer to quickly see that the club and axe must certainly be increased in damage.

These preliminary numbers for weapons can be then used to establish baseline numbers for objects other than weapons. For example, using a rough estimate that the average monster should die by the average weapon after about 10 hits, it could be inferred that the monster should have about 200 hit points (considering the axe as an average weapon). This average monster hit point value can then be used as the start of the baseline for the hit points of every creature in the game. Tough creatures will have more than 200 points, and weak creatures will have less. As long as the relationships between the weapons are maintained (the axe stays as average), then it is known how the hit points of an average monster, and therefore every monster, are affected by any weapon change.

These baseline weapon values can extend to systems beyond combat. As the least-damaging, but easiest weapon with which to hit, the dagger is an ideal weapon for novice characters. Using this logic, the designer may decided that the ability to use daggers can be acquired quite early within the play experience. Because daggers are easy to use, they may be the choice weapon for professions not suited to melee combat (such as a wizard). In turn, because the maul is the most-damaging weapon in the game, it would make sense to reserve its use for characters that are highly skilled in the ways of hand-to-hand battle.

Coding 'Number Simulations'

Establishing baseline values for major game systems should be a relatively rapid process. Therefore, it is likely that the system for which these numbers have been devised is yet to be implemented. This is where number simulations come into play.

Number simulations are small programs written by the designer in order to test the baselines. Because the time to code such programs should be short (on the order of days), they are ideally written in a rapid-development language (such as Python). Number simulations simply take user imputed data, apply prototypical system algorithms, and display the output.

In the example of combat, a number simulation reads in weapon data, armor data, and combatant attributes. The user can then run the program to view the resulting outputs of damage inflicted, attack speed, hits and misses, and so forth. By holding all but one of the variables constant, the designer can clearly see the effects of manipulating a single value. In addition, the set of attributes that constitute an object can be compared against other objects. For example, how does the club compare against the war axe? Is a combatant who is wearing chain-mail armor and wielding a maul likely to prevail over another combatant who is wearing leather armor and wielding a dagger? The number simulation enables the designer to begin answering these questions before combat has even been implemented.

Figure 1.3.1 shows a prototypical number simulation for combat. In this example, battle is restricted to two opponents. For each combatant, a template can be selected that corresponds to a collection of skills. In the case of the "Novice Warrior," the template may include skills that increase damage, attack speed, and ability to hit. A primary and secondary weapon may also be chosen, as well as armor. Note that the game values used for templates, weapons, and armor were obtained using the 'establish a baseline' method illustrated in Table 1.3.1. Combatant attributes are determined from the template, but the designer has the ability to fine tune them further if so desired. Since a system like combat tends to have random elements, it is usually necessary to run the simulation many times in order to generate definitive results. Therefore, this combat simulator offers the ability to iterate with the same values at an accelerated rate, recording data for statistical analysis. When the simulation is executed, each combat event is displayed in the output window.

The simulation results will invariably lead to the constant tweaking of baseline values in order to better balance them. Because the values for skills, weapons, and armor alter so frequently, it is a good idea to enable from this within the program, itself. In the example shown in Figure 1.3.1, the "Edit" button for each item summons another window where that item's values may be viewed and manipulated.

FIGURE 1.3.1 *An example of a combat number simulator.*

Keep in mind that it is not necessary for this combat simulator to consider every single factor that is expected to be in the final implementation. By just emulating the basic set of core functionality, the designer can make significant progress in balancing.

In addition to aiding in game balance, the number simulation offers a couple of other benefits. First, it helps the designer to more clearly demonstrate to the programmer how the simulated system should operate. While this is not a substitute for documentation, the ability to view a simple working prototype helps greatly in understanding the intended design. Second, pieces of the simulation code have the potential to be reused in or adapted to the actual implementation, thereby decreasing the amount of programming time required.

Establishing Game Metrics

As the project enters into its middle stages, the number simulations give way to the actual system implementations. During this time, it is important maintain the ability to easily manipulate and track game variables. Just as with the simulations, the designer must be able to quickly view and/or edit the values of any object within the game. Unlike the simulations, however, the designer is unable to completely control the environment for testing purposes. Other players, AI creatures, and various game elements constantly affect the playing field. As a result, game metrics become extremely important.

Game metrics are methods by which desired game values are tracked and recorded over time (maintained on a daily, monthly, yearly, or constant basis). The resulting data can then be used to determine how to further balance the values set during the number simulations. The following are a few examples of common factors to track in an MMP game and why they are useful for balancing purposes.

- **Player Advancement:** Measuring a player's progression through the game enables the designer to determine if advancement is occurring at the expected rate. Furthermore, if unusually large numbers of players have accumulated at a given level, it may reflect an excessively difficult or boring area (the players just gave up at this point). For a traditional MMP RPG, player progression is often simply tracked via the character level. If the game in question does not have this concept, it is still necessary to determine some method of recording and objectively tracking player progression.

- **Item Use:** This is arguably the most useful statistic for checking the balance of items such as weapons and armor. Players will naturally gravitate to those items that enable them to be the most successful. If one item is used 100 times more often than the next highest item, there is a clear indication that the items are unbalanced. Along the same lines, if another item is rarely used, it is probably underpowered. Tracking item use can be accomplished by recording each swing of a weapon or the length of time a given piece of armor is worn.

- **Actions:** It is important to track what the players spend their time doing within the game. Do they spend most their time fighting monsters or crafting weapons? Often, poor balance can result in the players spending too much time performing a given action. For example, if players are spending twice as much time recovering from wounds than fighting, perhaps healing rates should be increased, or healing spells should be made more effective.

Naturally, these are but a few of the many factors that can be tracked. The necessary metrics vary greatly from game to game. Careful consideration of metrics, however, is vital for the balancing process during the alpha- and beta-testing phases.

Alpha and Beta Testing

As the project moves into the alpha and beta stages, more and more simultaneous players are added. This, in turn, affects the game balance. It is important to note that by the time the game goes live, game balance must take the maximum number of supported players into account. For example, a dungeon that initially seemed difficult due to a high population of creatures may, in fact, be quite easy when hundreds of players are adventuring within it. An item that is offered to only one player an hour may seem reasonable at first, but it may become virtually impossible to obtain when thousands of players are trying to acquire it. Therefore, proper MMP game balance is only possible when the number of play testers approaches the numbers expected within the live game.

During these testing periods, the designer should devote a significant portion of his time to monitoring the player's every action. The game metrics established earlier are invaluable during this stage. They alert the designer to favorite items, skills, and actions, as well as documenting how quickly players are advancing through the game. When examining the test data, you would be well advised to give great attention to abnormalities in the values, such as excessive advancement rates or large quantities of wealth. Careful notice should also be taken of the areas where players devote most of their time. Unexpected game values and player behaviors often times point to improper balance.

Despite the best intentions, the discovery of poorly balanced systems will inevitably occur during alpha and beta testing. Invariably, the most-common mistake is in making the game too easy. Never underestimate the player's ability to play the game more efficiently than expected. It takes very little time for thousands of players to dissect every aspect of the game in order to determine the best way to succeed. Even if the numbers are hidden, players will discover them through exacting experimentation and then post their findings on the Web for all to see. Consider this example that the author once encountered: a system for recharging staves and wands was introduced into a game. The chance of success was determined by a number of factors, but the rate of failure was never to go below 1 in 137. About a week after the system was launched, the author discovered an article posted by a player, which described magic item recharging in every detail. But most shocking, however, was the player's discovery of the minimum rate of failure: "It appears that there's always a chance to fail. My guess is that it's around 1 in 150, but I'm getting 1 in 137." Be warned that MMP players can determine anything in large enough numbers. Do not be afraid to make the game harder as a result of watching players in action.

The testing period is the best time in which to experiment with the game. Make changes, and then watch their effects on the game metrics. Remember that this is the designer's last painless chance to test theories that were established during the number

simulation phase. Changes made after the game is released become much more complicated.

Balancing in a Live Game

Despite the best of intentions, balancing issues will arise after the game has been shipped. The question is what, if anything, should be done about them. Rebalancing within a live MMP game poses considerable dangers. Because everyone must use the same version, each player does not have the option to accept or reject the change. Therefore, if a change adversely affects certain play styles, it runs the risk of encouraging some players to quit. When deciding if a rebalance is necessary, ask the simple question: "Will leaving the imbalance alone cause more problems than fixing it?" If the answer is "Yes," then changes must be made.

As stated early on, the most common imbalance (and unfortunately the most detrimental) is that some system of the game is too easy for the players. For example, combat has become too easy because the players have determined that using a certain weapon with a certain tactic enables them to kill creatures far more powerful than they. In turn, those that use this weapon or tactic advance much more quickly that those that do not. Because this technique is so effective, many players build their characters around it, specializing in the necessary weapons and skills.

The solution to this dilemma would most likely be to decrease the power of the weapon, the tactic, or both. While this may require something as simple as altering a few game values, dealing with the ramifications to the player base is a different story. Those players who have built their characters based on the item being rebalanced will undoubtedly react negatively. In the worst-case scenario, these disgruntled players could also voice their displeasure before exiting, reducing the player base even more and causing bad public relations. Therefore, great attention must be paid to the fallout of rebalancing.

While such a rebalance rarely goes live without some ill feelings, there are things that can be done to alleviate the problems. First, alert the players to the problems well before making the change. Explain the imbalance, and how it is hurting the long-term entertainment of the game. Even though this will not eliminate those who complain, many people are willing to accept a sound presentation of the facts. Second, offer players the ability to be heard. Provide a forum that enables them to voice their concerns and offer their suggestions. Although only a small number of players will bother to communicate in this fashion, the PR rewards can be considerable. Last, make amends wherever possible to the players that are affected by the change. If the rebalancing adversely affects a valuable weapon, allow the players to exchange it for another, or to cash it in for game currency. If rebalancing affects a character's skill, allow the player to replace that skill with something else. It is simply not possible to

please everyone in such a situation, but overtures that show the designer's concern and consideration go a long way toward keeping the player base happy.

Balancing New Features

It is common to add new features to an online game after launch. While these additions are an excellent way to maintain and even increase interest in the game, they carry the same dangers as rebalancing. Even a seemingly small feature can have large ramifications as it interacts with all of the other game systems. Any new loophole it creates will be quickly discovered by the players, potentially unbalancing significant portions of the game. Indeed, even a tiny addition must undergo extensive testing to avoid this.

Testing should be accomplished by using a test server. Simply put, this is a current copy of the live game, except that it includes the new feature. Players should be given access to this test server and encouraged to use it. In this way, the designer is able to safely tweak game values and reduce the possibility of adversely affecting the game once the new feature goes live.

Conclusion

Balancing in an MMP environment is a process that begins at the early stages of development. It commences with the establishment of baseline values. These values are further refined through the use of number simulations. Game metrics are then used to observe and track the functionality of the values through alpha and beta testing. Game balancing does not cease at launch, for issues will continue to arise. Changes made at this point must take into account their effects on the existing player base. This holds true even for new features. Taking this holistic approach of incorporating game balance into each stage of development will result in a smoother launch and a smoother life thereafter.

1.4

GAME BALANCE AND AI USING PAYOFF MATRICES

John M. Olsen, Microsoft

infix@xmission.com

Game balance can be a very thorny issue and can require a huge investment of time to get right. In an MMP game environment, there is little margin for error; players have an amazing ability to work together to find and use even the smallest of advantages. In this environment, there are as many approaches to game balance as there are games. This article will present a way to use statistical analysis and some straightforward mathematics to simplify the job of balancing certain portions of games, and use the same techniques to make sure your Artificial Intelligence (AI) routines are taking advantage of the opportunities available to them.

What Is a Payoff Matrix?

Payoff matrices are one facet of game theory that primarily descends from ideas published by John von Neumann and Oskar Morgenstern [Neumann44]. These matrices are designed to show the rewards and penalties associated with decisions made by two or more players in a game. In the loose sense used by the broad field of game theory, a 'game' is any contest where one player wins and another loses after a series of one or more confrontations. The matrix is just a method of tracking who gets what score based on their choices.

First, let us show what happens to Player 1 in Figure 1.4.1. His score is found by locating his choice in the left column, and his opponent's choice is located along the top.

We also need to track what happens to Player 2. So, let us show a different version in Figure 1.4.2, which contains Player 2's scores.

Now, to simplify things a bit, the matrices can be combined with some color coding to show the scores of both players at the same time.

To use the matrix in Figure 1.4.3, you get the choices from both players and locate the appropriate cell within the matrix. The first number is the score for Player 1, and

	Player 2 Choice 1	Player 2 Choice 2
Player 1 Choice 1	Player 1 gets 0 points	Player 1 gets -1 point
Player 1 Choice 2	Player1 gets 1 point	Player 1 gets 0 points

FIGURE 1.4.1 *Player 1 reward matrix.*

	Player 2 Choice 1	Player 2 Choice 2
Player 1 Choice 1	Player 2 gets 0 points	Player 2 gets 1 point
Player 1 Choice 2	Player 2 gets 1 point	Player 2 gets 0 points

FIGURE 1.4.2 *Player 2 reward matrix.*

	Player 2 Choice 1		Player 2 Choice 2	
Player 1 Choice 1	0	0	-1	1
Player 1 Choice 2	1	-1	0	0

FIGURE 1.4.3 *Combined Player 1 and Player 2 reward matrices.*

the second number is the score for Player 2. The shading of the player label matches the shading of the value they get from each cell in order to make it easier to read.

There is an additional property in the matrix shown in Figure 1.4.3, as well. If you add the two score values in any cell, they add up to zero. This gives a zero-sum game, which ensures that for each turn where there is a winner, there is someone who loses. It also ensures the same thing over a series of contests; Player 1's score will be the inverse of Player 2's score.

"War" Card Game

The old game of *War* as played with a deck of cards is simple. Each player tosses out the top card from their hand. The player with the highest card claims both cards, with any tie remaining to be claimed by the next winner. Figure 1.4.3 can be used for a simplified version of this game. Each player can play a low card or a high card. If Player 1 plays a high card (Choice 2) and Player 2 plays a low card (Choice 1), then Player 1 gets one point, and Player 2 loses one point. If both play low or both play high, it is a tie, and neither takes the point.

This is a very simplified example, but is meant to give you a feel for how the matrix is applied to something familiar. Next we will move into some more-complex issues and uses.

Prisoner's Dilemma

The *Prisoner's Dilemma* [Tucker50] is a game in which two criminals have been appre-hended by the authorities. If neither confesses, the case against them is weak so they will each get one year in prison. If one confesses and testifies against his partner, the confessor will be rewarded with just a quarter of a year, while the other prisoner gets 10 years in jail. If both confess, they will each get eight years in prison. Each must decide to confess or be silent, without knowing the other's decision.

The matrix for this dilemma helps to clarify what happens, as shown in Figure 1.4.4.

It is easy to see that the best thing for Player 1 would be for him to confess while Player 2 is silent. The problem is that Player 1 does not know what Player 2 will do. The dilemma occurs because Player 1 must make his decision based on the worst that could happen due to Player 2's choice. If Player 1 is silent, the worst that can happen to him is 10 years in prison. If he confesses, the worst that can happen is eight years in prison.

	Player 2 Silent		Player 2 Confess	
Player 1 Silent	-1	-1	-10	-0.25
Player 1 Confess	-0.25	-10	-8	-8

FIGURE 1.4.4 *Prisoner's Dilemma payoff matrix.*

An interesting property of the state where both players confess is that neither player will choose to leave that state so long as the other player does not change his strategy at the same time. This is called a Nash Equilibrium [Nash50]. Leaving that state while the other player does not change his mind will add two years to the jail time of the player who changes and decides to be silent, so neither player will choose to leave on their own.

Payoff matrices are a highly compact way of storing this rich interaction of states and actions, where each player needs to consider the actions of the other players when making their decisions.

Simple Fighting Games

Now we move to something more action-oriented. A payoff matrix can be designed as shown in Figure 1.4.5 for a simple fighting game where each player can choose to attack, block, or wait. Some mechanics of the gameplay do not show up in the matrix, such as the duration of each state, which will be discussed in more detail later.

This matrix has purposely been built so that every state has some score adjustments to keep the game more dynamic. The elements of the matrix show the result of a successful attack, the cost to keep a defense up, or the benefit of resting.

There are some interesting game mechanics that can be pulled out of this matrix. If a player can put some distance between himself and his opponent, there is a benefit to resting. But as soon as the opponent closes in again, the benefit vanishes because of the extra vulnerability of resting during an attack. There is also a penalty to keeping a block active full time, because the blocker is continually losing points while the opponent can continually attack without losing points. Both of these features would tend to force the game to end rather than leading to a stalemate condition.

	Player 2 Attack		Player 2 Block		Player 2 Rest	
Player 1 Attack	-10	-10	0	-1	0	-20
Player 1 Block	-1	0	-1	-1	-1	1
Player 1 Rest	-20	0	1	-1	1	1

FIGURE 1.4.5 *Payoff matrix for a simple fighting game.*

Analyzing the matrix a little further, we can find a Nash Equilibrium by finding the best score in each row and column, and eliminating all other outcomes from that row or column. This is illustrated by drawing a transition arrow from the eliminated cells to the best value for that row or column. If an opponent is attacking, the best option is to block as long as the opponent keeps attacking. If an opponent is blocking or resting, the best option is to rest as long as the opponent blocks. A Nash Equilibrium exists in any cell having no transitions away from itself, so we are left with the equilibrium state of both players resting. These transitions are shown in Figure 1.4.6.

This works out much better than the paradoxical solution to the *Prisoner's Dilemma*. It makes sense that the best solution for preserving your health is for both players to rest.

In any symmetrical matrix (one that can be mirrored diagonally) where an equilibrium state is positioned anywhere off the main diagonal, the equilibrium states are mirrored about the diagonal along with the data. This means if you have an equilibrium state off the main diagonal, there will be another matching one that is mirrored on the other side of the diagonal.

Now we know the best thing to do; if you both want to be healthy, sit and rest. This result points out a state that you, as a designer, want to specifically track in order to curb abuse. Luckily, players in this game are not simply out to maximize their own health, but to reduce their opponent's health to zero. It is up to those game features not shown in the matrix—such as movement, position, and additional goals—to break up the equilibrium states and keep the game from being too predictable.

One thing to keep in mind is that a Nash Equilibrium does not take into account multiple transitions in a sequence. If you have two or more equilibrium states, you will not be able to move between them in one turn due to a decision from just one player. This means that no row or column of the matrix can have more than one equi-

FIGURE 1.4.6 *Directed payoff matrix showing how to reach Nash Equilibrium states.*

librium state, so the maximum number of equilibrium states is the smaller of the row count and the column count. It is still possible, however, to move between equilibrium states if both players change states.

A player may purposely decide to pay the penalties and move out of an equilibrium state via a series of predictable state changes that will eventually result in the player's strategically better state. This sort of situational equilibrium also adds complexity to the way the game is played.

As long as your matrix is symmetrical, where all players have the same abilities and penalties, you do not have any additional issues of player-ability balance, because all players behave the same. There is no way for one player to have a built-in advantage over another. You can still have some balance issues concerning overall playability, or the 'That's stupid!' factor, which tends to plague all designs to one degree or another.

Asymmetrical Abilities

Once player abilities diverge, you enter the realm of player balance, a most-challenging task due to the potentially massive scope of the problem. If you have players with widely varying abilities, levels, and classes, and have a collection of NPCs (computer-controlled Non-Player Characters) with widely varying abilities and statistics, you can quickly get an astronomical number of combinations to test.

In an MMP game, the scope of the testing can be segregated into specific areas. First, you want your players to be balanced against each other so one particular specialization or class cannot dominate the game. Second, after you have balanced players against each other, you can balance them more easily against the NPCs.

A player-to-player test is shown in Figure 1.4.7, where two players have mismatched abilities. Player 1 does more damage with an attack and uses more energy to block. This is still modeled after the fighting game described in Figure 1.4.5.

	Player 2 Attack		Player 2 Block		Player 2 Rest	
Player 1 Attack	-10	-15	0	-1	0	-30
Player 1 Block	-2	0	-2	-1	-2	1
Player 1 Rest	-20	0	1	-1	1	1

FIGURE 1.4.7 *Nonsymmetrical payoff matrix for a player-to-player test.*

Since the abilities are different, one player is probably going to have some advantage. These are the imbalances you need to watch out for when trying to create balanced, yet different player profiles.

Delays and Lockouts

Now it is time to add some additional complexity. Moving from a purely turn-based system to a real-time game imposes some new requirements. The first step is to put a minimum and maximum time on each state, and a transition list showing the states to which you can move when you are done with the first state. For example, let us take a quick stab at balancing the asymmetrical matrix by adding some delays to compensate for the overpowering physical abilities of Player 1. Figure 1.4.8 shows the same data as before, but with time ranges on each state and a list of allowable transitions. The only restrictions imposed in this matrix are that you cannot repeat a state, and that attacks must be followed by a rest.

This matrix is designed to show how well speed can be used to make up for the power advantage of Player 1. Given his ability to do more damage, it makes some sense that he should be a bit slower. Just looking at the maximum damage per second, Player 1 can now attack for 0.5 sec., rest for 0.3 sec. or more, and then repeat his attack. That gives him a maximum of 30/0.8, or 37.5 points per second. Player 2 can attack faster at 0.3 sec. and rest for 0.3 sec. or more, which leads to 20/0.6, or 33.3 points per second, indicating just over a 10% difference. The harder-hitting player still has an advantage, but it has been greatly reduced by the time requirements.

The restrictions on allowable transitions also increase the strategic component of the game. If Player 1 is attacking while Player 2 is blocking, then Player 2 knows he has a chance to get in a really good hit if Player 1 does not move from his upcoming rest state to block or attack as soon as he possibly can.

	Player 2 Attack (0.3 sec then rest)		Player 2 Block (0.1 to 2.0 sec then rest or attack)		Player 2 Rest (0.3 to ∞ sec then attack or block)	
Player 1 Attack (0.5 sec then rest)	-10	-15	0	-1	0	-30
Player 1 Block (0.2 to 2.0 sec then rest or attack)	-2	0	-2	-1	-2	1
Player 1 Rest (0.3 to ∞ sec then attack or block)	-20	0	1	-1	1	1

FIGURE 1.4.8 *Adding delays and allowed transitions.*

Another state-to-state transition lockout that was briefly mentioned earlier is that the player cannot attack if the player is out of range, thus limiting the allowed state transitions. One thing to be careful of is that you always have an allowable transition for any state that has a maximum time limit. If there were some state that lasted just one second and was required to end in an attack, you have a problem if you are out of range when it is time for the attack. This can be solved by either always allowing a transition to some state that is valid in all cases, or by creating a duplicate for the attack state, such as a 'swing and miss' that can be used in place of the attack state when no attack can be performed.

Automation

Two ways to apply all of this matrix and equilibrium theory to a real game are through automated matrix testing and logging of simulated or in-game combat. Any combat system can be mapped onto a payoff matrix with a little creativity. Down the left edge of the matrix are the choices available to one combatant, and across the top are the choices available to the other combatant. The payoff values may not be fixed values due to a combat system allowing either variable damage or missed attacks, but the scheme still works as well with variable payoffs.

You can think of it as two intersecting state machines. In the previous payoff matrix illustrations, Player 1's state machine is shown along the left edge, Player 2's state machine is shown along the top, and the intersection of those two state machines is the payoff information. State transitions are what allow you to move from one column or row to another by changing your action. One player controls column state changes, and the other controls row state changes.

Now that you can build a matrix by identifying a list of possible actions, pick two foes that are supposed to be closely matched and set up a matrix for them. An AI system with deep and complex responses can be built by evaluating the current list of possible destination states and choosing one of the possible new states. The most-complex part of the system is the evaluation function that needs to consider the AI's current state and the payoff for each valid action.

In a fantasy setting, the payoffs may be that attacking will cause X points of damage, based on current armor and weapons in use, and that resting will allow Y points of damage to heal, or casting a spell to temporarily paralyze an opponent can prevent a certain amount of damage. Once you have the results from the evaluation function for those three options, you can choose between them.

One method for choosing between the options is through a weighted random number, which creates a very rudimentary fuzzy-logic system. More detailed information on fuzzy-logic systems can be found in [McCuskey00] and [Dybsand01]. If the evaluation values show goodness values of 7, 5, and 8 (with higher numbers meaning it is a better option), then you can choose between them with a random number from

1 to 20 (7 + 5 + 8). This causes some good variation over time, with some actions being rare to keep things interesting. Any option that evaluates to a goodness of zero is automatically ignored using this scheme. Once you have generated the random number, a value of 1–7 maps to the first option, 8–12 (a range of five) to the second, and 13–20 (a range of eight) to the last goodness value in this example.

Many other methods of deciding between the various valid cell payoffs are possible, although some may not be as interesting as others. There is typically not much interest in single-minded opponents who only choose one action because it always slightly outweighs other options.

As mentioned earlier, each cell in the matrix that is a valid transition from the current cell should be evaluated. This goes back to the time limits and transition requirements shown in Figure 1.4.8. It is easy to save some AI CPU time if you are careful about the order in which you do things.

For your first test, you can check if a transition is possible. If not, you can bypass the entire AI system for that evaluation. A second test can be performed to filter out all those actions that are not allowed, given the current situation.

The evaluation function, itself, is highly game-dependent, but you will typically want to evaluate the situation based on things like resources used up or gained, the increase or reduction of stats (including health), and the effects those actions have on the abilities of friends and enemies.

Once the evaluation function is in place, you can then automate your balance and testing processes. Testing can be a combinatorial nightmare in some situations due to the large number of unique pairings of groups and individuals that can occur in the game. That makes it an ideal candidate for automation.

If you have a fairly small number of AI profiles to test against each other, it is reasonably simple to automate a round-robin competition where each profile is matched against every other. After repeating that automated tournament a few times, the logs will begin to show trends that indicate how evenly the various opponents are matched. Comparing the profiles by the number of wins will give you a good idea of how difficult the combatants are when compared to each other. Figure 1.4.9 shows the individual cells that store the number of wins of the left-hand players over the players along the top of the matrix. Players were not put into contests against themselves. It can be seen here that Player 1 is the best and Player 3 is the worst when comparing their total wins after being run through 20 rounds of competition. If you want those players to all behave at roughly the same level, the matrix numbers indicate you still have some tuning to do in order to improve the abilities of Player 3 and slightly degrade the abilities of Player 1.

You should be careful to not assume this round-robin testing is sufficient, since you are relying entirely on your preliminary AI code at this point. It may be possible

	Player 1	Player 2	Player 3	Win Totals
Player 1	0	8	15	23
Player 2	12	0	9	21
Player 3	5	11	0	16

FIGURE 1.4.9 *Sample win results after 20 rounds of competition.*

that there are loopholes for players to find that will totally invalidate your logged data.

Once you are able to log staged fights between AI-controlled opponents, it is time to start logging results between the AI opponents and human-controlled opponents. To be frank, this part of the job begins when you first turn on your combat code, and it will never be done until the game is finally shut down for the last time. Tuning between players and AI must be an ongoing process as your player base matures and as the game is updated over time. It can be as complex and involved as you want to make it. Any changes you make in the payoff matrices due to your human and AI interaction tests will show up in your AI-versus-AI automated tournaments, producing more-accurate results as the AI learns to fill in those player-discovered holes.

One-on-one logging is easiest to evaluate, but one of the main purposes of MMP games is multiplayer team effort. You can gain a whole new level of data by evaluating team-versus-team data, whether they are AI controlled or not. The complexity of the data can increase rapidly, and again it turns into an even more massive number of possible combinations. Methods for filtering the possible combinations down to the useful combinations will depend, once again, on your design. In general, you will want to start with the expected or observed cases in your game and add in extras when you notice odd things happening in your log files.

When you notice in your data that a particular AI profile or player type/group is winning or losing more often than normal, there are several options. You can search your historical data for trends, stage some automated tournaments, or simply watch what your users are doing in order to decide what payoffs within your matrices need to be adjusted. Something as simple as deciding to use one attack slightly more often

than another, or adjusting the delay on an action, can make all the difference when something is not working well.

Conclusion

Amazingly enough, Nash Equilibriums and the associated game theory are most usually applied to business- and economic-related simulations, and not to products of the interactive entertainment industry. A good outline of the history of game theory has been assembled by Paul Walker [Walker01]. Taking advantage of the solid theory behind the ideas discussed here gives you a much more rigorous definition of how your system should behave, and it is likely to be much easier to specify a uniform methodology at design time. It should also be easier to implement the design when compared to ad hoc systems that expand and change as testing discovers holes in the initial behavior.

From one viewpoint, this is just doing all those things that have always been done. You check to see what your options are, and you choose between the ones that make sense. You then find the static states and possible trouble spots by looking for cases that the players and AI favor.

The main advantage of the approach described in this article is the way it organizes what is usually a very complex and temperamental design into an easier-to-understand format. It helps you to build, analyze, and tune the AI and combat systems in a way that conforms to a uniform framework that lends stability without excessive restrictions or overhead.

References

[Dybsand01] Dybsand, Eric, "A Generic Fuzzy State Machine in C++," *Game Programming Gems 2*, Charles River Media, 2001.

[McCuskey00] McCuskey, Mason, "Fuzzy Logic for Video Games," *Game Programming Gems*, Charles River Media, 2000.

[Nash50] Nash, John F., "Equilibrium Points in N-Person Games," *Proceedings of the National Academy of Sciences of the United States of America*, 1950: pp. 36, 48–49.

[Neumann44] von Neumann, John, and Oskar Morgenstern, "*Theory of Games and Economic Behavior*," Princeton University Press, 1944.

[Tucker50] Tucker, A. W., "On Jargon: The Prisoner's Dilemma," *UMAP Journal*, Vol. 1, No. 101, 1980.

[Walker01] Walker, Paul, "History of Game Theory," available online at http://www.econ.canterbury.ac.nz/hist.htm, May 2001.

1.5

DESCRIBING GAME BEHAVIOR WITH USE CASES

Matthew Walker, NCsoft Corporation

mwalker@softhome.net

Modern MMP development projects are very large, involving many participants with different skill sets. It is rare for the same person to handle both game design and programming tasks. A new challenge arises from this need for specialization: communication of game requirements from designer to programmer. Games involve complex interactions between entities, requiring sophisticated state management and event handling. The creative vision of the game design must be systematically mapped into a technical design model so that the final implementation represents the initial intent. *Use cases* provide an effective method for doing this.

What Are Use Cases?

Use cases define a model of system behavior using natural language within a simple structure that designers and programmers can use as their common frame of reference. One of the primary functions of use cases is to decompose a large, unwieldy system specification into manageable parts. These smaller parts are easily described and, consequently, more-easily implemented.

Each use case represents a discrete unit of behavior with a clearly defined scope, distinct steps, and unambiguous preconditions and postconditions. The clarity of each use case's scope aids in developing a modular, robust system design by defining where specific responsibilities lie. Using distinct steps to describe a behavior illustrates what should be done to achieve the goal of the use case and ultimately maps into program code. Stipulating preconditions and postconditions for each use case ensures that the state of the system is known both entering and exiting the use case, and exposes dependencies between use cases.

Why Use Them for MMP Development?

On the large, teams typical of today's MMP projects, designers, artists, and programmers must communicate regularly and clearly to coordinate the product's creation. Much of this communication is between people of varying levels of technical expertise. The approach of using simple, but structured natural language in use cases reduces ambiguity without making too many assumptions about each party's degree of technical understanding. Designers and programmers can collaborate to build a fairly robust picture of the game they are creating without becoming mired in jargon or implementation details. Later, programmers can take the picture formed by the use cases and transform it into code more easily and with a greater understanding of the designer's requirements than if they were trying to do so directly from a textual game design document.

How to Write a Use Case

Use cases have been used in software development outside the game industry since their introduction by Ivar Jacobson in the early 1990s [Jacobson92]. Since then, many authors have written about use cases, presenting many different approaches to writing them. These range from intensely formal, cross-referenced, document hierarchies to little more than short, but consistent modular descriptions of functionality.

The goal of this article is to present an acceptably consistent and clear approach, one that has been used in real game-development projects, to illustrate how thinking in terms of use cases can aid MMP game development. Our technique will be to use a simple and repeatable structure, concise terminology using everyday vocabulary, and unambiguous English sentences.

Identifying Use Cases

Behavior that constitutes a use case is sometimes hard to identify. What starts a use case, and when does it end? These are questions we must explore at the onset. The identification of actors and events helps us to do this.

Actors

Actors are entities that exhibit behavior and initiate interactions with, and within, the system being developed. Actors cause use cases to happen. Identifying actors helps us to identify where a use case begins. A simple list of actors with descriptions, as shown in Table 1.5.1, should suffice to encourage completeness and expose duplicates.

Often, actors are external to the system. Common examples include human users and other software programs. This point of view is useful when developing user interfaces and other nonimmersive aspects of a game, and it is the most-common point of view in traditional software engineering projects.

Table 1.5.1 Actors in a Generic MMP Role-Playing Game

Actor	Description
Player Character (PC)	In-game representation of the player
Non-Player Character (NPC)	Computer-controlled entity that shares many characteristics of the PC, including the ability to chat, trade, fight, and join a party with a PC
Monster	A computer-controlled entity that can only fight with a PC or NPC

In game development, however, an extremely important concept is that of an actor being an entity within the game environment itself. Many games are open-ended simulations of some aspect of reality, and within such simulations, entities often interact in complex ways. In such immersive situations, it is more useful to model the player's character as an actor, rather than as the player himself. At this level, it becomes clear that individual computer-controlled entities, such as monsters, NPCs, and vehicles, benefit from being treated as actors. When we use this approach, we are able to break complex chains of activity involving multiple entities into discrete interactions between pairs of actors.

Events

At the highest level, use cases derive from events initiated by actors [Fowler99]. An effective way to start identifying use cases is by listing and describing these events. Simply listing all the events that can occur in a game is a great way to brainstorm our set of use cases.

We do this by identifying the actor that generated the event and providing a one-sentence description of the event, as shown in Table 1.5.2. There are a couple of reasons for using a single sentence for the description. First, one sentence is short enough to include in a list while remaining readable. This aids in remembering and referring

Table 1.5.2 A Sample List of Events from Our Role-Playing Game, with Descriptions

Event	Description
PC Attacks Monster	PC targets monster and engages in combat using the currently equipped weapon.
PC Casts Spell on Monster	PC targets monster and casts a damaging spell on it.
PC Trades with NPC	PC purchases an item from an NPC.
PC Heals PC	PC casts a healing spell on another PC.
Monster Attacks PC	Monster targets PC and engages in combat, using the currently equipped weapon.
PC Equips Weapon	PC retrieves a weapon from inventory and inserts it into the weapon slot.

to events by name when discussing development with team members. The second reason is to introduce a discipline that is easy to follow: an event is a single occurrence; one can easily describe a single event in one sentence. If it takes two or more sentences to describe what is happening, it is likely that we are describing more than one event. Combining multiple events in such a manner is likely to confuse one's understanding of what is really happening.

Elements of a Use Case: A Standard Template

Now that we have discovered the events that will initiate our use cases, we must establish a way to describe them. We do this using a standard template to guide us in capturing the important elements of our use cases.

A use case is a structured textual description of a unit of system behavior. The structure is helpful for maintaining clarity and consistency, and is best enforced using some kind of standard template. We need a form that is at once simple and complete, and which is easily transcribed from white board to paper to word processor. In the template shown in Figure 1.5.1, each field represents a key use-case element and contains a brief prompt that hints at its purpose. We describe each element in greater detail in the remainder of this section.

Title: *[A short descriptive phrase used to identify this use case.]*

Description: *[One to three sentences that summarize the use case and define its scope.]*

Basic Courses: *[List of key steps for executing the use case. Minimize conditional logic and refer to other use when necessary.]*

Extensions: *[List of conditions under which alternate steps are taken.]*

Preconditions: *[List of conditions required for the use case to execute successfully.]*

Postconditions: *[List of conditions resulting from the successful execution of the use case.]*

Notes: *[Additional information and/or footnotes that add details that would otherwise clutter the other sections.]*

FIGURE 1.5.1 *A suggested use case template.*

Title

Each use case has a title so that we can easily identify it. Initially, the title can simply be the name of the event from which the use case derives. Eventually, it may evolve into something more appropriate as the use case takes form. As an example, a use case from one of the events listed above could be titled:

> **Title:** Player Character Attacks Monster

Description

A high-level description of the use case serves two purposes. First, it summarizes the use case and serves as an abstract to be included in any survey-level communication, such as a status report, planning document, or memo. Second, and most important, it defines the scope of the use case. The description should include only activities that are implemented in the use case and explicitly exclude those activities that occur elsewhere. That is not to say that the description should detail all of the activities in the use case. Rather, it should set the boundaries within which all activities will occur. Essentially, the description should start with the event that initiates the use case and end with any response to the event. The description for our use case might be:

> **Description:** *The player character attacks a monster with the current weapon. The monster takes damage.*

Note that this simple two-sentence description tells us several things. The player character is the actor, the action is an attack, the subject is a monster, and the result is that the monster takes damage. This use case carefully avoids discussing what the monster does to retaliate, or whether the monster dies as a result of its wounds. Those concepts are probably better described in separate use cases.

The Basic Course

The core of the use case is its list of steps. These describe the details of the behavior we want to implement. We use them to show the order in which actions are to occur, any repetition, and the existence of conditional logic. The first step should be consistent with the start of the use-case description, and the last should reflect the final concept mentioned in the description. This ensures that the set of steps remains within the scope established in the description statement. If we find that a step appears to fall outside the scope of the use case, we need to either remove the step, possibly to another use case, or redefine the scope of the use case. An example set of steps that fall within the scope of our earlier description might be:

Basic Course:

1. *Player character targets monster.*
2. *Player character attacks monster with current weapon.*
3. *Compute chance of successful attack.*
4. *Compute amount of damage.*
5. *Apply damage to monster.*

Now our use case is starting to take form. It is still very simple, having only five steps. This initial set of steps, according to Jacobson, is called the *Basic Course* [Jacobson92]. Yet, we have discovered additional details about our use case. In order to attack a monster, we actually have to first identify it as a target. And, to allow for more interesting gameplay, we probably want to introduce some probability of failure for the attack. Finally, the amount of damage dealt to the monster may be dependent on many variables, so we introduce a step to compute this value. Here, we are hinting at the existence of other behaviors that may have additional complexity to be explored.

Referencing One Use Case from Another

The steps of a use case are written at a level of abstraction that maintains a balance between completeness and readability. Our use case is easy to read because it has few steps, and at our current level of abstraction, it appears complete. Of course, when we write the game code, we will need to know some additional details, such as what it means to compute damage.

We could simply represent these details as additional steps in our use case, inserted in place of our current step four. But, this would impair the readability of our use case. In addition, computing damage is something we might need to do in a scenario other than the one described by this use case: our player character could fall into a vat of acid, be burned by fire, or set off a booby trap.

The better way to represent the details of computing damage is to write them in the form of a separate use case, and refer to the new use case from our current one. Our new use case looks like this:

Title: *Compute Damage Amount*
Description: *Compute damage delivered to target, including any modifiers to both base attack and defense values.*

Basic Course:

1. *Retrieve base attack value A from attack weapon.*
2. *Retrieve attack modifiers AM from attacker's equipped items.*
3. *Retrieve special attack modifiers SAM vs. target type from attacker.*
4. *Retrieve base defense value D from target.*
5. *Retrieve defense modifiers DM from target's equipped items.*

6. *Retrieve special defense modifiers* SDM *vs. attacker from target.*
7. *Compute damage* D *using the formula shown here:*

$$D = ((A + AM) \times SAM) - ((D + DM) \times SDM)$$

Now, we alter the steps of Player Character Attacks Monster by inserting the title of the Compute Damage use case in step four:

Basic Course:
1. *Player character targets monster.*
2. *Player character attacks monster with current weapon.*
3. *Compute chance of successful attack.*
4. **INSERT: Compute damage amount.**
5. *Apply damage to monster.*

In this way, our first use case remains just as readable as it did before. However, now we have captured additional information in the form of another use case. In the event that this new use case describes a common behavior that appears in other parts of our game, we can write use cases that refer to it, just as this one does. This relationship between the referring use case and the new use case is known as the *uses* relation [Jacobson92].

Extensions

We use the term *extension* to describe a step in a use case where behavior can change based on some condition. Extensions include both error handling and nonexceptional branching logic. For clarity, it is useful to list the steps of the basic course as a straight sequence, with no extensions. In this way, readers can easily see what is supposed to happen under normal circumstances. Of course, a huge part of programming involves deciding how to handle conditional cases, so how do we represent those? This is a judgement call, but the primary guidelines are to keep your use cases readable and to minimize the overall effort required to manage them.

The more-traditional approach is to make every extension its own use case and to reference it from the main use case. The relationship between the referring use case and the new use case is known as the *extends* relation [Jacobson92]. This approach can be overkill, as many extensions require only one or two steps to describe the conditional behavior. However, when an extension actually describes a more-elaborate, alternate course of execution with many steps and its own well-defined scope, it becomes appropriate to create a new use case.

For simple extensions, such as detecting an error and stopping execution, or terminating a loop, it is best to leave the extension as part of the main use case. How this is done becomes a matter of style. One approach is to simply write the condition as a step in the normal sequence.

Below is the Player Character Attacks Monster basic course. The in-line extension has been added:

Basic Course:
1. *Player character targets monster.*
2. *Player character attacks monster with current weapon.*
3. *Compute chance of successful attack.*
4. **If attack fails, stop.**
5. *INSERT: Compute damage amount.*
6. *Apply damage to monster.*

Another way is to create a separate section for extensions in the use-case template [Cockburn01]. Here, each extension is listed and refers by step number to its corresponding step in the basic course. Our use case with a separate section for extensions is as follows:

Basic Course:
1. *Player character targets monster.*
2. *Player character attacks monster with current weapon.*
3. *Compute chance of successful attack.*
4. *INSERT: Compute damage amount.*
5. *Apply damage to monster.*

Extensions:
3a. **If attack fails, stop.**

Regardless of your choice of approach, applying it consistently is what matters most.

Preconditions and Postconditions

Use cases require specific preconditions in order to execute successfully. Preconditions constitute the state of the system prior to the execution of the use case or some input to the use case itself. After the use case has completed successful execution, it produces specific postconditions. These are manifested either as a change to the system state or some output of the use case. These two concepts are powerful tools for helping ensure that a model of the system is complete and that all important use cases are captured. If a use case has a precondition that is not met either by the postconditions of another use case or by input into the system, then something is missing. Likewise, if a use case produces a postcondition that is not required as a precondition of another use case or is not needed as an output of the system, the postcondition is likely unnecessary.

Using our use case template, we represent preconditions and postconditions as simple numbered statements:

Preconditions:

1. Monster is a valid attack target.

2. Player character has a weapon equipped.

Postconditions:

1. Monster receives damage.

In terms of game development, these concepts help avoid gameplay bugs starting early in the project. In our example, if something prevents the monster from being a valid target of an attack, that precondition is not met, and we cannot even begin to execute the Player Character Attacks Monster use case. Likewise, if the player character has no weapon equipped, the use case will not execute. These are clear signals to us to implement checks for these preconditions in our game code in order to prevent strange behavior and possible exploits. Furthermore, these signals tell us that we need to identify use cases that describe how a target becomes valid and how a player character might equip a weapon for an attack.

We also know we have to have some use for the postcondition of "Monster receives damage." We may update our display to show the monster's declining health, and we probably need a use case to handle what happens when the monster's health reaches zero. The point is, we are directed by our use case to attend to this question.

Preconditions and postconditions are counterparts. Using consistent language when writing them will help us identify associated pairs—and through them, dependencies between use cases. Avoid combining two or more preconditions or postconditions on a single line; doing so may lead us to infer natural associations between them that are merely coincidental. Sometimes, only a subset of a list of preconditions is required for the use case to succeed. We represent this by associating optional preconditions with the word "OR." It is not recommended to allow optional postconditions, because their presence suggests some overlooked extensions. When this happens, we review the use case and try to factor it in so that all postconditions are absolute. This may mean creating additional use cases to capture any extensions that may reveal themselves.

Notes

The final field of our template is for capturing details that may be too wordy or awkward to fit within the structure of the other template fields. There are two guidelines for this field. The first is to list and separately number each note, and then to refer to them from within the use case with a superscript footnote number. The second guideline is to avoid listing as a note anything that is better described in one of the primary fields of the template.

Pretty Pictures

When organizing, discussing, or documenting use cases, it is sometimes useful to draw diagrams that represent them and their relationships to one another. These diagrams, like the one shown in Figure 1.5.2, are called *use case model diagrams* [UML01]. They have three main purposes:

1. Provide a visual indication of the scope of the system.
2. Identify relationships between use cases.
3. Aid in refactoring and grouping associated use cases for subsystem design.

Note how Figure 1.5.2 shows the sharing of the Compute Damage Amount use case by PC Attacks Monster and PC Casts Spell on Monster. This is a handy way to document a modular design early on in the development process. These diagrams may be drawn in just about any diagramming tool that supports connecting shapes with lines and textual annotation. They are not required, but they are often helpful.

FIGURE 1.5.2 *A use-case model diagram.*

Getting to Implementation

Once we have written our use cases, how do we use them to guide the implementation of our game? At this point, we still have little more than nicely organized structured descriptions of what we want to create in code. Once again, we need to apply discipline, judgement, and experience.

Formal methodologists usually say that we should not code directly from use cases [Evans02]. There are valid arguments for this. While use cases do provide a better understanding of the structure and specific behaviors of our game, they still represent a high-level point of view. Naive translation of these use cases directly to code will invariably overlook key architectural considerations and gloss over important implementation details.

A commonly accepted approach is to flesh out a design model based on our use cases, applying various object-oriented design techniques—in particular, *sequence diagrams* [McNeish02]. Sequence diagrams depict the sequence of method calls between object instances that is required to implement a given use case. This provides an intermediate level of granularity that gives us an opportunity to explore class interfaces and object interactions in much greater detail. As we develop the sequence diagram, specifying the objects and methods we need as we go, we begin to develop a class structure that we can model in a static class diagram. From these, we encounter the architectural considerations and can address them much more effectively.

While the above may be the preferred approach, this article accepts the likelihood that many game developers may have neither the time, resources, nor will to adopt more formal methods so easily. Also, an adequate treatment of these techniques is beyond the scope of this article. Instead, we assume the reader to have sufficient experience in technical design and implementation, and to employ sound engineering and technical design principles at all times. The remainder of this discussion will focus on how to benefit from our use cases, even if we choose not to employ a formal approach.

Candidate Abstractions

Now that we know how our game will behave, we must determine the structure that will host this behavior. This is important, because a well-defined program structure is more robust, efficient, and more-easily maintained than one that is not well defined. By well defined, we mean that our code is organized so that related functionality and data are grouped together, implementation details are hidden behind interfaces that clearly indicate their purpose, and dependencies between program elements are explicit, rather than implicit.

To reveal this well-defined structure, we need to discover the abstractions that are responsible for performing the operations that we describe in our use cases. Each step of a use case is an English sentence with a subject and a verb, and often an object: some *thing* performs some *action*, often on some other *thing*. The *thing* that does the

action is *responsible* for performing that action. This *thing* is an abstraction that fits within, and helps to define our program structure. Therefore, the first step in discovering our abstractions is to identify the nouns in our use-case steps as either the subject or object of the step. Ultimately, such candidate abstractions will solidify into classes, data structures, or important attributes within our object-oriented design.

Refer back to our use cases Player Character Attacks Monster and Compute Damage Amount. The steps of these use cases, along with their preconditions and postconditions, identify several candidate abstractions. In Table 1.5.3, we list them

Table 1.5.3 Candidate Abstractions, Types, and Notes

Abstraction	Type	Note
Player Character	Class	Represents the player in the game world and performs all player-initiated actions.
Monster	Class	Represents AI-controlled characters in the game world. How much in common with Player Character?
Weapon	Class/Data Structure	An object that a PC (possibly Monsters, too?) wields and fights with. Contains information affecting the outcome of an attack. Q: How is *wielding* like *equipping*?
Damage	Variable	Transient value that is computed from inputs retrieved during an attack.
Attack Value	Attribute	Input to attack computation. Attribute of Weapon. Each Weapon may have different attack values. Q: What determines a Weapon's attack value?
Attack Modifier	Attribute	Input to attack computation. Attribute of equipped items (Weapon, enchanted Armor?)
Special Attack Modifier	Attribute	Input to attack computation; varies according to type of attack target. Attribute of Player Character. Q: Are there different SAMs for each target type? What happens when the target type is not one for which there is an SAM? What is this an attribute of?
Equipped Item	Class	An object that a PC (possibly Monsters, too?) can 'equip' (wear). May have attributes that modify attack computation.
Target	N/A	A *role* that other classes perform. Monsters (possibly PCs?) can be targets. Q: What other things can become targets? What makes something become a target?
Target Type	Attribute	A classification of a target that segregates it from other targets.
Attacker	N/A	A role that other classes perform. PCs (possibly Monsters?) can be attackers. Q: Does the state of being an attacker cause other things to happen (besides the attack), such as alert enemy AI, affect a PC's reputation, etc.?
Defense Value	Attribute	Input to attack computation. Attribute of target Monster (PC?). Each Monster/PC may have different defense values. Q: What determines a specific Monster's defense value?
Defense Modifier	Attribute	Input to attack computation. Attribute of equipped items.
Special Defense Modifier	Attribute	Input to attack computation. Varies according to type of attacker. Attribute of Monster. Q: Are there different SDMs for each attacker type? What happens when attacker type is not one for which there is an SDM?

and attempt to classify them as potential classes, data structures, attributes, or variables, and make notes about their meanings within the game. As we do so, the nature of our game's structure begins to emerge.

Analysis of Abstractions

This study has revealed some interesting facts about our game and raised some important questions that we must investigate further. Although we have not attempted to describe in use cases whether a Monster can attack a PC, it is reasonable for us to assume that one can in order to make for more-interesting gameplay. That said, it is likely that such behavior on the part of Monsters would be very similar to an attack by a PC. This leads us to the question, *how much do PCs and Monsters have in common?* This question demands additional investigation. We should probably revisit Player Character Attacks Monster and reverse the roles to see what happens. It is possible that these two abstractions, Player Character and Monster, specialize a higher level abstraction yet to be defined.

The Weapon abstraction has several interesting properties. It contains attributes that are important in computing the outcome of an attack. We have not yet discovered any behavior specific to a weapon, so it may merely be a data structure. It also raises the question about whether *wielding* a weapon is anything like *equipping* an item. At any rate, we have discovered an association between a PC or Monster and one or more items. We also encounter additional questions:

- What aspects of Weapons and other equipped items are different from other types of items in the game?
- Do we have other items that cannot be equipped?
- Can any equipped item be a Weapon?

Some answers may be immediately obvious. Other answers may require discovery through additional use cases.

We have found that the target and attacker abstractions are not distinct from PC and/or Monster; but rather, they describe roles performed by those other abstractions. Eliminating candidate abstractions that will not become classes, data structures, or attributes helps to clarify and simplify our model. Identifying these abstractions as roles instead hints that participants in an attack may undergo some change of status associated with the attack. It also indicates a relationship between attacker and target. We must therefore determine how becoming an attacker or a target affects a PC or Monster outside the context of the attack proper, and whether this relationship is explicit and long lasting, or implied and transient.

Developing a Class Structure

This look at our candidate abstractions helps us to build the structural view of our game. We have a possible class hierarchy involving PC and Monster, and another possible hierarchy involving Weapons and other items. We also have an association between PCs/Monsters and Weapons, and possibly other equipped items. We have another association between PCs and Monsters, in which one is the attacker and the other the target. Figure 1.5.3 illustrates this in a simplified class diagram. Simply reading the steps of our use cases tells us which of these abstractions perform which actions. This ultimately reveals the methods implemented by the classes we have discovered.

If we were to start writing C++ classes that implement what we know so far, they might look something like this:

```
class BaseCharacter
{
public:
        // ...
        bool SetTarget(BaseCharacter* pTarget);
        BaseCharacter* GetTarget();
        bool AttackCurrentTarget();
        void ApplyDamage(int iDamageAmt);
        int GetDefenseValue();
        const string& GetCharacterType();
        bool EquipItem(Item* pItem);
protected:
        bool AttackIsSuccessful();
int ComputeDamage();
```

FIGURE 1.5.3 *Initial class diagram from our use cases.*

```
Item* GetEquippedItem(const string& name);

    // dictionary of equipped items, keyed by name.
    hash_map<string, Item*> m_EquippedItems;
    int m_MaxHitPoints;        // our amount of "life"
    int m_CurrentHitPoints;
    int m_DefenseValue;
    string m_CharacterType;
};

class PlayerCharacter : public BaseCharacter
{
public:
    int GetSpclAttackMod(Monster* pTarget);
    // other player specific stuff to be determined
private:
    // mapping of SAM by target type
    hash_map<string, int> m_SpclAttackMods;
};

class Monster : public BaseCharacter
{
public:
    int GetSpclDefenseMod(PlayerCharacter* pTarget);
    // other monster specific stuff to be determined
private:
    // mapping of SDM by target type
    hash_map<string, int> m_SpclDefenseMods;
};

class Item
{
public:
    bool CanBeEquipped();
    bool Equip(BaseCharacter* pOwner);
    int GetAttackMod();
    int GetDefenseMod();
protected:
    int m_AttackModifier;
    int m_DefenseModifier;
    BaseCharacter* m_pOwner;
};

class Weapon : public Item
{
public:
    GetAttackValue();
Protected:
    int m_AttackValue;
};
```

These classes are mere skeletons for the implementation of our game. Yet, we derived them from only two use cases. As we write additional use cases that describe other important gameplay behaviors, we will solidify both the behavioral and structural models of our game. Certainly, many structural elements are also driven by architectural goals, such as networking, data persistence, 3D graphics rendering, and the use of third-party libraries. However, any structure influenced by architectural considerations must support, and will be further extended by, the game behavior we have documented in our use cases.

Use Case Guidelines

Those designers new to the technique usually grasp the mechanics of writing use cases quickly. Yet, as with most skills, good judgement and effective application come with experience. This part of the article presents a loose set of guidelines designed to help you avoid some of the more-common pitfalls normally encountered with use cases in the context of MMP development.

Describe the Problem, Not the Solution

Use cases are a technique for analyzing what needs to be created when we build a software system. They are a statement of the problem to be solved, not of how to solve it. We should avoid tainting our use cases with implementation details, such as descriptions of data structures, user interface elements, network protocols, database queries, or even algorithms.

The reason for this is simple: when doing use cases, we are still learning about our system, and we do not have enough information to justify making technical decisions that may be invalidated by later discoveries. Such decisions will likely be wrong, requiring us to revisit them. Worse, we may bias our use cases in favor of certain technical assumptions we have made, leading us to incorrectly represent the requirements expressed by our game design. The result is a game that does not live up to the designers' goals or expectations.

Iterate

Use cases are tools of discovery. They enable us to learn the details of what we want to build. As such, later discoveries will often cause us to refine points we thought we had understood from earlier discoveries. We should plan to make several passes over our use cases as we develop them, tweaking them as needed. We should also allow ourselves to begin implementing key use cases in code, even before we think we have found all of our use cases. Despite our best efforts at capturing our game's require-

ments on paper, once we begin implementing our game, we will discover details that were overlooked.

A good iterative approach is to write the use cases for a subsystem that has few dependencies on other unimplemented subsystems. Then, implement that subsystem as far as is reasonable, using what we learned from those use cases. Next, begin work on the use cases for a related subsystem, one that interacts in some way with the first. Knowing something about the actual implementation of the first set of use cases, we may be able to use this information in developing the second set. We will also probably have to refine our first set of use cases somewhat when we make additional discoveries from the second set. As we write the code based on our second set of use cases, we may have to refactor some of the code that came from our first set. This cycle continues, until our system evolves into a complete game.

Collaborate in Person

Use cases are a communication tool. Their main purpose is to convey ideas about the requirements of a system—in our case, the game design—to the implementers of the code. This is not a one-way street. Game designers who attempt to write a bunch of use cases on their own and hand them off to the programmers, or programmers who try to glean the contents of use cases from a game-design document, are asking for serious trouble.

Game-design documents are where designers try to express their creation on paper. However, there are myriad details and assumptions that are not captured on paper, and which come to light only within the context of the game designers' own thought processes. Collaboration between programmers and designers is essential. It allows the programmers to gain insight into the designers' thought processes. Equally important, it provides an avenue for the programmers' feedback to the designers, helping to ensure that the design is at once understood and logically consistent. Neither party can cover this ground alone.

Do Not Expect Use Cases to Capture All Requirements

Use cases are a valuable tool for identifying system requirements, but they are not the only tool, and they will not capture all requirements [Evans02]. Assuming that they will do so may lead us to some nasty surprises later on in the development process. Primarily, use cases model requirements relating to the functionality of our game. These include the rules of gameplay, interaction with objects in the game world, and the behaviors of supporting game systems, such as chat, inventory, locator maps, party management, and so on.

They do not model requirements related to security, performance, network latency, exploit prevention, process control, and other architectural considerations that are equally critical to the success of an MMP. Nor do they model operational support requirements, such as activity reporting or customer-support intervention. However, modeling use cases within the framework of these architectural and support considerations allows us to ensure that our functional requirements do not violate our architectural goals. For example, we may have a game design goal to allow players to upload their own content, but a customer-support goal will be to minimize the need to police player behavior. In such a case, we can employ use cases to define a system that requires a player to provide his consent before seeing the content uploaded by another player.

Communicate

When describing the game in development to team leads, producers, schedule managers, and members of other teams, use cases are invaluable. It is surprising how much information can be conveyed about the game by simply listing the titles of a group of related use cases. At that level, previously uninformed team members are told, in a simple list format, what features will be implemented in the game. For example, the list of use case titles:

- *Player Character Equips Weapon*
- *Player Character Targets Monster*
- *Player Character Attacks Target*
- *Compute Damage Amount*
- *Target Dies*

tells the casual observer much more about the game than the vague heading, "Combat System." At a deeper level of detail, the use-case descriptions serve as a thorough reiteration of the game design, describing what has been agreed upon between designers and programmers. This gives management a clear understanding about what will actually be implemented in the game.

Plan with Use Cases

Use cases lend themselves well to project scheduling. Since each use case represents a fairly small and manageable unit of development work, we can assign time estimates for implementing them. Because use cases reveal dependencies between different parts of our game implementation, they can help us order our task list to maximize effectiveness and avoid downtime in waiting for unforeseen dependencies to be resolved. Keep in mind, however, that since use cases do not model all requirements, they will not identify all tasks necessary to implement the game. Avoid the naive assumption that simply because all use cases are accounted for, the system is completely defined.

Avoid Linear Thinking

Because use cases are tools for discovery, we must not fall into the trap of expecting to define our game's behavior in a deterministic fashion. We may describe a use case in terms of ordered steps, but that does not mean we will learn what each step is in the order they are to be executed. As a part of our iterative development approach, we must be willing to consider inserting additional steps into, or removing them from, an already 'finished' use case.

We may believe that a certain step will expand into a full-blown use case, but if we have insufficient information at the time to flesh it out, we should not force it into existence. It may be that upon further investigation this significant step can be well described with a simple line of text rather than a complete use case. Rushing that discovery will create additional use cases that we do not need, adding to the administrative burden of managing them.

Be aware that our initial description statement may need to be revised as we refactor our use-case steps into something more reflective of our needs. Do not refuse to alter it simply because it describes the original intent of the use case. Rigid adherence to our first impressions will cause us to miss important game requirements or identify invalid requirements.

Do Not Overemphasize Tools

There are many current software design tools that claim to support use-case development. Many of them provide some valuable features, but usually at a significant cost, and they usually require that the project using them impose some form of rigid process to get the full benefit of their feature set. Very large projects may benefit from such tools, but the assumption of this article is that many game-development teams would be burdened more than benefited by them. Instead, we should use a simple word processor to capture use cases, following the template described in this article or some variation more appropriate for our project. If we desire diagrams, any drawing tool that allows us to connect shapes with lines and annotate them with text is enough. Anything else may distract us from our primary goal of developing our game, or burden us to the point that we give up on use cases entirely.

Emphasize Clarity of Communication over Notation

Do not get hung up on following the 'rules' for writing use cases set forth in this article or any other. Treat an approach as a generalized means to the end of describing your game's behavior so it can be implemented effectively. Clearly communicating the game requirements is much more important than following any convention. If writing every step as a separate line impedes our thought process and flow of collaboration, consider a more narrative approach. If it is clearer for us to write conditional

logic in pseudo-code in line with our steps, then so be it. The approach suggested in this article is intended to aid communication; but if this approach hinders rather than helps us, we need to refine it or try another approach.

Avoid Focusing on Client-Server Details

Many times in writing use cases for MMP games, the issue arises of which operations are performed on the client and which on the server. This article takes the position that this is an irrelevant implementation detail and should not normally be expressed in a use case.

Consider that, in a perfect world of infinite bandwidth and zero latency, an MMP game program would run entirely on the server. Each client would be the equivalent of a graphical 'dumb terminal' that merely displays a picture of what is happening on the server. This is because all interactions between players and the game exist in a single logical space, which must reside on the server.

Of course, we do not have infinite bandwidth and zero latency, so we must add functionality to the game client that simulates these conditions. We want a responsive game, so we predict certain actions—such as movement in the world, the performing of actions involving animations, and the like—on the client, and let the server correct us if the client guesses wrong. This functionality is clearly an implementation detail. Attempting to insert such details in our use cases can easily divert us from describing *what* is supposed to happen to *how* it should happen.

Separate the Game from the User Interface

A common mistake many use case writers make is to describe user interface interactions in a use case that is intended to describe game behavior. When we are modeling what the game will do, we should not care which button click, menu selection, or key press causes the behavior to happen. From the point of view of the game, these are implementation details. Whether a player equips his weapon by dragging it to a slot in a paper doll or dropping it onto the 3D model of his character does not matter to us. In either case, the weapon is being equipped, and the same game code will be used.

This is not to say that use cases should not be employed to model user interface behavior. They can be very effective for this purpose. When writing this kind of use case, we should focus only on the behavior of the user interface elements themselves, rather than the underlying game. Use cases of this nature will describe what happens when a player clicks on a button, selects an item from a menu, or displays a window. Instead of describing how the game reacts to the input, these use cases should describe how the display is updated, any input state changes that may occur, and the types of user input that are expected.

Decoupling game use cases from user interface use cases allows for better modeling of both subsystems, without polluting either model with implicit assumptions driven by the other.

Do Not Insist on Total Coverage

There are many reasons why use cases may not be applied to an entire project. Some technical areas (especially infrastructure areas such as database, networking, process management, and the like) may already be well understood by the implementers. Some programmers or game designers may resist the adoption of a new technique that has not proven its effectiveness to them directly. Certain members of management may not understand the benefit of use cases and feel that dedicating time on the schedule for use cases is not justified.

We should not assume that if we cannot express all aspects of the game with use cases, it is pointless to do them at all. Often, our game can benefit from strategic application of use cases in just a few areas, by as few as one designer and one programmer. Why waste our energy trying to convince people that resist using them, when we can demonstrate their effectiveness ourselves? If we want to gain support from other team members, we should document our use cases in a readable form and share them with the team. When we discuss the part of the game we are responsible for, we should discuss it in terms of the use cases, and refer other team members to them when they have questions.

If use cases are indeed valuable for other parts of the project, other team members will become interested in them. If not, at least our own work will have benefited from them.

Conclusion

Use cases are an effective way to translate the creative design of a game into a structured form that is useful for driving the technical implementation. Opinions differ in the software industry on effective approaches to writing use cases. The position of this article is to use whatever approach best suits our current project; and we must consider the nature of the game we are developing, the dynamics of our team, and our degree of willingness to accept discipline and formality. The approach suggested by this article is meant to be practical, easily understood, and simple to execute. Regardless of the approach used, the very act of thinking in terms of use cases leads to a better understanding of the problems to be solved by our implementation.

References

[Cockburn01] Cockburn, Alistair, *Writing Effective Use Cases*, Addison-Wesley, 2001.

[Evans02] Evans, Gary K., "Why Are Use Cases So Painful?", available online at *http://www.evanetics.com/articles/Modeling/UCPainful.htm*, 2002.

[Fowler99] Fowler, Martin, *UML Distilled Second Edition: A Brief Guide To The Standard Object Modeling Language*, Addison-Wesley, 1999.

[Jacobson92] Jacobson, Ivar, *Object-Oriented Software Engineering: A Use Case Driven Approach*, Addison-Wesley, 1992.

[McNeish02] McNeish, Kevin, "UML Sequence Diagrams," *CoDe Magazine*, March/April 2002, available online at *http://www.visualuml.com/whitepapers/UML%20Diagrams.pdf*.

[UML01] Unified Modeling Language, v1.4, available online at *http://www.omg.org/cgi-bin/doc?formal/01-09-67*, Object Management Group, 2001.

1.6

Using a Hit Point to Coin Conversion Factor

John M. Olsen, Microsoft Corporation

infix@xmission.com

The purpose of this article is to help you to assign proper values to objects based on their damage-dealing or damage-curing abilities, and to branch out from that baseline in order to understand how to assign values to items in most of your player economy.

It seems that in life, there is a price attached to almost everything. By extending this little truism to the application of hit points in your game, you can greatly simplify a whole range of mechanics that are typically hard to balance. In MMP games, it is absolutely critical to control and understand how money enters and exits your world, or your economy will crumble around your feet in no time.

This article is written on the assumption that you are using a fantasy setting, even though the concept is equally applicable to any game that uses the fairly standard approach where higher-level players and NPCs (Non-Player computer-controlled Characters) have a larger number of hit points and greater protection from damage. We will base everything here on a generic unit of measuring money: the coin. The goal is to find a programmable way of determining the cost of items within the game setting. This can be applied to a wide array of items. Once the relative values of items in the game have been figured out, you can decide what you want one 'coin' to represent.

In order to use this system, you must keep certain assumptions in mind in order to ensure the conversion remains balanced as characters advance. The first assumption is that the damage of a given weapon will not increase dramatically as the player advances in the game. It is perfectly acceptable to degrade the ability of a beginner to use an advanced weapon, but the base damage for a competent player should be uniform for a given weapon.

The Cost of Weapons

There are typically a lot of ways to do damage in a game. You can have one-shot effects, like arrows or spells, you can have items that are good for a fixed number of attacks and then vanish or need to be recharged, and you can have items that last for a long time and wear out gradually. We will assume that all weapons wear out uniformly over time. We make this assumption because we want to base our prices on the total damage capabilities of items and not just how quickly they can do damage.

Let us start with something simple and decide one coin equals one hit point. The baseline itself is actually arbitrary, and you can scale the base value as needed when you are done.

Table 1.6.1 shows a list of one-shot items and their related prices. The average damage would be calculated from simulating typical use, so the number is a bit fuzzy. For the examples here, we will just assume it is a straight linear damage table, so something that does from A to B points of damage will average $(A + B) / 2$ points.

This is easily scaled up if you have an item that is good for a fixed number of uses. If you happen to have a magic staff that has five charges rather than the one-shot effect of a scroll, then the cost is just the total damage, which is the one-shot damage multiplied by the number of charges. Based on the table values, the total cost is 750 * 5, or 3,750 coins.

It gets a little more complicated when you get to items meant for long-term use, such as a sword. For that calculation, we can assume you buy a brand new sword and use it until it is as worn out as it can get. Depending on how nice you are to the players, at that point, the sword will either bottom out or break. The number we want is how much damage that sword did over its life span.

It is time to state our assumptions again. First, the sword will do 1–15 points of damage in new condition, and will do just 1 point of damage when completely trashed. This gives it an average damage that ranges from eight to one over the life of the weapon.

Table 1.6.1 One-Shot Damage and Fixed Numbers of Charges

Description	Uses	Total Damage	Coins
Crude Arrow	1	1–5	3
Standard Arrow	1	2–10	6
Improved Arrow	1	6–12	9
Super-Duper Arrow	1	50–100	75
Magic Scroll of Infernal Inferno	1	750	750
Staff of Infernal Inferno	5	3,750	3,750

We can choose a life span for the weapon to be 18,000 seconds (5 hours) of combat time. This gives the player a lot of time to swing the sword before being forced to repair it. Assuming that only about 20% of the player's time is actually spent in combat, this same 5 hours of combat equals roughly 25 hours of fairly combat-intensive play. That should be long enough to keep players from taking too-frequent trips to the repair shop.

If the weapon takes five seconds to use in an attack, then the weapon is good for 3,600 attacks. The math in Equation 1.6.1 is fairly simple if the weapon degrades linearly over time.

$$\text{Cost} = \text{Attacks} \times \left(\text{AveWornDmg} \, \frac{\text{AveNewDmg} - \text{AveWornDmg}}{2} \right) \quad (1.6.1)$$

This calculates the shaded area under the line in Figure 1.6.1. The damage is represented by the vertical axis and the swings represent the horizontal axis.

Filling numbers into Equation 1.6.1 gives us Equation 1.6.2. This tells us what the sword is worth:

$$3{,}600 \times \left(\frac{(8-1)}{2} \right) = 16{,}200 \text{ coins} \quad (1.6.2)$$

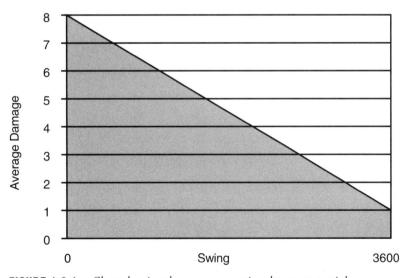

FIGURE 1.6.1 *Chart showing the area representing damage potential.*

As a second example, say you want something simpler, like a bronze dagger. It has lower damage and a shorter life span, so you would expect it to cost a lot less. If it has a life span of 1,000 attacks, ranges from a damage of one to four when new, and down to one when worn out, the cost of that dagger is shown in Equation 1.6.3. The 2.5 represents the average damage when new, which should not be confused with the maximum damage.

$$1,000 \times \left(1 + \frac{(2.5 - 1)}{2}\right) = 1,750 \text{ coins} \qquad (1.6.3)$$

Comparing that cost to our arrows in Table 1.6.1 above, you can trade one bronze dagger for just over 290 standard arrows, or about 23 of the super-duper arrows.

This also brings up the point of repair costs for those items that wear out over time. Since the repair cost can be mapped directly to damage, you can determine the cost based directly on how weapons wear. If the weapon is 50% worn out, the cost to repair it would be 50% of a new weapon's cost. If you want to encourage players to repair their weapons earlier rather than later, you could build in a nonlinear scaling that makes the repair cost grow slowly at first and then accelerate at the end of the object's life span. One such function to change what it costs to fix items is shown in Equation 1.6.4:

$$\text{FixCost} = \text{BaseCost} \times \text{WearPercent}^2 \qquad (1.6.4)$$

Reusing our example of a weapon with 50% wear, the cost on this nonlinear scale would then be 25% of the new cost. The squared term could be replaced with any continually increasing function that has input and output values that match at both 0% and 100%. Figure 1.6.2 compares two possible cost curves.

Note that this all plays in nicely with the idea that higher-quality weapons or those that last longer between repairs should cost more money. Weapons that do more damage also scale up in cost as you would expect. The players are then able to decide what they want and what they can afford. If they need a high-damage weapon, but do not have a lot of coins to spend, they must sacrifice durability and use a weapon that wears out faster and requires more-frequent repairs.

It is important to keep in mind that you must still make things fun for the player. If repair trips are too frequent, the players will not be having fun; so this is an area that you should plan on for a lot of play-testing to find the right balance as you implement object use and repair.

Table 1.6.2 shows a few sample weapons, based on the calculations described above. Note that for the last two entries, the number of uses for the weapon scales evenly with the cost.

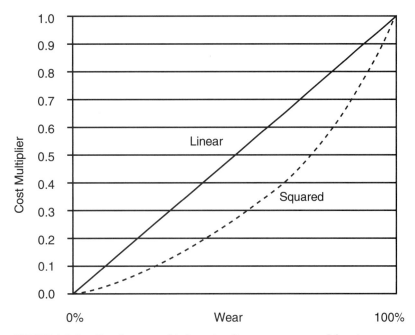

FIGURE 1.6.2 *Repair-cost multiplier using linear versus squared functions.*

Table 1.6.2 Items that Wear over Time

Description	Uses	New Damage	Worn Damage	Coins
Sword	3,600	1–15	1	16,200
Bronze Dagger	1,000	1–4	1	1,750
Crude Club	200	1–10	2	750
Finely Crafted Stiletto	5,000	1–5	1–2	11,250
Superb Claymore Sword	7,000	8–30	2–4	77,000
Bronze Claymore Sword	1,000	8–30	2–4	11,000

Healing, Armor, and Damage Mitigation

The same numerical methods can be equally applied to items that repair damage, such as healing potions or medical kits. The amount of healing determines the cost of the item. If the amount healed can vary, then you need to base the cost on the average amount, just as discussed above for variable weapon damage.

Armor also fits nicely into the scheme of things so long as you track a little extra information. All you need is the number of hit points that it can absorb or direct away from the player before the armor becomes useless. This is the number of hit points

that you map directly into coins in order to determine the cost of the armor. This can be done fairly easily with either a general armor class setting, by distributing the damage evenly across all armor pieces, or a targeted attack scheme where the damage is applied to a particular armor piece.

Armor repairs work just like weapon repairs. The repair restores the armor's ability to absorb damage, just like a weapon repair restores its ability to do damage.

NPC Loot

Now that we know how to price some of our items, where do all those items come from? Loot, of course! How do you balance the amount of loot a particular NPC gives to the player who defeated it?

The basic rule here is that the average loot should slightly exceed the number of points of damage required to kill the NPC plus the number of points damage that creature will do to the player. You need to pay the players for both wear on their armor and wear on their weapons. If you are using a nonlinear repair multiplier, as shown in Figure 1.6.2, you can probably reduce any loot-scale multiplier to be very close to one.

The base amount of loot varies with how fast the creature is killed. Since we are working with probabilities, it is fairly safe to generalize and assume players will do damage at roughly the same rate the creature does. Armor and magical protections can also skew the data, but it is possible to compensate for those effects. The base calculation is shown in Equation 1.6.5. The base loot value is not scaled to allow for a profit in these equations.

$$\text{BaseLoot} = (\text{WearOnPlayerWeapon} + \text{WearOnPlayerArmor}) \qquad (1.6.5)$$

Since we decided statistically that the wear on the player's weapon is roughly equal to the wear on their armor, we can simplify this, as shown in Equation 1.6.6.

$$\text{BaseLoot} = 2 \times \text{WearOnPlayerWeapon} \qquad (1.6.6)$$

The total amount of wear, therefore, determines the base loot, or how much loot a critter should be carrying, on average. Or to go the other way, if you know what loot it will give and what sort of protections it has, you can determine how many hit points it should have. Solving for hit points leaves us with Equation 1.6.7.

$$\text{WearOnPlayerWeapon} = \frac{\text{Base Loot}}{2} \qquad (1.6.7)$$

In Equation 1.6.8, we can also add that the wear on the player's weapon is divided between wear on the NPC's hit points and wear on the NPC's armor. So, the wear on the weapon is the sum of those two values.

$$\text{WearOnPlayerWeapon} = \text{WearOnNPC} + \text{WearOnNPCArmor} \qquad (1.6.8)$$

Solving once again for the base loot, we get Equation 1.6.9.

$$\text{BaseLoot} = 2 \times (\text{WearOnNPC} + \text{WearOnNPCArmor}) \qquad (1.6.9)$$

For instance, let us say unarmored Orcs have a 50% chance of dropping a crude club with a base value of 750, and drop nothing the other 50% of the time. If the club is always 50% worn out (using the simpler linear scale), the loot value as shown in Equation 1.6.10 is one-fourth that of a new club. It is important to use both the frequency and the wear amount when scaling the base loot, since you want to deal with averages.

$$\text{BaseLoot} = 750 \times 0.5 \times 0.5 = 187.5 \qquad (1.6.10)$$

If we assume the Orc has no armor, then all the damage goes directly to hit points. We plug the numbers into Equation 1.6.7 in and get Equation 1.6.11, a value that shows how much wear will be put on the player's weapon. Since this wear is all going straight into damage to the NPC, we also know this can be used for the NPC's hit-point maximum.

$$\text{WearOnPlayerWeapon} = \frac{187.5}{2} = 93.75 \qquad (1.6.11)$$

The amount by which you increase loot or decrease hit points from this starting point determines how fast players can accumulate wealth in the game. This is an area where you can start with a base scale factor of one and tune it as needed during play tests.

An Orc wearing armor that absorbs 20% of the damage inflicted on him (15 hit points) would have an extra 30 coins added to its base loot value because of the extra damage that would have to be done to it and the extra damage it would do before being dispatched.

In some cases you may want particular NPCs to be very expensive to kill, with their base loot being far below what you would expect based on their hit points and armor rating, or you may want to have an NPC that players flock to because it drops disproportionately more loot than other NPCs. There are reasons why you may want to do either. In the first case, the particular creature may occasionally drop a rare and coveted item that makes up for its lack of monetary value. In the second case, you could be trying to encourage players to visit an out-of-the-way location.

Averages and a general understanding of statistics come in handy here. If you want a weak and easily killed creature to drop some very expensive loot, you need to adjust the frequency of those loot drops so the average is still near the base loot value

for that NPC. For instance, if you want a lowly rat to drop a highly prized gemstone, it must happen very rarely.

Manufacturing

If your game has trade skills that allow players to manufacture weapons, you can encourage the use of those skills by giving the craftsman player a bonus as compared to buying directly from NPC vendors. If players can make something for a discount, you can bet that some players will take advantage of trade skills to provide goods and services at a price that undercuts the NPC vendors.

When building a weapon, the cost of the components should never exceed the value of the weapon or your players will have little reason to build them. You also do not want to go too far the other way, or you will have build a money-printing machine into the game where players will build and sell at a profit to NPC vendors in an endless cycle until your economy is a complete wreck.

You will need to determine the maximum amount of profit a player can make by manufacturing items and undercutting the NPC vendors. Once you know that value, you can determine the combined cost of the components. It may take a bit of trial and error to get what you think are reasonable costs on all the components that go into building things. Therefore, you may need to carefully adjust and tune the recipes involved. Keep in mind that you can always add on any number of coins in the manufacturing process to even things out if your component costs turn out to be too low.

Unrelated Goods

There will be some items in the game that are completely unrelated to combat, armor, or the healing from damage. You are on your own in those cases, but remember that you will have a long list of equipment and trade-skill items with known values. You can use the list of known items to come up with a price that seems to fit in with the rest of your data.

For example, you may know the value of sticks gathered from the forest because they are used to build arrows, and you may know the value of cloth because it is used in some armoring recipes. If you need to come up with the value for a cot, you can use the known cost for a specific number of sticks, add it to the known cost for the cloth required, add in a little cost for labor—and you then have a value for a cot.

Food goods are one area where you are likely to not get much crossover from weapon manufacturing components, so you will just need to estimate something that sounds fair, based on the prices you already know. Once you have some initial pricing in a new category, you can relate objects to each other through recipes to make them all consistent with each other.

Verification

Once you have a system up and running, you should log all trades and compare the player-to-player values with those you have set. It should become obvious in a hurry if you have something priced wrong during your online testing, because either the price between players will be different, or you will suddenly see a surge or drop in the sales of an item.

The players should have little incentive to use prices very far out of line with the ones you have determined, so when there is a significant difference, it will bear investigation on your part to find out why. It could be just an incorrect price, or it could be a game exploit. Price checks will help you track those problems down.

Conclusion

In closing, keep in mind that none of these conversion factors and pricing methods must be upheld at all costs. They are intended as guidelines that can help in balancing a typically problematic portion of MMP games. It may be that you want to encourage players to specialize in repair skills, or you may want to encourage manufacturing by adjusting repair or component costs.

It could also be that your game has no need for trade skills, allowing you to ignore the whole issue of manufacturing costs. The variations that can be made are pretty much endless once you have the basic concept down. This gives you a starting point for the pricing structures within your game.

1.7

DESIGNING MASSIVELY MULTIPLAYER GAMES FOR NARRATIVE INVESTMENT

Paul McInnes, Micro Forte

paulmc@syd.microforte.com.au

In recent years, we have seen the birth of a new genre of commercial computer games: the Massively Multiplayer (MMP) game. The lure of ongoing revenue from subscribers and the success of most of the existing commercial MMP games have led to a great deal of interest in this market segment. One of the most-urgent practical challenges facing designers is how to reach and hold a commercially viable subscriber base in an increasingly crowded market.

How do we reach and retain players? The issues here are quite complex. On one hand, we have well-understood designs that have proven, long-term appeal to dedicated online players. They combine complex abstract game systems, character advancement as both a means and an end, and character progression systems that require thousands of hours to achieve the highest levels. The appeal of a game that takes a huge investment in time and tenacity to beat is very strong with the more-hardcore players.

At the same time, there are only so many hardcore games that can survive in the market. As the audience grows, it will involve more and more casual players who are curious about online gaming, but not willing or able to invest so much time in the game. In fact, the very things that give existing games their longevity serve as serious barriers to the casual player's entry. How do we appeal to a broad audience and keep players interested in the game after the initial novelty has worn off?

The issues here are nontrivial, touching on the nature of the gaming experience, the role of stories in computer games, and the fundamental properties of the MMP medium, itself. The first part of this article provides a theoretical analysis of the issues that are implicated in creating meaningful and narratively loaded action in an MMP. The second part of this article looks at some specific strategies for achieving these goals.

Toward a More-Meaningful MMP

One of the striking features of the current generation of MMP games is that they *are pure games*. Chess and *Tetris* are pure games. Pure games are enjoyed as ends in themselves and can be understood purely in terms of their own internal logic.

While current MMP games offer immediate and engaging 3D worlds to explore, the activities are repetitive and meaningless outside the immediate mechanical goals of the game. This stands in contrast to the single-player games in the same genre, where there is greater concern with story, personalized character interaction, and the creation of a wider, meaningful context for the player's actions.

If we could harness some of those features in MMP games, it could broaden the audience, lessen barriers, and allow for a wider range of players. However, simply adding stories to massively multiplayer games is not a solution. It takes hundreds of man-months to create the detailed and personalized experience for 40–80 hours of gameplay in a typical computer role-playing game. A player who is online 5 hours per week for three years consumes 780 hours of gameplay. 'Traditional' methods of adding meaning to a game will not work with MMP games.

Instead of trying to create linear stories, we need to find alternative, more-scalable ways of achieving the effect provided by the presence of a story.

Stories in Games: An Awkward Marriage

The mixture of stories and computer games is a rather awkward marriage. Games imply openness of outcomes within the scope of the rules. In this sense they are akin to playing sports. The fun in computer games comes from the combination of openness and new forms of interactivity made possible in simulated 'worlds.' Openness does not require total freedom, but it requires the capacity to meaningfully determine the outcome of the game.

Stories require a linear or semilinear structure. The power of storytelling in books or movies comes from the fact that there is a singular story to be told, and the storyteller is in charge of the pacing and outcome. In a book, movie, or play, we know that the story has a definite end. It also has an unchanging end. If the end changes, it is a different story. Branching structures provide, at best, a superficial extension of this linear notion of story. They are a railroad track with a switch or two, but we are still stuck on the tracks.

The problem is that in computer games the openness of the interactive medium fights the expectation of a structure to the story. So when we play a game with a story, we are caught in a tension between the structure of a predestined story and the desire

to genuinely determine the outcome. This can be a productive tension, but it is a tension nonetheless. If stories sit so awkwardly in computer games, why do we use them at all?

The Function of Stories in Computer Games

It is common to argue that computer games, including MMP games, need more or better stories. See [Klugg02] and [Luban01] for some typical examples, and see [Koster01] for a different approach. In practical terms, we use stories in computer games because they do useful work in creating an engaging interactive experience. Whereas the storytelling might be considered the end in a book or movie, they are very much the means to an end in a computer game. There are two primary functions that stories fill in single-player games.

Stories Provide Structure

A story creates a familiar, structured point of contact for casual gamers. Much of our entertainment is based on storytelling. A story allows people who are uninterested in pure games to connect with the experience of a game by giving it a familiar and comforting structure. In doing so, it broadens the potential audience. Some can enjoy the product as a game, others can enjoy it as a story with game-like interludes.

A story creates an implied linear progression. Many games take the format of a story that is revealed by overcoming challenges in the game (puzzles, combat). When we get the next cut-scene or piece of exposition, the game is acknowledging that we have achieved something. It is a natural and satisfying way of rewarding the player, and exploits their basic expectations of how stories work.

Similarly, the presence of a story promises closure. Not everyone wants a game that they can play forever. The presence of a story is a promise that the game has a definite and satisfying ending. Completing the story is proof of the completion of the game, even if we have not completed all of the challenges or experienced all of the content.

This function of a story exploits the fact that we like to see a story through to its conclusion—a tactic employed by serial narratives, such as comic books, when a new plot starts at the same time that the old plot concludes.

Stories Provide Meaning to Player Action

The combination of story and setting opens up new fantasies to explore. Computer games provide us with a chance to do those things that are impossible, dangerous, or inappropriate to do in the real world. They provide us with a chance to explore new fantasies, from sporting hero to ruthless criminal. A fantasy requires context and stories, and combined with the general setting, it creates the context for action.

A story allows us to anticipate features of the game experience, allowing us to make sense of the context and the things we have to do very quickly. We are all familiar with the standard structures, roles, plots, and developments within stories. We can use this knowledge of how things happen in stories to anticipate what might happen in the game. If we play a game where a malevolent wizard has kidnapped our character's sweetheart, we already have a huge array of hypotheses and expectations we can use to anticipate what will happen.

By marrying action with a 'dramatic situation,' a story gives a layer of meaning to the action within a game. Killing six beasts to rescue a sweetheart is different than killing six beasts for the fun of the combat action. The game *Doom* provides a wonderful example of a dramatic situation with minimal attempt to tell a story but a strong sense of purpose. This is important in computer games, because we are actively advancing the game by doing things, not passively observing the unfolding of the story.

In the process, the story makes it easier for the player to make an emotional investment in the game experience. It creates the chance to care about the situation in the game, to revile the villain and celebrate with the hero. There is something of interest beyond the mechanical properties of the game as a game. To put it another way, a story has an integrative function as well: it ties or links together the meaningful aspects of the game.

In summary then, stories are important in single-player computer games because they provide a familiar structure for the player, and they create the context for meaningful action within the game. But why is meaningful action important in a game?

Challenging More-Cognitive Capabilities

For the purpose of analysis, we can make a distinction between pure games and theatrical games. Pure games are ends in themselves and need minimal context to be successful. *Tetris* is a good example of a pure game. Theatrical games exploit the theatrical possibilities created by placing a central character in an interactive world, working with a purpose.

It is possible to play theatrical games as pure games, with the aim of beating the game. It is possible to play them at a more-narratively immersive level where disbelief is suspended to some degree. There are players who love the theatrical aspect of games, for whom the opportunity for meaningful action is essential.

We can categorize players as pure gamers or theatrical gamers if we like, but there is a better way of thinking about the situation. We can think of the satisfaction in gaming arising out of the active deployment of a variety of cognitive capabilities in an interactive way. Playing a pure game as a pure game involves a certain set of cognitive capabilities (reflexes, observation skills, and spatial and logical intelligence). Engaging

a theatrical game as a theatrical game involves a different set of cognitive capabilities (social, narrative, and emotional intelligence).

Playing any reasonably complex game will involve invoking various capabilities at various times. In the heat of battle in a First-Person Shooter (FPS) such as *Quake* or *Half-Life*, we are testing our reflexes and spatial skills. In the aftermath of combat, we are testing our powers of perception and logical ability when we attempt to find a way into a locked room. When we deal with the NPC who provides story exposition, we are engaging our narrative skills.

Why is meaningful action important? There is a clear bias within the computer game world toward games that test reflexes and spatial abilities. The success of *The Sims* demonstrates the potential for computer games to engage and challenge our social and emotional intelligence. When action is meaningful, it automatically engages a wider range of cognitive capabilities.

The Perfect Place for Meaningful Action

There are good, pragmatic reasons for trying to introduce some of the elements provided by stories in single-player games to massively multiplayer games, but the opportunity is far greater than this. MMP games are *uniquely suited* to creating a meaningful, narratively engaging interactive experience. By providing both a social space and a persistent virtual world, they create the perfect environment for narratively rich experiences.

Massively multiplayer games offer players persistent worlds to explore and inhabit. This is one of the defining differences between MMP games and single-player games. There is no saving and restarting. Actions have consequences and cannot be 'taken back.' In a single-player game, the world leaps into existence when the player starts the game and vanishes when they turn it off; but the MMP world exists and keeps on going, regardless of the player's presence. This gives MMP games a uniquely 'real' feel to its consumers.

The illusion of an 'objective world' is reinforced by the fact that players remain involved in the MMP longer than they do in most single-player games. This means that they will be playing after the novelty of the gameplay has worn off. Repeated involvement has the potential to create stronger ties to the game as a world and not just as a game. This alone can encourage a greater degree of investment in the game experience.

MMP games create shared social worlds. Players provide each other with a mutual audience that can appreciate and respond to their interests within the game. Experiences can be shared in a way that is impossible in a single-player game. This effect is reinforced by the longer duration of playing. It is also reinforced by the creation of sympathetic audiences in the form of networks of friendships and communi-

ties within the game. What makes MMP games special is that they allow players to act (in a physical, emotional, and social sense) *while being seen*. See [Baron99] for a discussion of some of the less-happy implications of this.

This makes the MMP medium inescapably theatrical. In real life, we are constantly engaged in 'identity games,' reading, displaying, and playing with various cues to who we are. The online space enables and magnifies these mundane practices. The anonymity of the Internet and the ability to create a visible alter ego makes the world a theatrical one. Players can project their real personality, an adopted personality, or a combination of the two. Like it or not, each action performed by this alter ego is a cue to other players about the real person behind the alter ego.

If the only meaningful action possible in a game world is mechanical character progress, then there is no scope to be a hero or villain, to belong to the world, to 'be' anything other than a ruthless consumer of game content. A game built entirely around mechanical character progress actively quashes the human theatrical and narrative instincts. This is entirely appropriate if the target audience is 'pure gamers.' It is less appropriate if you want to reach a broader audience.

Single-player games that want to engage the narrative or emotional capabilities of the player need to have a structure of some kind, because the universe is a very lonely one. The only inhabitant with any depth is the player. In an MMP game, the world is already filled with socially interesting, emotionally complex inhabitants in the form of the other players.

Adding a Narrative Layer to MMP Gameplay

If MMP games are so easily social and emotional, why do we need to care about the narrative level of the game? The narrative aspect of the game is one of the natural structures that can bring players together for their mutual entertainment. It is a universally shared 'language' that tests a distinct cognitive capability. We can generate a story-like experience out of the raw materials provided by a game without any explicit, hand-crafted plot, provided the context is rich and narratively loaded.

So how do we add a narrative layer to an MMP? There are three areas where we can add narrative richness, with only a modest investment:

- We can take game elements that have progression and add a narrative layer to them. Character progression is one very obvious example of this.
- We can create background to establish dramatic situations within the game world. A dramatic situation is a back story that creates context for action so that the action itself becomes the unfolding story.
- We can create opportunities for involvement in public events and situations that have a narrative shape to them. Being involved in a cause is a good example of this approach.

Character Progression as Narrative

Everywhere there is a structure that gives shape to player actions, there is a nascent 'story' waiting to be advanced. Making these structures more explicitly narrative in form and meaningful within the wider game is one way of adding narrative resources for the player.

Most games have some system of character progression. They can provide much-needed structure to a player's activities without having any narrative qualities, but it seems very natural to narratively load character progression. After all, 'coming of age' is a fundamental story line. The more interesting we can make the process of growing a character, the more attractive continued investment in the game will appear. This is particularly crucial if the game uses a single linear dimension of character progression.

Of course, such an approach requires careful design. While many players will respond positively to making the progression system more interesting, most players end up playing the objective possibilities of the system. In particular, they will look for ways of advancing that minimize the risks and maximize the returns, even if it involves tedious and repetitive actions that make no sense in terms of the game world.

This is something that should be utilized rather than despised. It means that the reward system can be used to acknowledge and reinforce the kinds of activities that are narratively loaded in the game.

An excellent example of this is the use of the 'honor' score in the classic paper-and-pencil RPG, *Bushido*. In this game, players require a number of experience points and honor points to attain a level. Losing honor could result in the loss of a level until honor is restored. What is intriguing about this approach is that it is actively rewarding players for paying attention to a complex set of narratively loaded ideas. The presence of an honor score was an implied promise for an interesting 'metagame.'

In this system, it was perfectly sensible to use flashy swordplay that penalized accuracy in order to gain more honor in a victory. It provided a perfect 'hook' for encounters or missions that rewarded displaying the samurai virtues. It worked because we are all familiar with the idea of honor and face, even if we do not know all the details of the actual system in medieval Japan. By making honor objective and a fundamental mechanic, it provided tangible rewards for player actions while bringing a new layer of meaning to the power-playing imperative.

The rewards for actions in an MMP game do not have to be material or related directly to character prowess, provided they have are measurable in some sense and have objective consequences in the game. Honor, prestige, social rank, and reputation can all provide medium-term goals for players, and are all very natural candidates to be narratively loaded.

Used judiciously, these kinds of measures can break down the simplification of the game that occurs when it has a single linear progression path. When a player has

real choices about which aspects of their character to advance, the advancement itself becomes a statement about player priorities and the basis for the character's place in the game world. These in turn become resources to be used by other players. Being notoriously and objectively honorable (or dishonorable) can be an end in itself. Social reputation is inherently narratively loaded.

Exploiting Dramatic Situations

A dramatic situation is the back story to the overt game action that gives purpose and meaning to player activity. Unlike the more-structured linear plots found in most single-player games, a dramatic situation sets up the action then moves to the background, and gameplay unfolds the story. It promises action with a purpose, without imposing a linear structure to the game.

Some of the strongest computer games have used a dramatic situation rather than a linear story to create context and purpose within the game. The original *Doom* game is a perfect example of this approach. You are a hard-nosed space marine. You have been sent to a moon base and left behind when your buddies went off to fight. There has been horrible screaming and now silence.

The back story does just enough to set the scene. Your character is defined in very simple terms, and the goal (survive and avenge your fallen comrades) is established. From that point onward, the game uses the occasional placement of dead marines and the overall linear structure of the game itself to keep things progressing. Only in the transition between episodes is there any real plot development, and this involves a twist on the original setup: now you are in hell and the challenge of survival has gotten even harder.

The advantage of this approach is that you do not need a story or an unfolding plot. There are no cut-scenes to get in the way of the action. Playing the game by shooting and surviving implicitly advances the 'story,' but the action is primary and the story very deliberately secondary. This approach works particularly well if the dramatic situation is a very basic archetype.

In order to work, the back story and the real goals of the game must be in harmony. There is no point in creating an intricate back story about noble heroes and the struggle against evil if the game is actually about killing anything and everything in order to grow stronger. If the game is about killing everything, then the back story should explain why everything must be killed and character prowess maximized.

A dramatic situation can be applied at a variety of different levels. It can be applied at the level of a single character, a region, the entire game world, or a social actor. It will work best if there is some genuine possibility of resolving the situation or changing the world: in *Doom* the marine returns to Earth after defeating the hordes of hell. If the situation is an 'eternal' situation, then dimensions of character progress should be linked to involvement in the situation.

To be convincing, the dramatic situation needs to be 'written' into the game world. There needs to be consistent references and hints as to the situation. The gameplay needs to flow naturally from the conflicts and challenges created by the situation. It does not matter if the situation is simple or even cliché, because it is the action that matters in the end.

For example, if the Towers of Fear are a site of perpetual struggle between the forces of light and darkness, then boosts to character reputation or factional standing arising from involvement in the region become narratively loaded. If the Towers can be claimed and held in the medium-term, then the region itself becomes narratively loaded. This will be stronger if the heroes who achieved the victory are explicitly acknowledged within the game.

Public Causes

A third approach to adding a narrative dimension to a game is to create dynamic, persistent game elements that have a life of their own. These can be concrete entities like a settlement or abstract elements like a cause or a crisis. The key is that they have the capacity to change over time in response to the activities of the players, and their future trajectory is not predetermined. This allows players to have a genuine sense of involvement in the evolution of the game.

The realm-versus-realm combat in *Dark Age of Camelot* and the contest between the Rebels and the Empire in *Star Wars Galaxies* are simple examples of this approach. What is unusual about this approach is that it marries a narratively loaded game dimension with the openness of the interactive experience.

A different approach would be to add dynamic crises to the game world that can be resolved over time by sustained player action. For example, a particular location might become 'infested' with a noxious enemy, making an important trade route more dangerous. Only by sustained effort can the infestation be removed. Such a system can build on the basic spawning systems in the game.

The great strength of these approaches is that they provide a story-like situation that can be resolved in the shared public world in a way that involves multiple players. It draws on the inherent strengths of MMPs (e.g., persistence and shared social world) and computer games in general (e.g., openness of outcome). Unlike standard stories, players really can shape the outcome, and if structured correctly, the unfolding history of action in the game can take on a distinctly narrative form. What is lost in terms of explicit plotting, such as plot twists or protagonists, is more than regained in the genuine sense of involvement with the game world.

Each situation or crisis becomes a cause that can be taken up by the players. In some cases this is a player-versus-environment cause; in others it can be player versus player. There are some powerful synergies if these causes can be integrated into both

the dramatic situations in the game world and the character progression system. The player who comes to an MMP expecting stories not only discovers stories, but they discover stories that they can genuinely shape.

Conclusion

The creation of the commercial MMP game has established the basis of a new medium. It is as distinct from single-player games as television is distinct from live theatre. Like all media, it has its own fundamental strengths and weaknesses. Its great strengths are the creation of shared worlds, the freedom for engaging action, and the possibility for long-term achievement.

Existing games are very much 'pure games.' They challenge and engage players' logical and analytic skills. They are most-naturally suited to the power-gamer. Expanding the reach of the MMP medium will require expanding the range of cognitive capabilities that the game engages. In particular, creating MMP games that allow for more-meaningful and more-narratively loaded action will engage the social, emotional, and narrative skills of the players.

There are some very simple and practical approaches that can be used to add these layers to the MMP gaming experience. This article has discussed three of these layers: character progression, the use of dramatic situations, and the creation of persistent, dynamic situations. But there are others. These elements not only broaden the appeal of MMP games, but they can also provide substantial barriers to exit for players once the immediate novelty of the setting and interest in gameplay have worn off.

References

[Baron99] Baron, Jonathan, "Glory and Shame: Powerful Psychology in Multiplayer Online Games," available online at *http://www.gamasutra.com/features/19991110/Baron_01.htm*, November 10, 1999.

[Klugg02] Klugg, Chris, "Implementing Stories in Massively Multiplayer Games," available online at *http://www.gamasutra.com/resource_guide/20020916/klug_01.htm*, September 16, 2002.

[Koster01] Koster, Raph, "Two Models for Narrative Worlds," available online at *http://www.legendmud.org/raph/gaming/narrative_files/frame.htm*, January 29, 2001.

[Luban01] Luban, Pascal, and Joël Meziane, "Turning a Linear Story into a Game: The Missing Link between Fiction and Interactive Entertainment," available online at *http://www.gamasutra.com/features/20010615/luban_01.htm*, June 15, 2001.

1.8

CUSTOMER SUPPORT AND PLAYER REPUTATION: IT'S ALL ABOUT TRUST

Paul D. Sage, NCsoft Corporation

psage@ncaustin.com

One customer can cost you 40 customers in less than an hour. Unless you believe that one sentence, and you are committed to eliminating the problem, paint a target on your box art or Web page with a bull's eye that says, "Griefers go here!" Few things are more frustrating for any person in a Massively Multiplayer (MMP) experience than having someone harass, annoy, or otherwise prevent them from having fun. What can a designer do to prevent 'Hugh' (our hypothetical griefer) from ruining the experience for 'Raistlyn' (our hypothetical normal player)? Let the reputation of Hugh speak for itself.

Griefing

First, it is important to define what the term *griefing* means. Basically, griefing is the intent of one person to use any means available to harass, threaten, or otherwise annoy another person within the confines of the service. It is not worthwhile to explore why people do it; what matters is that it does occur—and it often occurs with no real motivation apparent.

In *Ultima Online* (*UO*), a player who frequented the Pacific shard would kill over 40 people in the span of a few hours, leaving a trail of bodies over the course of one week larger than that of Hannibal Lector. Every night he caused over 50 calls to come into the Game Master (GM) queue, our in-game service request line, from his victims. Each one had a different story:

- "Hobbes is a cheater."
- "Hobbes is killing for fun."
- "Hobbes took my stuff."
- "This guy is crazy and is using profanity."

Was Hobbes really cheating? We did not know. Was Hobbes killing for fun? We can make a good assumption, but we would not have had proof. Did Hobbes take somebody's items? (Maybe our tools did not allow us to track that at the time.) Was he using profanity? Well, he did call someone a "seminiferous tublodial buttsnoid."

Some might be quick to point out that early on in *Ultima Online*, players were allowed to be mass murderers, which catered to griefing. Well, there is some truth to that, but since that was the game as it was intended, Hobbes was in fact playing within the confines of the game rules. So should Hobbes have been allowed to stay when he was making the other players so miserable? The answer might seem shaded here and not so clear cut, but the real answer is "No." He did get to stay, though, because there was a lot of idealism going on that led us to choose the answer that *seemed* right rather than what *was* right. The road to no subscribers is paved with good intentions.

Rules Are Tools

The first reaction to a situation like that mentioned above could very well be to change the rules of the game to disallow such behavioral patterns. Taking a look at those rules and how they might break down is critical to understanding what rules need to be implemented. Some of the suggested rules could have been:

1. Disallowing player killing might be a viable alternative or not, depending on the game. For instance, if *Dark Age of Camelot* (*DAoC*) were to implement a 'no killing' rule, the only thing killed from then on would be the purpose for a large portion of that game. Clearly, that is not a rule that fits in with the intent of all games.

2. Limiting killing to a certain amount of people within a specific time period was tried by *UO*. Over time, this rule and the penalties involved for any players who went over that limit became more complicated. Many of the people who were penalized by the rule should not have been; and likewise, many of the people who should have been penalized managed to find ways around it.

3. A 'no looting' rule could also have worked, but consider this: part of the design goal of a game could be to allow the players themselves some degree of freedom in giving out rewards to those willing to risk their necks against other players. In a case like this, a 'no looting' rule would remove one of the legitimate reasons to allow player killing and leave the *sociopathic* killers as the only people killing. Of course, players generally do not need a reason to kill one another.

4. No speaking to someone you just killed—the way *DAoC* handled this was priceless. It was clear that this was part of the design of the game, and it was highly effective in removing the temptation for killers and would-be griefers

to turn a simple player-versus-player battle into a rude and humiliating encounter. Still, in *UO*, a game without chat channels, this would be ill-advised as a solution. Eliminating the ability for one person to speak to another would just allow the friend of Hugh to taunt the victim. It's hard to believe anybody wants to see proxy-griefing in practice.

5. No profanity—this is a tough one. We hate to admit that we curse like a sailors with our friends—but the fact is that we sometimes do. Limiting player speech is a bit scary, and we may not be at that point. If you want to create a normal gathering place for players to bond with their friends, you might want to allow profanity; or simply allow players the option to turn off/on any profanity filters if they so choose. Still, in my opinion, a service provider has every right to limit speech among the player base in any capacity they deem necessary. The problem is in catching it. If you believe that players are not able to think of a good way to insult someone without profanity, you are probably underestimating the creativity of your players.

So five rules up, and five rules down. Lots more could be mentioned or tried; the point is not to try to find solutions via rules, but rather to bring up a very hard to cope with idea: every rule, no matter how good, can probably be twisted or exploited unless that rule fits into the intent of the game design. Do not kill the design of the game while trying to remove all of the Hughs out there, because it is pretty much guaranteed that at least some subspecies of player is going to do their best to cause grief to other players. A more-solid approach is to define clear-cut boundaries for your game, and to remember that the boundaries of social propriety vary from player to player.

Intent

The most important thing to tell designers who are worried about their service and their ability to stop griefing is to come to a very important realization: you cannot divine the intent of a player based on their actions alone. In *UO*, people were allowed—and even encouraged—to strike back at people who tried to grief them. When rampant killing became a significant issue, a decision was made to limit the amount of people one could kill in a certain time period. The assumption went something like this: it is unlikely that you will be griefed more than five times in a given period of time. Therefore, players were given the ability to strike back at least four times within the specified time frame before they were considered murderers. The *murder counts*, as they were called, decayed over time, meaning that anyone who used up their allotted kills could kill more players later on without penalty, provided sufficient time had passed. So, if Hugh were to call Raistlyn a pickle-brained lout with less evolution behind him than a paramecium, our friend, Raistlyn, would be able to attack Hugh to cut such utterances from his vile tongue. The problem is that if Hugh

knows that Raistlyn had killed four people that day, Hugh can insult him all he wants without fear of retribution, because if Raistlyn were to kill Hugh , he would be considered a murderer by the system. Therefore, Hugh can make it his job to goad Raistlyn into attacking him. The problem is that Hugh's intent is to cause another player grief, and Raistlyn's intent is merely to defend his honor. Instead of working within the game system, as is Raistlyn's goal, Raistlyn is punished by the system.

Another example of a different system: within *Everquest* (*EQ*), there is a location known as the chessboard. On the chessboard, there are about three to four spawn points of undead creatures ripe for killing, spread out over several screens' distance from each other. A player of a level and class that can go to the chessboard can solo some of the easier spawns without too much worry. But what if the player ended up in a dispute with another player about who had been there first and who should be allowed to take the 'kills.' The first player has no intention of being a kill stealer, and might offer to go into a rotation, but the other player might truly believe that they have the right to take on every creature on the board alone, so much so that a Customer Support Representative (CSR) would be called. Upon arrival, the CSR simply says that they have to play nice. End of support. Why didn't the CSR do anything? The CSR could not divine the intentions of either of the players in the given situation, and no one would be happy with the results.

A CSR or any human observer is no more able to understand the intents of each of the parties involved in a situation than the developers are able divine intent through the game system. So having a CSR review the situation will not likely make the situation any better. The only people you can trust to deliver a somewhat accurate view are the people involved in the situation.

Current Services Are Doing It, But They May Not Know It

Experience will lead the former CSR or GM to believe that there are two kinds of complaints related to player interaction. One complaint type revolves around one player or group of players who make it their job to make everyone else's play experience as miserable as possible. The other, and far more common complaint involves a difference of opinion about what was right or wrong to do in the game, with each involved party believing they are in the right. In almost every situation, though, it is nearly impossible to tell one type of complaint from the other unless you know the parties involved, and that is where the real problem can clearly be identified and solved.

In the latter case, you have two individuals or groups who may just have a disagreement over a specific issue. This issue may have a real resolution, but likely it does not. If it did, it would probably already have been handled within the rules of the

game. If both parties are reasonable, they probably just want a resolution to their issue or a way to express their displeasure in a meaningful way.

In the former case, you have a real problem on your service. You have someone who really wants to destroy your game, and the only way to ever find this out is to hope that your customer service department is keeping track of every situation they hear about related to the specific troublemaker. This process is time consuming and will cost you money. Not only do the bad apples strain your service to customers, but they will directly raise your support costs. Ninety-nine percent of the time, the only way such customers are identified is through the hard work and dedication of customer service departments as they try to track down problem players by stringing together tons of complaints filed on one account.

"Isn't that what our Customer Service (CS) department is for?" you may ask. No. A CS department is there to cover all of those issues your development team has not identified or solved through game mechanics, review problem players, and enforce *Terms of Service* agreements. In this case, a CS department has to track player complaints about our friend Hugh for some time before Hugh is identified beyond all reasonable doubt as a pretty bad fellow. Once you finally identify Hugh as a problem player, you have spent considerable time and money to discover something that many of your players already knew, which is that Hugh is very annoying.

Reputation

Our friends at *Merriam Webster's* define reputation on their Web site thusly:

Main Entry: **rep·u·ta·tion**
1: an overall quality or character as seen or judged by people in general **b :** recognition by
 other people of some characteristic or ability <has the *reputation* of being clever>
2: a place in public esteem or regard **:** good name

In each definition, other people are the judges of the person in question. At no time in a game where social interaction is a draw should this be forgotten. Players are, every day, making judgments about their interactions with other players. Most of the time, those judgments are favorable; but sometimes they are not. When multiple players over the course of time think that a specific player is a bad person, they are probably right.

eBay is an interesting example of a nonclosed, very large community. For those not familiar with eBay, it is an online auctioning service where a seller can advertise a certain item and potential buyers can bid on the item. The person winning the auction is committed to purchasing the item from the seller. As you might imagine, the potential for fraud is great. eBay cleverly combats this by allowing the buyer and seller to leave positive or negative feedback about the transaction.

While this reputation system may not be perfect, it at least gives potential buyers and sellers a way to form some opinion about an individual before doing business

with that person. It allows a good salesperson a way to prove themselves as reliable, and generally discourages dishonorable trade practices. There may be some question as to how accurate all the information is, and whether it can be griefed or not; but without the system, eBay would probably not be as popular or as successful as it is.

Most potential browsers of the eBay feedback system look for one thing: consistency. Either bad or good, if you see consistent feedback, the opinion you have about that person usually feels more validated.

The Good

When people bring up reputation systems, more often than not they are discussed as a way to prevent or discourage negative behavior. While reputation systems should be used to stop or prevent as much negative behavior as possible, they should also be used to encourage and reward good behavior in the community. When you look at people who are truly admired by a community, each one will likely exhibit vastly different traits that make them admirable. Not everyone will be pleased by the same interactions, but the fact remains that if a person feels good about their interactions with another, that person should be able to express their gratitude, regardless of what made them feel happy.

We could get into the philosophical discussion that people should help people because they want to, and not because they are going to get something out of it. Giving something away, even if it is only a mark of stature, will change the motivations for why people are helping others and promote the wrong people to try to exploit the system. Yes, we could get into that discussion; but instead, let's say this: "I sure would hate to have people being nice to one another for the wrong reasons." Seriously, the point is to have people be nice to one another. Second-guessing the motive behind the behavior falls into a distant second when you have a situation where kindness is favored over rudeness.

Summary

The objective is not to try to make it so that people are being slavish and sycophantic with one another, but are being rewarded for efforts at being nice. Carefully balancing whatever rewards you give for a good reputation will of course be important.

1. Allow people to say when they are happy in their dealings with someone else.
2. Reward good behavior in a balanced way.

The Bad

Reputation would not be reputation if it only encouraged good behavior; it also needs to discourage bad behavior. Certainly, if your community can clearly see who the bad people are in the community, they are less likely to interact with those people. While

that might deter some people, we can guess that our friend Hugh would probably not care what kind of reputation he had if being bad did not have a concrete downside.

We won't suggest what punishments should or should not be given out, since those should be very service-specific. However, using the reputation system to lightly label other players as "bad" should be discouraged. Players need to understand what constitutes an offense worthy of a negative mark and what kind of occurrences do not. GMs have their share of troublesome complainers—people who feel that everyone in the game is causing them issues, and who believed it is the GM's job to get rid of all of those other problem makers. A reputation system could seem to be the perfect solution for them; but in fact, it could be a dangerous tool in the wrong hands.

Letting people call other people "bad" in a willy-nilly fashion is not going to give an accurate portrayal of the society. Petty bickering will start to cause bad reputations to become the norm. A good reputation system should encourage people to weigh the decision carefully before calling another player "bad." If someone is labeled as a troublemaker in any community, the accuser's own credibility is being on the line. For example, a negative feedback left on eBay by a person with a proven habit for leaving negative feedbacks holds very little weight—unless the person on the receiving end of that feedback has multiple other negative feedbacks as well, making it clear that the black mark was very likely deserved. But more often than not, a person with a penchant for leaving negative feedbacks too often is seen as someone whose main goal is to ruin the reputation of others, and their own reputation is the one that ends up suffering.

Summary

Reputation needs to encourage good behavior, and it also needs to discourage bad behavior.

1. People determined by society to be 'bad' should face some consequence in order to promote their change or remove them from society.
2. Players should not be able to accuse other players of being bad without seriously weighing their decision to do so.

Diversity Makes All the Difference

No matter what one person says about someone else, it does not make it true. There needs to be multiple good or bad things said about an individual before that person can begin to be fairly judged one way or another.

If our friend Hugh were to jump into the game and have five people say he was great, that would not make Hugh a great guy. It would only make him a great guy to whatever percentage those five people were of the total society population during that time.

Raistlyn may have a bad day and end up being labeled a 'bad' guy by someone. Before taking this as a definite, though, look to see if Raistlyn has a pattern of poor behavior. Most good players will have a breakdown at one time or another; everyone has a bad day. However, grief players, for the most part, cannot alter their behavior enough over the course of time to establish a credible reputation. Though not impossible for them to do so, it is not likely that an evil Captain Kirk is going to fool a good Mr. Spock for long (remember the *Star Trek* episode, "Mirror, Mirror"?)

Summary

You can't judge a book by its cover. And the same is true for an Avatar.

1. Judge players not on the word of a few individuals, but their actual mark on society.
2. Judge players by pattern behavior; are they causing grief over time?

Current Pattern Tracking

There are lots of ways to track patterns and develop systems that will accomplish the goals covered in this article. *Advogato's Trust Metric* is a system designed to handle large-scale community interactions. There also might be answers in *Bayesian analysis*, especially within large communities. Whatever methods are chosen by the developer, a small chart, such as that shown in Figure 1.8.1, might help determine how to use the information garnered.

	Time Low	Time High	Low # of Players	High # of Players	Results
Positive	X		X		GF
Negative	X		X		YF
Positive		X	X		GY
Negative		X	X		RF
Positive	X			X	YF
Negative	X			X	RF
Positive		X		X	GF
Negative		X		X	RF

FIGURE 1.8.1 *Tracking reputation patterns.*

- **GF = Green Flag:** This player is probably a good player, or has not done enough to warrant suspicion.
- **YF = Yellow Flag:** Something is suspicious about this player, and they might bear more investigation.
- **RF = Red Flag:** This player needs attention from the CS department; either someone is trying to make them look bad, or they are a real troublemaker.

A Few More "Gotchas"

One of the most important things that must be addressed is anonymity. While there are a number of valid reasons to allow players to take on different roles and personas, no positives outweigh the negatives involved with allowing a player to maintain two separate reputations in your service. Of course, someone could want to 'role-play' an evil character and a good character, and by no means is it suggesting that this is a bad thing. However, when a player is allowed to represent themselves as something they are not, and they harm society in doing so, you need to throw that idea out. It is not a matter of what is right or wrong; it is a matter of what is more right, or more wrong.

By 'no anonymity,' we're not suggesting the divulgence of someone's address or real name on the service (though that would probably get rid of 99% of the trouble-makers online). What is suggested is that the service provider be diligent in trying to identify each account holder. If an account holder has multiple accounts, their reputation should follow them. And here's an even more radical idea: that one day a player's reputation follows them not only within a given service, but on all game services, much like credit ratings or tenant-tracking in apartment complexes. We are becoming too integrated with our virtual lives to believe that it is okay to remain anonymous anymore. If we cling to the ideal that it is okay to be anonymous, no business will be able to sustain itself online.

Is such a system going to stop griefing? Nope. You are working to minimizing it, and the best system in the world is not going to stop it completely. An individual who is dedicated to breaking the rules is going to be able to beat any system because they can analyze the system for weaknesses. When it is you versus 100,000–1,000,000 people or more, the odds are that you are going to lose a few battles. Über-guilds might be able to blacklist someone over time. A player might be dedicated enough to develop a great reputation and then go out of their way to destroy the game in any way they can. This is where your CS department will prove invaluable.

Using the Reputation

Eventually, you will have to determine how to use the reputation system you develop. Without going into specifics of the User Interface (UI) for this system, caution is advised against making it difficult to rate another player. As in everything else, players

need to be able to quickly identify who they are interacting with and how they feel about them. Furthermore, you probably do not want to require both parties to be present. A lot of griefing can occur post-transaction when one party may not be online.

Also, let your CS department use your reputation system as a proactive tool for keeping your community on track. Quickly identifying troublemakers will save your community and your service a lot of time and money—money that is better spent working on fun systems for the game.

Conclusion

Allowing a player to make their opinion known about another player and tracking that opinion is a tool that serves multiple purposes:

- Players who have a good interaction with another player often just want to give them something more than a "thank you."
- Players who have a bad interaction with a player want an immediate way to let that player and other players know how they feel.
- It allows a player to build up over time a real portrait of how they have treated and interacted with other players.
- Players are rewarded for good behavior.
- Players have real control over their community.

In other words, it allows a player to develop a reputation that has meaning within the community, which is established by players.

It is going to take trust. The developer is going to have to trust the community enough to make judgments they are already making. The community is going to have to trust in the opinions of one another as well as the ability of the developer to look into any problem players. It is a foundation for trust, not a replacement for it.

MMP ARCHITECTURE

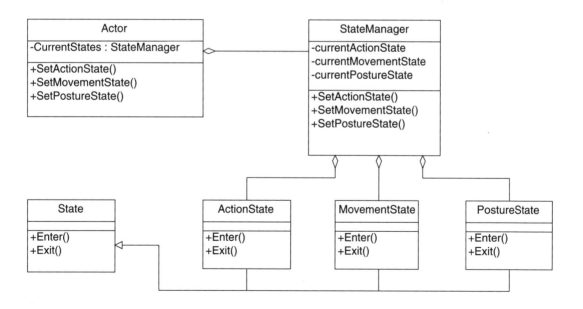

Building a Massively Multiplayer Game Simulation Framework, Part 1: Structural Modeling

Thor Alexander, Hard Coded Games

thor@hardcodedgames.com

A commercial Massively Multiplayer (MMP) game is much more of a service than a product. A successful online game service will have a lifetime of at least five years. Over this time, the code base must be maintained and modified in a timely fashion in a production or live environment with hordes of pesky players critiquing every change. To survive in such an environment, a code base needs to be built on a solid engineering foundation. This article presents such a well-engineered MMP simulation framework.

We will leverage techniques from both *design patterns* and the *Unified Modeling Language* (UML). A design pattern is a very useful and proven software engineering tool that has gained favor in recent years. A pattern is a recurring solution to a standard problem. (For more information on patterns, see [Gamma94].) UML is a design process for visualizing and specifying a software system. This article presents UML class and sequence diagrams. For an in-depth discussion of UML, see [Booch98].

This article includes and extends many concepts that were first presented in a previous article by the author [Alexander02]. This article is broken into two parts. Part 1 deals with structural modeling that yields the class diagrams. These class diagrams are used to build the simulation framework in Part 2.

Architecture Overview

The architecture presented in this article is built around established, object-oriented principles. It is designed to be both flexible in terms of the platforms that it can be implemented on and highly extendable in order to allow the user to customize it to match the needs of a given project.

Client/Server Components

At its core, an MMP is a client/server system. It provides a network layer that relays message packets across the Internet between the client and server processes. These message packets are received and interpreted by the game-simulation layer. This layer is responsible for maintaining the consistency of the game state-space on the client and the server. Detailed simulation of the physical representations of the objects that occupy this state-space is handled by the physics layer. Since the client-rendering layer presents only what the player can perceive, the number of objects simulated at any given time on the client need only be a subset of those on the server. This allows the client to perform the physics simulation at a much higher level of detail than the server physics layer. Figure 2.1.1 presents an overview of this architecture.

Simulation by Proxy

The game simulation layer on the server holds the one true representation of the state-space. It must serve as the arbitrator if any clients that it serves fall out of synch. The server broadcasts changes to the actors and objects in the state-space as simulation events that are sent down to the client. The client uses these events to update the proxy objects that make up its local approximation of the state-space. The user interacts with the server simulation by sending action requests that the server simulation layer must validate before the action takes place. Figure 2.1.2 depicts the

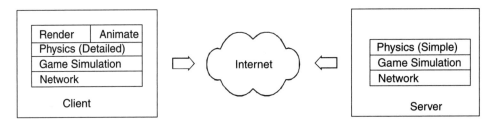

FIGURE 2.1.1 *Client/Server game architecture.*

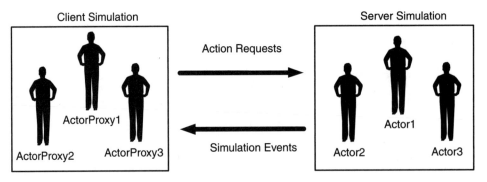

FIGURE 2.1.2 *Client/Server simulation via actors and proxies.*

request/event flow. For security reasons, an MMP design must never trust the client's representation of state-space.

Support Classes

Before we jump into the core classes of our architecture, we need to define a few support classes. These support classes will be used to construct the core classes of the system.

Dictionary/Hash Tables

A dictionary is an abstract data type that stores items associated with values. Basic operations are *AddEntry*, *LookupEntry*, and *RemoveEntry*. A good dictionary implementation method is the hash table, which is an associative array in which keys are mapped to array positions by a hash function. Figure 2.1.3 shows the class diagram for such a dictionary. This dictionary will prove to be the workhorse data structure of this architecture.

SimulationEvent

Simulation events are the transactional objects of this system. When an actor interacts with the environment by performing actions, the results of these actions are broadcast to other actors that can perceive them as events. An event object contains the event type, source actor id, and target actor id, as well as a list of arguments specific to the event type. Additionally, it has a channel attribute that is used by the receiver of the event to filter out the categories of events that it is interested in.

SimulationState

SimulationState is our implementation of the state pattern. For the sake of clarity, we present a simplified version of the pattern that does not include a state machine or

Dictionary
-HashMap
+AddEntry() +CountEntries() +GetFirst() +GetNext() +HasKey() +LookupEntry() +RemoveEntry()

SimulationEvent
-argList -channel -sourceId -targetId -type
+GetArglist() +GetChannel() +GetSourceId() +GetTargetId() +GetType()

FIGURE 2.1.3 *Support class diagrams.*

state manager. For a detailed and more-robust implementation, see [Boer00] and [Dybsand00]. SimulationState serves as the base class for all states in our architecture. Basic operations are *CanTransition* and *Transition*. The base CanTransition is a pretest method that validates if the specified context object can make a valid transition to this state. Derived state classes can implement additional checks to meet their individual needs. The Transition method is where all of the real work takes place. Each child class will need to implement this method and provide any specific behaviors that occur when this state is entered.

ActionState

Action states are the typical game simulation operations, such as slapping an opponent or opening a door. Each *ActionState* has its own *durationTime* attribute that details how long this action takes to execute. Typically, this attribute is used to synchronize the server simulation with the animation playback time on the client. The ActionState also maintains the *startTime* attribute. This is useful for calculating the time index into an animation when a spectator enters view of the actor at some time after that actor has already transitioned into an action state (see Figure 2.1.4).

ControlState

The *ControlState* defines from where the associated actor can accept commands. This allows the actor to be under player control, AI (Artificial Intelligence) control, or in some additional mode, such as a scripted state for use with in-game cut-scenes. The ControlState can be swapped on the fly to transition the actor between one of these states. Another use for control states is for training by observation. When in such a training state, the player controls his actor as he would in the user-controlled state with the computer snooping in on his actor and learning from his actions. For more details on training by observation, refer to [Alexander02a].

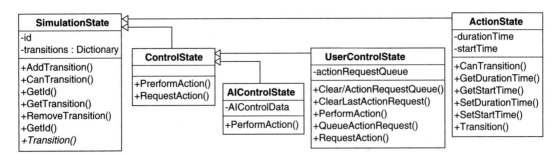

FIGURE 2.1.4 *Simulation states class diagrams.*

UserControlState

The *UserControlState* maintains a queue of pending action requests that have been received on the server from the user on the client. This control state's *PerformAction* method will pull requests from this queue when it is called.

AIControlState

The *AIControlState* is responsible for determining the appropriate action to perform when an actor in this state calls its PerformAction method. This decision process should be implemented with an AI technique that best suits a given simulation's game mechanics, such as finite-state machines, neural nets, or fuzzy logic. For one example of such a decision subsystem refer to [Alexander02b].

Core Classes

Now that we have defined our helper support classes, let us move on to the core classes that will make up the backbone of our simulation.

SimulationObject

A *SimulationObject (SOB)* forms the base for all of the core classes that the simulation deals with, including *Actors, Areas, Items,* and *Obstacles.* Figure 2.1.5 shows the core class hierarchy. An SOB is assigned its own *id* that designates it as a unique object. A SimulationObject communicates with another object by sending a *SimulationEvent.* They can

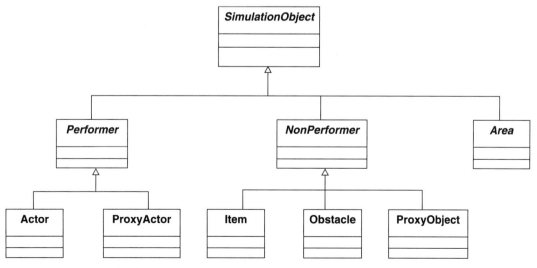

FIGURE 2.1.5 *Core class hierarchy.*

subscribe to the events that they care about with other simulation objects. Each SOB maintains a *subscribers* dictionary that it uses to publish events that it generates.

An SOB may contain other simulation objects. Each SOB maintains a *contents* dictionary of the objects that it contains as well as an *ownerId* that refers to the SOB that contains it. SimulationObject containment serves as an abstract concept that can facilitate many features for the child classes. Actor subclasses can use it to implement inventory item management systems. Items can become in-game containers, like chests and bags, which contain other items. Areas, which are abstract spatial representations, make use of containment to track other simulation objects that enter and exit their boundaries.

Similar to containment, simulation objects also maintain a dictionary of *links* to each other. Links provide an aggregation, or 'whole/part' relationship between simulation objects. This provides for a simple, but powerful way to allow objects to receive events from component parts on a transitory basis. Links can be used to implement portals or doorways between areas that can be opened and closed. Compound items can be constructed from parts by linking items together.

Simulation objects also provide a *property* dictionary for storing game system-specific attributes per object in a data-driven fashion. Each SimulationObject subclass can add its own properties to the dictionary as needed. The contents of this dictionary can be replicated down to the associated proxy object on the client in an intelligent, just-in-time fashion that minimizes the network traffic overhead. Examples of properties include attributes like the object's location in the world space, movement speed, hit points, and mana.

Finally, simulation objects provide a persistence mechanism that allows the simulation layer to interface with storage systems in a generic fashion. Each SimulationObject maintains a *dirty* flag that is set when persistent properties and data are changed. The simulation layer can call the *Store* method on the SOB when needed. Store tests the dirty flag and archives the object if it is set. The *Restore* method performs the converse operation and loads the object into the simulation. These methods can be implemented in the target application to save the objects to flat-file formats, such as eXtensible Markup Language (XML), or relational databases, such as Oracle or MS-SQL (see Figure 2.1.6).

Performer

The abstract *Performer* core class provides for the shared client/server functionality and common interface of the Actor and *ActorProxy* simulation object classes. Figure 2.1.7 shows the class diagram for Performer. The Performer class maintains a *schedulePriority* attribute that is used by the simulation for scheduling. A performer also maintains the object's *currentActionState,* which represents the action that the object is currently performing. This attribute is determined and set by the PerformAction

Actor
-currentControlState : ControlState -defaultControlState : ControlState -eventQueue -id
+GetCurrentControlState() +PerformAction() +ProcessEventQueue() +RecieveEvent() +RequestAction() +ResetControlState() -SetCurrentControlState()

FIGURE 2.1.6 *SimulationObject class diagram.*

Performer
-currentActionState : ActionState -id -schedulePriority
+GetCurrentActionState() : ActionState +GetPriority() *+PerformAction()* *+RecieveEvent()* *+RequestAction()* +ScheduleNextAction() -SetPriorioty()

FIGURE 2.1.7 *Performer class diagram.*

method. More-advanced simulations can be implemented by expanding the object to contain several parallel action states for mutually exclusive activity layers, such as movement states, posture states, and conversation states. (See Section 2.7 of this book for a detailed discussion of parallel-state machines.)

Actor

An actor is defined as a server-side SimulationObject that is capable of interacting with the simulation environment. Actors have a ControlState that allows them to be controlled by a number of different agents, including players, AI, and scripted cut-scenes. The PerformAction and *RequestAction* methods are delegated down to the current control state, where the controlling agent is responsible for providing the appropriate

implementation. The Actor class also maintains an *eventQueue* that is populated by the *ReceiveEvent* method. This queuing of events allows the actor to batch them up and defer handling them until its next scheduled PeformAction method. This passive, just-in-time event-handling scheme allows the system to avoid having to decide what it needs to do every time an actor receives an event. In a high-event simulation, like in MMP games, where the actors need to be aware of everything going on around them, this is a critical improvement over the immediate processing of all events as they occur.

The ReceiveEvent method can also filter out event types that require immediate attention and bypass the queue to perform the required handling when the event is received. See Figure 2.1.8 for the Actor class diagram.

Actor
-currentControlState : ControlState -defaultControlState : ControlState -eventQueue -id
+GetCurrentControlState() +PerformAction() +ProcessEventQueue() +RecieveEvent() +RequestAction() +ResetControlState() -SetCurrentControlState()

FIGURE 2.1.8 *Actor class diagram.*

ActorProxy

An ActorProxy is the client-side counterpart of an Actor. It shares the same SimulationObject id as its actor and replicates the actor's relevant data. The client-side simulation will route all incoming events to the appropriate ActorProxy, where it will be handled by the ReceiveEvent method. The proxy also provides a RequestAction method that routes outbound action requests to the associated actor on the server. Finally, there is a PerformAction method available to process any client-side-only behavior that does not need to be replicated by the server simulation, such as dynamic soundtrack selection or triggering of User Interface (UI) elements. See Figure 2.1.9 for the ActorProxy class diagram.

ActorProxy
id
+PerformAction() +RecieveEvent() +RequestAction()

FIGURE 2.1.9 *ActorProxy class diagram.*

Nonperformers

Much simpler than performers are the other core classes that do not directly interact with the simulation environment. These objects do not perform actions and do not receive any scheduled processing time from the simulation. All events must be handled actively as these objects receive them.

- *Item*—Small game objects that can be picked up, moved, and dropped by actors.
- *Obstacle*—Nonmoveable objects in the game that cannot be picked up.
- *ProxyObject*—Client-side counterpart of Item and Obstacle classes.
- *Area*—Abstract, spatial representations used to partition the simulation space down into manageable sections. Areas define the local potential visible set that is used to filter who can and cannot see (or if need be, hear) simulationEvents.

Managers and Factories

Managers and factories are implemented as singletons [Gamma94]. A singleton comes in handy when a single global object needs to be accessed by several different classes and objects. They are created when the simulation layer is initialized and remain in service until it is shutdown. Parallel managers are maintained independent of each other on both the client and server.

SobFactory

The *SobFactory* is responsible for creating simulation objects and guaranteeing that they have a unique id number. To achieve this, the SobFactory is the sole keeper of the *nextSobId*. The factory provides a *Create* method that takes an SOB-type argument, specifying what subclass of SimulationObject (Actor, Area, Item, etc.) it creates. If the client-side simulation needs to create local simulation objects, it can maintain its own SobFactory, which will need to implement a scheme to ensure that client-side SOB ids do not conflict with those generated on the server. The class diagram for our Sob-Factory is shown in Figure 2.1.10.

SobFactory
-nextSobId
+Create() : simulationObject -GenerationSobId()

FIGURE 2.1.10 *SobFactory class diagram.*

SobManager

A *SobManager* is responsible for maintaining a dictionary of simulation objects. The main function of this manager is to resolve SOB ids into object references via the *LookUpById* method. This manager also provides methods to Store and Restore all of the objects under its supervision. These two methods delegate the actual object persistence implementation down to the specific simulation objects. This allows for a single call to be made transparently from the simulation layer to save or load all of the objects within it (see Figure 2.1.11).

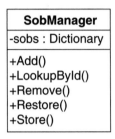

FIGURE 2.1.11 *SobManager class diagram.*

ScheduleManager

The *ScheduleManager* is responsible for scheduling a PerformAction method callback for all of the Performer simulation objects that are active in the simulation. It also provides the *ProcessTasks* method, which takes a time slice argument and calls all of the pending scheduled callbacks that it can process within that time, sorted by the Performer's schedulePriority. Figure 2.1.12 shows the class diagram. Although an effective schedule can be implemented with a directory, as shown here, a more optimized solution is the priority queue. For an excellent article on implementing priority queues refer to [Nelson96].

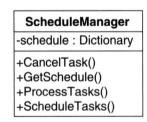

FIGURE 2.1.12 *Class diagram for ScheduleManager.*

LookupManager

The *LookupManager* provides a fast and effective mechanism for accessing static game data at run time. Typically, this data is stored in relational or object databases and is loaded on simulation start-up. The data is mapped into a nested dictionary with a

primary *Table* key and secondary *Entry* keys. Some examples of static game data include initial ActionState data, SimulationEvent types and SimulationObject properties. (For a detailed discussion of a LookupManager, see Section 5.2 of this book.) Figure 2.1.13 shows the LookupManager class diagram.

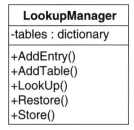

FIGURE 2.1.13 *Class diagram for LookupManager.*

Simulation Classes

Now that we have defined the support, core, and manager classes, we need to wrap them all up in a nice top-level interface for managing the client/server simulation layers. The *BaseSimulation* class provides such a common interface. It contains all of the object references to our manager singletons, as well as a reference to the root SimulationObject. This object represents the entire simulation universe and provides a point to anchor all top-level Area simulation objects to. The simulation maintains two instances of the Sob-Manager, an *areaManager* and an *actorManager*. This separation of simulation objects is useful for debugging, maintenance, and archival purposes (see Figure 2.1.14).

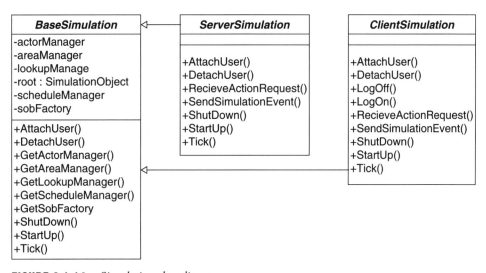

FIGURE 2.1.14 *Simulation class diagrams.*

Conclusion

This part of the article defined the class structures needed to build an MMP simulation framework. Part 2 (Section 2.2) will build on this class framework and demonstrate how to extend these classes into a working, online simulation.

References

[Alexander02] Alexander, Thor, "A Flexible Simulation Architecture for Massively Multiplayer Games," *Game Programming Gems 3*, Charles River Media, 2002.

[Alexander02a] Alexander, Thor, "GoCap: Game Observation Capture," *AI Game Programming Wisdom*, Charles River Media, 2002.

[Alexander02b] Alexander, Thor, "An Optimized Fuzzy Logic Architecture for Decision-Making," *AI Programming Wisdom*, Charles River Media, 2002.

[Boer00] Boer, James, "Object-Oriented Programming and Design Techniques," *Game Programming Gems*, Charles River Media, 2000.

[Booch98] Booch, Grady, *The Unified Modeling Language User Guide,* Addison-Wesley, 1998.

[Dybsand00] Dybsand, Eric, "A Finite-State Machine Class," *Game Programming Gems*, Charles River Media, 2000.

[Gamma94] Gamma, et al., *Design Patterns,* Addison-Wesley Longman, Inc., 1994.

[Nelson96] Nelson, Mark, "Priority Queues and the STL," *Dr. Dobb's Journal*, also available online at *www.dogma.net/markn/articles/pq_stl/priority.htm*, January 1996.

2.2

BUILDING A MASSIVELY MULTIPLAYER GAME SIMULATION FRAMEWORK, PART 2: BEHAVIORAL MODELING

Thor Alexander, Hard Coded Games

thor@hardcodedgames.com

This article builds on the class framework detailed in Article 2.1. We will demonstrate how to extend those classes into a working online simulation.

Attaching Users to Actors

The *ServerSimulation* and *ClientSimulation* classes each implement *AttachUser* and *DetachUser* methods that provide a mechanism for requesting that the calling User be mapped to a specific Actor instance on the server, as well as its associated ActorProxy on the client. Attaching a User to an Actor allows that User to send action requests and receive simulation events. It is up to the current control state of the target Actor to arbitrate whether or not the Actor will accept or decline the attach request. Such an attachment mechanism has the added benefit of supporting such advanced features as allowing multiple Users to attach to the same Actor. A few uses for this feature in an MMP are to allow customer support personnel to take over control of a troublesome player's character, or to be able to see the game from the exact perspective of a newbie player who is having trouble and is requesting help.

Action Requests

Once attached to a User on the server, the client's primary outbound communication comes in the form of action requests. The *SendActionRequest* method on the ClientSimulation takes an *ActionStateId* and an argument list representing the User's desired action, and passes them to the server simulation layer. The server, in turn, delegates these requests down a chain of responsibility from the attached Actor to its control state, where it is processed or rejected. Figure 2.2.1 illustrates the action request process with a UML sequence diagram.

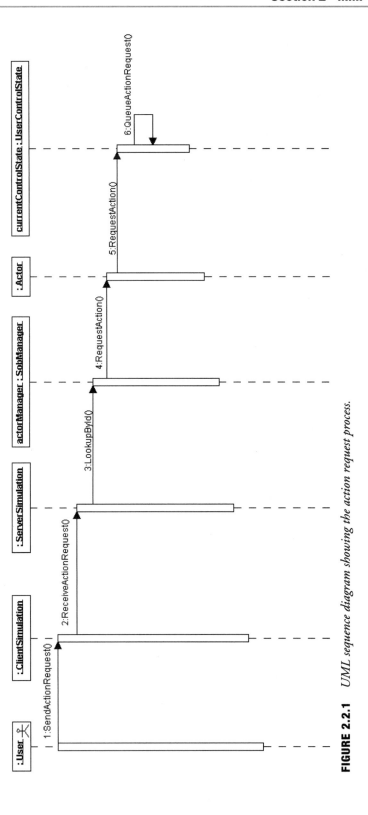

FIGURE 2.2.1 *UML sequence diagram showing the action request process.*

Action Scheduling

The ServerSimulation provides a single *Tick* method that can be called from outside the simulation layer to trigger the processing of all pending actions. This method is responsible for calculating the available time slice for simulation processing, and it is responsible for handing it over to the schedule manager via the ProcessTasks method. Since the server physics layer must typically be processed at a higher frequency than the simulation layer, the Tick method serves as a good callback method to be registered with the physics layer that maintains the main game loop (see Figure 2.2.2).

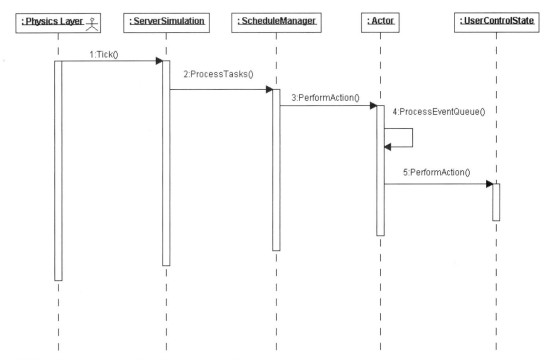

FIGURE 2.2.2 *Action-scheduling sequence diagram*

Event Broadcast and Handling

The PerformAction method on the ControlState determines the *desiredActionState* for the calling Actor to attempt to transition. If this ActionState passes its CanTransition pretest, then its Transition method is called to do the heavy lifting. Each ActionState needs to provide its own specific implementation. Typically this implementation will need to inform other simulation objects of the state transition. This is accomplished through simulation events. The acting SimulationObject maintains the subscribers

dictionary of other objects that have registered an interest in its actions. These sub-scribers are notified by calling their ReceiveEvent method. The receiver can determine if it needs to give the event immediate or passive attention. In the former case, it is handled as it is received; in the latter case, it is queued and is processed on the receiver's next PerformAction Tick. Figure 2.2.3 shows this sequence diagram.

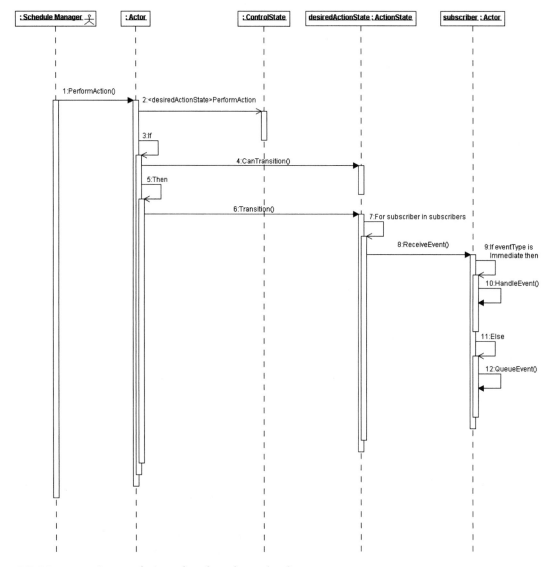

FIGURE 2.2.3 *Server-side Actors broadcast the results of action transitions as events.*

Server-Side Event Handling

When an event subscriber receives an event broadcast, it hands that event off to the appropriate event handler for the specified type of event. That handler is responsible for performing any and all server-side handling tasks. Additionally, it needs to check and see if the Actor has an attached User. If so, it needs to echo the event down through the ServerSimulation to the ClientSimulation. This is will require that the event object be broken open and packed into an event message that can be sent over the network to the client. This process is illustrated in Figure 2.2.4.

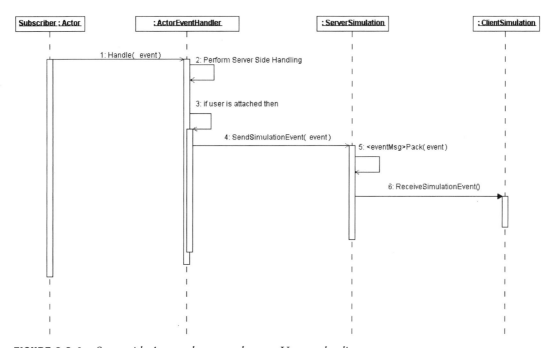

FIGURE 2.2.4 *Server-side Actors echo events down to User on the client.*

Client-Side Event Handling

Once the event message is received by the client, it needs to be unpacked back into an event object. The *sourceId* of the event is extracted from that object and used by the actorManager of the ClientSimulation to lookup an ActorProxy. This proxy object is the client's representation of the corresponding Actor object on the server. If no such proxy object is found by the actorManager, then this means that this is the first time the client has dealt with this Actor, or that it has been cleared out of the limited cache

of proxy objects that the client cares about. In such a case, the client will need to use its SobFactory to create a fresh ActorProxy and add it to the cache maintained by the actorManager. Now that we have a proxy object, we can pass the event from the server, as shown in Figure 2.2.5.

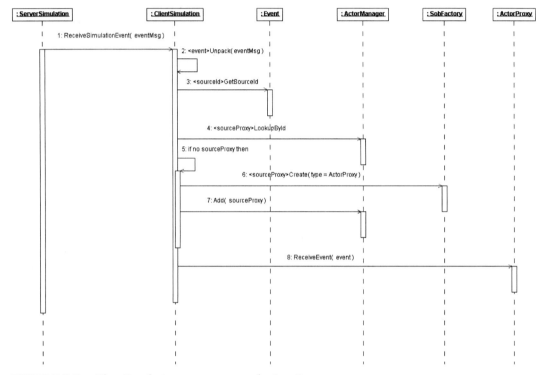

FIGURE 2.2.5 *ClientSimulation routes events to the ActorProxy.*

Client-Side Proxies

When the client-side proxy object receives an event, it performs a process very similar to the one that was performed earlier on the server. The ActorProxy determines the appropriate handler for the event type and passes it the event. This is not the same handler object found on the server, but instead is a *ProxyEventHandler* that is responsible for performing client-side processes. Generally, these processes entail transitioning the ActorProxy to the proper *ProxyActionState* to replicate the state of the corresponding object on the server (see Figure 2.2.6).

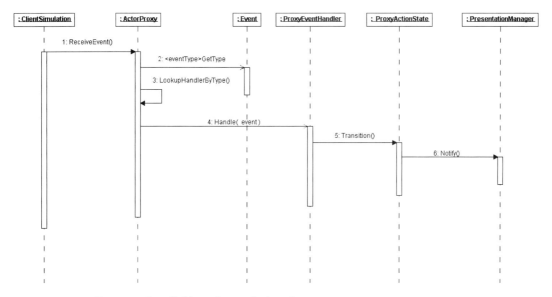

FIGURE 2.2.6 *Events are handled by a client-side ActorProxy.*

Separation of Simulation and Presentation

Typically, such a state transition will need to be visually represented by the client. To allow for this, the simulation framework provides a hook to notify any presentation managers that have an interest in when a state change or some other relevant event occurs. These managers could include user interface elements, an audio player, or a 2D/3D rendering engine. This notification system is based on the *Observer* design pattern, as shown in Figure 2.2.7. Our ProxyActionState has an *Attach* method to

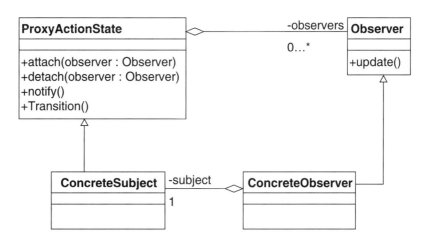

FIGURE 2.2.7 *The observer pattern helps decouple the simulation from the presentation.*

allow any Observer to register its interest in the state, as well as a *Notify* method that will inform all registered observers when the state changes by calling each observer's *Update* method. A detailed discussion of the Observer design pattern can be found in Section 2.2.8.

Such a system allows us to maintain a strong separation between the simulation layer and any presentation layers. By decoupling the presentation from the simulation, we can easily port our game to different platforms without having to rewrite our client/server code bases. We can also swap out different rendering engines as graphics technology continues its relentless pace forward, allowing our MMP game to always be the best looking on the market. This decoupled architecture will also allow us to open up our game service to emerging platforms, such as console and wireless MMP gaming.

Conclusion

Developing an MMP game is an often-underestimated task of huge proportions. Starting with a framework based on solid engineering principles like the ones presented in this two-part article will get you off to a good start and allow you to focus more of your time and effort on creating innovative and engaging gameplay.

2.3

CREATING A 'SAFE SANDBOX' FOR GAME SCRIPTING

Matthew Walker, NCsoft Corporation

mwalker@softhome.net

ON THE CD

Source code from this article is included on the companion CD-ROM.

The technical and support demands of Massively Multiplayer (MMP) games require a robust server architecture. Yet, the nature of regular, dynamic content development risks introducing bugs that can open opportunities for exploits or can unbalance the game. One way to mitigate this risk is to build a 'safe sandbox' within which game designers can write code that realizes their creative intent while insulating them from sensitive subsystems. This article explores how to create such a sandbox using the high-level programming language, *Python,* to implement an encapsulated, event-driven environment that lets designers safely focus on gameplay as their first priority.

Scripting Languages and MMP Development

Scripting languages such as Python, JavaScript, Perl, and UnrealScript [Sweeney98] run within a *virtual machine*. This is essentially a program that simulates a CPU. A virtual machine executes other programs that are expressed in platform-neutral *byte-code* instead of the processor-specific machine code generated by languages such as C and C++ [Kohlbrenner99]. Using this architecture for a programming language allows the language to hide many complex details of memory management, resource management, and operating system functionality. Isolating these details also limits the severity of errors that can be caused by programming bugs.

Scripting languages employ *weak data typing*, which means that variables can contain different types of data at different times, and *automatic type conversion*, which allows one type of data, such as a number, to be easily converted to another, such as a string. This allows a great deal of flexibility in developing function/method interfaces and data structures. Finally, these languages usually provide very high-level objects, such as strings, lists, dictionaries, and the like, which make it very easy to be productive [Ousterhout98].

MMP games are service-based products requiring consistent reliability and regular updates of dynamic content. This means that MMP games must undergo constant improvement and modification while preserving a stable and maintainable code base for the life of the project. These two objectives often compete, as frequent changes to software can often mean a loss in stability. The features of scripting languages make them invaluable to meeting both of these objectives.

Python vs. Implementing Your Own

It has been sort of a tradition in the game industry for a development team to implement their own custom scripting language, tailored to their specific needs. UnrealScript and QuakeC are two of the better known examples. Yet, is designing, implementing, debugging, and extending a programming language a good use of a development team's time? It is true that we may get the exact features we need from a custom-built language, but this benefit is offset by several disadvantages:

- Game development using the custom language must always lag behind development of the language itself. This is a self-imposed risk to the development schedule.
- At least one full-time programmer will be dedicated to developing and maintaining the language for much of the project.
- A customized, *special-purpose* language requires making certain assumptions about the code to be written. These assumptions may eventually prove too inflexible to meet the evolving needs of the project.
- A customized, *general-purpose* language must be carefully engineered and will likely exceed the scope of the project. Its size and breadth may prove too much to maintain over the long term.
- Any customized language will be unfamiliar to most programmers and will lack the training resources, such as reference books and Web sites, that exist for mainstream languages. This will limit the rate at which skilled programmers can become productive on the project.

An attractive alternative is to use an existing general-purpose scripting language that has been in use for some time and has proven itself in many applications. This article recommends Python for the following reasons [Python01]:

- It has a very simple and easy-to-learn syntax.
- It is relatively fast, with most of it being implemented in C or C++.
- It integrates well with C, C++, and other compiled languages.
- It is object-oriented, supporting classes, single and multiple inheritance, and well-defined scopes and namespaces that promote good engineering practices.
- It takes fewer lines of code to write a given piece of functionality than most other languages.

- It has a rich set of built-in libraries, providing functionality ranging from text processing to database interaction, process control, file I/O, networking, cryptography, and much more.

The Justification for a Safe Sandbox

It is common in the maintenance and evolution of any long-lived software project for expediency and shortsighted 'creativity' to introduce dangerous practices and unstable code into the system. The greatest danger to the integrity of the code base lies in the code that is most often changed. Over the life of the service, this code is usually related to the high-level systems that implement the rules of the game and define what makes the game fun. Game-balancing, special events, new items and abilities, and so on require frequent modifications to keep the game interesting.

In contrast, critical infrastructure systems (e.g., networking code, database interfaces, physics, movement, hack detection, etc.) should be changed very rarely and very cautiously. It is particularly important to avoid accidentally affecting these critical systems while updating the game systems. The converse is almost just as important: it is undesirable to inhibit changes to game systems for fear of introducing such instability.

Creative Talent Does Not Equal Technical Skill

Often on MMP projects, game designers having limited technical experience are expected to implement gameplay rules and scenarios in code. While they are highly creative and valuable team members who know how to make a game fun, they usually do not know how to engineer it to be robust and maintainable. Expecting designers to appreciate the importance of concepts such as minimizing dependencies, defining consistent interfaces, abstraction, and the like is not realistic.

A Safe Place to 'Play'

Enter the concept of the *safe sandbox*. This is a contrived term intended to convey the notion of a protected space for game designers and content developers to 'play' without fear of harming the system in which they are working. The goal of the safe sandbox is to completely isolate the 'play area' from the critical infrastructure, allowing access to specific subsystems via well-defined interfaces on an as-needed basis only. Here are some examples of practices that should probably be avoided during game coding or content maintenance:

- Arbitrarily creating or destroying game objects outside of the normal framework.
- Directly controlling the movement, location, or orientation of objects in the game.

- Conditionally adjusting AI or path-finding to suit a specific scenario.
- Bypassing the game database and writing game data to the local file system.
- Opening a socket to another server or client instead of using the provided messaging system.
- Directly querying or updating the database using embedded SQL instead of existing update and retrieval interfaces.
- Sending arbitrary text messages to the game client.
- Utilizing an existing subsystem in ways contrary to its design.

We would usually not consider allowing these practices during the initial development of the game. Yet, we often do not plan to restrict their use by others who come after us, who may be tempted to take short cuts in order to meet the immediate objectives of running a live service.

The Design of a Safe Sandbox

Designing a safe sandbox into our architecture from the beginning helps us avoid many of these pitfalls later on.

Python's Restricted Execution Feature

Our safe sandbox utilizes a unique feature of Python called *restricted execution*, which consists of the rexec and Bastion modules [Python02]. The rexec module allows us to create a separate Python run-time environment with its own namespace within the context of our game server. We can use rexec to restrict which Python services are available from within the sandbox and to control which elements of our own infrastructure are available to the sandbox. The Bastion module allows us to wrap objects we might want to present to the sandbox with a protective proxy that permits access to only a subset of its normal interface.

Key Elements of the Safe Sandbox

Every game server will define its own architectural policies and requirements, so we can only provide a purely academic and representative implementation of this concept. Our safe sandbox comprises the following major design elements.

SandboxRExec Class

This class is derived from the RExec class of the Python rexec module, and it customizes the default restricted execution environment to meet our game's needs.

The SandboxRExec module defines the _GetSandboxPath() function, which returns a search path for modules supported in our environment. This path is used in place of the built-in, sys.path attribute normally available to Python code, which allows the interpreter to find modules when it is told to load them [Python03].

```
def _GetSandboxPath():
    return ['/usr/lib/python2.2',
        '/usr/lib/python2.2/plat-linux-i386',
        '/usr/lib/python2.2/site-packages',
        '/usr/lib/python2.2/site-packages/Numeric',
        '/usr/local/lib/gameserver/']    # our server's area
```

The RExec base class maintains attributes containing *tuples* of modules to which to either permit or deny access. A tuple is a Python data structure that is essentially an immutable list. In the SandboxRExec class, we simply override these tuples with our own list of modules. The attributes having the suffix _names identify keywords or functions that are to be enabled (ok_) or disabled (nok_). Those having the suffix _modules identify whole modules that are controlled by this environment. Finally, the ok_path attribute is initialized by the _GetSandboxPath()function.

```
class SandboxRExec(rexec.RExec):
    nok_builtin_names = rexec.RExec.nok_builtin_names + \
        ('compile', 'delattr', 'execfile', 'globals',
        'input', 'locals', 'raw_input', 'vars')

    ok_builtin_modules = ('math', 'operator', 'time')
    ok_path = _GetSandboxPath()    # load the valid path
    ok_posix_names = ()    # no os module access
    ok_sys_names = ()    # no sys module access

    ok_library_modules = \
        ('types', 'operator', 'copy', 'string',
        'math', 'cmath', 'random', 'time')
```

We add our own attribute, ok_server_modules, which lists modules implemented in our game server to which we want to allow access. Another custom attribute, ok_packages, identifies *packages* in our system from which any module may be imported. A package is a construct in Python that groups related modules together.

```
    ok_server_modules = \
        ('safesandbox', 'events', 'errorhandler', 'log')
    ok_packages = ('sandboxmodules',)
```

Finally, we aggregate the list of all available modules into a single tuple, ok_modules, which is recognized by the base class.

```
    ok_modules = ok_builtin_modules + \
        ok_library_modules + ok_server_modules
```

The RExec base class provides hooks for certain core Python functions that we want to behave in a certain way. These include r_exec(), r_eval(), r_execfile(), r_import(), r_reload(), and r_unload(). These hooks are called instead of their

normal Python counterparts, which do not have the "r_" prefix. We do not want to allow access to the file system at all, so we override the r_open() function to raise an exception whenever open() is called from within the restricted environment.

```
def r_open(self, filename, mode=None, bufsize=None):
    raise IOError, 'No access to filesystem is allowed.'
```

To cause a specific module to run within our restricted environment, we create an instance of SandboxRExec and import the module via its r_import() method. We do this instead of using Python's import keyword as we would normally do. This method checks the tuples we declared earlier to determine what it can import.

```
def r_import(self, modulename):
    okToImport = 0

    if modulename in self.ok_modules:
        okToImport = 1
    else:
        # special test to see if module is a
        # submodule of an allowed package
        for pkg in self.ok_packages:
            if len(modulename) >= len(pkg):
                if modulename[:len(pkg)] == pkg:
                    okToImport = 1

    if okToImport:
        # call base class implementation
        mod = rexec.RExec.r_import(self, modulename)

        # if module is in dotted-path notation,
        # must get the left-most name
        components = string.split(modulename, '.')
        for comp in components[1:]:
            mod = getattr(mod, comp)
        return mod

    raise ImportError('Restricted: %s' % (modulename,))
```

From within the code running inside the restricted execution environment, only the modules or functions permitted by r_import() may be imported and executed.

Bastion() and BastionClass

The Bastion() function is a factory that creates an instance of BastionClass, which surrounds an object we want to protect from unauthorized access. These facilities are supplied directly by the Python Bastion module, and we use them unmodified. The default behavior of a bastion-ized object is to prevent access to all data members and to any method that is prefixed by an underscore, "_".

With this default implementation, given an instance *x*, we could legally call:

```
loc = x.GetLocation()
```

However, if we tried to call:

```
x._SetLocation(1.5, 3.7, 0.0)
```

we would be greeted with the Python exception:

```
AttributeError: _SetLocation
```

We can customize this behavior, however, by supplying an optional filter function as the `Bastion()` function's second argument. This function must accept a string containing an attribute name and return *true* if access to the attribute is allowed or *false* if access is not allowed. In this way, we may develop a protocol for exporting methods from our protected classes to the `SafeSandbox` environment. Such a filter might take the form:

```
def LegalMethodFilter(name):
  if name[:5] == 'game_':
   return 1
  return 0
```

Then, when we create a protected instance of an object using this filter, we call the `Bastion` function, like so:

```
ob = SomeObject()
safeob = Bastion.Bastion(ob, filter=LegalMethodFilter)
```

Now, every method of `safeob` that is prefixed by the string "game_" may be called from within our restricted environment; all others are prohibited.

One way to be very specific about which methods are accessible is to override the default `BastionClass` to support explicitly listing each exported method, rather than using a naming convention, as in our example. We can even write our own implementation of the `Bastion` function to allow direct attribute access for specific attributes only, preventing access to others. See the Python Bastion.py module on the companion CD-ROM (in the lib directory of the Python distribution) for more information and ideas.

ON THE CD

SafeSandbox *Base Class*

The `SafeSandbox` class is an *abstract base class* from which the authors of game script derive their own implementation classes. The scope of these derived classes aligns with an environment within the game world, or it aligns with a context within which certain rules are followed or certain behaviors are expected. Examples of such environments might include a public area where people socialize or engage in commerce, a combat arena, a magical forest, or an abandoned space station.

The SafeSandbox base class manages the scope of the environment, serving as the tangible barrier between the interior of the restricted environment and the rest of the server framework. It also aggregates services provided by the server framework, behaving similarly to the *Facade* design pattern [Gamma95], save that we inherit from the Facade rather than delegate to it. These services include the dispatching of game events within the sandbox, accessing objects in the game world, and other utility functions.

The standard constructor of our class accepts a reference to the world object, which provides access to game objects in the world. It also initializes an instance of the EventManager class, which is provided by our server framework to dispatch game events.

```
class SafeSandbox:
    def __init__(self, world):
        self.__world = world # access to the game world
        self.__eventManager = eventmanager.EventManager()
```

The class also declares _FrameworkInit(), which serves as a post-creation initialization hook. This method calls Init(), which is optionally implemented by the derived class. We use this technique to guarantee that our base class initialization is always called by our framework, without requiring derived classes to call a base class implementation of Init(), which is a step that might be forgotten in the derived class.

```
def _FrameworkInit(self):
    # do post-creation SandBox init stuff here
    # ...
    # let derived class init if it likes
    if hasattr(self, 'Init'):
        self.Init()
```

We wish to allow only the ability to handle game events from within a SafeSandbox, and not to post them. We can override the built-in method, __getattr__(), to control access to the EventManager instance that is held as an attribute of our SafeSandbox class. Here, we simulate implementing the RegisterHandler()and UnRegisterHandler() methods by assigning references to the methods implemented by EventManager to attributes of our class having the same names.

```
def __getattr__(self, name):
    # Posting of game events is not allowed within the
    # sandbox, so we only expose registration and
    # unregistration methods.
    if name == 'RegisterHandler':
        return self.__eventManager.RegisterHandler
    elif name == 'UnRegisterHandler':
        return self.__eventManager.UnRegisterHandler
    else:
        raise AttributeError(name)
```

Certain game mechanics require that our SafeSandbox gets access to in-game objects, such as player characters and items in the world. Yet, not all features of these objects should be available to the restricted environment. We protect them by returning them wrapped in a BastionClass proxy.

```
def GetGameObject(self, obId):
    # Return a protected game object from the world
    # region, based on its object id.
    gameobject = self.__world.GetGameObject(obId)
    return Bastion.Bastion(gameobject)
```

Because our SafeSandbox base class imports modules from our server framework that are not intended to be used from within the restricted environment, our derived classes cannot import the SafeSandbox module directly, as in:

```
import safesandbox # exposes modules imported by safesandbox
class MySandbox(safesandbox.SafeSandbox):
    # implementation
    # . . .
```

Instead, we establish the inheritance relationship at run time, *after* we import the derived class's module via our restricted environment. This is easy with Python, because a given class's set of base classes is represented as a tuple of class objects, which can be changed at any time. At server start-up time, the _InitSandboxClasses() function creates a dictionary of SafeSandbox-derived class objects that is used by the CreateSafeSandbox() factory function to create instances at run time.

```
# a global instance of our restricted environment
g_re = sandboxrexec.SandboxRExec()

# a global dictionary of protected sandbox classes
g_classDict = {}

def _InitSandboxClasses(sandboxModules):
    for module in sandboxModules:
        # expand the row tuple into its elements
        moduleName, className = module

        # import the module via the restricted environment
        try:
            module = g_re.r_import(moduleName)
        except ImportError:
            print 'Cannot import %s.' % (moduleName,)
            continue

        # get the class object from the sandbox module
        safeSandboxClass = getattr(module, className)
```

```
        # disallow implementing __init__() in derived classes
        assert not hasattr(safeSandboxClass, '__init__'), \
            '%s must not define __init__()' % (safeSandboxClass,)

        # Add the SafeSandbox class into the list of bases,
        # creating inheritance without the derived class
        # needing to import this module.
        bases = safeSandboxClass.__bases__
        safeSandboxClass.__bases__ = bases + (SafeSandbox,)

        # store the sandbox class object indexed by its name
        g_classDict[className] = safeSandboxClass

    # end for
```

Note that we disallow derived classes from implementing the __init__()constructor method. This is because we do not want to worry about whether or not a derived class implements the constructor with the correct parameters and calls the base class implementation. All derived class initialization is performed by the Init() method, as previously described.

Finally, we have our factory function that creates instances of derived SafeSandbox classes based on a lookup of the class name in the dictionary that we initialized at server start-up in _InitSandboxClasses(). In our case, the factory also calls the _FrameworkInit() hook.

```
def CreateSafeSandbox(world, className):
    # Factory function that returns an instance of the derived
    # class of SafeSandbox, as indicated by the className. The
    # world parameter is an object containing information
    # about the physical game world and the objects it contains.
    try:
        s = g_classDict[className](world)
        s._FrameworkInit() # let derived classes init
        return s
    except KeyError:
        print 'No sandbox class for id [ %s ]' % (className,)
        return None
```

Our game server infrastructure calls the CreateSandbox() factory function to create an instance of the appropriate derived class of SafeSandbox whenever one or more players enters such an environment. Each derived class is specialized to the environment, implementing methods that handle events that occur in the environment in a way that reflects the rules for that area. Perhaps combat is not allowed in a social space, so handlers could detect an attempt to attack someone and level a severe punishment in response. In an abandoned space station, a leaky air lock might either blow its doors or be repaired, depending on events generated by players or other game objects.

Writing Safe Sandbox Game Code

Writing game code in our protected environment is as simple as writing a single Python class for each sandbox. No special initialization is required by the framework, and we do not even have to directly inherit from the SafeSandbox base class.

Below is a sample sandbox for an environment containing a trap that can damage a player. Imagine that we have a trigger device somewhere on the map that will detect when a player enters some region. When he does, an alarm is activated with a 5-second pulse, and the player has 30 seconds to find the reset button somewhere on the map. If he does not find it, then a bomb explodes at his location.

First, we import the modules we need from our game. At this point, we can only import legal ones:

```
# all our imported modules are legal
import sandboxmodules.alarm     # an alarm that alerts others
import sandboxmodules.bomb      # a bomb class (deadly!)
import events     # event ids to register for
```

Next, we declare the class, DangerousArea, which is our derived class of SafeSandbox. We implement Init() to set up the objects in our scenario and register event handlers that are implemented by our derived class. This method is called by _FrameworkInit().

```
class DangerousArea:
    def Init(self):
        # Do our own initialization and register event handlers
        # upon start-up here. Called by SafeSandbox.

        # alarm goes off every 5 seconds when triggered
        self.alarm = alarm.Alarm(interval=5)
        self.alarm.Arm()

        # bomb explodes with a radius of 10 meters
        self.bomb = bomb.Bomb(radius=30, damage=100)

        # register handlers with the SafeSandbox base class
        self.RegisterHandler(events.TRIGGER_ACTIVATED, \
            self.OnTrigger)
        self.RegisterHandler(events.ALARM_ALERT, \
            self.OnAlert)
        self.RegisterHandler(events.BUTTON_RESET, \
            self.OnDisarm)

    # maximum number of pulses the alarm can fire
    # before the bomb goes off (5 sec * 6 pulses = 30 sec)
    self.maxAlarmPulses = 6
```

Our event handlers are where most of the fun happens. OnTrigger() is called by the server framework when the TRIGGER_ACTIVATED event is posted, which happens when our victim walks across a pressure plate or is detected by a sensor (use your imagination).

```
def OnTrigger(self, player):
    # Handle the trigger event. The activator is
    # the player who tripped the trigger.
    self.alarm.Alert(player) # announce who set off the alarm
```

When the ALARM_ALERT event fires, the OnAlert() handler is called.

```
def OnAlert(self, player, pulsecount):
    # Called once for each pulse of the alarm.
    # The pulsecount is how many times the
    # alert pulse has occurred.
    if pulsecount < self.maxAlarmPulses:
        # boom. . . right at players location
        self.bomb.explode(player.GetLocation())
```

If our victim is clever enough to find our alarm and disarm it, the BUTTON_RESET event fires, causing OnDisarm() to be called.

```
def OnDisarm(self):
    # We stop the alarms pulsing when
    # the reset button is pressed.
    self.alarm.Disarm() # whew!
```

Violating the Restrictions

We can see that there is no direct reference to our restricted environment in our game code. This is because everything is automatically handled for us by the sandbox framework. Yet, if we were to attempt to import a restricted module, as in:

```
import database    # let's query the DB!
```

as soon as our module is imported, we would see the exception:

```
ImportError: Restricted module: [ database ]
```

This is because the module database is not listed among our permitted modules in the ok_server_modules list of our SandboxRExec class.

Similarly, if we wanted to store the names of players who have been caught by our little trap in a file, along the lines of:

```
f = open('victims.dat', 'a')    # append to existing data
f.write(player.GetName())
f.close()
```

we would run afoul of our rules and be reminded with the exception:

```
IOError: No access to filesystem is allowed.
```

Finally, if we tried to access a restricted member on the `player` object in our example, such as directly reducing his health rather than letting the bomb apply its damage, as in:

```
player.health = player.health - 100
```

our error would be apparent from the response:

```
AttributeError: health
```

As game scripters, we do not have to worry about what we can and cannot do. We will be told when we overstep our boundaries.

When the Safe Sandbox Is Not Safe

We must understand that the techniques described in this article are not intended to prevent malicious acts by rogue programmers. All the code in the sandbox is intended to encourage desired behavior by willing contributors who should not have to be bothered by the architectural trivia associated with our server framework as a whole. The target user of the system is a creatively minded individual with some degree of basic programming or scripting skill, and a primary focus on creating fun and engaging experiences for the player.

Anyone who wishes to deliberately thwart the controls imposed by this system can probably find a way given the time, skill, and motivation. For this reason, it is not recommended to trust this approach to enforce hack-prevention rules in client code.

Conclusion

It is common that the best game designers on an MMP development team are not always the best programmers. They were hired for their imagination, creativity, and sense of fun, rather than their ability to write structured code or design relational database schemas. Yet, the disciplines of programming and game design converge at the point where game rules and scenarios are implemented in code. Here, it is often best to encourage designers to apply a hands-on approach to bringing their ideas to life.

Yet the need for sound engineering practices does not cease at this point. The safe sandbox approach can help an MMP development team encourage desired programming practices in the creation of game code by creating an environment that enforces those practices. This frees the designers to focus on their design, aids the program-

mers in the knowledge that their server's integrity is solid, and reduces the volume of bugs introduced by an unforeseen use of system functionality.

References

[Gamma95] Gamma, Erich, *Design Patterns: Elements of Reusable Object-Oriented Software,* Addison-Wesley, January 1995.

[Kohlbrenner99] Kohlbrenner, Eric, et. al., "Introduction to Virtual Machines," available online at *http://cne.gmu.edu/itcore/virtualmachine/index.htm,* 1999.

[Ousterhout98] Ousterhout, John K., "Scripting: Higher Level Programming for the 21st Century," available online at *http://home.pacbell.net/ouster/scripting.html.*

[Python01] van Rossum, Guido, "Comparing Python to Other Languages," available online at *http://www.python.org/doc/essays/comparisons.html.*

[Python02] van Rossum, Guido, "rexec — Restricted execution framework," Python Library Reference, Fred L. Drake, Jr., ed., available online at *http://www.python.org/doc/current/lib/module-rexec.html,* April 2002.

[Python03] van Rossum, Guido, "sys — System-specific parameters and functions," Python Library Reference, Fred L. Drake, Jr., ed., available online at *http://www.python.org/doc/current/lib/module-sys.html,* April 2002.

[Sweeney98] Sweeney, Tim, "UnrealScript Language Reference," available online at *http://unreal.epicgames.com/UnrealScript.htm,* December 1998.

2.4

Unit Testing for Massively Multiplayer Games

Matthew Walker, NCsoft Corporation

mwalker@softhome.net

Unit testing is the practice of writing software to exercise the functionality of other software within a consistent set of conditions, and testing the behavior against an expected result. A *unit* is a cohesive software element with a well-defined interface and few dependencies on other elements. Unit tests consist of one or more *test cases* that exercise the functionality of the unit in specific ways, checking the results of every test case. Multiple test cases are grouped together into *test suites* so that they can be run as a single batch process. Unit tests require one or more specific data sets against which to run the software being tested. These data sets are called *fixtures*. Using the same fixture in every run of the test ensures consistent input, so that any variation in the behavior of the tested software can be attributed to changes in the software, not the data.

Unit testing has been used in software engineering for several years. Most recently, it has gained in popularity within the *Extreme Programming* (XP) movement. XP is a software development discipline that emphasizes the values of "simplicity, communication, feedback, and courage," [XP99]. Unit testing is included among its core practices, along with continuous code integration, small releases, pair programming, collective code ownership, and other practical methods for quickly and efficiently developing high-quality software [Jeffries01].

Why Unit Testing for MMP Games?

Single-player games and online games that are intended to be operated by the consumer are normally released with the expectation of generating most of their revenue very soon after release. Few changes are made to these games after they ship, except to fix critical bugs that threaten retail sales. By contrast, massively multiplayer games are created as a service that is expected to generate an ongoing stream of revenue for many years. Such a service requires a large staff of developers and support personnel

throughout its life. During its life cycle, a Massively Multiplayer (MMP) game undergoes many changes to both its code and content in an effort to provide a fresh and interesting experience for subscribers. In an MMP, a bug can bring down the online service or introduce significant upsets to game balance. These problems threaten the stability of the revenue stream and the overall success of the project. There are two key benefits of unit testing that are readily apparent to MMP development:

1. It ensures the integrity of code during initial development, especially during integration.
2. It minimizes the risk of introducing errors into production code as the game evolves.

The longevity of MMP products and the support demands placed on them require greater attention to managing software-development risk than that required of traditional computer games. The practice of unit testing minimizes risk by exposing errors early and often.

Defining a Unit Test

Three main entities must be clearly defined in order to design an effective unit test. These are the unit, the fixture, and the test itself.

Define the Unit

The unit of software being tested must have a well-defined interface and few exposed dependencies on other units. All dependencies should be abstracted behind the unit's interface so that the code performing the test need not know about them. Most often, a unit is a class in the object-oriented sense.

Well-designed software usually consists of collections and hierarchies of related objects. It is most useful to define units starting with the innermost, lowest level, or most fundamental classes first. Then, work toward the outer layers of the system to higher level classes. This approach follows the natural evolution of the code and works to ensure the correct functioning of code on which more-complex code depends.

Some examples of low-level units include a `DataBuffer` class for creating networking packets, a `Thread` class for concurrent processing, and a `Crypt` class for encryption. Higher-level classes include such things as an `ObjectManager` for keeping track of objects running in the game, an `EventManager` for dispatching asynchronous messages, and a `CollisionManager` for detecting object intersections.

Define the Fixture

Each unit test has one or more fixtures that establish the data sets with which the unit will be tested. A fixture may be as simple as a hard-coded string used by the `Data-`

Buffer class, or it may consist of a collection of objects with collision geometry that will be fed to the CollisionManager. For example:

```
// test string for the DataBuffer
const char* data = "the quick brown fox";

// collection of Collider objects
vector<Collider*> colliders;
colliders.push_back(new Collider(0.0, 1.0, 0.0));
colliders.push_back(new Collider(1.0, 0.0, 0.0));
colliders.push_back(new Collider(0.0, 0.0, 0.0));
```

Different tests on the same unit may require different fixtures. A *positive path* test (a test designed to succeed) of the ObjectManager may require a collection of different objects with unique ids. A *negative path* test (a test designed to trigger a failure) may require a collection containing duplicate references to the same object in order to force a failure. Define as many different fixtures as necessary to thoroughly test all aspects of the unit.

Often, fixtures can be hard-coded right into the unit test. This is certainly the easiest approach, as the tester has total control over the data provided to the unit. However, when testing higher-level units, it is not uncommon to use fixtures that require external data. External data is data read from a file, database, socket, or other resource outside the code of the unit test. The reason for this kind of fixture is to allow the unit being tested to receive data in the same manner within the test as it would when the running game.

The difficulty in using external data in a fixture is in ensuring that the data is always present for the test, and that the data has not changed since the last run of the test. This requires careful management of the testing environment and segregating test data from data intended for production. Using production data in fixtures subjects the unit test to unpredictable changes resulting from project objectives that differ from those driving the development of the unit being tested. The unit being tested must 'own' its test data to ensure its integrity and consistency.

Define the Test

Unit tests must exercise all major functionality of the unit being tested. This means calling methods or functions that are declared in the unit's public interface. All code that computes a derived value or changes the state of the unit should be tested. It is usually not necessary to test trivial accessor (Get) and mutator (Set) methods unless they return derived values or influence state changes in the unit.

It is usually not possible to test private or protected interfaces of the unit. Most languages that enforce access protection, such as C++ and Java, prevent test code from accessing private or protected methods. This should not be a problem, however,

because unit tests are intended to simulate code that uses the unit being tested, and such code is also prevented from accessing restricted interfaces. Altering the interface of an object purely to facilitate testing of otherwise restricted code is discouraged.

When testing a unit, we must compare the actual result of calling the function or method against an expected result. If the actual result matches the expected result, the test passes; if not, it fails. When a test passes, the unit test does nothing; when it fails, the unit test raises an exception that can be handled by error-reporting code that is part of the test framework. The expected result is predefined as part of the unit test code and depends entirely on the fixture and the code being tested.

The manner in which we test results against expectations varies. For computed values, simply compare the computed result against the predicted result. For example:

```
// test derived damage value
BattleDrone d;
d.SetWeaponType(PULSE_RIFLE);   // damage=energy*0.4
d.SetEnergyLevel(150);
d.AddDamageBonus(15);
int damage = d.GetAttackDamage();
assert(damage == 75); // (150 * .4) + 15
```

Testing state changes in the unit is more complex. The main challenge here is getting access to the state being changed. This is no problem if the state is accessible via the public interface, as shown here:

```
// test string concatenation
MyString* s = new MyString("hello");
s->Append(" world");
assert(s→GetContents() == "hello world");
```

However, sometimes internal state changes manifest themselves as changes in the behavior of the unit. In this case, we may need to write code that detects this behavior change. Here is an example:

```
// test collision manager
Collider* pC1, pC2, pC3;
pC1 = new Collider(0.0, 0.0, 0.0); // start at origin
pC2 = new Collider(1.0, 0.0, 0.0); // 1 away from c1
pC3 = new Collider(-1.0, 0.0, 0.0); // 1 away from c1

CollisionManager manager;
manager.AddCollider(pC1);
manager.AddCollider(pC2);
manager.AddCollider(pC3);

// first, ensure not colliding
bool bCollided = false;
bCollided = manager.TestCollision(pC1, pC2);
assert(!bCollided);
```

```
bCollided = manager.TestCollision(pC2, pC3);
assert(!bCollided);

bCollided = manager.TestCollision(pC1, pC3);
assert(!bCollided);

// move pC2 closer to pC3
pC2.SetPosition(-1.0, 0.0, 0.0);

// test collisions again
bCollided = manager.TestCollision(pC1, pC2);
assert(!bCollided); // still not colliding

bCollided = manager.TestCollision(pC2, pC3);
assert(bCollided);  // this pair is now colliding

bCollided = manager.TestCollision(pC1, pC3);
assert(!bCollided); // still not colliding
```

In the previous example, we can see how changing the location of one of the Col-lider objects so that it intersects with another causes the CollisionManager to register a collision where one had not previously existed.

Unit Testing Frameworks

It is fairly simple to write software that exercises the functionality of other code. Unit tests are merely batch processes that initialize data, call methods or functions that constitute the test case, and detect errors. To be most useful, these batch-oriented programs should provide facilities for reinitializing the fixture for each test case, isolating test cases from each other, handling expected failures and unexpected errors, gathering statistics, and reporting the results.

We could write these facilities ourselves, but why bother? Much of this additional functionality is mundane and, while necessary, is also repetitious and often uninteresting. Today there are many well-engineered unit testing frameworks available for our use. Most of these frameworks implement ideas based on a testing framework for Smalltalk, which was first introduced by Kent Beck in 1994 [Beck94]. Beck's framework became known as "SUnit" and quickly established itself as a standard approach for implementing the common functionality needed when running unit tests.

xUnit

Beck's framework has been rewritten in many languages, including Java (JUnit), Python (PyUnit), C++ (CppUnit), and other languages. These frameworks are known collectively as *xUnit* frameworks [xUnit02]. They provide tools that make writing unit tests easy, effective, and efficient. Implementation details vary from one framework to another, but they all implement some semblance of the following classes.

TestCase—This class hosts the actual test code. Writers of unit tests normally write a subclass of this class for each of their unit tests. Each TestCase-derived class implements one or more methods that represent a single test case. It also implements a setUp() method that initializes the fixture and a tearDown() method that cleans up as needed. Each instance of this class executes only one of its test methods, which is identified as a constructor argument. The designated test method is invoked via a standard run() method, which first calls setUp(), followed by the test method identified in the constructor, and finally by tearDown(). This guarantees a fresh data set from the fixture for each test case.

TestSuite—This class is responsible for aggregating multiple test cases so that they can be run as a set. An instance of a TestCase-derived class is created for each test to be run and is added to the TestSuite's collection of tests. When the unit test is executed, the TestSuite iterates through its collection of TestCase instances, calling run() on each of them. Specialized functionality may be created by subclassing from TestSuite, but normally this class is used directly.

TestResult—This class captures the results of each test as it is run, making note of *failures*, which are test conditions that are not met, and *errors*, which are unexpected exceptions. The TestResult also records details about specific failures and errors so testers can diagnose the problems encountered.

TestRunner—This class manages the batch execution of all TestSuites, aggregates the TestResults, and writes the results to the desired output resource. Variations on this class may be used to generate output in different formats, such as text, XML, or HTML.

Using xUnit

Python is a simple language that is easily read by most programmers, even if they have never seen it before. Because of this, we will use the Python testing framework, PyUnit [PyUnit02], to demonstrate some of the features of xUnit. We are illustrating general concepts, which are essentially language-independent. The examples shown here should translate easily to the CppUnit, JUnit, or other xUnit-based frameworks.

Consumable Attribute Test Example

The following example demonstrates a test of the Attribute class, which is responsible for managing consumable attributes such as health or *mana* (magical power) in a role-playing game. The class contains two values, current and max. The current value may be increased or decreased, but may never exceed the value of max. Normally, current equals max. If current decreases, a refresh timer starts that will cause current to increase by a certain number of points over a certain number of seconds, until it once again equals max. The max value may also be increased or decreased. If it is decreased to a value less than current, current must also decrease accordingly. If max is increased, the refresh timer will start, gradually increasing the value of current.

The test is contained in a single Python *module*, or source file, `attribute_t.py`. This module defines the test class and provides the initialization code that allows this test to integrate with the overall framework.

```
# attribute_t.py
# Unit test of the Attribute class.

from unittest import TestCase      # always need this
import time                        # needed for our test
from attribute import Attribute    # unit being tested

#
# Test class for testing Attributes
#
class AttrTest(TestCase):  # derive from TestCase
    # class-level test suite member
    suite = unittest.TestSuite()

    #
    # Fixture definition
    #
    def setUp(self):
        # init with 100 pts current and max value
        self.attr = Attribute(100,100)
        self.attr.SetRefresh(1,5) # 1 pt every 5 sec

    def tearDown(self):
        pass # nothing to do, cleanup is automatic

    #
    # Test methods
    #
    def testChangeCurrent(self):
        # Ensure changes are reflected correctly
        a = self.attr

        a.ChangeCurrent(-50)  # decrease 50 pts
        self.assert_(a.current == 50, "Decrease failed.")

        attr.ChangeCurrent(25) # increase halfway to full
        self.assert_(a.current == 75, "Increase failed.")

    def testChangeMax(self):
        # Ensure changes to max are reflected correctly
        a = self.attr

        a.ChangeMax(-50) # max reduction reduces current
        self.assert_(a.max == 50, "Max decrease failed.")
        self.assert_(a.current == 50, "Current > max.")

        a.ChangeMax(25) # regain max, current stays
        self.assert_(a.max == 75, "Max increase failed.")
        self.assert_(a.current == 50, "Current grew.")
```

```
def testRegeneration(self):
    # Ensure depleted current value increases over time
    a = self.attr

    a.ChangeCurrent(-50)
    time.sleep(5)  # regen period of 5 seconds
    self.assert_(a.current == 51, "5 sec failed.")

    time.sleep(10) # should get 2 more pts
    self.assert_(a.current == 53, "10 sec failed.")

    a.ChangeCurrent(47) # take us back to max
    time.sleep(10) # should have no more refresh
    self.assert_(a.current == 100, "Excess refresh.")

#
# Module-level test suite initialization.
# PyUnit framework will call this function.
#
def suite():
    # Add reference to each test method to the
    # TestSuite, so the framework can call it.
    AttrTest.suite.AddTest(AttrTest.testChangeCurrent)
    AttrTest.suite.AddTest(AttrTest.testChangeMax)
    AttrTest.suite.AddTest(AttrTest.testRegeneration)

    # The returned suite will be combined with others
    # by the framework.
    return AttrTest.suite
```

The module-level method suite() returns the suite object that has been initial-
ized by our test class. The suite object is held as an attribute of the AttrTest *class*,
rather than as an attribute of each class *instance*. This means there is only one suite
object for all instances of AttrTest. The suite object contains a list of references to our
test methods. When the tests are run, the framework will create an instance of
AttrTest for each test method listed. Each of these instances will, in turn, call
setUp(), the test method, and tearDown().

Smaller Tests Are Best

Note that our test methods are very simple. Each focuses on a specific area of interest.
There are two reasons for this. One reason is that smaller test methods are easier to
read and understand. The other is that errors are reported by raising an exception via
the assert_() method of the base class TestCase. (Other error-reporting methods
exist; check the PyUnit documentation for details [PyUnit02].) This causes execution
of the current test method to stop, which prevents any subsequent code in that
method from being executed. A greater number of small test methods generates more
information about test failures.

Test-First Design

One of the most effective applications of unit testing is *test-first design*. This approach emphasizes testing as the driver of software design, rather than as a by-product [Langr01].

Test Code Before It Is Written

The key to this paradigm is to write the unit test before any of the code to be tested is written. At first, this approach may sound alien. Yet it is a simple practice to adopt and produces very quick results. If a test executes without errors the first time we run it, one of two possibilities has occurred: a) our code is flawless, and we are being paid far too little; or b) we did not actually exercise the code we want to test. For most of us, b) is the more-likely scenario.

We must be certain our unit test actually executes the code being tested and that the tested code works correctly. The simplest way to do this is to write a test for code that we know is broken, and then fix the code to produce a successful test. The earliest point at which we can get broken code is before the code is even written.

The Cadence of Coding

Test-first design operates at a regular cadence that acts as a drumbeat accompaniment to our development progress. The rhythm goes like this:

1. Write the test code for a function or method that does not exist.
2. Compile the code if necessary; compilation will fail.
3. Fix compilation problems by writing a stubbed version of the function or method to be tested.
4. Run the test; it will fail, lacking functionality.
5. Fix the test by writing the body of the function or method to be tested.
6. Run the test. If it fails, fix the code. If it succeeds, write another test.
7. Repeat.

If we follow this cadence, we find that we can bring our code to life quite quickly and naturally. More important, we bring our design into reality with the confidence of knowing that every major feature has been thoroughly tested and proven to work.

We Become Our Own First Victims

Test-first design emphasizes writing code from the point of view of the consumer. That is, we write code as we wish to use it, rather than as we think others *might* use it, or even how they *should* use it. This puts us, the author of the functionality, first in the line of victims of our design decisions. This is a humbling experience that quickly

causes us to rethink our assumptions and makes us more likely to produce code that others find useful, understandable, and reliable.

It is often the case that we do not really understand the code we write until we use it ourselves. Some programmers never even get to use their own code, but rather "throw it over the wall" to a quality assurance person or other programmer to run. Test-first design, in particular, and unit testing, in general, accelerate the process of understanding the impacts of our own design decisions.

Unit Tests and Refactoring

As new features are added to the code base and bugs are fixed, earlier design decisions morph to adapt to new requirements. When this is done well, it involves *refactoring* the code. Here, classes, modules, methods, functions, and data structures are split, combined, and rewritten in a manner that fits the new design into the existing code in an organic but deliberate process [Fowler99].

Test-first design is a natural fit for this process. The pattern followed in this case is:

1. Identify the code to be refactored.
2. Write a unit test that proves the existing code works.
3. Begin refactoring, making small, deliberate changes to the code.
4. Recompile and run the unit test with each change; the test will break.
5. Rewrite the test to fit the new code.
6. Rerun the test, and if it works, continue refactoring; if it fails, fix the new code.
7. Repeat.

Practical Considerations

Incorporating the practice of unit testing into a development process involves a little more than simply writing the tests. Attention to the logistics of testing, and developing a strategy for handling a variety of testing environments will improve our overall success. Here, we discuss some of these considerations.

Automated Testing Process

In addition to proving that a given unit of code works during its initial development, unit testing can identify when changes to shared code break other code that depends on it. This is best done by establishing an automated testing process. This is not a function of the QA department; it is a development tool that should be managed by the programming team. The process should regularly:

1. Retrieve the latest code from the repository.
2. Compile and link the code.

3. Run all unit tests.

4. Report the results to the team.

The objective of the process is to have all tests pass 100% of the time. It should ideally run several times a day so that errors that might impact multiple team members are identified quickly. When a test fails, fixing the failure is a top priority for the team. By following this practice, the team has greater confidence that all code in the repository works.

Stand-Alone Test Driver

The simplest way to drive our unit tests is through a stand-alone executable that invokes all tests as a batch process. We simply write a main module that loads the framework, identifies the tests to be run, and executes them. For more flexibility, we can develop tools that automatically add new tests to the driver program when they are added to the code base. We can also enhance it with report generation features, such as e-mailing the results or generating a Web page.

We should use this approach whenever we can because of its ease of implementation. It is best suited for testing code units that have few dependencies on external systems or resources and that have modest initialization requirements. Examples of such code units include class libraries and middleware facilities, low-level APIs, I/O routines, data-management utilities, and other self-contained fundamental elements of the game.

Integrated Run-Time Test Driver

Sometimes the code we want to test depends on a particular run-time environment to execute at all. This is common for systems that have complex initialization requirements, such as game servers that load data from a database and interact with other processes via a network. In theory, this initialization could actually be considered part of a unit test's fixture, and each run of the test could invoke a new instance of the run-time environment. This is not practical, however, because the resource requirements and execution time involved in such an approach would be prohibitive.

Instead, we can invert the model and execute our tests from within the run-time environment. This way, our unit tests can gain access to the resources provided by the host process. In using this approach, we must take care to avoid polluting our production code with invocations of our test framework. Tests should be executed in batch mode from a single point in the host process. Often, this point will be immediately after all necessary initializations have completed. The point of invocation should ideally be a single line of code that calls a function to start the testing process. All the real work of test identification, initialization, execution, and reporting must be done within code executed by that function. In this way, the function can be conditionally compiled out of the code for our production builds.

This kind of testing environment is best suited to large systems that make use of many smaller fundamental systems. Examples of code units that fall into this category include major game systems such as AI, high-level movement controllers, exploit detection systems, map or level initialization systems, object managers, event dispatching systems, graphics and collision management systems, and the like.

Asynchronous Testing

A major challenge in writing unit tests for MMP games is testing code that is *asynchronous*. This involves invoking code that returns control to the calling program (i.e., the unit test) immediately, while the primary functionality executes in another thread, process, or in a future iteration of the current thread's main loop. Most batch-oriented testing approaches are *synchronous*, expecting the tested code to block until it finishes executing. Acting on this assumption in an asynchronous environment will most likely cause the test to believe it has finished before the tested code has even started running.

Testing such code takes more care in designing the unit tests. The trick is to allow the code being tested to execute completely while forcing the unit test to wait for it to finish. This can be done in various ways, depending on how the asynchronous behavior is implemented. If the asynchronous behavior results from a nonblocking I/O call, such as to a network socket, we can use standard operating system calls, such as `select()` on Linux or I/O completion ports on Windows operating systems, to wait for an acknowledgement or reply. If the functionality is dispatched to a separate thread, we can use the operating system's thread management facilities to wait for specific events before checking our test results.

Finally, if our asynchronous behavior results from scheduling a method call to be executed in a future iteration of the current thread, we can write a callback function that sets up a condition we can check for when the tested code completes. This situation arises primarily when we are running our tests within our game's run-time environment, rather than from a stand-alone driver. In this case, we have the extra requirement of ensuring that we allow the current thread to keep processing while we wait. We can do this by encapsulating the main loop in a function that can be called from within the test. Remembering that our test is itself running within the main loop, this means that each call to this function introduces a one-level-deep recursion of the main loop. This is normally not a problem if all code being invoked within the loop is safely re-entrant. The following Python example illustrates this concept:

```
import unittest
import gamethread # main game thread module
import dbclient   # database interface
import player, weapon   # persistent objects to test
```

```
# object persistence test
class PersistenceTest(unittest.TestCase):
    suite = unittest.TestSuite()

    def setUp(self):
        db = dbclient.InitDB()
        self.conn = db.OpenConn() # open a DB connection
        self.dbFinished = 0

    def dbCallback(self):
        # called when db processing is done
        self.dbFinished = 1

    def testSaveAndLoad(self):
        p = player.Player()
        p.name = 'Test Player'
        p.health = 100
        p.strength = 50
        p.weapon = weapon.LongSword()

        # test save; provide callback
        self.conn.Save(p, self.dbCallback)

        # allow game loop to continue
        while not self.dbFinished:
            gamethread.Iterate()

        # done, now load
        p2 = player.Player()
        self.conn.Load(p2, dbCallback)

        self.dbFinished = 0 # reset
        # allow game loop to continue
        while not self.dbFinished:
            gamethread.Iterate()

        # now check result
        self.assert_(p2.name == 'Test Player')
        self.assert_(p2.health == 100)
        self.assert_(p2.strength = 50)
        self.assert_(isinstance(p2.weapon, weapon.Sword))
```

The principle enabler of this technique is the gamethread module, which exposes the Iterate() function. This function is called within a while loop that permits the rest of the game to operate normally until the callback is called, setting the flag that breaks the loop. This is a powerful concept that opens up many avenues for testing that are otherwise not possible.

Conclusion

Unit tests are a valuable tool for ensuring code integrity in an evolving code base, such as those found in MMP projects. We can leverage existing frameworks and tool sets to provide the standard testing functionality, allowing us to concentrate on the quality of our tests. The xUnit framework is the most common and widely supported of these frameworks, and is easily adaptable to our testing needs. Following the principles of Extreme Programming, we can employ test-first design, refactoring, and automated testing processes as disciplines to ensure the ongoing integrity of our code. We should adapt our testing environment and tools to best fit the code we are testing, being mindful of dependencies and initialization requirements. Such adaptations take us beyond stand-alone test drivers to include executing tests within our run-time process and making provisions for asynchronous execution when necessary.

References

[Beck94] Beck, Kent, "Simple Smalltalk Testing: With Patterns," available online at *http://www.xprogramming.com/testfram.htm*, 1994.

[Fowler99] Fowler, Martin, *Refactoring: Improving the Design of Existing Code*, Addison-Wesley, 1999.

[Jeffries01] Jeffries, Ron, "What is Extreme Programming?", available online at *http://www.xprogramming.com/xpmag/whatisxp.htm*, November 2001.

[Langr01] Langr, Jeff, "Evolution of Test and Code Via Test-First Design," available online at *http://www.objectmentor.com/resources/articles/tfd.pdf*, March 2001.

[PyUnit02] van Rossum, Guido, "unittest —Unit Testing Framework," *Python Library Reference*, available online at *http://www.python.org/doc/current/lib/module-unittest.html*, April 2002.

[XP99] Wells, Don, "The Rules and Practices of Extreme Programming," available online at *http://www.extremeprogramming.org/rules.html*, 1999.

[xUnit02] xUnit Testing Frameworks, available online at *http://www.xprogramming.com/software.htm*.

USING THE TWISTED FRAMEWORK FOR MMP SERVICE INTEGRATION

Glyph Lefkowitz, Twisted Matrix Labs

glyph@twistedmatrix.com

Source code from this article is included on the companion CD-ROM.

Massively multiplayer games are among the most-complex software systems in the world. Allowing thousands of people to run around in the same space at the same time, fighting the same enemies, and exhausting the same resources is a pretty major challenge. There is another important challenge that these games must face, though, which is often ignored and deferred to ad-hoc implementation later by a live team. Integrating external services into an MMP virtual world is difficult and will increase in importance as MMP games make their way further toward the mainstream gaming audience, and as the stakes for keeping subscribers get higher.

There are some obvious bits of functionality that a game will need that external tools can help with. Games need a chat system—if for nothing else, to interact with your customers and provide support inside the game. Third-party messaging systems can implement that. External reporting tools can extract game data from a relational database and provide reports to marketing personnel and executives.

Once the game's core functionality is already designed, it may be tempting to ignore integrating extra stuff. Why bother integrating an external chat system when you have a perfectly clear design for one? The organizational effort, both political and technical, of providing mechanisms for third-party integration is substantial, and it is a common decision to forego it for schedule-related reasons.

Looking at only these initial problems, the call is difficult to make. Integration provides some benefits, but may not be worth the effort. Once you start looking out toward the horizon of a game's lifetime, though, it becomes clear that integration is unavoidable: the best you can do is prepare for it.

For example, let us say that (as it inevitably happens) there is a bug in some version of the client software that a group of player figures out how to exploit in order to crash other people out of the game. If there is only one mechanism for accessing the

game world, the release game client (perhaps with game-master extensions for trusted users), then there is no recourse for support personnel's accessing the game world and correcting potential problems caused by this flaw until it is corrected by developers; this may take days or even weeks, depending on the severity or complexity of the problem.

The complexity of simple additions, such as chat, is often underestimated. For example, players who find the in-game chat system too restrictive or limiting will resort to using other, external programs that better suit their needs. Your support staff may find themselves responding to reports of players being harassed by other players on chat services like Internet relay chat, (servers that they cannot even log in to, let alone get log files and administrator access.)

The benefits of integrating with a relational database for data storage rather than doing one's own ad-hoc data storage mechanism are more widely understood: writing your own data storage layer means you need to write all of your own reporting and extraction tools as well, not to mention the difficulty of getting storage management done right in the first place!

This may all seem like a long-winded appeal to the well-worn, object-oriented software-reuse rhetoric. It is not the same, though; integrating with existing, working, proven solutions is better than writing your own in cases where the problem is not your business's core area of competency. Even if your organization is capable of making fantastic reuse of code developed internally, it is not as good as never having to do that development at all.

In other words, do you *really* want to be developing yet another technical support, ticket-tracking system this year, or do you want to be writing a game that is compelling and fun?

The Problems with Doing It Yourself

Questions of integration and extensibility work their way into every layer of a system. Making a robust, extensible infrastructure is a very challenging problem. It is also a totally different problem than making a simple, playable, shippable game. In fact, as the *Extreme Programming* methodology indicates, it is a waste of resources to prematurely plan for extensibility; the only way to really determine if a particular mechanism for extension is necessary is to find a *use-case* for it (see Section 1.5, "Describing Game Behavior with Use Cases").

This does not mean that you will never need extensibility. It means that the only way to build an extensible system is to have it hammered on over a long period of time by a large base of users with diverse interests in order to expose where it really needs to be extended, improved, and stabilized.

Purpose-built frameworks do not integrate different services well precisely because their audience is limited and their time of development is often short. It is difficult to anticipate the hooks you will need later in development in order to provide unexpected functionality; and guessing wrong will take time away from important core features to implement potentially useless extensions. Building an infrastructure that works great for your gameplay may end up being a serious liability for your customer support staff.

Finally, if you build an infrastructure yourself from top to bottom, even if it is brilliant and wonderful and extensible, what third-party developers will be able to add features, either for free or in commercial bundles, that you will find useful? Even the best-designed modular integration package is not useful if knowledge about how to build modules for it is limited to a small group.

The Problems with Paying Somebody to Do It for You

Existing turn-key MMP solutions have surprisingly similar problems. While they provide a lot more tools out of the box, their extremely high cost keeps third-party developers from creating any additional tools. At best, you will be in a situation where you can price different components of infrastructure from the same vendor separately, but these models are still unusual. Restrictive licensing agreements make development of open-source components for these systems difficult if not impossible. As more and more games turn to BSD and Linux servers, using open-source components internally, like Python and Lua, the importance of these robust back-end tools is increasingly obvious.

Packaged MMP solutions are also sometimes flexible in the wrong areas. They will provide a complete implementation of game-world infrastructure, limiting the possibilities for unusual gameplay, but they will not provide external tools that are not interesting for game developers to experiment with.

Outside of the game industry, other kinds of general-networking, distributed computing, and data-storage infrastructure exist. This category comprises things like implementations of the J2EE API. From their product descriptions, these might sound like appropriate starting points for game infrastructure.

Unfortunately, most of these products are very expensive middleware targeted at batch-transaction processing. Games involve dynamic, event-based interactions. Infrastructure that cannot respond to player actions in real time cannot be made to work for the most basic operations in the game world, regardless of suitability for any other integration tasks.

A Summary of the Problem

In order to allow for the flexibility necessary to economically run a massively multi-player game, it is important to use a development infrastructure that allows for the event-based nature of multiplayer games, provides enough services to make any additional training expenses worthwhile, and provides public programming interfaces so that more than one group's expertise can be brought to bear on the very different problem domains that make a complete MMP solution.

Framing a Solution

The *Twisted Network Framework* is one such solution. Although it is a completely generic network applications platform that is already in use in several different application domains, it was designed from the beginning with support for massively multi-player games as a design goal. As open-source software, there is a large and enthusiastic community. It is also an event-based networking platform with support both for high-level programming (in Python) and speed-critical extensions (in C and C++).

Twisted may not be appropriate for everyone. If for some reason the specific implementations described in this article are inappropriate for your specific needs, keep in mind that the problems remain, and similar approaches to the solution are probably a good idea.

In providing code examples, we will assume a familiarity both with the basics of network programming and with Python. We will be discussing these tools in the context of a hypothetical game called *Metamorphosis Online* [Kafka], in which the players are clinically depressed insects.

A Gentle Introduction: Generalized, Deferred Execution

One of the most basic ways in which Twisted allows network applications to be integrated is that it specifies a general mechanism for wrapping potentially blocking activities. In many asynchronous networking frameworks, the primary way that blocking activities are represented are as callbacks. Objects conforming to a specific interface must be passed in as an argument to any function that needs to wait for a blocking operation. These interfaces often differ for different types of blocking operations, which creates two problems. First, passing additional arguments to the callbacks may be unwieldy. Second, since the interfaces are different, any two blocking systems that want to communicate must have specific glue code between them and often present a third, different public interface.

Twisted eliminates these problems with the `twisted.internet.defer` module. *All* functions that may wait on a blocking operation will return `Deferred` instances. A `Deferred` acts as two logical chains of functions, one for errors and one for results. When

the result of a Deferred becomes available, it passes to the first callback in the chain and then passes the result of that callback to the second callback. If there is ever an error, the error-handling callback is invoked instead. This was inspired in part by the Eventually operator in the E language [Steigler02] and has most of its deadlock-avoidance properties. Also, because Deferred will accept any function that takes one argument and returns one result, many Python standard library functions will work fine.

Here are some examples of how Deferred is used:

```
# defer-examples.py

def printResult(x):
    print 'result:',x

# remote method call
remoteObject.callRemote("test").addCallback(printResult)

# database interaction
dbInterface.runQuery("select * from \
random_table").addCallback(printResult)

# threadpool execution
def myMethod(a, b, c):
    return a + b + c

# adding a callback
deferToThread(myMethod, 1, 2, 3).addCallback(printResult)

# Remote method calls that invoke a database connection and wait
# until the database is done returning its query before turning
# the query into a string and then sending the string as the
# result of the remote method call.

class MyClass(Referenceable):
    def remote_doIt(self):
        return self.databaseConnector.runQuery( \
            "select * from foo").addCallback(str)
```

Now that you have seen a basic introduction, let us look a little deeper into what makes that callRemote work.

High-Level Network Services: Perspective Broker

One of the most powerful tools that Twisted provides to the network application developer is its own multipurpose remote method-invocation protocol, *Perspective Broker*, affectionately known as PB.

PB was designed from the ground up with several integration-minded goals:

- PB operates over a single transport connection, allowing both client/server (untrusted, widely distributed) and server/server (trusted, locally clustered) com-

munication. This can reduce the total amount of communication code your system needs.

- PB is highly customizable and provides hooks at all three layers of decoding: (un)marshalling, (de)serializing, and message routing. This allows PB to remain very generic and compatible, but still be very responsive to the needs of your specific application.
- PB provides object-to-object, not process-to-process communication. This allows multiple services to be transparently multiplexed over one connection, which in turn allows independent functionality to be integrated into existing servers and clients.
- PB uses dynamic method lookup and method routing. This allows upgrade transitions from one client/server version to the next to be smooth; your choice of how long to maintain support for legacy clients is not made by fragile technology.
- PB provides for secure, robust authentication at the protocol level.

Many of these features are interesting and useful, but most critical is the ability to integrate independently developed services over the same network connection without time-consuming integration work on disparate code bases. This is useful both externally (e.g., making use of code available from third-party vendors and volunteers) as well as internally. Using PB or a technology like it will allow you to parallelize your server-side development process by allowing teams working on abstractly unrelated features like chat and inventory to be completely independent of each other.

Authentication, too, is an important part of this puzzle. Regardless of the type of service being accessed, the user will need to be authenticated with some service in order to verify that they have the authority to use that service.

Twisted uses its authentication model, `twisted.cred`, to unify services in Perspective Broker.

An Interlude with twisted.cred

`twisted.cred` breaks down authentication into four major abstractions:

1. `twisted.cred.service.Service`
2. `twisted.cred.perspective.Perspective`
3. `twisted.cred.authorizer.Authorizer`
4. `twisted.cred.identity.Identity`

The first two are specific to your application, and the second two are specific to authorization.

A `Service` is an over-arching abstraction that represents the whole service you want to provide. This object performs a role similar to the *Manager* design pattern [EventHelix], for whatever objects need to be globally tracked in a particular subsys-

tem. A `Service` should contain all the state related to one logical service. In the average application, you will end up writing at least one subclass of `Service`, and probably two or three.

The primary objects that your `Service` will be managing are `Perspective` instances. For each `Service` subclass there will generally be a corresponding `Perspective` subclass, and the `Service` will only manage `Perspective` instances that it instantiated itself. A `Perspective` represents the state of a user with respect to a given `Service`. It is the contact point between the user's persona and the functionality that they are working with in the `Service`. Each `Perspective` has a name.

The object that manages authentication is an Authorizer. In the average Twisted application, you will not need to implement an Authorizer, because you can use an existing one. You can authenticate out of a file, a database, or a table in memory. Depending on where you want to store your authentication, it may be necessary to implement your own Authorizer to load and save account information.

An Authorizer is essentially a persistent collection of Identity instances. Each Identity generally represents one real person who has access to the game system. The only reason you would ever need to implement a new variety of Identity is to implement a new style of authorization. Twisted comes with Identity implementations that can use plain password and challenge-response authentication. A secure-shell, public-key cryptographic authorization mechanism is also implemented for use with secure-shell clients. An Identity maintains not only the credentials that the user must present, but information about what `Perspective` instances that user has access to, once validated. `twisted.cred` interfaces very tightly with Perspective Broker.

The examples here will be covering the use of built in authentication mechanisms, and creating new services. Let us take some of these basic building blocks and explore an example of their use in a real-world situation.

A Simple Example: Fritz and Franz Go to the Psychologist

In our initial day in the life for *Metamorphosis Online*, two players, Joe and Bob, login to play their characters, Franz and Fritz. Franz and Fritz need to meet each other for group therapy at the psychologist's office.

In this example, Franz and Fritz first coordinate with each other by talking about the appointment on their cell phones, then negotiate the game-world's hazards, and finally arrive on time to the office.

While the game simulation is difficult to factor into separate services, the notion of globally addressing the player (with all the attendant concerns for feature-completeness, like logging, auditing, message throttling, obscenity filtering, and so on) is definitely separable.

For this example, we will be implementing our own simple cell phone-based chat system. In a more-realistic situation, it would probably be advisable to use the integrated `twisted.words` chat package and attendant utilities.

About the Code Listings

The following code examples are each meant to be in one source file. These listings, plus a Twisted installation, should make a complete (although small) application.

```python
# cellphone.py - cell phone service
from twisted.spread.pb import Service, Perspective

class Cellphone(Perspective):
    def attached(self, remoteEar, identity):
        self.remoteEar = remoteEar
        self.caller = None
        self.talkingTo = None
        return Perspective.attached(self, remoteEar, identity)

    def detached(self, remoteEar, identity):
        del self.remoteEar
        self.caller = None
        self.talkingTo = None
        return Perspective.detached(self, remoteEar, identity)

    def hear(self, text):
        self.remoteEar.callRemote('hear', text)

    def perspective_dial(self, phoneNumber):
        otherPhone = \
        self.service.getPerspectiveNamed(phoneNumber)
        otherPhone.ring(self)

    callerID = True

    def ring(self, otherPhone):
        self.caller = otherPhone
        if self.callerID:
            displayNumber = otherPhone.perspectiveName
        else:
            displayNumber = "000-555-1212"
        self.remoteEar.callRemote('ring', displayNumber)

    def perspective_pickup(self):
        if self.caller:
            self.caller.phoneConnected(self)
            self.phoneConnected(self.caller)
            self.caller = None

    def phoneConnected(self, otherPhone):
        self.talkingTo = otherPhone
        self.remoteEar.callRemote('connected')
```

```
    def perspective_talk(self, message):
        if self.talkingTo:
            self.talkingTo.hear(message)

class PhoneCompany(Service):
    perspectiveClass = Cellphone
```

In this first listing, we have a cell-phone service that is usable on its own and not specific to any game. Each player is represented to this service as a `Cellphone` instance, uniquely identified by a phone number, which serves as the name of this perspective. Note the methods whose names begin with `Perspective_`; these can be called directly by a network client of this service.

```
# metamorph.py
from twisted.spread.pb import Perspective, Service

class Bug(Perspective):
    angst = 0
    def attached(self, remoteBugWatcher, identity):
        self.remoteBugWatcher = remoteBugWatcher
        self.psychologist = None
        self.angst += 5 # It's hard to get up in the morning.
        return Perspective.attached(self, \
        remoteBugWatcher, identity)

    def detached(self, remoteBugWatcher, identity):
        self.remoteBugWatcher = None
        if self.psychologist:
            self.psychologist.leaveTherapy(self)
            self.psychologist = None
        return Perspective.detached(self, \
        remoteBugWatcher, identity)

    # Remote methods.
    def perspective_goToPsychologist(self, name):
        psychologist = self.service.psychologists.get(name)
        if psychologist:
            psychologist.joinTherapy(self)
            self.psychologist = psychologist
            return "You made it to group therapy."
        else:
            return "There's no such psychologist."

    def perspective_psychoanalyze(self):
        if self.psychologist:
            self.psychologist.requestTherapy(self)
            return "Therapy requested!"
        else:
            return "You're not near a therapist."
```

```
                # Local methods.
                def heal(self, points):
                    self.angst -= points
                    if points > 0:
                        feeling = "better"
                    else:
                        feeling = "worse"
                    self.remoteBugWatcher.callRemote(
                        "healed",
                        "You feel %s points %s. Your angst is now: %s." %
                        (abs(points), feeling, self.angst))

        class Psychologist:
            def __init__(self, name, skill, world):
                self.name = name
                self.skill = skill
                self.group = []
                world.psychologists[name] = self

            def joinTherapy(self, bug):
                self.group.append(bug)

            def leaveTherapy(self, bug):
                self.group.remove(bug)

            def requestTherapy(self, bug):
                for bug in self.group:
                    bug.heal(self.skill + len(self.group))

        class BuggyWorld(Service):
            perspectiveClass = Bug
            def __init__(self, *args, **kw):
                Service.__init__(self, *args, **kw)
                self.psychologists = {}
                Psychologist("Freud", -5, self)
                Psychologist("Pavlov", 1, self)
                Psychologist("The Tick", 10, self)
```

In this second listing, we define an extremely simple game. This provides an additional class for the simulation beyond the perspective and service (the psychologist), to demonstrate mediated communication between perspectives. Again, `Perspective_` methods comprise the remote interface between clients and servers for this game.

We have now implemented two modules that are complete but completely unrelated. The way in which they have been implemented is important, however. Their parallel structure, imposed by the Perspective Broker, allows us to integrate them into a single server with just one short file.

```
# fritz-franz-setup.py
from twisted.spread.pb import AuthRoot, BrokerFactory, portno
```

```
from twisted.internet.app import Application
from twisted.cred.authorizer import DefaultAuthorizer

# Import our own library
import cellphone
import metamorph

# Create root-level object and authorizer
app = Application("Metamorphosis")
auth = DefaultAuthorizer(app)

# Create our services (inside the App directory)
phoneCompany = cellphone.PhoneCompany("cellphone", app, auth)
buggyWorld = metamorph.BuggyWorld("metamorph", app, auth)

# Create Identities for Joe and Bob.

def makeAccount(userName, phoneNumber, bugName, pw):
    # Create a cell phone for the player, so they can chat.
    phone = phoneCompany.createPerspective(phoneNumber)
    # Create a bug for the player, so they can play the game.
    bug = buggyWorld.createPerspective(bugName)
    # Create an identity for the player, so they can log in.
    i = auth.createIdentity(userName)
    i.setPassword(pw)
    # add perspectives to identity we created
    i.addKeyForPerspective(phone)
    i.addKeyForPerspective(bug)
    # Finally, commit the identity back to its authorizer.
    i.save()

# Create both Bob's and Joe's accounts.
makeAccount("joe", "222-303-8484", "fritz", "joepass")
makeAccount("bob", "222-303-8485", "franz", "bobpass")

app.listenTCP(portno, BrokerFactory(AuthRoot(auth)))
app.run()
```

Finally, we unify these services by creating accounts for Bob and Joe. The real meat of this example is the makeAccount method, which produces identity instances that have the correct perspectives attached.

By modifying this one file, we can add arbitrary additional services. There are three steps to this process:

1. Instantiate the new Service (in the section "# Create our services".)
2. Call our service's createPerspective method to generate a new perspective.
3. Add a key for that perspective to the appropriate Identity object, declaring that a user who presents credentials to that Identity is permitted access to it.

Now, how do Joe and Bob actually get into the game? A full-blown, interactive client could be the subject of another article, but here is a simple example that will log in to *Metamorphosis* and play it for five seconds.

```python
# metaclient.py
from twisted.spread.pb import authIdentity, getObjectAt, portno
from twisted.spread.flavors import Referenceable
from twisted.internet import reactor
from twisted.internet.defer import DeferredList

class BugClient(Referenceable):
    def gotPerspective(self, pref):
        print 'got bug'
        pref.callRemote("goToPsychologist", \
        "The Tick").addCallback(self.notify)
        pref.callRemote("psychoanalyze").addCallback(self.notify)

    def notify(self, text):
        print 'bug:', text

    def remote_healed(self, healedMessage):
        print 'Healed:', healedMessage

class CellClient(Referenceable):
    def gotPerspective(self, pref):
        print 'got cell'
        # pref.callRemote()

    def remote_connected(self):
        print 'Cell Connected'

    def remote_hear(self, text):
        print 'Phone:', text

    def remote_ring(self, callerID):
        print "Your phone is ringing. It's a call from", \
        callerID

bugClient = BugClient()
phoneClient = CellClient()

# Log-In Information
username = "bob"
password = "bobpass"
bugName = "franz"
phoneNumber = "222-303-8485"

# A little magic to get us connected . . .
getObjectAt("localhost", portno).addCallback( \
    # challenge-response authentication
    lambda r: authIdentity(r, username, password)).addCallback( \
    # connecting to each perspective with 'attach' method
```

```
# of remote identity
lambda i: DeferredList([ \
i.callRemote("attach", "metamorph", bugName, bugClient), \
i.callRemote("attach", "cellphone", phoneNumber, \
phoneClient)]) \
# connecting perspectives to client-side objects
).addCallback(lambda l: (bugClient.gotPerspective(l[0][1]), \
phoneClient.gotPerspective(l[1][1])))

    reactor.callLater(5, reactor.stop) # In five seconds, log out.
    reactor.run() # Start the main loop.
```

The primary responsibility of client code is to provide client objects for each perspective that exists on the server, to receive notifications that the server may send. A few lines of glue code are required to get those client-side instances hooked up to server-side perspectives, but these mostly use glue code provided by the server.

Figure 2.5.1 is a visual explanation of the log in sequence that PB applications require. There are eight basic interaction steps that client and server go through in order to get a working session set up, which are represented by the numbered arrows.

1. The client contacts the authorizer and requests to log in.
2. The client provides a user name and password via a challenge/response conversation, ensuring that the password is secure, even on unencrypted connections.

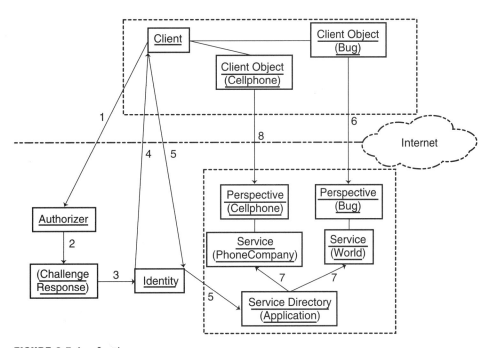

FIGURE 2.5.1 *Log in sequence.*

3. The challenge/response process locates an `Identity` object and validates against it.

4. The client is then given a remote reference object that points at the `Identity`.

5. The client makes a request for some perspective using a service-name/perspective-name pair, and specifies a 'client' object to connect to the perspective, once located; this is the `attach` method in the `Identity` interface.

6. If the `Identity` has a key for that service/perspective name pair, the `Identity` looks up the appropriate service.

7. The service then loads the perspective from its persistent storage and returns it, calling the attached method on the loaded perspective.

8. The perspectives are returned to the client and associated with client-side objects; then communication from client objects begins.

Emergent Features

Metamorphosis was a very simple example of the application of Twisted, but it nevertheless applies a number of very useful technologies. The most immediately obvious benefit of the example is that extremely simple clients such as this one can be very helpful for server load-testing. The ability to access the game server with alternate, simplified clients can be indispensable for support personnel as both a defense against potential instabilities in portions of the official client code and as a mechanism for automation of simple, frequently-performed tasks.

You also benefit from the lower-level networking architecture in Twisted. After generating an encryption key, you can secure the PB connection using the industry-standard Secure Sockets Layer (SSL). This is as simple as replacing the server's call to `listenTCP` with `listenSSL`.

One of the other advantages of this approach is that it has good security properties. Often, you will want to provide certain convenience functionality for game masters in the distributed client, but you do not want users to be able to access it. In `twisted.cred`, you can encapsulate this risky functionality in a separate perspective and never even give player `Identity` objects a key to access a perspective of that type. This reduces the need for writing access checks in methods; by avoiding the need for these checks, you cannot forget to put such a check in—by default, insecure functionality just will not be available.

Web-Based Tools

Any discussion of network technology integration in this increasingly Web-driven era has to include some mention of HTTP or legacy protocol support. Twisted includes a robust, flexible Web server that can function both as a stand-alone server and as a framework for publishing other Twisted objects on the Web.

Web browsers are ubiquitous, robust clients. The Web can serve as a convenient mechanism for statistics reporting, an administrative front end for support technicians, a place to display persistent laddering information for bragging rights, and even a minimal game client for users.

In addition to a Web server, Twisted provides a templating and application framework for browser-based applications. Taken together, the working title for these tools is *WebMVC*. WebMVC takes a slightly unusual approach to the problem of building Web applications. Many Web-specific languages and server APIs treat a relational database as the integration point between the Web and your application, and assume that your whole application is being written for the Web alone. Twisted, instead, assumes that you have existing application components that you will want to put on Web pages, and therefore hooks those objects directly to the Web.

To put it more simply, WebMVC treats the Web more like a GUI toolkit in the Model-View-Controller pattern [Helman] than a batch-output format. It is designed for real-time, Web-based interaction with a running system.

In that spirit of publishing existing objects on the Web, let us take the previous example and integrate some simple Web functionality with it by displaying a listing of all players.

First, we will create a HTML template, `metaweb.html`, which specifies our intent.

```
<html>
<head>
<title>Metamorphosis Player Rankings</title>
</head> <body>
<h1>Metamorphosis Player Rankings</h1>
<table view="bugDisplay" border="1">
    <tr> <th>Rank</th><th>Name</th> <th>Angst</th> </tr>
    <tr rowOf="bugDisplay">
        <td columnOf="bugDisplay" columnName="rank" />
        <td columnOf="bugDisplay" columnName="name" />
        <td columnOf="bugDisplay" columnName="angst" />
    </tr>
</table>
</body>
</html>
```

WebMVC expects all template files to be well-formed XML (eXtensible Markup Language). If you are already familiar with HTML, but not with XML, this just means you need to put a "/" before the ">" in any tag that does not close, such as <HR> and
.

This file is *only* a template. It does not specify any presentation logic or data, only what the output ought to look like. Notice that we are notating certain parts of the document for use by the code, with attributes such as `view`, `rowOf`, and `columnOf`.

```
# metaweb.py
from twisted.web import wmvc, microdom
from twisted.python import domhelpers

class MBuggyWorld(wmvc.WModel):
    def __init__(self, world, *args, **kw):
        wmvc.WModel.__init__(self, world, *args, **kw)
        self.world = world

class CBuggyWorld(wmvc.WController):
    pass

class VBuggyWorld(wmvc.WView):
    templateFile = "metaweb.html"
    def factory_bugDisplay(self, request, node):
        rowNode = domhelpers.locateNodes([node], "rowOf", \
        "bugDisplay")[0]
        node.removeChild(rowNode)
        bugList = self.model.world.perspectives.values()
        bugList.sort(lambda a, b: a.angst < b.angst)
        rank = 0
        for bug in bugList:
            rank += 1
            rnode = rowNode.cloneNode(1)
            node.appendChild(rnode)
            colNodes = domhelpers.locateNodes( \
            [rnode],"columnOf","bugDisplay")
            bugDict = {"name": bug.perspectiveName,
                "angst": bug.angst,
                "rank": rank}
            for cn in colNodes:
                cn.appendChild( microdom.Text( str( bugDict[ \
                cn.getAttribute( "columnName") ] )))
        return node

wmvc.registerViewForModel(VBuggyWorld, MBuggyWorld)
wmvc.registerControllerForModel(CBuggyWorld, MBuggyWorld)
```

After creating a template, we create a presentation logic module, where we retrieve and format the data using the WWW Consortium (W3C) standard Document Object Model (DOM) API [W3C]. Presentation logic in WebMVC is evaluated in roughly four steps.

1. The template is read in to a DOM tree.
2. Particular nodes (those with view attributes) are found in a depth-first search.
3. Methods named factory_[view attribute] are invoked with those nodes. These methods modify the nodes in the parsed XML tree that resulted from the template.

4. The tree, thus manipulated, is sent to the Web browser as a stream of XHTML text.

We now need a way to test this code. This will require going back to the earlier example, `fritz-franz-setup.py`, and modifying our server to also run an HTTP server in addition to a PB server. Add the following snippet to that file, before the `app.run()` line.

```
# add-web.py
from twisted.web.server import Site
from twisted.web.static import File
from twisted.web.script import ResourceScript
f = File('.')
f.processors = { '.rpy': ResourceScript }
app.listenTCP(8080, Site(f))
```

This creates a Web server that serves files out of the same directory where the server is running. It also specifies a type of file that is to be interpreted as dynamic content: any file with the extension `.rpy` is a `ResourceScript`, which means it is a Python file that is evaluated to produce an instance of a Web resource.

As a final step, we must create a `.rpy` file (`metaweb.rpy`), which specifies the model of the Web application.

```
import metaweb, __main__
resource = metaweb.MBuggyWorld(__main__.buggyWorld)
```

Since `fritz-franz-setup.py` is the `__main__` module of this program, we can locate the `BuggyWorld` service that we instantiated there.

The game is now running its own Web server, which is both a full-featured, secure, file-system Web server and a dynamic window into the game world.

Of course, there is also the simple question of the corporate Web site for the game. Twisted Web provides direct support for the *Zope* application server [O'Brien01], which is rapidly becoming an industry standard for content management. While the development of a corporate Web site is outside the scope of this article, Zope integration makes it easy to take the components described above and put them into a Web site with news updates, message boards, and all the amenities of a portal site—all with a few clicks on a management interface.

Integrating Independent Objects

Object-Oriented Programming (OOP) techniques have long been touted as a solution to integration problems. As any experienced software developer should know, there is some truth to this claim, but it has been endlessly exaggerated by software development tool companies. The hit-and-miss nature of OOP can mostly be traced to two factors:

an overly broad definition of what is and is not object oriented, and an institutional unwillingness to separate the techniques used in OOP into good and bad categories.

So far, we have discussed how to make use of Twisted's services to facilitate integrating with external tools. Now we will touch on how it is that Twisted can provide such a diverse array of services internally without suffering from an entanglement of dependencies.

The chief concept governing Twisted's design in this regard is *separability*. The easier it is to separately instantiate two different classes and have them perform their function, the less likely it is that changes in one will destabilize the other. Also, the less a new user needs to know in order to use one of the classes, the better.

Since separate instances are generally considered a good thing, Twisted avoids inheritance in most cases, using it only where two classes must be very tightly coupled, or the base class is very simple and provides only utility functionality.

Again, this approach has good security properties. When some objects are network accessible, it is important to carefully separate out sensitive operations and make sure they are far from a potential source of access. If most functions are factored into separate classes, that separation guards against mistakes in access control.

This is an old idea. In fact, it was in some ways the origin of object-oriented programming, stemming from the *Actor* model of simulation. The Actor model is still mainly of interest for the reasons mentioned above: networking and security. This is also a new idea. Most of the substance of the craze over various "component architectures" can be boiled down to one simple feature. Such architectures force objects to separate their functionality into discrete, separately usable packages.

Twisted has such a boiled down component architecture in `twisted.python.components`. This is based heavily on the *Zope3* component architecture. While it does offer some advanced features, it is generally a very simple system. It is almost entirely based around one feature, which is the `Adapter`.

This listing shows the basic use of an `Adapter`. Strictly speaking, an `Adapter` is simply a class that takes one argument to its constructor. Adapters are registered to represent another class in contexts where a certain interface is required, so Adapters will always implement at least one interface.

```
# component-example.py
from twisted.python.components import getAdapter, registerAdapter,
Interface

# Define an interface that implements a sample method, "a".
class IA(Interface):
    def a(self):
        "A sample method."

# define an adapter class that implements our IA interface
class A:
```

```
        __implements__ = IA
        def __init__(self, original):
            # keep track of the object being wrapped
            self.original = original

        def a(self):
            # define the method required by our interface, and have it
            # print 'a' then call back to the object we're adapting
            print 'a',
            self.original.b()

    # the hapless B class doesn't know anything
    # about its adapter and it defines one method which displays 'b'
    class B:
        def b(self):
            print 'b'

    # register A to adapt B for interface IA
    registerAdapter(A, B, IA)

    # adapt a new B instance with an A instance
    adapter = getAdapter(B(), IA, None)

    # call the method defined by interface IA
    adapter.a()
```

The component system in Twisted has been presented here as a way to integrate external game services. Much of the 'behind the scenes' work involved in the examples, especially the WebMVC examples, was being done by adapters. The same properties that make it useful to develop a Web-publishing system that is agnostic to the objects being published make it useful for other sorts of separation—for example, a Magic system that is agnostic to world geometry representation.

Low-Level Integration: Protocols and Networking

The lowest level of the Twisted infrastructure is `twisted.internet`. This portion of Twisted is the bedrock upon which the rest of it is built. Mostly, `twisted.internet` is a networking core implemented in the style of the *Reactor* event-response pattern [Schmidt].

Part of Twisted's design is that it is pluggable at every level, from the highest-level message abstraction to the bits and bytes being sent on the wire. This follows directly from Twisted's original MMP focus: this allows your Twisted application to satisfy diverse requirements for efficiency and flexibility, depending on your exact needs.

The previous examples have already used the `twisted.internet` APIs in order to connect Web and PB servers to the Internet. Here we will show how to write your own kind of server. The simplest example of how to extend Twisted at this level is an *echo server*.

```
# echoserver.py
from twisted.internet.protocol import Protocol, Factory

# Class designed to manage a connection.
class Echo(Protocol):
    # Method called when data is received.
    def dataReceived(self, data):
        # When we receive data, write it back out.
        self.transport.write(data)

class EchoFactory(Factory):
    # Build Protocols on incoming connections
    def buildProtocol(self, address):
        return Echo()

from twisted.internet import reactor

# Bind TCP Port 1234 to an EchoFactory
reactor.listenTCP(1234, EchoFactory())

# run the main loop until the user interrupts it
reactor.run()
```

This small Python script is a fully functional, asynchronous, multiplexing server using Twisted as a library. This would be a good basic example to begin working with in order to build a server-side processing system that needs to interact with a non-standard legacy protocol in an existing multiplayer infrastructure.

It is often desirable to implement alternative clients for such servers to automate frequently performed tasks or to perform load-testing. Twisted also provides complete client-side support, which is intentionally designed to mirror the server-side support as closely as possible.

```
# shoutclient.py
from twisted.internet.protocol import Protocol, ClientFactory

# Class designed to manage a connection.
class Shout(Protocol):
    # a string to send the echo server
    stringToShout = "Twisted is great!"

    # Method called when connection established.
    def connectionMade(self):
        # create an empty buffer
        self.buf = ""
        print "Shouting:", repr(self.stringToShout)
        self.transport.write(self.stringToShout)

    # Method called when data is received.
    def dataReceived(self, data):
        # buffer any received data
        self.buf += data
```

```
        # if we've received the full message
        # then close the connection.
        if self.buf == self.stringToShout:
            self.transport.loseConnection()
            print "Echoed:", repr(self.stringToShout)
            reactor.stop()

class ShoutClientFactory(ClientFactory):
    # Build Protocols on incoming connections
    def buildProtocol(self, address):
        return Shout()

from twisted.internet import reactor

# connect to local port 1234 and expect an echo.
reactor.connectTCP("localhost", 1234, ShoutClientFactory())

# run the main loop until the user interrupts it
reactor.run()
```

Notice that both the client and server examples end with reactor.run(). The same reactor object is used on both client and server. In fact, any number of clients and/or servers can be run within the same process.

Development Community

Twisted provides many other protocols that may be of use. Currently, it supports more than 10 RFCs (Request For Comments) , including Internet mail protocols, asynchronous database access, domain name servers and clients, and Internet relay chat.

More interesting than the additional tools that already exist, though, is the potential for future development. A developer community with sustained interest and investment in your platform of choice is important in ensuring that support does not disappear overnight. Also, the ability to collaborate with and get support from an existing community can potentially vastly reduce the amount of time it takes to develop a feature that does not yet exist.

A large and lively support community like Twisted's can arise from projects that are not open source, such as [Java]. Such a community, however, is indispensable to the reliability of a framework.

As an added bonus, open-source development communities tend to be interested in obscure and difficult problems that are tricky to get right, but which are not really a competitive advantage for anyone. People who are working on tools for their own use, like Twisted, very concerned about stability, and the collective focus of many diverse organizations on one project amplifies its robustness considerably.

Conclusion

When you are developing an MMP game, it is not just a game. It is an entire small universe of infrastructure. You need tools for continuing development, marketing, and support. The problems required to provide those tools are complex, deep, and not much fun to solve if you are concerned with games.

Using an existing solution is a good idea if the solution is suitable. It is difficult to find suitable solutions, though, and many of them are missing some useful, if not critical qualifications.

Twisted can be a useful solution for many games. It provides many different network-access mechanisms, including a flexible, general client-server protocol and Web publishing. Spanning these protocols are useful abstractions like authentication.

Twisted was designed with security in mind. It is important to its authors' development team to keep it secure and stable, since it is used to run the twistedmatrix.com domain.

Twisted is extensible at many levels. If the functionality you need does not exist, the hook to build it probably does exist. A large and diverse development community ensures that this will continue to be the case.

Very few people will need all of what Twisted has to offer, but it is still not hard to apply some of it by providing only one or two ancillary game services from a Twisted server. Evaluating an infrastructure solution is very important.

References

[Caromel] Caromel, Denis, "Towards a Method of Object-Oriented Concurrent Programming," available online at *http://citeseer.nj.nec.com/300829.html.*

[Cunningham] Cunningham, Ward, et al., "Proto Patterns," available online at *http://www.c2.com/cgi/wiki?ProtoPatterns.*

[EventHelix] Event Helix, Inc., "Manager Design Pattern," available online at *http://www.eventhelix.com/RealtimeMantra/ManagerDesignPattern.htm.*

[Helman] Helman, Dean, "Model-View-Controller," available online at *ttp://ootips.org/mvc-pattern.html.*

[Java] "The Java™ White Paper," Sun Microsystems, available online at *http://java.sun.com/docs/white/index.html.*

[Kafka] Kafka, Franz, "The Metamorphosis," available online at *http://www.kafka.org/transl/english/metamorphosis.htm.*

[O'Brien01] O'Brien, Larry, "And Then Came Zope . . . ," available online at *http://www.sdtimes.com/cols/webwatch_023.htm, February 1, 2001.*

[Schmidt] Schmidt, Douglas C., "Reactor — An Object Behavioral Pattern for Event Demultiplexing and Event Handler Dispatching," available online at *http://www.cs.wustl.edu/~schmidt/PDF/reactor-siemens.pdf.*

[Steigler02] Steigler, Marc, "E in a Walnut," available online at
 http://www.skyhunter.com/marcs/ewalnut.html, 2000.

[W3C] World Wide Web Consortium Document Object Model Working Group,
 "W3C Document Object Model," available online at
 http://www.w3.org/DOM/.

[Zadka] Moshe Zadka, "Writing Servers in Twisted", available online at
 http://twistedmatrix.com/documents/howto/servers.

2.6

Beyond 2: An Open-Source Platform for Virtual Worlds

Jason Asbahr, ASBAHR.COM, Inc.

jason@asbahr.com

Any team undertaking the task of building a massively multiplayer virtual world faces many design challenges. Creating a persistent, three-dimensional synthetic reality that can be experienced by users who are geographically spread out requires a minimum of three architectural components: a shared-state model (typically one or more servers), a human-oriented view (typically a number of graphical clients), and a mechanism for control (typically an action-oriented request protocol). Regardless of the application—chat community, educational simulation, or entertainment—there are common patterns that emerge for the underlying technologies. Rather than reinvent the wheel with each project, we propose reusing existing technologies whenever practical. The most reusable of technologies are those to which one has source-level access. This article describes these architectural design issues in the context of an open-source virtual world system called *Beyond 2*.

Beyond 2 is a step toward a unified platform for networked virtual worlds. It is an open-source system that can be leveraged to speed the development of new virtual world projects. Beyond builds upon another open source system, the *Twisted* network server [Leftkowitz02], and extends it to enable arbitrary 3D clients to connect to a common simulation framework. Beyond also provides a 'reference' client, which is built using the open-source 3D engine, the Nebula Device [Nebula02]. Together, the server, client, and simulation layers provide a foundation upon which unique new games can be built.

This article will discuss patterns for common simulation concepts, high-level architectural componentization, and communication protocols.

Overview

Well-designed simulation code can execute with or without a graphical representation. A simulation remains independent from the scene graph and other subsystems by exercising good object-oriented design principles that separate the model from the viewer and controller [Burbeck92]. Simulation processes can be run either on the client side or server side of the virtual world, because the distinction between client and server is fairly arbitrary. "Client" and "server" are useful terms, but they can also be thought of as 'observer' and 'arbitrator.'

Beyond has established actions on the model that are appropriate to the simulation domain, not to the method of presentation, and it provides interfaces to the action system that may be invoked from a number of user interfaces. Simulation code can support interactions between multiple graphical clients, text-only clients, or abstract debugging views of simulated entities.

Since various subsystems can plug-in via common interfaces, a project using this approach may remain independent from a particular subsystem implementation. Migration between subsystems can be used to take advantage of new technologies and for deployment on various software and hardware environments.

In Beyond, an object that is active in the simulation domain is called a *SimObject* [Asbahr98]. Simulation elements are modeled as SimObject attributes, with instance variables representing the state and methods that implement the behavior of the simulated elements.

SimObjects support data-driven state and behavior by maintaining sets of Actions and Activities. Actions and Activities embody a core simulation principle of Beyond—that is, 'simulation as scheduling.' At the highest level, Actions are instantaneous events, and Activities are collections of Actions executing over time. Simulations are updated as received events drive the initiation of Activities and their contained Actions.

An Action is an abstraction consisting of a SimObject method and the arguments to that method. An Activity is an abstraction consisting of a set of time-ordered Actions. The relative time of an Action within an Activity is represented as a real number, and the delay between Actions in a given Activity is variable. Several Actions given the same execution time are considered 'simultaneous.' As time passes in the simulation, a time delta is computed and Actions are selected for execution if they fall within the range of the delta. SimObjects perform Actions by calling and executing methods on themselves and on other SimObjects. The relationship between SimObjects, Activites, and Actions is shown in Figure 2.6.1.

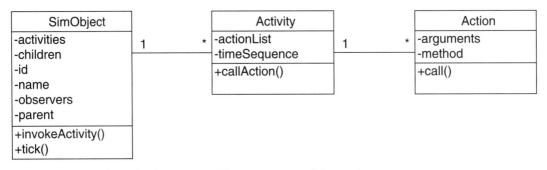

FIGURE 2.6.1 *Relationship between SimObject, Activity, and Action classes.*

Server Architecture

The server is the program (or set of programs) that maintains the definitive state of the simulation [Singhal99]. In addition to maintaining the collection of SimObjects comprising the simulation, servers provide mechanisms for handling client requests, for authentication, and for representing users in the system.

Beyond 2 builds upon the *Twisted* network server. Twisted is an open-source project initiated by Glyph Lefkowitz and supported by dozens of developers from all over the globe. It supports a wide variety of common network protocols, database integration, dynamic Web content generation, and provides a lightweight and efficient remote-object protocol known as Perspective Broker.

Beyond 2 utilizes and extends several of Twisted's classes to support virtual world simulations. The top-level interface to the simulated world is represented by a subclass of Service, called Simulation. Users are managed and authenticated by a subclass of Authorizer, and each user account is implemented as a subclass of Identity. The user, himself, is represented in the simulation by a subclass of Perspective, called Presence. A Presence manages one or more avatars in the virtual world, and each avatar is an instance of a Beyond class, called Character.

Communication between Beyond simulations, both client-server and server-server, is handled via the Perspective Broker. Methods on server or client objects can be registered as remotely callable and then may be invoked from either end of the connection. Both the values passed as arguments and the values returned from the remote methods are automatically processed for transmission across the wire. Perspective Broker provides a serialization mechanism for transferring, copying, and caching structured data between processes. Basic types, such as numbers, strings, lists, and dictionaries, are directly supported, and user-defined types can be transferred after first registering them for serialization and deserialization.

SimObjects multiply-inherit from one of the four types of Perspective Broker classes as appropriate, depending on how the object will be seen remotely. These classes include Referenceable, Viewable, Copyable, and Cacheable. Referenceable and Viewable present a remotely callable interface, and transfer no state, while Copyable and Cacheable transfer state, but present no interfaces to call.

Referenceable objects expose methods that can be invoked directly from the remote side. Viewable objects present a proxy of the object to the remote side, which exposes a set of methods, each of which accepts a user Perspective as the first argument and can execute differently based on which user Perspective invokes it. This is valuable for having logic that is only executed for special types of avatars, such as Characters who can see in the dark, or more practically, for administrative 'game master' avatars who need to change the simulation at will.

Copyable objects states are transmitted to the remote side each time the copy is serialized. Cacheable objects transmit the full object state to the remote side the first time it is serialized, but on subsequent serializations, a reference to the original object is transmitted. Cacheables provide support for the incremental update of object state via explicitly defined methods for the piece of state in question.

The server simulation loop first collects input via Perspective Broker method calls from various clients and other servers connected to the system. Next, collected simulation updates from the remote simulations are processed, setting the state of various objects represented in the server simulation. The server simulation is 'ticked' forward by a time delta that is calculated to advance the simulation to a new state. Finally, this new state is rebroadcast out to clients via cacheable data chunks so local simulations may update and render the current shared state. A subset of the class hierarchy under discussion is shown in Figure 2.6.2.

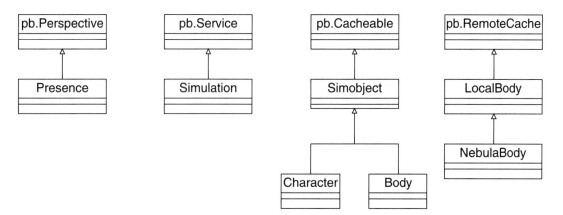

FIGURE 2.6.2 *A subset of the Beyond 2 class hierarchy.*

Client Architecture

The software that allows a user to enter and experience the virtual world is typically built as a separate client program. One or more clients connect with the server to mirror some subset of SimObjects, to render them for users, and then translate user input into Action requests.

The 'reference' client for the Beyond system is built using a 3D engine known as the *Nebula Device*. Developed by Radon Labs for their commercial game, *The Nomads*, the Nebula Device is a free, portable rendering engine that supports Direct3D and OpenGL, and runs on Windows, Linux, and Mac OS X. Beyond is currently integrated into the Nebula Device and is able to direct object loading, animation, and rendering, while communicating with remote simulation servers.

Once connected to the server, the client mirrors a subset of the potential simulation maintained by the server and stores copies of those SimObjects locally. These SimObjects are transmitted via the Perspective Broker and represented in the client simulations as instances of LocalBody and other classes.

The client accepts input from the user and translates it into requests for changes in the simulation. Requests in Beyond are expressed as remote method calls on server-side SimObjects via the Perspective Broker.

The client engages in an ongoing dialog with the server, receiving simulation updates and sending action requests for specific SimObjects. Requests made by the client are performed by the server if and only if all checks for that request pass on the server. The state-of-mirrored SimObject is subject to correction and adjustment based on server arbitration.

All simulation decisions are made by the server, which maintains the set of SimObjects representing the 'one true' version of simulated reality [Asbahr01]. Clients accessing the simulation merely present a view of that reality. Attempts to directly change the state of a client's mirrored SimObjects will invalidate the client's local representation of the simulation, but will not affect the consensus reality maintained by the server.

Finally, the client performs the actual rendering of graphics and sound to present the simulation to the user in a form it can perceive. In Beyond *2*, cached versions of Bodies and their scene graph nodes are implemented with analogous scene graph nodes from the Nebula Device, such as n3Dnode, nMeshNode, nLightNode, and nSoundNode.

Simulation Model

Simulations are assembled by hierarchically organizing SimObjects into containment graphs, where logically general instances contain more logically specific instances, similar to the approach described in the *Swarm* system [Minar96].

Simulations of different problem domains are created by connecting SimObjects of appropriate abstractions into trees. For example, a physical simulation concerned with Newtonian forces may be built out of SimObjects that represent mass, volume, and velocity; while a simulation of a murder mystery may contain SimObjects that represent suspects, clues, and murder weapons.

Multiple simulations can run in parallel, and SimObjects within a given simulation may have delegation/notification relationships with SimObjects in another simulation. In the previous example, a weapon SimObject that tracked fingerprints and bullets in one simulation would be associated with a physical SimObject that tracked position, orientation, and mass in the other simulation. In this manner, complex virtual worlds can be assembled. Beyond specifies four levels of virtual world simulation:

1. Physical
2. Logical
3. Cognitive
4. Narrative

Physical

The physical simulation framework of a virtual world system needs to support the description, measurement, and manipulation of scenes in space. Physical simulation as Beyond means it must include four primary areas of consideration: visuals, volumes, forces, and collisions.

SimObjects at the physical simulation level represent 'models' in the scene (as described in WavesWorld [Johnson95]), and they encapsulate shape, shading, and state information. These abstractions, called Bodies, expose Actions and contain Activities that allow the construction and manipulation of specific physical elements in the scene. Since they are SimObjects, Bodies can contain other Bodies, and Bodies organized hierarchically in this way form scene graphs. The Action and Activities of Bodies allow for parameterized control over scene graphs and animation sets.

The visual aspects of the virtual environment are assembled by the creation of scene graph subsets. Bodies assemble scene graph subsets out of connected and malleable pieces of 3D geometry. Bodies load geometry from disk or dynamically construct geometry by calling methods of the scene graph API. Bodies can be placed, rotated, and animated. They activate, deactivate, and set floating values of various features of the scene graph API for the particular scene graph subset they control, including texture-mapping, alpha-blending, scaling, and other visually interesting effects.

Logical

The logical simulation framework of Beyond is concerned with the creation and interaction of SimObjects that represent entities in the real world. Logical SimObjects

have symbolic meaning to humans—for example, a rubber sphere in the physical simulation might be represented as a 'basketball' SimObject in the logical simulation.

The Beyond object framework provides classes for logical simulation: object communication collision response, abstract logical interaction, activity initiation, and character control. SimObjects represent instances of approximately human-scale abstractions and operational rules common to domains we are familiar with, such as characters, houses, and weapons.

Examples of Logical SimObjects include doors that open, close, and lock; weapons that cause damage; armor that absorbs damage; tools that can be used to craft objects; and generally inert elements of the environment, such as trees, bushes, and rocks with which to collide.

The interconnection of logical and physical SimObjects allows logical Actions, such as a crate being smashed or an arrow being shot out of a bow, to trigger physical Actions or Activities causing pieces of geometry to disappear or appear, and move as appropriate.

Cognitive

The cognitive simulation framework of Beyond is concerned with those elements of the virtual world that appear to 'think for themselves.' Cognitive SimObjects act as 'virtual brains' for the logical SimObjects they control.

Abstractions at this level include Sensors, Effectors, and Behaviors. Cognitive SimObjects simulate autonomy by connecting input Sensors and output Effectors with internal state machines—sets of Activities containing Behaviors. Sensors can determine distance, direction, and collision with other SimObjects by using concentric bounding volumes, and they assemble objects into collision lists for processing [Terzopoulos94]. Effectors are extensible Actions that involve locomotion, manipulation of other logical SimObjects, and communication. Domain-specific simulations may add additional Action functionality to Characters, such as combat, crafting, interrogation, and so forth.

The cognitive simulation also introduces the abstraction of Character, which represents sentient beings in the virtual world. Characters may be controlled by users or may be fully autonomous.

An autonomous cognitive SimObject can have a simple or complex behavior model based around the purpose or role of the character in the simulation. Many games have sentient beings that 'die' when they take enough damage; in this example, the SimObject would additionally model health and consciousness. Emotional states can also be simulated, including fear, anger, desire, and energy, which could result in firing Character Activity responses, such as fleeing, attacking, and pursuing at different levels of speed and frequency [Bates94].

Narrative

Narrative simulation is that highest level of simulation that captures the game-like and story-like aspects of the virtual world. SimObjects at this level are concerned with quests, story arcs, points, win conditions, and failure conditions. They interact with SimObjects on the logical and cognitive levels by initializing values in those SimObjects, registering triggers to be called, and potentially creating and placing SimObject in the virtual world. Narrative SimObjects are the most 'meta' of SimObjects, providing a control mechanism for the underlying layers and tying events and actions into a seamless whole.

In their simplest form, narrative SimObjects track per-game and per-level statistics, such as number of items collected, items delivered, characters spoken with, and stages of quests completed.

An example set of narrative SimObjects could include a game SimObject that contained several-level SimObjects, each of which contained some number of Quest and Goal SimObjects.

The game would encapsulate the outermost narrative experience; the levels would encapsulate portions of the story arc and references to the geographic, logical, and character elements of them; and the Quest and Goal SimObjects would encapsulate individual measurable steps within those arcs. In addition, logging SimObject could track per-user status and scoring.

The narrative simulation has the most potential for research, stretching to encompass more-complex story lines, dynamically generated stories, responsive stories, and educational systems [Bruckman98].

Conclusion

Using Beyond means taking a 'platform' approach to virtual world development. Games using Beyond extend the simulation models with new classes and properties appropriate to the domains those games want to simulate. The physical model is extended with new scene graph nodes (e.g., BSPNode, MegaParticleSpray). The logical model is extended with new interactive-fiction classes (e.g., knives, forks). The cognitive model is extended with new artificial intelligence (and potentially player) classes (e.g., BigDragon, Sergeant, MyFluffyBunny). And the narrative model is extended with new story components or game-flow classes (e.g., Level, FetchAndCarryQuest, Soliloquy, KnockKnockJoke).

Many companies and teams are moving to enter the MMP market space and build their own worlds. However, since the effort and expense of constructing a virtual world system from the ground up is enormous, few individuals or companies can successfully take on this task and see it through to completion. By providing implementations of the various MMP components in a open-source system, Beyond 2

can help reduce the cost to develop and time to market for new MMP games. Beyond 2 is an ongoing project, and developers are welcome to visit the project site at *http://www.beyond2.org*.

References

[Asbahr98] Asbahr, Jason, "Beyond: A Portable 3D Simulation Framework," Proceedings of the Seventh International Python Conference: pp. 103–109, available online at *http://www.asbahr.com/papers.html*.

[Asbahr01] Asbahr, Jason, "Python for Massively Multiplayer Worlds," Proceedings of the Ninth International Python Conference: pp. 39–42, available online at *http://www.asbahr.com/papers.html*.

[Bates94] Bates, Joseph, "The Nature of Characters in Interactive Worlds and the Oz Project," *The Virtual Reality Casebook*, Van Nostrand Reinhold Publishing Co., 1994: pp. 96–102.

[Bruckman98] Bruckman, Amy, "Community Support for Constructionist Learning," ACM Conference on Computer Supported Cooperative Work, Seattle, Washington, November 14–18, 1998.

[Burbeck92] Burbeck, Steve, "Application Programming in Smalltalk-80: How to use Model-View-Controller (MVC)," 1992, available online at *http://st-www.cs.uiuc.edu/users/smarch/st-docs/mvc.html*.

[Johnson95] Johnson, Michael B., "WavesWorld: A Testbed for Three-Dimensional Semi-Autonomous Characters," MIT Media Lab Ph.D. dissertation, 1995, available online at *http://xenia.media.mit.edu/~wave/PhDThesis/outline.html*.

[Leftkowitz02] Leftkowitz, Glyph, et al., "The Twisted Network Framework," Proceedings of the Tenth International Python Conference: pp. 83–101, available online at *http://www.python10.com/p10-papers/09/index.htm*.

[Minar96] Minar, Nelson, et al., "The Swarm Simulation System, A Toolkit for Building Multi-Agent Simulations," June 1996, available online at *http://www.santafe.edu/projects/swarm/overview/overview.html*.

[Nebula02] RadonLabs.de, "The Nebula Device 3D Engine," available online at *http://www.radonlabs.de*, September 2002.

[Singhal99] Singhal, Sandeep, et al., *Networked Virtual Environments*, Addison-Wesley, 1999.

[Terzopoulos94] Terzopoulos, Dimitri, et al., "Artificial Fishes with Autonomous Locomotion, Perception, and Learning in a Simulated Physical World," *Artificial Life IV*, Brooks & Maes, ed., MIT Press, 1994: pp. 16–27.

2.7

PARALLEL-STATE MACHINES FOR BELIEVABLE CHARACTERS

Thor Alexander, Hard Coded Games

thor@hardcodedgames.com

A demo to accompany this chapter is included on the companion CD-ROM.

As more resources become available for creating deeper and more-engaging game-play, we game developers will begin empowering our game characters with greater and more-varied abilities. Characters controlled by both players and AI will gain greater repertoires of actions that they can perform on other characters and on game world objects. As this pool of actions grows, we will be able to create characters that move and act in a much more believable and engaging fashion.

This article focuses on the use of parallel sets of state machines for controlling these believable characters. State machines are a common tool used in game development.

They provide the following properties that make them ideal for our purposes:

- States provide an excellent mechanism for modeling behavioral changes.
- States and the transitions between them can be shown in easy-to-read state graphs.
- States can be replicated between client and server for use in online games.
- States can be reused by multiple game subsystems, as illustrated in Figure 2.7.1.

Some figures contained in this article are shown using UML notation. For an in-depth discussion of UML see [Booch98].

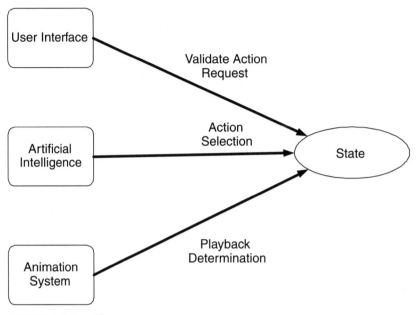

FIGURE 2.7.1 *Character states can serve many uses.*

The State Pattern

Separating behaviors into distinct objects is useful when the separation can benefit from the object-oriented property of polymorphism. Polymorphism allows two objects to be used equivalently, invoking the same methods, even though the objects implement these methods in dissimilar ways. Polymorphism allows a generic interface to be specified by a superclass, leaving its subclasses to implement the methods as needed.

The state pattern is an exceptionally effective software design pattern [Gamma94] that makes use of polymorphism to define different behaviors for different states of an object. Figure 2.7.2 shows the UML class diagram for an example of the state pattern. Here, our character, or Actor object, has a ConcreteState object named currentState. This state method's interface is defined by its superclass, AbstractState. The child class implements the Enter and Exit methods specified by its superclass. These methods are typical of state machine implementations, and are called at run time when the state is transitioned into and out of, respectively.

Figure 2.7.3 expands on this example and demonstrates where polymorphism comes into the picture. Here we show a toy example, with concrete states for the three possible fighting states our Actor can perform. Each of these fighting states is derived from the abstract base class, State. The Actor has a SetCurrentState method that can transition its currentState attribute into one of these fighting states.

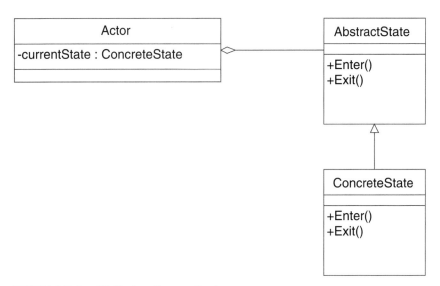

FIGURE 2.7.2 *UML class diagram for the state pattern.*

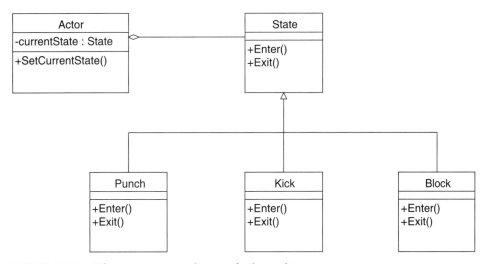

FIGURE 2.7.3 *The state pattern makes use of polymorphism.*

The following code shows a sample implementation in [Python]:

```python
class Actor:
    def __init__(self):
        self.fightingStatePunch = State.Punch()
        self.fightingStateKick = State.Kick()
        self.fightingStateBlock = State.Block()
        self.currentState = self.fightingStateBlock
```

```
def SetCurrentState(self,targetState):
    self.currentState.Exit(self)
    self.currentState = targetState
    self.currentState.Enter(self)

def Punch(self):
    self.SetCurrentState(self.fightingStatePunch)

def Kick(self):
    self.SetCurrentState(self.fightingStateKick)

def Block(self):
    self.SetCurrentState(self.fightingStateBlock)
. . .
```

Notice how the Actor object is passed into the Enter and Exit methods in the SetCurrentState method. This allows the state code itself to have access to the Actor without being directly coupled to it and defines the context for which the state is performing actions.

Parallel State Layers

As we add more and more abilities to our characters, their state graphs become increasingly complex and difficult to work with. To manage this complexity, we will divide these abilities into separate conceptual layers. We assign abilities to a layer if they can be performed in a mutually exclusive manner from the other abilities in the layer. Activities that can be performed independently and concurrently are assigned to a separate layer. Figure 2.7.4 shows the basic activities found in an MMP game character, split into three layers.

FIGURE 2.7.4 *Mutually exclusive activities are split across parallel layers.*

The Movement Layer

Our most-primitive activities deal with moving our character around the game world. In most modern game implementations, movement is independent of the actual animation that is playing (e.g., walking, running, swimming). Movement deals only with the translation through the game world of the 2D or 3D object that represents the character's collision shape. This is the area for which our movement layer is responsible. For the sake of clarity, this article will deal only with translation, and will bypass discussion of an additional layer that would control independent rotation of our character (e.g., turning right or turning left). Design and implementation of such a steering layer is left as an exercise for the reader.

Table 2.7.1 lists the states for the movement activities that our character will need to perform. These states can be combined to form a movement state machine by defining the legal transitions between each state. Transitions can flow from one state to another or loop back to the same state, as shown in Figure 2.7.5. A state that loops back on itself represents an activity that can be repeated, like falling or walking.

Table 2.7.1 Movement States

Movement State	Description
Stop (Default)	At rest, not moving
MoveBackward	Backing up
MoveForward	Moving forward
MoveLeft	Strafe to the left of forward position
MoveRight	Strafe to the right of forward position

Now that we have defined our movement states and the transitions between them, we can transform them into a class diagram, as shown in Figure 2.7.6. Each of our states is derived from the common `MovementState` superclass using the state pattern shown in Figure 2.7.5. These state subclasses will inherit their shared method interface from the abstract `MovementState` superclass.

The following Python code shows a partial implementation for the `MovementState` layer:

```
class MovementState():
    def __init__(self):
        self.id = 0
        self.transitionList = []

    def CanTransition(targetState):
        if targetState.GetId() in self.transitionList:
            return 1 ### Valid transition.
```

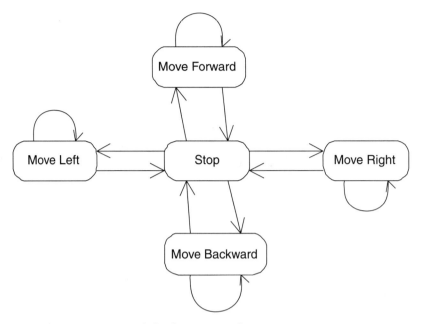

FIGURE 2.7.5 *State graph for the movement layer.*

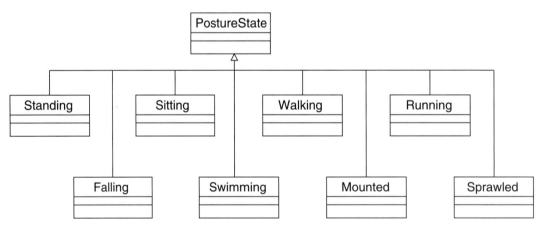

FIGURE 2.7.6 *Class diagram for the movement layer.*

```
            else:
                return 0 ### Invalid transition.

        def GetId(self):
            return self.id

        def Enter(self,actor):
            return

        def Exit(self,actor):
            return

    class MoveForward(MovementState):
        def __init__(self):
            self.id = 1
            self.transitionList = [
                MovementState.MoveForward.GetId(),
                MovementState.Stop.GetId() ]

        def Enter(self,actor):
            ### perform move-forward tasks on the actor here.
            . . .
    return

        def Exit(self,actor):
            ### perform state-exit cleanup tasks here.
            . . .
        return
    . . .
```

Notice that each `State` maintains its own unique `id` and `transitionList` attributes. The valid transitions that each state can make are stored in its `transitionList`. The `CanTransition` method uses this list to verify that the `targetState` is a valid transition for the current state to make.

The Posture Layer

The next layer represents the different postures that our character can assume. While the movement layer handles the issues surrounding the actual translation of our character throughout the game world, the posture layer handles how the character looks while it is moving. This layer controls transitions like sitting to standing and standing to walking. It can also help us manage advanced travel modes, like riding a horse or swimming in water. Figure 2.7.7 and Table 2.7.2 show some basic posture states and their valid transitions.

Two obvious uses for posture states are to: a) signal the animation subsystem when to change the animation it is playing for the character, and b) to accept or reject state

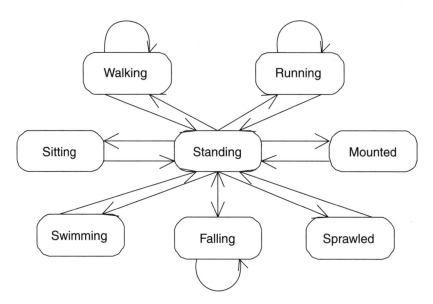

FIGURE 2.7.7 *State graph for the posture layer.*

Table 2.7.2 Posture States

Posture State	Description
Standing (default)	Idle standing state
Sitting	Sitting on the ground
Walking	Walking on the ground
Running	Running on the ground
Falling	Falling in mid-air
Swimming	Swimming in the water
Mounted	Riding a horse
Sprawled	Lying on the ground

change requests from the user interface. A very powerful, but less-obvious use is to feed the state to the enemy AI that is in view of the player so the enemy can react to changes in the character's posture. For example, the AI might ignore a player when he is in a neutral posture, but attack him if he is in a combat posture with a weapon drawn.

The class diagram for the posture layer shown in Figure 2.7.8 follows the state pattern and derives all of the concrete posture states from the abstract `PostureState`

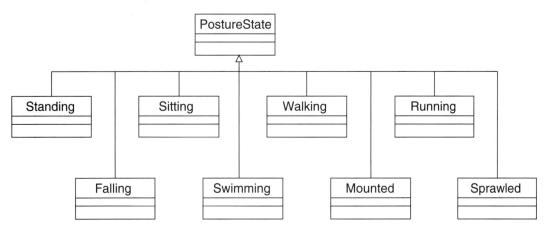

FIGURE 2.7.8 *Class diagram for the posture layer.*

superclass. The implementation of the posture layer closely follows that of the previously shown movement-layer code, so it is not repeated here.

The Action Layer

Our final layer deals with the various actions that our character can perform. Here, we define action to be activities that are performed independent of changes in posture and movement. For example, our actor needs to be able to swing his sword, whether he is running or standing still or even riding a horse. It may help to think of the action layer as dealing with upper-body activities and posture as lower-body activities. However, there are some exceptions to this, such as swimming and falling, where we may need the posture layer to subsume the upper-body state and block the action layer. We will handle these exceptions later when we discuss cross-layer blocking. Figure 2.7.9 and Table 2.7.3 show an action layer with common activities for an MMP game. These facets all come together to form the action layer class diagram, as shown in Figure 2.7.10.

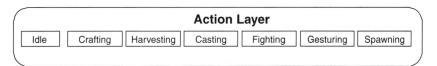

FIGURE 2.7.9 *The action layer for a typical MMP game.*

Table 2.7.3　Action States

Action State	Description
Idle (default)	Idle state
Crafting	Building or repairing an item
Harvesting	Gathering materials like wood, ore, etc.
Casting	Invoking a magic spell
Fighting	Attacking a character or object
Gesturing	Waving, dancing, etc.
Spawning	Materializing into the game world

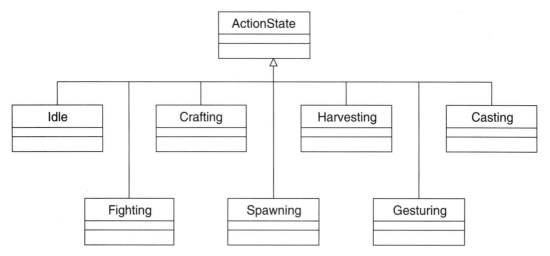

FIGURE 2.7.10　*The action layer class diagram.*

The State Manager

Now that we have separated the activities that our character will perform into parallel layers, we need another class to manage them. Here we introduce the StateManager class. Each instance of our Actor class holds a reference to this manager, called CurrentStates. The StateManager maintains a reference to the current state of each of our layers: currentActionState, currentMovementState, and currentPostureState as shown in Figure 2.7.11.

The following Python code shows a sample implementation of the StateManager:

```
class StateManager:
    def __init__(self):
        self.currentActionState = ActionState.Idle()
        self.currentMovmentState = MovementState.Stop()
        self.currentPostureState = PostureState.Stand()
        . . .
```

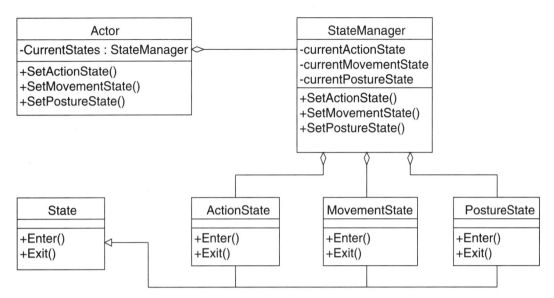

FIGURE 2.7.11 *Class diagram for the StateManager with our state layers.*

```
def SetActionState(self,actor,targetState):
    if self.currentActionState.CanTransition(targetState):
        self.currentActionState.Exit(actor)
        self.currentActionState = targetState
        self.currentActionState.Enter(actor)
        return 1 ### Successful transition.
    else:
        return 0 ### Cannot transition.

def SetMovementState(self,actor,targetState):
    if self.currentMovementState.CanTransition(targetState):
        self.currentMovementState.Exit(actor)
        self.currentMovementState = targetState
        self.currentMovementState.Enter(actor)
        return 1 ### Successful transition.
    else:
        return 0 ### Cannot transition.
    . . .
```

Cross-Layer Blocking

For the majority of cases, the states in each of our layers perform independently of the other layers, but there are always those pesky exceptions. For instance, if our character falls from a high elevation, we will want to block him from moving or performing actions while he is in mid-air. To do this, we need a mechanism to enable cross-layer blocking.

If we add a Boolean attribute, `blocked`, to our `MovementState` superclass, we will be able to set and clear it with the `Block` and `Unblock` methods, as shown in the following code sample:

```
class MovementState():
    def __init__(self):
        self.id = 0
    self.transitionList = []
    self.blocked = 0 ### false

    def Block(self):
        self.blocked = 1

    def Unblock(self):
        self.blocked = 0
```

Then we can add a new check to the `CanTransition` method to return a transition failure code if the state is set to blocked.

```
        def CanTransition(targetState):
            if self.blocked == 1:
                return 0 ### Transitions are blocked

            if targetState.GetId() in self.transitionList:
                return 1 ### Valid transition.
            else:
                return 0 ### Invalid transition.
```

Now we can block the movement state from transitioning, like so:

```
class Falling(PostureState):
    . . .
    def Enter(self,actor):
        actor.currentStates.SetMovementState(actor,StopState)
        actor.currentStates.SetActionState(actor,IdleState)
        actor.currentStates.currentMovementState.Block()
        actor.currentStates.currentActionState.Block()
        . . .
        return

    def Exit(self, actor):
        actor.currentStates.currentMovementState.Unblock()
        actor.currentStates.currentActionState.Unblock()
        . . .
        return
```

Here, the `Enter` method for the `Falling` posture state will force the actor into the movement state `Stop` and the action state `Idle`, and then block those states from transitioning. Once the actor exits from the `Falling` state, it will unblock those states.

Conclusion

This article presented a design and implementation of parallel-state machines based on the tried and true state design pattern. It serves as a good starting point for building the advanced state mechanics that are needed to bring more-believable characters to the next generation of games. The state pattern also defines each state as a singleton so that the system has only one instance of any given state in memory. This serves to keep memory usage low and is a recommended optimization to the solution presented here.

References

[Booch98] Booch, Grady, *The Unified Modeling Language User Guide*, Addison-Wesley, Inc., 1998.

[Gamma94] Gamma, et al., *Design Patterns*, Addison-Wesley Longman, Inc., 1994.

[Python] Python Language Web site, http://www.python.org.

2.8

OBSERVER/OBSERVABLE DESIGN PATTERNS FOR MMP GAME ARCHITECTURES

Javier F. Otaegui,
Sabarasa Entertainment
javier@sabarasa.com

The Observer/Observable (O/O) design pattern, introduced by [Gamma95], can be a powerful tool for Massively Multiplayer (MMP) game architectures. In this article, we present the O/O design pattern applied to MMP engine architecture design.

The presented architecture is the basis for an all-purpose simulation replication engine for MMP games. This architecture frees the game programmer from such tedious tasks such as object replication and message management. This architecture offers a good approximation of the simulation in game clients, the most important responsibility of a multiplayer engine [Sweeney99].

Observer/Observable Design Pattern

The O/O design pattern consists of two abstract classes, *Observer* and *Observable*, which interact with each other. An Observable has a collection of references to his Observers. When the Observable is modified, all the Observers are informed about the event with a *Touch()* or *Update()* method (see Figure 2.8.1). When the Observer

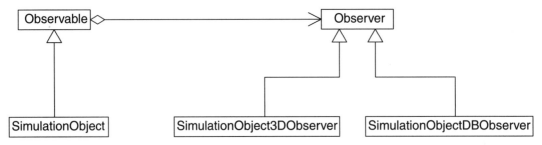

FIGURE 2.8.1 *Observable/Observer design pattern UML diagram.*

needs to do something with the observed object, it first checks to see if the object is dirty (i.e., was modified), and then it queries it and updates its own internal state.

Observers can have a variety of roles. For example, we could implement a 3DObserver, which knows how to represent a certain object in our favorite 3D engine, or an IsometricObserver, which displays it in an isometric world. We could also support backup Observers to persist the object's state to a database or to files.

Basic Architecture

The O/O design pattern is extremely useful for the design of MMP games because it allows us to have a single implementation of the world simulation, using exactly the same class on both the server and the client. On the server, the simulation is observed by classes that will constantly transmit all the changes detected in the observed simulation down to the clients. The same simulation objects can then be used on the client and be observed by graphic observers that know how to generate and display them in any graphical representation we choose for our game.

The advantage of having the same simulation running both on the server and on the client is that we can feed both simulations with the same clock signal and achieve the same result on the server and all the clients (i.e., effective simulated proxies). The server will accumulate changes for a while and then send them to the clients for correction/update. A change will also be accumulated when unpredicted events occur—for example, when a user performs an action.

Additionally, we can have other Observers on the server. We could use Observers that back up the entire simulation to files or a database system. We could also attach Observers to allow the system administrators to query details of the underlying simulation from a world-management application (see Figure 2.8.2).

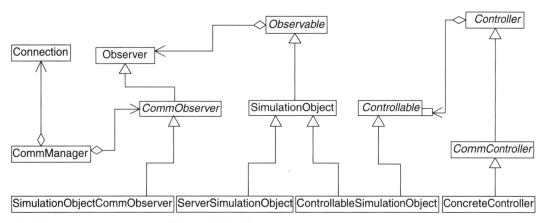

FIGURE 2.8.2 *Basic system architecture UML diagram.*

Server Architecture

The server is composed of simulation objects, the corresponding communication Observers, and the communications manager *CommManager*. Simulation objects are created at server start-up. Each simulation object creates its corresponding Observer and registers it with the communications manager. The server handles creation, modification, and deletion of simulation objects, as well as the addition of new communications clients that receive the complete state of the simulation.

Each simulation object implements the Observable interface, and, in the server application, specific classes should be defined to add the server-side behavior to the simulation objects. The *CommObserver* class implements the Observer interface, adding the communication-related method. Each simulation object has a peer *SimulationObjectCommObserver*, which is derived from CommObserver, requiring it to define the *Pack()* method (see Figure 2.8.3).

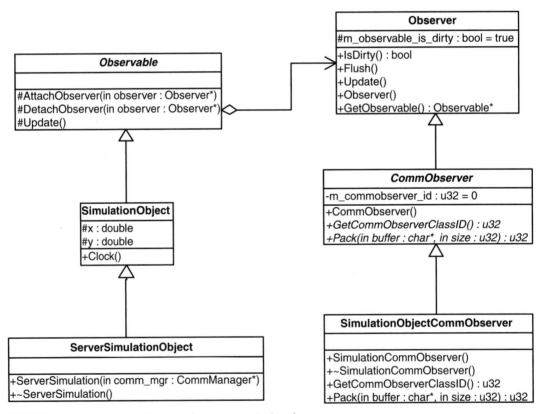

FIGURE 2.8.3 *Server simulation architecture UML class diagram.*

The communications manager, CommManager, is responsible for tracking all CommObserver instances. It also knows how to send different kinds of network messages. It supplies methods for subscribing and unsubscribing clients (*Connections*), and provides the *SendChanges()* method. The SendChanges() method cycles through all CommObservers, sending the update messages to the clients (see Figure 2.8.4).

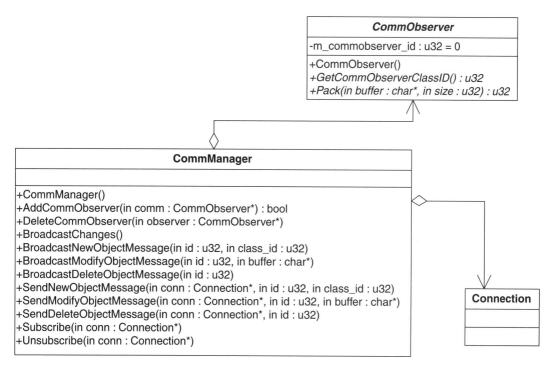

FIGURE 2.8.4 *Server communications architecture UML class diagram.*

Update Messages

The communications manager has a reference to each of the CommObservers. When a certain server condition is reached (a timeout, or when the outgoing queue is empty), the server will cause the communications manager to send all of the changes that have occurred since the last update to all connected clients.

The server will then loop through all the simulation Observers. If an Observer is marked as dirty, it is queried for an update buffer to be sent to the client. Each Observer is responsible for knowing about the observed object, how to read its data, and how to pack that data into a byte stream. The server will take this buffer, and it will generate a modification message that includes an Observer's id, so that clients can know which object to modify in their object pool. On receipt of these updates, a client applies them to synchronize the simulation state with that of the server.

When a simulation object stores a pointer to another object, for example an element that stores inventory items, its reference should also be sent to the client. A naive approach would be to dynamically assign each Observer a unique id, but this will cause problems in the Pack() method, because the Observer can know of the observed simulation object, but there's no way of telling the Observer from the Observed without violating the O/O design pattern (see Figure 2.8.5). The solution is to use the address value of the pointer to the observed object as the unique id. This is a problem with game-server farms, where the memory spaces can overlap. This is easily solved by creating compound ids made of machine id and the address value of the pointer. We will analyze the unpacking method later in the article.

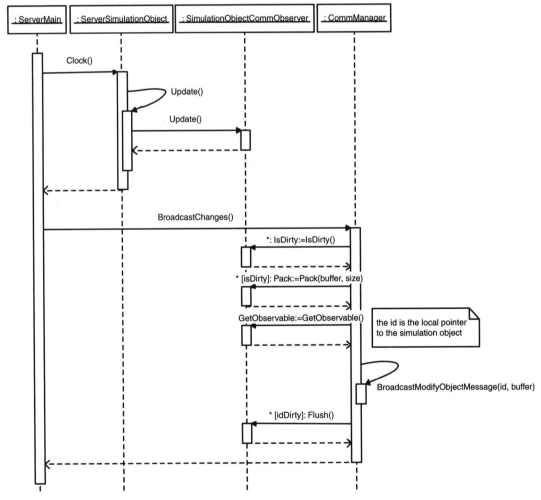

FIGURE 2.8.5 *Update object server UML sequence diagram.*

Creation Messages

When the server simulation creates a new simulation object, it must inform all clients about the new object. It must issue a create-object message that includes the class identifier and the unique id of the object.

When a new simulation object is created, it must create its corresponding communications Observer. That is one of the reasons why we need to specialize the simulation object classes as server simulation object classes. Correspondingly, the client simulation object classes create their graphical user interface observers.

When each communications observer is created, it must attach itself to the communications manager. The class id must be queried to the observer with a *GetClassID()* method. The object id is determined by the value of the pointer to the observed simulation object. Then the communications manager issues the *NewObjectMessage*, including class id and object id, to all the clients (see Figure 2.8.6).

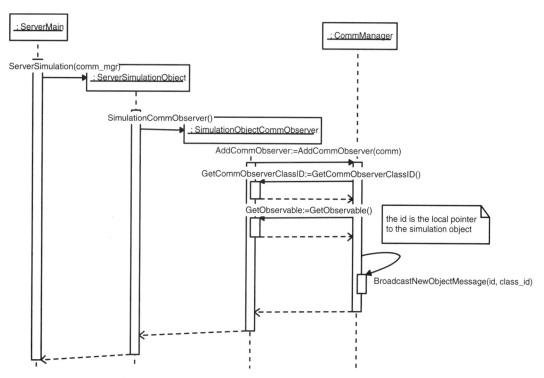

FIGURE 2.8.6 *NewObjectMessage UML server sequence diagram.*

Deletion Messages

Object deletion is similar to object creation, but this time we will only need the Observer's id to issue the *DeleteObjectMessage*. When a simulation object is destroyed, it must also destroy all its corresponding Observers (in case we are not only using communication Observers). As there is a one-to-one mapping for each Observer/ Observable pair, each Observable is responsible for deleting its Observers.

When a communications Observer is destroyed, it must detach itself from the communications manager. The detach method is responsible for broadcasting the deletion message to all listening clients. When the client receives this message, it deletes the Observer and informs all other simulation objects about the object deletion so they can remove any references to it (see Figure 2.8.7).

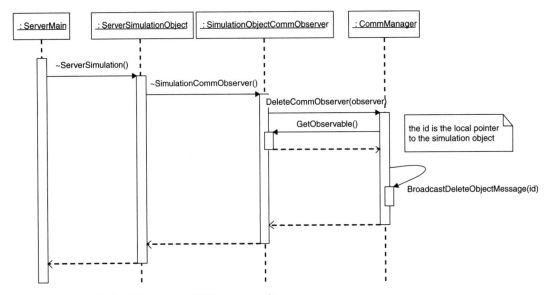

FIGURE 2.8.7 *DeleteObject server UML sequence diagram.*

New Client Messages

A last case for the server is when a new client subscribes to the simulation. The client should receive the complete state of the simulation before it can start receiving the update messages.

When a new client subscribes, it must first receive all the creation messages for all the objects in the simulation. After it creates the objects, it must synchronize the internal states for all the objects via a set of update messages.

In a very large simulation, this approach may result in performance issues because of significant bandwidth usage. There are several options for addressing this—a simple one being a priority scheme associated with object transmission, where the highest priority (and presumably most relevant) objects are updated first. Lower-priority objects are updated later in subsequent simulation loops (see Figure 2.8.8).

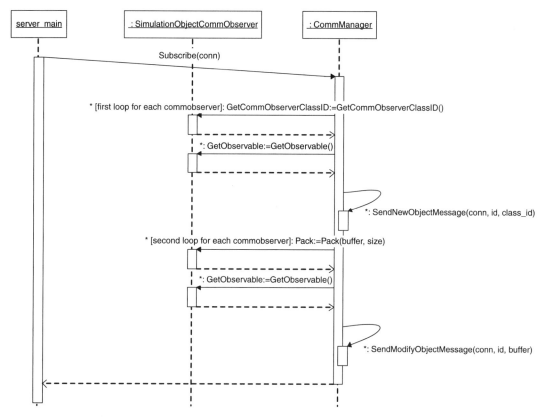

FIGURE 2.8.8 *New client server UML sequence diagram.*

Client Architecture

The client is composed of simulation objects, their corresponding graphic Observers, and a communications controller. Each simulation object implements the *Controllable* interface, allowing them to unpack the messages from the server and update their internal state. The communications controller handles creation, modification, and deletion of simulation objects. It really does not require creating a special new client case, as these events are sent as individual creation and modification messages of the simulation objects (see Figure 2.8.9).

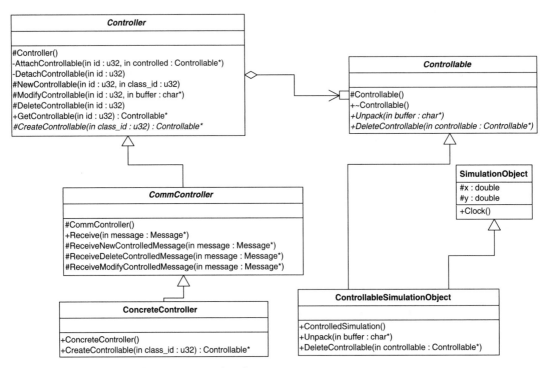

FIGURE 2.8.9 *Client architecture UML class diagram.*

Creation Messages

When the communications controller receives a creation message, it must create the appropriate object and map the received id to the new client instance's pointer. The *Controller* class defines the basic behavior of the controller mechanism used to control all the simulation objects. The *CommController* class defines the specific methods for interpreting the various messages.

When a message arrives to create a new object, the Controller receives the class id of the object to create, and it should have a mechanism for creating the appropriate class for the given class id. The application should then create a *ConcreteController* class that inherits its behavior from CommController, in order to define the abstract method, *CreateControllable()*. This method receives a class identifier and returns a newly created simulation object (see Figure 2.8.10).

After the object is created, the corresponding lookup entry is entered into the map so that subsequent messages can be delivered to the appropriate simulation object instance.

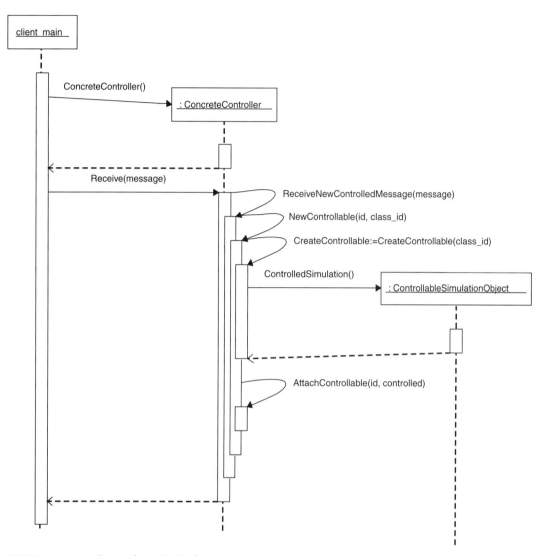

FIGURE 2.8.10 *Create object UML client sequence.*

Update Messages

When the communications controller receives an update message, it must first determine which of the simulation objects should receive the update. This simply involves retrieving the mapping between the id and the pointer to the object with the *GetControllable()* method. Once it has a reference to the object, the Controller sends it the corresponding update buffer. Every *ControllableSimulationObject* knows how to process this buffer through its implementation of *Unpack()*.

If, perhaps, an Unpack() method must decode a pointer to another object, the server should have sent it the appropriate id of that object. The ControllableSimulationObject simply calls GetControllable() to get the reference to that object and thus assigns it into its internal state. If the id is nonexistent, the method should return a null pointer (see Figure 2.8.11).

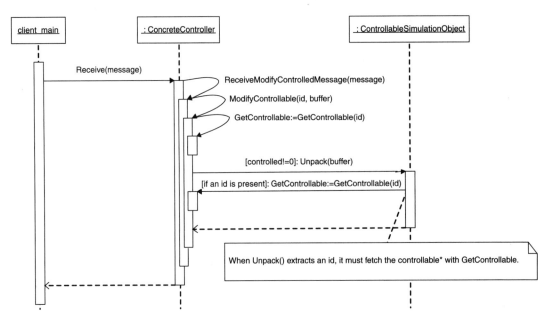

FIGURE 2.8.11 *Update object client UML sequence diagram.*

Deletion Messages

When the communications controller receives a message to delete an object, it must destroy the ControllableSimulationObject and remove all references to it. An update message for the object that holds a pointer to the deleted object could still arrive, and we clearly don't want an invalid pointer around in our simulation. The best solution is to execute a *DeleteControllable()* method in all the ControllableSimulationObjects, so they properly remove any references to it. On the client, the ControllableSimulation Object destructor should also destroy all graphic observers (see Figure 2.8.12).

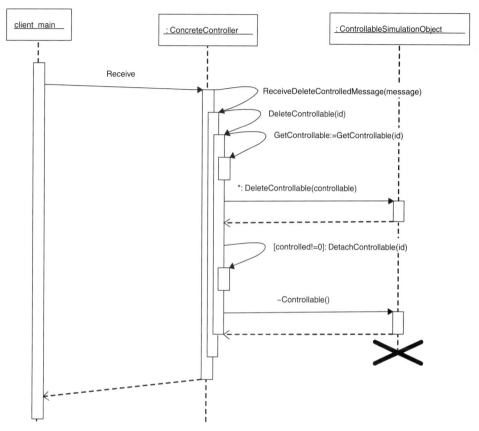

FIGURE 2.8.12 *Delete object client UML sequence diagram.*

Enhancements

The following enhancements make good additions to the base system described above.

Difference Observers

The first enhancement we can make to the basic multiplayer O/O model is to add the capability of sending only those attributes that have changed since the last update. This will result in optimized bandwidth usage, as we will only be sending relevant data. Unchanged data will never be sent over the Internet and thus will not waste bandwidth. This can be achieved by using a bitmap, with each bit representing an attribute of the simulation object.

We must plan a new class, *DifferenceObservable*, which has a new Update() method that receives an id for the attribute. Each time an attribute is changed, it must call the Update() method with the corresponding id. From the Observer's point of view, we should create a *DifferenceObserver* that must check the bitmap for ones indicating a modification and conveniently Pack() only those attributes. A mechanism is needed to tell the Unpack() method which attributes have been sent—for example, sending the bitmap (if it's not very large) or sending the indexes of the sent attributes. Once the bits have been sent, the bitmap is reset to zeroes.

A further improvement can be made with the introduction of a general-purpose DifferenceObserver. This would save us the task of writing the corresponding *SimulationObjectCommDifferenceObserver* for every simulation object type. It would provide a mechanism for attribute registration (e.g., using pointer and length of data). This improvement has the potential to realize significant savings in implementation effort.

One Observer for Each Connection

In the actual model, we only have one communications observer for each observable simulation object. This ensures that all the clients will receive the same update messages in the same sequence, and thus have the same simulation running on their computers.

A possible optimization is to assign one Observer for each connection. This will manage bandwidth usage better for clients with differing connection throughput. A slow receiver would let changes accumulate for a longer time and then just issue the SendChanges() method. A fast receiver may receive changes every frame. This architecture is somewhat different from the proposed model and should be rethought from scratch. It's worth analyzing a decoupled O/O pattern, as described by [Lopez02], to prevent the notification delays by having a common queue for all the Observers running in a separate thread.

Priority and Field of View

As discussed by [Sweeney99], better bandwidth usage is enabled when the different objects are given different priorities. This will result in more bandwidth allocation for the most-relevant game objects. The actual UpdateChanges() just sends every updated object to all the clients. This could be rewritten to send only the most-relevant changes based on current bandwidth use.

Another bandwidth optimization is to only send updates for the objects that are within the client's field of view. Additional management code must be designed to handle the incorporation of an object into the field of view (similar to adding a new client to the simulation). This can be achieved through a *Relevance()* method that ver-

ifies, for a given client, if a specific object is inside the client's field of view. The problem with this is that if the field of view changes very rapidly, the overhead of resending and rebuilding can cause great lags.

Conclusion

As shown, the Observer/Observable design pattern is a robust and appropriate base architecture for MMP games. This architecture can grow to become quite complex, but it will shorten the game design and development cycle, as the engine will automatically handle all the communication and replication issues. Game programmers are then free to focus on the *game simulation*, rather than *communication issues* or developing separate simulation models for the client and the server.

The Observer/Observable design patterns offers a good client approximation of the real simulation model on the server, because it constantly sends object updates and allows the client simulation to process the clock signal as well in order to have a real, simulated proxy of the central simulation.

References

[Gamma95] Gamma, Eric, Richard Helm, Ralph Johnson, and John Vlissides, *Design Patterns: Elements of Reusable Object-Oriented Software*, Addison-Wesley, 1995.

[Lopez02] Lopez, Albert, "How to decouple the Observer/Observable object model," available online at *http://www.javaworld.com/javaworld/javatips/jw-javatip29.html*, August 2002.

[Sweeney99] Sweeney, Tim, "Unreal Networking Architecture," technical paper from Epic MegaGames, Inc., July 21, 1999

SERVER-SIDE DEVELOPMENT

3.1

SEAMLESS SERVERS: THE CASE FOR AND AGAINST

Jason Beardsley, NCsoft Corporation

jbeardsley@ncaustin.com

Today's Massively Multiplayer (MMP) games typically support multiple thousands of concurrent players and require a distributed server environment that spreads all game-related computation across multiple processes and across multiple host machines. One common method of achieving this distribution is by dividing the game world into pieces, or regions, that are managed by different server processes.

In such an environment, the game world itself can be categorized as *seamless* or *zoned*, depending on whether the server process boundaries are explicitly observable inside the game. A seamless world is one in which a player may be unknowingly interacting with objects that are actually being controlled by multiple game processes or servers—there is no perceivable difference from the client's viewpoint. A zoned world consists of independent geographical areas between which there is no (or very little) contact, where players only interact directly with other objects on the same server.

The decision to implement a seamless or zoned world is an extremely important one, and this decision must be made very early during the game's design. What may not be obvious is just how much this choice affects practically every single aspect of a game's development—starting with design and programming, and then on to art production and world building, and throughout the game's live operation and maintenance. This article will attempt to impress upon the reader the significance of that decision.

There's More Than One Way to Slay the Beast

The basic premise here is that in order to achieve some desired number of concurrent players, the game simulation must be split along geographical lines and assigned to multiple servers. While this is definitely the most-prevalent solution, it is clearly not the only way to partition the server load. The question is, for a given game design, is there another way to divide the processing across multiple servers? The answer to this depends on the game design itself and the number of players that will inhabit the world. These factors dictate the types and amount of computing being done. We present a few possibilities here for the sake of completeness as well as comparison.

Split Physics and Game Computation

Modern MMP games are usually set in 3D worlds, and therefore they spend a significant amount of time verifying character movement as well as performing collision detection and other physics-related activities in a 3D space. It may be possible to segregate 3D movement and collision-processing from the rest of the game, and handle it in a separate server. In such an arrangement, the 'physics' server would handle movement and collision, and then send updates to the 'game' server.

See Figure 3.1.1 for an example server architecture based on this scheme. Clients connect to a front-end server that redirects packets to either the game or physics server, depending on their type.

Finally, it is worth noting that a game utilizing a 2D tile-based world requires less computing power for physics, and therefore may scale even better using this approach.

FIGURE 3.1.1　*Server architecture with separate physics and game servers.*

Let AI Run Free

Another idea for partitioning the server load is to separate the Artificial Intelligence (AI) processing into its own server, which essentially acts like a super-client for all AI processes. This concept sounds fairly simple to implement, but it has some drawbacks. Data must be replicated, since AI decision-making often relies on the properties of player characters and other game objects. Replication introduces obvious synchronicity issues and also increases inter-server communication needs. The latter is probably just a minor inconvenience, given the available bandwidth on modern local networks.

A more important issue is that of code duplication. Since AIs often use the same game systems that players do (e.g., combat, magic, etc.), its code probably has to reside both on the main game server and the AI server, but possibly in slightly different forms. If not carefully managed, that code could get out of sync, leading to difficult-to-find bugs or anomalous behavior.

Spend More Money

Finally there is always the 'brute force' approach of using more-powerful (and more expensive) server machines. This means going with multiprocessor boxes and utilizing multiple threads. Writing multithreaded game code is certainly more difficult compared to a single-threaded model, but it is no more difficult than performing the same kinds of operations between multiple servers.

At some point, the 'big iron' needed to support a large (and ever-increasing) player base becomes cost-prohibitive. For example, an eight-processor server costs more than twice as much as a four-processor server. And ultimately, there is some game-dependent, hard limit to the number of people that can be online simultaneously. As more game content is added, this limit only decreases.

Summary

There are definitely nongeographic solutions to the server load distribution problem, some of which may even be simpler to put into practice. Whether or not these can scale up to the same degree as a spatially partitioned world is another question entirely.

The claim being made here is that breaking the world up into pieces scales better, because it spreads all of the various types of game processing equally across server machines. At the same time, it is easier to add more game content (e.g., a new continent to explore) without impacting current server loads.

Another way of looking at things is to notice that the alternative solutions presented here correspond loosely to various methods used to speed up modern CPUs. The first solution, separate 'physics' and 'game' servers, is akin to a processor pipeline, which most MMP server architectures already resemble. The second solution, a separate AI server, is roughly analogous to a superscalar CPU with independent integer- and floating-point units. The third, 'brute force' solution is comparable to increasing the processor clock speed. Geographically dividing the world is most similar to using multiple CPUs. And parallel processing is well-established as being far more scalable than a single processor (no matter how fast) *if the task at hand can be partitioned appropriately.* For an MMP game world, this is most definitely the case.

A Prototypical Seamless World Pattern

Before discussing the pros and cons of a seamless game, we present a high-level 'blueprint' for such a system and enumerate the issues that need to be tackled in a seamless design. This will serve as a basis for later sections.

The general idea is to take the game world, divide it into chunks, and add some interserver communication between neighboring chunks that allow each server to act in a mostly autonomous fashion. This is achieved by having servers notify each other of objects that are 'close' to chunk borders so that each server can manipulate (to some

extent) remote objects through their local proxies. If this sounds conceptually simple, rest assured that in practice, it is not.

Split the World

The first issue is how to best split up the world. This is a very game-specific question. In a terrain-based game where the player controls a humanoid avatar (e.g., the typical online RPG), it is most likely possible (and easiest) to just pretend the world is planar and split it up along a 2D grid, even though the world is three dimensional. For true 'six degrees of freedom' space simulation, this is probably not a good approach, so an oct-tree or other spatial subdivision is liable to be more suitable.

Share and Share Alike

The next thing to consider is how large the shared boundaries between adjacent regions need to be. At a minimum, they need to be as large as the client's game world and/or player's awareness radius. Any smaller, and a player near a server boundary may not have the same objects in view as another player on the opposite side of the boundary, which is likely to result in many game exploits.

Figure 3.1.2 depicts this situation. Servers A and B share a common border, in which objects are mirrored on the other side. Player P2 is inside the shared border region, player P1 is not. P1's visible object set includes P2, as denoted by the dotted circle surrounding P1. But since P1 is not mirrored on Server B, P1 is not visible to P2, even if P2 has the same visibility range. Server B is unable to inform P2 about P1,

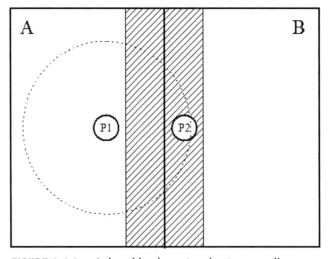

FIGURE 3.1.2 *A shared border region that is too small.*

since it is completely unaware of P1's existence. P1 may be able to attack P2, but the reverse is not possible.

Detailed or Accurate Proxy Objects (But Not Both)

The border region contains the objects that can be interacted with across a server boundary. When an object enters a border region, the owning server communicates this to any neighbors, which then creates a proxy to represent the remote object. When an object moves from a border region to the server's 'interior,' proxies are likewise destroyed.

The amount of information a proxy object presents to the game is another issue to address. Too little information, and it is very difficult to write any game code that does not involve asynchronous message-passing. Too much information, and there is simply that much more data that needs to be kept in sync, and consequently that much more data that can be out of sync. The essential characteristics that a proxy object really must have to be minimally useful include position, orientation, collision presence, and object type. Any other game-dependent, immutable properties could also be included (e.g., scale, color, etc.).

To cut down on the inter-server communication related to keeping proxies updated, a priority scheme for object properties can be employed. That is, identify each individual characteristic that needs to be mirrored, and determine how immediate that update has to be. When a low-priority property gets changed, the update may happen later (or never, depending on the circumstances). Naturally, this only exacerbates the synchronicity problem, but it does allow one to balance efficiency versus accuracy.

Define the Line

Another technical detail to consider is whether the server boundaries are *soft* or *hard*. A hard server boundary is one that always transfers an object across to another server as soon as it has been crossed, with no delay. A soft boundary allows an object to 'stray a little' across the border before initiating a transfer. This may cut back on the number of object transfers, which are presumably expensive, but it is slightly more complicated to code. For example, any game code that acts differently on proxy objects (of which there are always some, no matter how hard one tries to avoid it) cannot do a simple "inside my boundary?" check to discriminate between local and proxy objects.

Is That Thing Moving?

The final concern is about whether the server boundaries can change while the game is running—that is, whether they are static (unchanging) or dynamic (moveable). Dynamically adjustable server boundaries are *significantly* more complex to correctly

design and implement. For instance, entire groups of objects may have to be migrated in one atomic transaction without causing a noticeable delay for players. If boundaries involve more than two servers (which is practically unavoidable), then adjusting the border involves three or more participants.

Even given the actual mechanism itself, the policy of determining exactly when and how to adjust server boundaries can be complicated. Adjusting too often leads to higher overhead. Moving borders too infrequently can lead to overburdened servers, particularly if there is some reason that a large number of players simultaneously flock to a single place (e.g., a new dungeon opening up). When determining the new boundaries, one has to be sure that the resulting server load is balanced such that future process repetition is unlikely. Server load is a function with many parameters— number of players, number of AIs, how many collidable objects there are in the world, and so forth. Getting this right takes a lot of tweaking.

Summary

A picture is worth a thousand words, and so this section ends with Figure 3.1.3. The figure shows a three-way server intersection, with objects in various places along the borders.

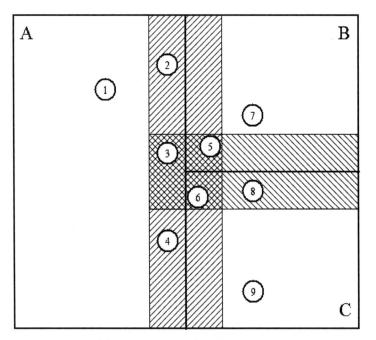

FIGURE 3.1.3 *Three servers and a boundary.*

The shaded areas represent the shared border, in which object mirroring takes place. The cross-hatched areas must be mirrored to both neighbors. Objects one, seven, and nine are strictly local to their respective server. Objects two, four, and eight have a single proxy on the corresponding adjacent server. Objects three, five, and six have two remote proxies.

Benefits of a Seamless World

As one reads the previous section, it becomes apparent that the technical aspects of designing and implementing a seamless world are fairly daunting. Naturally, there had better be some good reasons for that effort.

Bigger Is . . . Better?

One definite advantage is size. A seamless world can have larger contiguous areas in which to play the game, whereas a zoned world can only support an area as large as the number of players that a single server can support. Seamless worlds lead to a more-immersive environment for players and result in more-realistic game simulation. Depending on the game's design, it may even be unfeasible to break up the world into independent zones, in which case a seamless world is a requirement.

As a counterpoint to this argument, consider that a larger world does not automatically result in a better or more-enjoyable playing experience. A game's entertainment potential is not a function of how massive the world is. In fact, it is possible that much of a huge game world is empty space, designed to separate the places where players are likely to frequent.

Scalability and Reliability

A more-tangible benefit of a seamless world is increased scalability. As the world becomes more populated, the servers can be adjusted to handle the increased load. This is especially true for dynamic server boundaries that self-balance at run time. But even if server boundaries are static, they can be adjusted during down time based on trends in player population, achieving much of the same effect.

Another result is the potential for higher reliability. If one of the server machines breaks down or a server process crashes, then the server boundaries can be adjusted to spread the load over the remaining servers. An extra-strength, dynamic server boundary implementation might even do this automatically when it detects a server crash.

Where's My Line?

Dynamic server boundaries have an additional benefit in that they can potentially reduce the ability of players to exploit the extensive classes of bugs that involve moving data back and forth between servers. The reason is simple—players do not have a

definite idea where the server boundaries actually are, and by the time these boundaries are found, the servers can readjust before an exploit can be triggered.

However, odds are someone is eventually going to get lucky, so this is not a security blanket under which to hide. Obviously, the underlying bugs must still be found and fixed.

Map Load? No Thanks!

A seamless world even has a positive effect on the client. The dreaded 'map load' time is greatly eliminated (aside from initialization); amortized as smaller chunks of the world, they are loaded in only when required.

So What Is the Bad News?

Now that we know what a seamless game world can provide, it is time to find out what price must be paid. In general, the overriding theme here is complexity. *Everything* to do with the game's development and maintenance becomes harder when compared to a zoned server design. *Everything*.

The Uncertainty Principle: Not Just for Clients

The difference in complexity between zoned and seamless servers is analogous to the difference between a single- and a multiplayer game. In a single-player game, there is a single game simulation, a single process that manages it, and a single external entity (the player) that is presented an exact representation of the game state. In a client/server multiplayer game, each client has its own view of the world—all of which are slightly different and inaccurate. The canonical state of the world exists on the server. In other words, a multiplayer game introduces an unavoidable degree of uncertainty *on the client* that has to be reckoned with. Fortunately, there are well-known techniques that have been developed to deal with that uncertainty (e.g., dead reckoning).

In a seamless server environment, that same type of uncertainty now also resides *on the server* in the form of the inexact proxies that represent remote objects. The game design must take into account that proxy objects cannot be completely synchronized with their real counterparts without imposing an extreme amount of overhead. This means that many otherwise simple player interactions must be implemented asynchronously (e.g., using message passing) in order to avoid using potentially stale data. Asynchronous processes, by their very nature, have a much larger number of failure cases that have to be accounted for. Furthermore, the lack of proxy object synchronicity is the source of an astounding number of bugs, which themselves are the source of most player exploits.

Design Implications

Designing game systems that function properly across server boundaries is, shall we say, nontrivial. The number of race conditions and failure cases increase dramatically. The expertise required to diagnose and fix these problems is high. The cost of not fixing them is a broken game.

For example, in a zoned server, trading items between players can be accomplished in a single, atomic transaction (once the two players have approved the deal). In a seamless world, the players may be on different servers, and therefore a multi-phase approach is required, possibly involving a third-party arbiter object (or the database directly). In addition, one of the servers itself may crash at any time during the trading operation, so each phase must be able to recover from a wide range of potential faults.

Another difficulty encountered in designing game systems that work across servers is in treating the incompleteness of proxies. A check on an object may rely on properties that are not mirrored, causing a rethinking of the system in question. Suppose that a weapon can do extra damage to characters with an 'evil' alignment. If proxies do not reflect character alignment, this weapon will not function correctly when used to attack a remote character.

Practically every game system can be examined—movement, combat, character advancement, and crafting—to find that they are more complicated and more error-prone in a seamless world. This translates directly into a longer development cycle, a less stable game, or most likely a bit of both.

Example: Give Item

Since the design-complexity point cannot be overemphasized, we will take the time here to present a detailed example. The game mechanic being implemented is simple: give an item to another player—not two-way trading, simply a transfer of a single object. Furthermore, to eliminate some client-server round trips, suppose that the target player cannot refuse the item. This should be trivial.

In a zoned world, the entire game code that implements this feature might look like the following:

```
def Give(srcPlayer, trgPlayer, itemId):
    if not srcPlayer.HasItem(itemId):
        WARN("illegal give: src=%s trg=%s item=%s",
            srcPlayer, trgPlayer, itemId)
        srcPlayer.SendMessage(GIVE_FAILED, itemId)
    elif not srcPlayer.CanRemoveItem(itemId):
        # perhaps it is cursed, or non-tradeable
        srcPlayer.SendMessage(ITEM_NOT_GIVEABLE, itemId)
```

```
elif not trgPlayer.CanAddItem(itemId):
    # inventory full? already got one?
    srcPlayer.SendMessage(GIVE_FAILED, itemId)
else:
    # do the transfer (and update the clients)
    srcPlayer.RemoveItem(itemId)
    trgPlayer.AddItem(itemId)
    # make it persistent
    srcPlayer.SaveToDatabase()
    trgPlayer.SaveToDatabase()
```

This code is quite readable and easy to understand. There are three general phases:

1. Source player checks `HasItem()` and `CanRemoveItem()`
2. Target player checks `CanAddItem()`
3. Commit operation

The same cannot be said for the equivalent code in the presence of seamless servers, where source and target players may reside on different server processes. We simplify the task somewhat by requiring that objects, themselves, can be messaged regardless of which server they are on, and that messages will eventually be delivered even if the target object is in the middle of being transferred between servers. Furthermore, if a message cannot be delivered for any reason (including server crashes or objects not being in the game), an indication of failure returned to the sender.

Therefore, the transaction does not take place between two servers, but between two players—no matter which server they are on at the time (even if it is the same server). Without getting into the gory details (i.e., the code), here is the general sequence of events, given that the source player is P1 and the target player is P2.

1. **Server receives a `Give` request from P1's client.**
 a) Perform source player checks `HasItem()` and `CanRemoveItem()` on P1. If they fail, handle as above and immediately return.
 b) Else, lock the item to prevent P1 from doing anything else with it, such as giving it to someone else or dropping it on the ground.
 i. This locked state is transitory and is not stored in the database or maintained if P1 moves to another server. As a consequence, if P1 migrates to another server or logs out, a `GiveCancel` message must be sent to P2 (see Step 8).
 c) Send a `GiveRequest` message to P2.
 d) If the `GiveRequest` message could not be delivered, then unlock the item, send `GIVE_FAILED` to P1's client, and stop.
2. **P2 receives `GiveRequest` message from P1 (sent in Step 1c).**
 a) Perform target player check `CanAddItem()` on P2.
 i. Since the item itself is not necessarily a local object, enough information must be passed with the `GiveRequest` message in order to satisfy this check. In the

extreme case, a temporary copy of the item may have to be instantiated on P2's server.

b) Send the result of `CanAddItem()` to P1 in a `GiveCanAddItem` message.

 i. We want to minimize the amount of state in this transaction and only want to commit as the very last step. Therefore, we do not 'reserve' a spot in P2's inventory for the item. As a result, we do not need to handle the failure to deliver the `GiveCanAddItem` message.

3. **P1 receives a `GiveCanAddItem` message from P2's server (sent in Step 2b).**

 a) If the result is false (i.e., the item cannot be given), unlock the item, send `GIVE_FAILED` to P1's client, and stop.

 b) Otherwise, temporarily remove the item from P1's inventory and put it aside. Do not update P1's client or the database just yet.

 c) Send a `GiveAddItem` message to P2. This message represents the passage of ownership from P1 to P2.

 d) If the `GiveAddItem` message could not be delivered, put the item back in P1's inventory, send `GIVE_FAILED` to P1's client, and stop.

4. **P2 receives a `GiveAddItem` message from P1 (sent in Step 3c).**

 a) Verify that `CanAddItem()` still succeeds for P2. After all, P2 may have done something to change its status in the interim. If it does not succeed, send `GiveFailed` back to P1.

 i. Again, we do not need to worry about the failure to deliver this message, as no state on P2 has been changed.

 b) Else, temporarily add the item to P2's inventory. Do not update P2's client or the database.

 c) Send `GiveAddedItem` back to P1.

 d) If the `GiveAddedItem` message cannot be delivered, remove the item from P2's inventory and stop.

 i. In this case, P1 is not there to acknowledge the transfer, and so we must undo the temporary modification to P2's inventory.

5. **P1 receives a `GiveFailed` message from P2 (sent in Step 4a).**

 a) Place the item back in P1's inventory, send `GIVE_FAILED` to P1's client, and stop.

6. **P1 receives a `GiveAddedItem` message from P2 (sent in Step 4c).**

 a) Finally, a successful item transfer. Or is it? At this stage, P2 has only temporarily obtained the item. Now we 'permanently' remove the item from P1's inventory and update P1's client and the database.

 b) Then, send a `GiveAddedItemAck` message to P2.

 c) If this last message cannot be delivered, we must roll back the changes made in Step 6a—that is, put the item back in P1's inventory (breaking any game rules if necessary), inform P1's client, and update the database.

7. **P2 receives a `GiveAddedItemAck` message from P1 (sent in Step 6b).**

 a) It is only now that the item has really been transferred. Update P2's inventory, persist this change in the database, and notify P2's client.

8. **P2 receives a `GiveCancel` message from P1 (at any time).**

 a) This is notification that P1 has logged out or moved between servers. Depending on which phase of the process we have reached, there are different recovery steps. However, we can guarantee that this message will not be received after Step 7, so any state changes made to P2 have yet to be made permanent.

As we have seen, a mind-numbing, trivial game mechanism that takes a dozen or so lines of code to implement in a zoned world expands into a multiphase transaction as soon as multiple servers are involved. (And it is entirely possible that the process above fails to handle some obscure race condition. After all, it has yet to be subject to real-world testing.) Just imagine what a complex game system mutates into when placed in this type of environment.

World Building

The process of creating the physical space in which a game takes place is known as "world building." World building consists of tasks such as molding terrain, painting textures, and placing objects. It should not be surprising that making a seamless world is more difficult than a zoned one. For starters, the entire world is most likely far too large to be edited all at once; and therefore, the game editor needs to be able to work on smaller chunks. Couple this with the need for multiple world builders to work simultaneously, and it becomes apparent that a chunk-granular revision control system is required to manage concurrent access to the game world.

Extra time must be spent on 'cleaning up' the borders between regions that have been edited by different people. Special care must be taken when placing large objects, since they may straddle a server border, and this may cause problems. For example, if objects inside buildings are assumed to be on the same server (say for efficient culling), then a building that intersects a potential server boundary line is going to have to be moved.

Contrast this with a zoned game world in which the editor can work on a single contiguous region with no bordering areas and no placement limitations. Chances are some kind of locking will still be needed, but it can operate at a much higher level of granularity (e.g., the map file) instead of some arbitrary subset of the entire world.

Art

It may be difficult to believe, but even art production can be complicated by a seamless world. The creation of large objects, such as buildings, may be affected by the size of the server boundary region. The maximum allowable size of any object may need to be smaller than the size of the shared border; otherwise, such an object could extrude beyond the border region and cause problems.

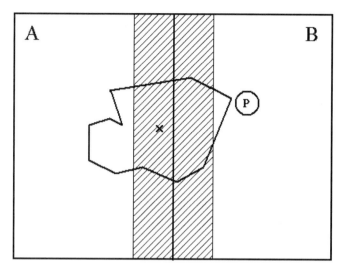

FIGURE 3.1.4 *Overly large object near a server boundary.*

In Figure 3.1.4, a large object is located inside Server A, but inside the shared region. Player P on Server B may not actually see the object (because P is outside the shared border, which happens to be exactly the width of the player awareness radius); yet it should clearly be visible. Worse yet, P may collide with it, causing unnecessary grief for the user and spurious bug reports for the live team.

Operations and Expansion

An MMP is never finished, so the saying goes. Expansion packs with more features, more places to discover, and more things to do are standard—it is what players expect to get for their monthly subscription fees. So, all of the above development-related issues apply even after shipping the product. It takes increased effort to create more content in a seamless environment, even if a good amount of the groundwork has already been taken care of. And, if the game's live team is not staffed from the original development team, the multitude of issues and restrictions that seamless servers bring with them may be forgotten—much to the detriment of that live team!

In addition, server boundaries are where a large number of game exploits will be found. Object duplication is a fairly common issue, even in a zoned world. But along the server borders, the race conditions that are typically the root cause behind duping become easier to trigger. Proxy objects cannot be kept perfectly in sync with their real counterparts, which opens up a raft of 'stale state' issues. Finding and fixing these kinds of bugs will be a major component of the live team's duties.

Continuing the 'give item' example introduced earlier, imagine that sometime in the future, some extra conditions need to be checked. These checks are encapsulated in the functions `CanGiveItemTo` and `CanTakeItemFrom`, which use other game systems to determine whether or not a transfer is legal (e.g., giving items to members of guilds that the source player's own guild has declared war upon is now forbidden; war is hell). Modifying the zoned code is trivial; it involves adding a few more lines of easily tested code. Updating the seamless server's implementation, however, is obviously much more time consuming and is likely to be incorrect. For example, consider the dilemma if these new functions cannot work on proxy objects.

Mismanaging the Extra Complexity

To reduce the additional labor involved in designing game systems that work across servers, one may be tempted to take the easy way out and simply not allow certain activities across server boundaries. For example, only support item trading between two players on the same server. This idea sounds like it just might work.

Unfortunately, it really does not in the long run. Not only does this advertise server boundaries to the players in a painfully obvious manner, it opens the door for even more game exploits. Suppose that combat is one of these 'lobotomized' game systems. Now, if a player is being chased by a particularly nasty monster, it is likely that the player can repeatedly hop across a server boundary (thus avoiding the monster's attacks), heal up, and re-engage the battle.

Another pitfall to avoid is that of logic duplication. Obviously, it is much quicker to perform the 'give item' action when both participants are located on the same server. So, the game code could check for this situation and invoke the original zoned code, instead of starting the message-passing process. This suggestion should immediately set off a very loud alarm in the mind of the reader—it results in two code paths that (theoretically) do the same thing. The chances of these two paths diverging increase as time goes on; and when they do end up different, it is not going to be pretty.

In short, there is no magic bullet when it comes to dealing with the complexities of server boundaries. If they are in the game design, then every game system has to deal with them.

Conclusion

This article has presented the incentives for seamless servers for an MMP, as well as the drawbacks associated with such an approach. It has also provided a number of reasons why the 'seamless or zoned' decision is not one to be taken lightly, as it affects a game on every level, from the beginning of design to ship date and beyond.

The designer must question, given the difficulties associated with seamless servers, why anyone would ever want to employ them. Intractable game design requirements aside, going with a zoned game does seem to be a no-brainer. Indeed, the author's opinion is that seamless servers are not worth the effort involved. They lead to a longer schedule, increase the complexity of practically every line of game code, and impose limitations on what can be done in the game itself. The time spent across all disciplines on seamless-server boundaries can instead be used to make game systems more fun or intricate, create a more detailed world, produce more textures/meshes/animations, or arrive at the ship date that much earlier. In short, that time can be put to use making a better game, sooner.

However, much like a siren song, one cannot deny the attractiveness of a seamless world, both from the game-play standpoint as well as from the technical side. It is also an engaging research project for the server programmers, should they be so inclined. Just make sure to watch out for the rocks.

Ultimately, the seamless-server question is one of, if not *the* most critical issue to be addressed when designing an MMP. Make the decision carefully, and make it early.

3.2

SERVER-SIDE OBJECT REFRESH RATES

John M. Olsen, Microsoft

infix@xmission.com

When considering the usefulness of this article, you may be thinking to yourself, "What's the big deal about sending lots of data from the server? We have broadband now, right?" One of the primary budget concerns of any MMP game is the cost of bandwidth. It can consume a large percentage of your user fees. As of this writing, wholesale bandwidth typically costs in the neighborhood of five dollars per gigabyte of data transferred. When you add up the data requirements of tens of thousands of concurrent users (or hundreds of thousands if you are lucky) you begin to see why it is such an important issue to manage the amount of data you send.

This article starts with some groundwork to point out information that will be critical to your decision-making process, then finishes by describing a way to cull and organize your data packets to make effective use of your network.

Visual Continuity vs. Accuracy

All real-time online games struggle to some degree with latency issues and how to accurately or believably portray the state of the game. Your goal should be to deliver a good look and feel, even at the expense of some small amount of visual accuracy.

If your players see what looks like a consistent game state, and they see the other PCs (Player Characters) and the computer-controlled NPCs (Non-Player Characters) moving in believable ways, then they will be unaware of any small latency errors that are present.

Players will quickly notice when another player or NPC pops from one location to another. This is usually due to lag caused by either lost network packets (network and hardware limitations) or data being sent too infrequently (implementation problems). It is also useful to note that a uniform amount of latency is generally easier to compensate for than variable latency.

Some games adjust for latency in an adaptive fashion, adjusting positions smoothly to bring objects to the expected location. Depending on the amount of error being corrected, this can lead to anything from imperceptible adjustments to highly distracting and bizarre skating.

A general guideline to apply when evaluating the concepts involved in finding good data refresh rates is, "If you can't tell, then it doesn't matter."

What Data Needs to Be Sent?

There are several types of data that need to be sent between the player and the server, and each needs to be considered differently, based on how time-critical it is.

Environmental Changes

Changes in the environment are a very high priority. If the player's view of the world and the server's view of the world do not match, it can lead to a whole host of collision and synchronization behavior problems. A player may wonder why they keep missing a moving platform, for example, when their local information differs from that on the server. Due to the highly critical nature of environmental changes, you should expend significant effort toward reducing the need for this type of data transfer.

Active terrain elements within the environment should be a very small portion of your data stream. This data would include things like doors being opened and closed, as well as cyclical movements, such as a turning windmill, where you want collisions for all players to stay in sync with the visual representation. It would look rather silly to watch a player run straight through an arm of the windmill, while another collided with the empty spot between the arms.

Player-to-Player and Player-to-NPC Interactions

Some examples of interactions triggered by players or by NPCs include combat, trade, and all the various forms of chat. In most cases, this should be a relatively small portion of your data stream. Trade and chat are not very time-critical, and can easily be delayed for a short period without the player noticing. On the other hand, combat information is at least as time-critical as any environmental change. If you support voice traffic that is routed through the server, it would be both high priority and a large portion of your bandwidth.

PC and NPC Movement

Most important, you need to send PC and NPC movement information often enough to give the player a good sense of visual continuity, but not so frequently that you swamp your network usage.

Bandwidth Limits

Games currently on the market all share similar bandwidth usage numbers, averaging in the neighborhood of one kilobyte per second per player. This data rate is a useful benchmark for two reasons. First, it is modem-friendly, because even a lowly 28.8k modem can keep up with that data rate. Second, it is a good value for budgeting. Even if some players decide to stay connected to the game full time for a month (and believe it or not, some will), you still have some of their monthly fee left over to pay for your hardware, office space, and employees.

Refresh Frequency

Keep in mind that the frequency of refreshes can have an impact on your overall data size. Each packet sent over the network will have a header attached that varies in size from 28 bytes for a UDP, nonguaranteed data packet up to 72 bytes for a fully loaded, guaranteed-delivery TCP packet.

More frequent refreshes mean you send this extra header data along more often. Ideally, you will be packaging up all the available information to send to a particular player and sending it all at once as a single network packet, even if it contains several different types of information for the player. If you are using both TCP and UDP packet streams between the server and player, you will need to break those into two separate sends, but you should be able to merge all TCP data into one packet and all UDP data into another packet.

If you package up the available data and send it too often, you eat up extra bandwidth unnecessarily through packet headers; this makes it easier for players to spot lag when it occurs due to the change in the behavior of your game. The network transport layer may merge smaller packets automatically for you, but you cannot control how or when the combining is done in that case.

If you send refreshes too infrequently, it emphasizes visual popping and warping of PCs and NPCs as you give the player less-frequent position refreshes. Sending data too infrequently can also cause the packets to increase in size; they are broken up by the network and reassembled on the other end, although this is handled transparently by the network. These larger packets are also more susceptible to loss, since losing any part of the message means the whole message is thrown away and must be resent.

Zones vs. Continuous Terrain

From a network perspective, zoned and continuous terrain models have similar requirements. In either case, you must come up with some scheme to refresh the player's world state, concentrating more heavily on those things that are happening close to the player. A zoned terrain system automatically caps the far range, where a continuous terrain system needs some additional code to decide on your limits.

Data Needed Per Player on the Server

Before we can define a good scheme to trim and prioritize the data, we need to identify what information we will store per active player on the server. Your actual implementation may vary quite a bit, but the basic idea is that each player needs a send queue on the server.

This send queue contains the messages that need to be sent from the server to the player. Each player record on the server also needs to have a list containing its position at each of the recently sent refreshes. The position list should have the same number of elements as the send queue, which will be described in detail later.

Data Size Management

One thing we want to avoid is the exponential growth of the memory required to store character data. The number of possible relations between n players is n^2, so we need to trim n to the smallest number we can get away with.

Ideally, you will have built some mechanism to partition your environment into areas where you can readily identify which players are to be considered within sight of each other. In something like a portal system, you could identify per portal which other portals are important and close enough that you need the information on the PCs and NPCs in that area.

Lacking that mechanism, you will need to do periodic range checks and store each player's list of PCs, NPCs, and environmental objects that player can see. This second solution could require a great deal more memory and processing time, however.

The Update Queue

The send queue for each player consists of a list of time slots, as shown in Table 3.2.1, where the head of the queue represents the data to be sent immediately. All updates in the first slot will be transmitted to the player during that player's data refresh by merging those updates into as few packets as possible. This means that a player refresh happens once for each slot containing any network packets, from the server's point of view. This has nothing to do with the screen-refresh rate as seen by the client, and is in fact much slower than the screen-refresh rate.

Table 3.2.1 Sample Data Queue Before Sending Data

Slot 1	Slot 2	Slot 3	Slot 4	. . .	Slot n
Update A	Update C	Update D	Update F		Update G
Update B		Update E			

This data queue is used for all updates to be sent to the player, so it will contain movement data, chat messages, commerce, and all other data traffic going to the player from the server.

When sending each update in Slot 1, the update is evaluated to see when it needs to be repeated. If it is a recurring update, such as a player position, the update is moved to some other slot so it will be sent again fairly soon. If it is a one-time update, such as a chat message, it is discarded after being sent. Once the slot has been fully processed, the now-empty slot is moved to the end of the list, moving the other slots up by one position, as shown in Table 3.2.2.

Notice in Table 3.2.2 how Update A was moved to Slot 2, to be immediately repeated (an opponent's position update for instance), and Update B was removed (as a chat message would be). Slot 2 is now the head of the queue. Since we at times will purposely delay when data is sent, we need to pay special attention to how and when we gather the data to be sent. The data needs to be identified by the particular update message (such as player so-and-so's position), but the actual information needs to be gathered at send time (e.g., the position is X, Y, Z) so we always send the most-current information available.

It is a good idea to have at least a soft limit on the number of updates per slot. If you have filled up a slot with updates, then you are pushing your limits on anticipated maximum bandwidth and should selectively delay some items. This can be done automatically by moving an update to the first slot with room for an update, starting at the slot you would prefer to put the update in. This should only be done for updates that are not order-critical, such as position updates. You do not want to potentially scramble the order of text messages, for instance.

There may be cases where you absolutely have to send some data without delaying it or to guarantee delivery order, so you should allow for either overfilling a slot or bumping another update from the end of the desired slot to the head of the next slot. This could cause a chain reaction if the destination slot was too full. When this overflow situation occurs regularly, it indicates either that your slots are too small or that your data is being sent too frequently. You will need to evaluate the total network throughput to determine where the problem lies.

Table 3.2.2 Sample Data Queue After Sending Data

Slot 2	Slot 3	Slot 4	. . .	Slot n	Slot 1
Update C	Update D	Update F		Update G	
Update A	Update E				

Default Frequency of an Update

How do you decide how often something gets sent? How do you tell how many slots back to put an NPC's position update for a particular player? This decision determines how often the player will get updates for that NPC and how smooth the motion for that NPC will appear to the player.

In general, you want close items to be updated frequently, as often as every refresh, which is very likely to be more than once or even twice per second. Things in the distance need to be sent less often. There will always be cases where this general rule needs to be altered, which will be addressed shortly.

Calculating Ranges

Accurate range calculations can require a lot of CPU time. To find the distance between two points typically requires calculating the square root of the sum of the squares of the orthogonal distances between the two points, as shown in Equation 3.2.1:

$$dist = \sqrt{dx^2 + dy^2 + dz^2} \tag{3.2.1}$$

Since we do not want to take that much time, we will look for a shortcut. Going back to one of the original themes of this article, if the player cannot tell, then it does not matter. The calculated range is something the player never actually sees directly, so we can cut some corners and use the Manhattan distance, as shown in Equation 3.2.2, so named because of the way it calculates how many square city blocks you would walk to get from one point to another. Other estimates work just as well, so long as they are in the ballpark.

$$estimate = abs(dx) + abs(dy) + abs(dz) \tag{3.2.2}$$

Once we know the approximate distance, we can drop an update into a slot based on how far away an NPC is from the player. The easiest way to do this is with a linear function. If you know your maximum visibility range and have an estimate for how far away the specified item is, it is a simple calculation to find out how many slots back from the front you should go, as shown in Equation 3.2.3.

$$slot = floor(slotcount) * estimate / range) \tag{3.2.3}$$

Due to the approximations used, you should always clamp the slot offset to a valid range, since it could fall beyond your farthest slot.

Priority Adjustments

So far we have determined how to base the frequency of regular updates on distance. There are a couple of further steps that can optimize the data stream. First, some PCs and NPCs will be stationary for long periods of time. These position updates need to be sent initially so that the player knows the initial location, with an occasional update after that just in case a packet was lost.

There are also PCs that you will want more-regular updates from. Anyone you are currently grouped with in the game should have either a slot offset or a specialized off-set clamp to increase the frequency of their updates to you. A similar update increase should be used for any PC or NPC the player has selected as a target. Since the player has indicated they want to know about that PC or NPC for some reason, it makes sense to oblige them and give them more frequent updates.

Another priority adjustment that can be done requires a little bit more effort. You can use a list of previous player positions to assign a player a priority adjustment based on how predictable their position is. Any player sitting in one place for more than a few seconds should start to build up a priority adjustment that makes updates of that player less and less frequent. The same is true if they are running in a straight line, and their position can be accurately extrapolated with high accuracy from known data. If a player is running and stopping in short bursts, or otherwise is turning and moving erratically, they need a bias toward more frequent updates.

A fairly extreme adjustment can be made for things that move only rarely and have been stationary for a long time. The first time such an item comes up in the queue, it needs to be sent normally. But when you evaluate it for future updates, consider adding a 'do-not-transmit' flag. When that flag is set, you will skip all future transmissions of that update unless something has happened to change its status when it is evaluated in the future.

To cut down on evaluation time, all items that are given this do-not-transmit flag should be placed in the last available bin at evaluation time so that they come up as infrequently as possible.

The priority adjustments for PCs and NPCs should be calculated on a regular basis as the server updates the player's state; but due to the nature of the delays built into the queue system, it is generally not critical that these changes get propagated immediately.

Queue Adjustments

In most cases, it will be sufficient to just let the queue grind through the data and send updates in whatever order they arrive in the queue. This will occasionally cause some of those discontinuities (discussed earlier) when a player does something like switching from sitting in one place for a long time to running around erratically.

If a player has suddenly changed its priority adjustment by a great deal, you will want to add a new update to the queue. This should only be done for updates that can be sent multiple times with no bad side effects, since the original update is still in the queue for processing at some other time. The other update is still in the queue, so this added update needs to be flagged as a one-time update in order to keep from suddenly having two updates for the same PC or NPC in the queue.

You will also need to add a new update to your queue when PCs and NPCs come into the range of a player, and remove them when they go out of range. This includes entering and leaving the game, as well as via normal movement. When they come into range for the first time, an update needs to be added to the queue, using the standard queue slot calculations as previously discussed.

There is a nice shortcut for removing updates for things that have gone out of range. Since it is necessary to assemble data on an update when an update is to be sent, the out-of-range items can be culled when they are due to be sent. This saves you from needing to search through everyone's queues to remove stale updates. A substitute message then needs to be sent, telling the client that the object being updated is no longer visible.

Conclusion

Bandwidth management is a critical issue with easily defined costs associated with it. The quality of the job you do in managing your data stream can be easily measured in dollars spent and saved. The difficulty comes in balancing bandwidth with an enjoyable player experience, and making the environment as smooth as possible, given limited network resources. The seamlessness of the player experience, as partially determined by how often you send information to them, determines to a great degree how satisfied your players will be with your design.

Utilizing the techniques described here, you will be well on your way to finding that perfect balance in giving the player the experience they are after without using up unnecessary network bandwidth.

3.3

MMP Server Development and Maintenance

William Dalton, Maxis

bdalton@maxis.com

The primary difficulty in delivering an online, persistent game world is the lack of a well-defined finish line. While there may be some consensus on what constitutes its minimum feature set, any successful game will require active development for its entire life cycle, above and beyond routine maintenance. This article presents techniques to manage development on a live product when both ongoing maintenance and feature development are required. The developer is advised to adopt these practices as early as possible in the game's lifecycle. As soon as your first server is running and taking client connections, you are providing a live service. It is not easy to support the developers, producers, artists, world builders, designers, and executives that will need to use your server every day; and it is not going to get any easier when you add 5,000 or 500,000 paying customers to that total.

The bulk of online game development is invariably done on the server side. Among the many sound reasons for this weighting are:

- Security—The server is the component over which the developer has absolute control. This article will not discuss security in any depth, but the most important step in securing your game is to pull every single piece of sensitive data from the client to the server.
- Customer preference—Customers hate client patches because they delay getting into the game. Server patches, on the other hand, do not.
- Ease of development—If your game client will be run on multiple operating systems/hardware configurations, patching and testing every possible combination is labor intensive and error prone. A typical online game's server architecture is uniform across the entire service and, therefore, much easier to reliably test and update.

Therefore, this article will focus on techniques to keep your development team, testers, content generators, designers, producers, and executives rolling productively through delivery of your game and even after the game goes live.

The Fundamental Questions

Answering some fundamental questions up front will help to smooth the development process.

What Server Am I Using?

This is a surprisingly frequent question in the early phases of online game development. Most game programmers are comfortable developing on a PC and are willing to trust calls to a network library to 'do the right thing' and get them to a server. Connecting to a game is a fairly minor victory if you cannot determine any of the server's characteristics. For instance: is the server compatible with my client? How recent is the code that built it? Is this server connected to the 'right' database?

Enable your client programmers and other users to answer these questions for themselves. It takes a load off your shoulders, and it will increase the utility of any bug reports filed against your game. A simple approach is to have every piece of your system report its version to any other piece that it connects to. Each component maintains a list of components that have connected to it, and forwards this entire list to any other component to which it connects. Clients connecting to the server must be able to query that component for this list and display it to the user. This gives the user an absolutely accurate list of components (including versions) that they are using.

In Figure 3.3.1, we have an example of a bad server component. In this case, it would appear that one of the database servers is out of date. Given the version-reporting mechanism described above, the user can immediately detect this problem without ever logging into a server machine directly, and before they have stumbled across any bugs this situation might introduce.

The exact same logic can be used to propagate other information through the system, aside from the version. For example, the process id and hardware id of every server component to which a given client is connected will prove useful. If the server spans many pieces of hardware in a cluster, this sort of functionality will greatly aid debugging.

Where Can I Connect?

How will client developers and other users determine which server installation is best for them to use at any given time? If the first fundamental question above can be answered, they can try each server they know about until they hit what they think is the best combination of server components and client code. Alternatively, they could get their information by word of mouth or by e-mail. But a much better technique is to centralize all of the information they need to make a choice in one universally available location, like a Web page. This resource should provide a list of all known servers, whether they are currently running or not, their version number, and anything else required to make an informed connection choice.

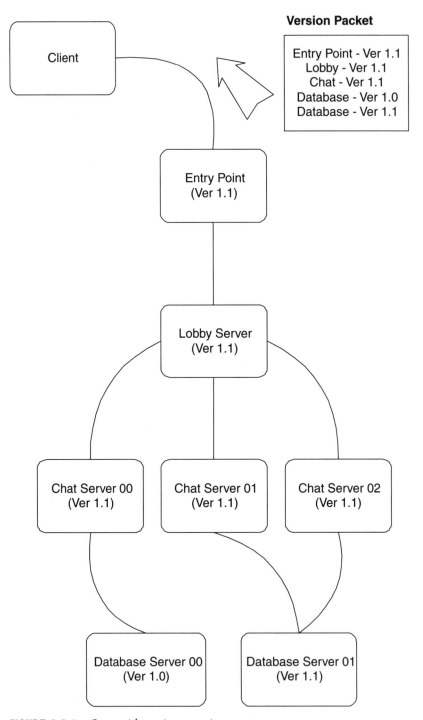

FIGURE 3.3.1 *Server-side version reporting.*

A final caution: since hard coding server addresses in your client code effectively hides that information from most of your users, it is a particularly bad idea.

How Can I Figure Out What Is Wrong with My Character?

Do your users have the ability to debug simple problems with their connection/play session on your server? The possibilities here are virtually endless, and every team must face the choice of how much effort to expend developing this capability, and they must endure the consequences of their choice.

Assuming that not every member of your development staff is up to speed on server development, or even has access to the server hardware, here are some minimal suggestions:

- The server should give useful error feedback to the client whenever possible. A frequent source of "The server is broken" complaints can be headed off in this way. Return a sensible error to the client if you can determine that an out-of-date protocol is being used, or if a malformed packet is being sent. Avoid sending generic "server disconnected" error messages when you can tell the client that its version is out of date or the server is shutting down (intentionally). Give accurate error feedback to the client as much as possible; this will save your team countless hours of erroneous bug hunting.

- Reveal the server logs to the user, or some reasonable portion of the logs. Better yet, give your users the ability to search the server logs (which is a very good reason to be writing concise, useful game logs). Some information can be shuttled back to the client from the server on demand; but again, a better way to generally do this is through a Web page with potential access to the logs from all of the server processes.

- Actively monitor all of your servers. Server engineers should be aware of server-side game problems before the majority of the team. Systems that periodically survey all known servers looking for problems are a great aid. Parse log files for sever-error conditions, and make sure the right people on the development team are notified of any discovered problems. Run periodic diagnostics for network problems, runaway processes (CPU or memory shortage), filled disks, and any other hardware-specific problems that might come up. Scripts to periodically collect this data and forward it to your team are easy to write. As always, surfacing this sort of information on a Web page is also an appealing idea.

A simple bash script snippet follows that does active monitoring and reporting. On a Unix system, this could be called periodically via a *cron* table. Similar scripts can

be used to cull all game logs for serious problems, or even to check the health of the hardware on each server (e.g., available disk space, memory, etc.).

```bash
#! /bin/bash

### Intention: Find all of the core files in ~/production directory
on ### a set of server clusters.
HOME_DIR=/home
    HOSTNAME=`hostname`

SERVER_LIST= devdaily devtest livedaily livetest liveregress

OUTPUT_FILE="coreReport.txt"
MAIL_LIST="bdalton@maxis.com"
SUBJECT_LINE="Core Sweeper Report: ${HOSTNAME}"

### Init file nulling out results from previous run
cp /dev/null ${OUTPUT_FILE}

for SERVER in ${SERVER_LIST}; do
    echo "——-cores on ${SERVER}:" > ${OUTPUT_FILE} 2>&1
    FILELIST=`ssh ${SERVER}"find ${HOME_DIR}/prod96 -name core*"`

    if [ "${FILELIST}" != "" ]; then
       for FILE in ${FILELIST}; do
           REPORT=`ssh ${SERVER} "ls -l ${FILE}; file ${FILE}"`

         ### Format output in whatever way is useful to you

           FIELDS1=`seq -s"," 1 9`
           FIELDS2=`seq -s"," 16 19`
           echo $REPORT | cut —delim=" " —
           fields=$FIELDS1,$FIELDS2 | column -t > \
           ${OUTPUT_FILE} 2>&1
       done

    fi
    echo "—————————————————"      > ${OUTPUT_FILE} 2>&1
    echo ""                       > ${OUTPUT_FILE} 2>&1
done

mutt -s "$SUBJECT_LINE" "$MAIL_LIST" < "$OUTPUT_FILE"
```

Managing Complexity

Here are several techniques that haven proven useful to help minimize complexity.

Branching

At some point prior to shipping your game, you will need to branch the code base. This is probably the best way to maintain a live game that is also undergoing active development. Typically, your team will establish a *Live* branch and a *Development*

branch, and we will use these as concrete examples here.

Branch development of a client server game is relatively difficult for most organizations. Development teams typically have less visibility into the game's server internals than they do into any other game component. This lack of visibility leads to increased frustration, erroneous defect reports, and, ultimately, lost development time. Do everything you can to simplify this process for your servers and for yourself.

- Use naming conventions everywhere, and stick with them. Your Development servers should all have "Dev" or a similar string in their names to help guide potential users. All Live branch servers/test centers should be named accordingly. (If you have already implemented the solution discussed in the first of the 'fundamental questions,' above, then this naming convention is easily surfaced for any connected client.)
- Establish separate environments for Development and Live servers. Never put Live branch code on Development servers, and vice versa.
- You should be using an automated build system to do daily builds and check builds. Establish independent Live and Development build machines. Each should be the sole source of builds for its environment, and ideally each should be incapable of syncing to code from any branch but its own.

Figure 3.3.2 shows a fairly simple schematic of a possible environment layout. Depending on your team's development technique and discipline, you may find a need for more pieces, but it is unlikely that you can do with less.

Remember also that this is just the server picture. The client should also have corresponding build box(es) that should feed into whatever mechanism you use to update your team's client installations. This could simply be an image of the client software available on a shared network drive or something more sophisticated, like a series of patching channels.

In Figure 3.3.2, the game's entry point is assumed to show all available servers from all branches and environments. This is usually sufficient if the entry point is a simple enough process. A more-complex entry point might require branching along with the rest of your code. This would likely apply if, for instance, the entry point were involved in client-patching decisions or otherwise incorporated interesting game features.

In the figure, we have also presumed that a single database instance is sufficient to support each branch. This may or may not be the case for your game; but whatever the case, you must be prepared to support persistence for all of your servers. Bear in mind that this will include cutting-edge developer servers that have their own, possibly new database requirements.

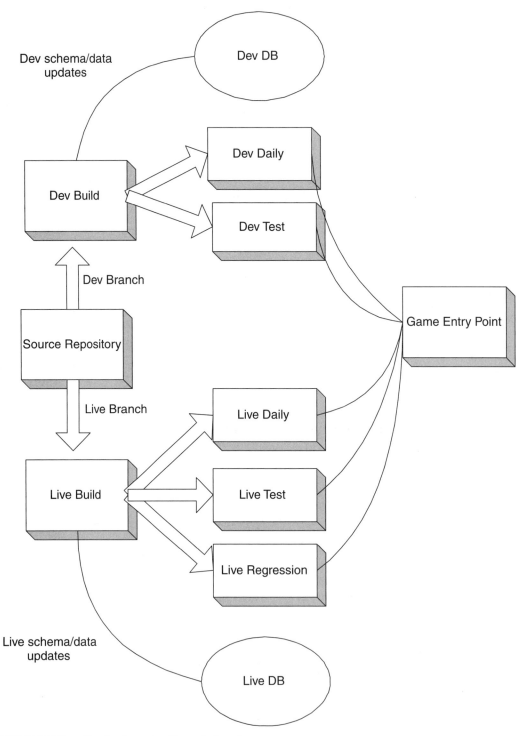

FIGURE 3.3.2 *Simple schematic of branched environments.*

Shared Code

How do you build your client software and server software? Are both built on the same operating system (OS)? Are they run on the same OS or hardware? These are important questions to answer before deciding whether your client and server will share code.

"Shared code" sounds like a good idea because it hints of 'code reuse.' Code that is reused is modified in one place and tested in multiple places, so it generally is expected to be of higher quality, either by design, by evolution, or both. Platform independence similarly implies higher-quality code. However, sharing code between client and server introduces liabilities that must be weighed against the quality advantages.

- A popular PC compiler actively encourages the use of non-ANSI C++ code. If your client programmers use this product, and your server developers use an ANSI-compliant product, you will invariably suffer server build breakages due to this difference.
- Does the code you share between client and server imply other shared assets? Are these assets portable between client and server OS platforms? Are there endian issues between the target client and server hardware? What does this imply about patching your servers and clients?
- Finally, consider what security holes shared code introduces into your game. To an expert, your client is an open book. Should you supply a road map, even a partial one, to the internals of your server?

Conclusion

The overarching theme of this article has been visibility. Do everything in your power to make your servers approachable to your users. Users should always be able to determine which server process(es) they are using. When problems do arise, users should have the tools available to help solve the problems. In development, your system should offer as many cues and clues to the user as possible to help them understand what the server is actually doing. Use naming conventions, use technology, use the game itself; use anything and everything to keep your users informed.

3.4

SMALL PORTALS: TAPPING INTO MMP WORLDS VIA WIRELESS DEVICES

David Fox, Next Game

davidfox@ureach.com

From the player's point of view, a top-notch, Massively Multiplayer (MMP) game usually has smoothly animated creatures, teeming towns, buildings with detailed architecture, layered environmental sound effects, and other hallmarks of virtual reality. The latest consoles and PCs continue to push such realism onward and upward.

But as any devotee of massively multiplayer text-only games can tell you, successful immersion into an MMP world is not about the visuals—it is about unrestricted access to another dimension. Of all the technological hurdles of the early twenty-first century, none focuses on unrestricted access as much as mobile phones and other wireless devices. Most people, after all, carry their cell phones with them everywhere they go. MMP games that support wireless devices can draw gamers into a level of immersion that has never before been experienced.

In most MMP games, game assets remain active even when the player has logged out. The player's characters, structures, and plans may be devastated while he or she is sleeping. Furthermore, important opportunities for diplomacy or partnership may be lost while the player is away. By tying a game to a wireless device, however, a player is essentially never logged out. At the very least, the player can receive wireless e-mails or SMS (Short Messaging Service) messages whenever something important happens. Better yet, a game may allow the user to issue simple high-level commands, such as "Place all units in defensive mode."

Ideally, a truly portable game allows players to use handheld devices to fully tap into the game world and do everything they could do on their desktops. A gamer could be instantly notified of a sneak attack and surreptitiously log in during a business meeting to, then and there, engage in a subtle and intricate battle scenario.

Wireless Devices and Networks

Although the power and speed of wireless hardware is improving at an impressive clip, wireless devices are wrought with heavy limitations. Most screens are black and white, and sized at about 100 by 100 pixels; processor speeds are hundreds of times slower than desktop machines, and memory is usually measured in kilobytes instead of megabytes.

Furthermore, most second-generation (2G) wireless networks exchange data at a rate of only 9.6 kilobits per second (kbps). European mobile phones primarily operate on the Global System for Mobile Communication (GSM), which sends data at 9.6 kbps. Some networks use Time Division Multiple Access (TDMA), which is similar to GSM and has the same 9.6-kbps limit. Most networks in North and South America, Russia, Israel, Eastern Asia, and Central Africa transfer data based on a standard called Code Division Multiple Access (CDMA), which runs at a peppier 14.4 kbps. Although 2.5-generation (2.5G) and third-generation (3G) networks are slowly being rolled out, it will be years before a critical mass of users is able to operate on them.

To make things even worse, wide area wireless networks are high latency because of the inherent interference and noise of radio wave communications. Most wireless networks force data packets to hop over many routers. Satellite-based wireless networks generally add even more latency. It is not rare to experience network delays of one or even two seconds in normal use.

As limited as these devices and networks are, they certainly are prevalent. One group predicts that the number of mobile wireless Internet users is expected to expand from approximately 39 million worldwide at the end of 2000 to approximately 729 million in 2005 [Intermarket01].

The question is how to use these high-latency, low-bandwidth, CPU-deficient devices to fully immerse players in a game world while suspending the player's disbelief? First, it is worthwhile to know which languages are used to write wireless games and what their strengths and weaknesses are.

Java Micro Edition

Java, created by Sun Microsystems, is emerging as a standard language for wireless devices. The language is open, and all necessary development tools are provided free of charge.

Java runs in a virtual machine, which means that as long as developers follow the right procedures, the same Java byte code can theoretically run on any supporting

platform. Java has also been designed to be easy to use. It is object-oriented with no explicit pointers, no complicated memory operations, and automatic garbage collection. System events, such as receiving a voice call while using a game, are automatically handled. Most important, Java applets cannot access functions or memory outside of their secure 'sandbox,' which means that it is virtually impossible to write malicious code or viruses.

Java 2 Micro Edition (J2ME) [J2ME01] is an attempt to take the best aspects of standard Java and pare them down for smaller devices, such as mobile phones, pagers, and handheld organizers. Almost every major mobile-phone manufacturer has joined with Sun to create the CLDC (Connected, Limited Device Configuration) [CLDC01] along with the MIDP (Mobile Information Device Profile) [MIDP01]. A Java applet written for a mobile phone, then, is called a "MIDlet."

Various device manufacturers have released extension APIs for J2ME. For example, Siemens has an extensive game API that sits atop MIDP. NTT DoCoMo does not use MIDP, but has a separate Java profile known as I-Appli.

Currently, MIDP 1.0 has several limitations: it does not support graphic transparency or floating-point math; and it cannot directly access the device hardware, file I/O, or memory via native code. The only protocol that MIDP devices *must* support is HTTP. As such, it is recommended that any MIDP games are designed for the lowest common denominator—using HTTP.

MIDP 2.0, designed for more powerful devices. It addresses and improves upon many of these shortcomings.

Binary Run-Time Environment for Wireless

Qualcomm has created a virtual machine and language called the "Binary Run-Time Environment for Wireless" (BREW) [BREW01]. The language is open and based on C++. Qualcomm has embedded BREW right onto the chipset for many CDMA phones. BREW can also support other languages. For example, Qualcomm is collaborating with IBM to create a Java virtual machine that sits atop BREW.

BREW has no sandbox security model, which means you can directly access the file system, network sockets, memory, and the screen. Full sprite transparency is also supported. There is also a built-in resource file system, making it easy to load up images and audio.

Additionally, the BREW Distribution System (BDS) standardizes the way applications are purchased online and downloaded directly to the device. This centralized billing system makes things much easier for the developer as well as the end user.

On the downside, the current version of BREW only supports 500 bytes of dynamic memory, with no static data. Actually developing a final BREW application (app) requires the purchase of the ARM compiler, which is very expensive. The

phones that currently support BREW are also on the expensive side, and they have very limited memory. There is also no easy way to debug your app once you have it running on an actual handset.

Since most upcoming devices support J2ME, and since Java can actually be written atop BREW, examples in this chapter will be written in Java. The concepts herein, however, can be implemented using most any language.

Wireless Interface and Game Design Overview

Taking a beautiful-looking virtual reality and porting it to a small device requires a fundamental paradigm shift. Every game environment consists of people, places, and things. How a player interacts with this environment is known as 'gameplay.' Both the environment and gameplay must be altered.

People, or characters, form the center of most games. Games generally revolve around a protagonist, often doing battle against an antagonist. In order for your rich characters to come alive on a wireless device, you must boil them down to their essence. Obviously, you will have to strip away any pretty 3D bodies or complicated statistics. Characters must devolve to the golden age of video games where personalities were expressed as sprites, using a few animated pixels. Lara Croft must become Pac Man.

Places are where all the game actions take place. Three-dimensional spaces can usually be adequately expressed as a 2D map. You may need to implement fog-of-war or other tricks to avoid giving one group of players a tactical edge. Furthermore, complicated physics or other environmental interactions will need to be greatly simplified. It is a good idea to only take what is the most fun about your game's environment and simulate that aspect on mobile devices.

Things that will need to be adapted to the 2D environment are the weapons, treasures, keys, and doors that allow your character to progress through the game. That which appears real on the monitor or TV must become abstract on small screens. All objects must be reduced to schematics, icons, or other such simplifications.

Finally, and most difficult to accomplish, gameplay itself must change. A mobile phone's input is usually limited to a few cursor keys. Also, due to high latency, any play that relies on quick reflexes must be altered. In essence, you will need to make part of your game turn-based. A good way to think about this paradigm shift is as coach versus quarterback. Here the player 'coach' sends input in the form of the order to run the ball, rather than the actual move to position *x,y* commands of the quarterback.

Table 3.4.1 contains several examples of how major elements of a console or PC game can be expressed on a mobile device.

Table 3.4.1 Game Elements: Large to Small

	Console/PC	Handheld Device
Outdoors	Open countryside punctuated by towns, natural resources, ruins	Tourist map, with icons for special places or features
City Streets	3D or isometric maze	Top-down scrolling maze
Indoors	Rooms separated by corridors with locked doors, moving elevators, etc.	Architectural blueprint with icons indicating locks, stairs, etc.
Cut Scenes	Cinematic	Static image with some text
Other Characters	Animated representations	Icons on map
Character Stats	Spreadsheet with charts	Baseball card
Inventory	Graphical drag-and-drop	Shopping list with checkboxes
Character Interactions	Precise, special-user interfaces, special animations	Textual or iconic
Larger Battles	Cinematic, bird's eye view	Textual sportscaster
Strategy	On the fly	Planned in advance using branching diagrams, with ability to update
Tactics (unit vs. unit)	Twitch input, quickly switching weapons, spells, modes	AI proxy with coaching ability
Shopping	Wander through mall, store shelves	Hierarchical series of menus
Hearing	Speakers, headphones, or comic-book bubbles	Scrolling ticker
Talking	Microphone, or typing	Canned, predefined messages

The key thing to remember is that while the experience of playing on a mobile device may be quite different, the actual game world need not change. Instead of using the first-person perspective of a soldier running through war-torn streets of a village in northern France, approach it through the eyes of a general controlling one particular soldier's progress from a computer-enhanced, satellite's point of view.

Object Design

Due to the drastically different ways in which the same objects will be represented on wireless devices versus desktop versions, it pays to have a highly scalable architecture. Every person, place, and thing should be built from the ground up to support wildly varying inputs and levels of detail. While the key attributes of every object (such as its location in the world and its hit points) will remain constant, the means of input/output and visualization of the object must be flexible.

There are two primary challenges to overcome: sending the proper objects and events to each platform, and dealing with user input. The key to success lies in crafting every single data type in your game to be customizable and scalable, depending on the situation. This design pattern will not only help you expand your game to wireless devices, but it can improve the overall performance of the game across various platforms and types of networks.

Sending Down Objects

Let us suppose that a mobile user's character and a desktop user's character are standing next to each other in a virtual game tavern. Each player needs to receive the same type of information: surrounding buildings and characters, and nearby objects. But the actual content to send to each client may be drastically different.

We can look at existing standards for ideas on how to structure such a system. For Web applications, the Extensible Stylesheet Language Transformations (XSLT) [XSL01] is a template language used to translate the same XML data for vastly different types of clients (see Figure 3.4.1). For example, the same content can be formatted for a Web browser via HTML, for a wireless device via the Wireless Markup Language (WML), or for a telephonic device using VoiceXML.

FIGURE 3.4.1 *How XSLT works.*

XSLT helps separate the logical structure of data from the presentation. You can create a similar design pattern for your game. For example, your character's data can be expressed using the base class shown in Figure 3.4.2.

Assume that each attribute in the class is its own separate class. This allows every attribute to perform special functions, have parent attributes, have child attributes, and so forth. For instance, the Character class can be expressed via the following XML:

```
<CHARACTER>
    <HITPOINTS>100</HITPOINTS>
    <NAME>Bartender</NAME>
```

FIGURE 3.4.2 *A basic Character class.*

```
    <DESCRIPTION>This swarthy character can serve you a fine mug of
ale!</DESCRIPTION>
    <LOCATION><X>100</X><Y>320</Y><Z>99</Z></LOCATION>
    <SPEED><X>23</X><Y>0</Y><Z>0</Z></SPEED>
    <DIRECTION><X>1</X><Y>0</Y><Z>0</Z></DIRECTION>
    <STATE>pouring</STATE>
</CHARACTER>
```

As a simplified example, you may want to send all of the above data to a console user, but restrict the data that is streamed to a wireless user:

- Only send the state if it is FIGHTING or DEAD, in which case the state should be simplified to "F" or "D".
- Only send updated *X* and *Y* coordinates, not speed or direction.
- Skip the description.

That is, you would only want to send the XML equivalent of:

```
<CHARACTER>
    <HITPOINTS>100</HITPOINTS>
    <NAME>Bartender</NAME>
    <LOCATION><X>100</X><Y>320</Y></LOCATION>
</CHARACTER>
```

The DeviceSender interface allows you to set up rules for each attribute and transform them on the fly in XSLT fashion. Basically, every data type should implement the DeviceSender interface. This interface is shown in Figure 3.4.3.

The sendToDevice method should return a string, byte array, character pointer, or any other data type that you will be using to form your network messaging. The class that holds each character's State information, then, can have a method similar to the following:

```
public String sendToDevice(Device d)
{
```

FIGURE 3.4.3 *The DeviceSender interface.*

```
    if (d instanceof Wireless)
    {
        if (thestate = State.FIGHTING)
            return "F";
        if (thestate = State.DEAD)
            return "D";
        else
            return null;
    }
    return thestate.toString();
}
```

When sending data or events down to a client, simply parse through each piece of data and call its sendToDevice() method.

Handling Input

Now, suppose that the mobile user and desktop user decide to do battle. The mobile user must be given an update of the fight, perhaps textually, as well as be allowed to send in high-level 'coaching' commands, which may be selected from a nested series of menus.

The desktop user, meanwhile, may be madly twitching his joystick while he sees two 3D characters duking it out. All things being equal, of course, the desktop user's ability to react to unexpected situations more quickly will give him an advantage. But if the AI is designed well, you can give the mobile user a fighting chance. A superior unit controlled from a cell phone should be able to beat a beginner unit controlled from a desktop.

Most MMP games have a master Simulation Object (SOB) class from which all characters, places, and objects are derived [ALEX02]. The relationship between these SOBs allows the server to maintain a fully detailed simulation of the game world. SOBs may be stored in a database, in memory, or as XML, depending on the implementation.

On the client side, these SOBs will be special proxy objects. For example, an `ActorProxy` may implement two main methods: `ReceiveEvent` to handle incoming events from the server and `RequestAction` to tell the server to attempt a given action.

Events sent down from the server (to the client's `ReceiveEvent` method) should implement the `DeviceSender` interface, as well. In this way, an event can be transformed differently, depending on the destination platform.

The client's `RequestAction` method will look very different on a console versus a wireless device. The server must be able to transform received events appropriately. When an event is received, the device that sent the request should be passed into a class that derives from an abstract `EventHandler`, as shown in Figure 3.4.4.

You should create a separate `EventHandler` class for each type of device your game supports. A `WirelessEventHandler`, for instance, can translate generic wireless events to larger game events. The event handler can also tap into the main game simulation

EventHandler
-SOB : SimulationObject
+handleGameEvent(ge: GameEvent)

FIGURE 3.4.4 *The EventHandler abstract class.*

object to determine how to deal with an event. For example, an event requested from a wireless device may have taken so long to arrive that it is no longer relevant, in which case it can be ignored by the handler.

Intelligence Everywhere

Most games only use artificial intelligence routines for nonplayer characters. In order to build a world that continues functioning no matter how little or how much user input is received, it is recommended that *every* character be able to tap in to a strong AI control state. This can put each actor and other game object under the control of your game's most-complicated AI.

A sample `AIControlManager` class, shown in Figure 3.4.5, can hold links to all `ControlState` classes, and can then poll the right class at various times, when it is time to perform an action. Every character should have its own `AIControlManager`. In this way, the same character can run on autopilot, be occasionally coached, or be completely controlled by the user. Since AI is computationally expensive, you may even want to scale the AI level based on the server's current performance.

AIControlManager
-controlStates : List of ControlStates -currentTime : long -defaultControlState : State -holdLockUntil : long -lockHeld : boolean -lockHeldBy : ControlState Id
+GrabLock(controlStateIndex: int, time: int) +PerformAction() +ReleaseLock(controlStateIndex: int)

FIGURE 3.4.5 *The AIControlManager class.*

The ControlStates array points to every ControlState that a given character can utilize. The PerformAction method within AIControlManager checks to see if the lock is held by a particular ControlState. If so, that class' PerformAction method is called. If a lock is not currently held, the default control state's PerformAction method is called.

For instance, suppose a wireless user senses an imminent sneak attack and requests that a specific canine unit go on guard duty for the next 10 minutes. The server should set the UserControlState class as the currently active controller, which will execute the user's Guard request. The UserControlState should hold the lock for 10 minutes unless the user issues another request. As soon as the time is up, the lock will be released, and the AI (the default ControlState) will regain control.

Note that in addition to locking based on time, you may want to lock via priority; and make sure to call the ReleaseLock method when needed. For example, your guard dog will guard for the next 10 minutes *unless* it nears death, in which case it will release the lock and let the AIControlState take over in an attempt to save itself.

Network Design: Proxy Power

The server will send simple updates to the client whenever something relevant happens. The question is, how can the server determine what is relevant to various clients? Usually, the client keeps a local game simulation running and is able to tell the server the information it needs to know. Since mobile devices have such limited memory, however, it often is not feasible to keep an entire, or even approximate simulation of the game on the client.

A proxy service can simulate the client's point of view and send down only the most essential information to a small device. Furthermore, many mobile phones, especially those using MIDP, are limited to using HTTP as the communications protocol. You will certainly not want to restrict all your game packets to HTTP. Instead,

write your game server using any protocol you wish. The proxy server will then translate and package the relevant information using HTTP.

Proxy servers will, of course, add extra latency. But they will also allow you to create a better experience for devices that support better network protocols. For example, the proxy can intelligently handle different classes of devices by scaling what information gets sent and how often.

Conclusion

Bringing a rich, graphical, multiplayer world to a tiny device involves a tremendous amount of sacrifice and compromise. Not only must you support two client code bases, but you must actively design, test, and tweak so that play is fun and balanced on all target platforms. But with a few major design considerations, every last game feature can be made accessible across a multitude of devices. This can give your players the ability to drop into your alternate universe while commuting, at work, in class, or lounging around the house. Making your world easier to reach will develop a community of players that is more involved, ultimately blurring the line between game and reality.

References

[BREW01] Qualcomm.com, BREW home page, *http://www.qualcomm.com/brew/*.

[CLDC01] Sun.com, "CLDC Information Page," available online at
 http://java.sun.com/products/cldc/.

[ALEX02] Alexander, Thor, "A Flexible Simulation Architecture for Massively Multiplayer Games," *Game Programming Gems 3*, Charles River Media, 2002.

[Intermarket01] The Intermarket Group, "Mobile Wireless Internet Briefing," 2001.

[J2ME01] Sun.com, J2ME information page, *http://java.sun.com/j2me/*.

[MIDP01] Sun.com, "MIDP Information Page," available online at
 http://java.sun.com/products/midp/.

[XSL01] W3.org, "The Extensible Stylesheet Language (XSL)," available online at
 http://www.w3.org/Style/XSL/.

3.5

PRECISE GAME EVENT BROADCASTING WITH PYTHON

Matthew Walker, NCsoft Corporation

mwalker@softhome.net

Source code presented in this article can be found on the companion CD-ROM.

Event-based systems have been used for years to implement the high degree of interactivity expected from modern software. These systems are used to simulate concurrency and improve the software's ability to respond quickly to unpredictable inputs. Most commonly, they are used in *Graphical User Interfaces* (GUI), such as those found in almost all commercial applications. When computer games evolved from simple DOS-based programs into sophisticated, 3D virtual reality engines, event-based systems became important to game development. In Massively Multiplayer (MMP) online games, events are more important than ever, because a great number of players are causing many things to happen at any given time.

This article presents three successively more sophisticated models for implementing high-level game events in an MMP server using the *Python* programming language. The source code presented in this article can be found on the companion Figure. Each model builds on the features of its predecessor to increase the power and flexibility of the system. Along the way, we discuss the advantages and limitations of each implementation. The third and final model is presented as a technique for precisely controlling how events are dispatched and handled, creating a highly efficient and flexible framework that a variety of game systems can leverage.

Event-Based Programming

The term *event-based programming* refers to a technique for simulating concurrency in a process without using threads. Threads are a general-purpose system for managing concurrency that is implemented in the operating system. They are difficult to use properly because code execution may be pre-empted at any time. They require special management of shared data, are hard to debug, and often break abstraction by

requiring classes and modules to be aware of timing dependencies. In contrast, events are not pre-emptive: they execute when the application invokes them, and they run until they complete their task. This makes programming with events much easier to understand and debug, isolating timing dependencies at well-known points in the code [Ousterhout96].

Synchronous and Asynchronous Calls

Event-based programming relies on an understanding of two complementary concepts: *synchronous* and *asynchronous* calls. Synchronous, or *blocking* calls are operations that do not return control to the caller until execution completes. The caller of a synchronous operation relies on the knowledge that when the call returns, the requested operation has been carried out. By contrast, asynchronous, or *non-blocking* calls are operations that return immediately from the point of view of the caller, but they continue executing independently of the caller's execution. The caller of an asynchronous operation must make special arrangements to be notified when the asynchronous call completes. Usually, this takes the form of a *callback* function that is invoked by the asynchronous operation at the end of its task.

Concurrency Simulation

Providing an illusion of concurrency is critical in MMP server architectures because of the need to support hundreds or thousands of players in the game at any given time. Event-based systems do this by treating each player request as a small atomic operation. Requests are serviced one at a time, as they are received. Complex operations that can be safely decomposed into two or more asynchronous operations are dispatched to the event system to be handled in a future iteration of the game loop. Because no request takes very long to process, new requests are accepted very quickly, providing the illusion that multiple requests are being handled concurrently.

High-Level Game Events

The focus of this article is on using an event-based approach to handling high-level game operations. This includes most functionality that is invoked by a direct player request, such as interactions with objects in the game world, other players, and key game systems. It also includes similar behavior initiated by AI-controlled autonomous actors. It excludes functionality such as low-level networking code, physics, collision detection, movement control, and the like. Yet, some of these lower-level systems may expose hooks that the event-based game code can utilize. An example of such a hook might be for the collision system to invoke a callback registered by the game code that indicates when an actor has penetrated a collision volume. Such a hook can be easily treated as an event.

The Game Server Main Loop

The main loop of the game server is the root of an event-based system. It is exceedingly simple, as shown by the following pseudocode:

```
mainloop()
{
    while(game_is_running)
    {
        // wait for incoming requests
        WaitForRequests();

        // handle requests
        ProcessRequests();
    }
}
```

The `WaitForRequests()` call puts the server into an efficient wait state until there is something to do. This can take many forms, from using `select()` on an I/O resource (such as a socket or in-memory file), or I/O completion ports and Asynchronous Procedure Calls (APC) [MSDN01] to a looping call to `sleep()`, followed by checking an input queue for data.

The `ProcessRequests()` call retrieves any waiting requests and dispatches them to the appropriate code to handle them. A request consists of either a player request received from a game client or an asynchronous call that was made in an earlier iteration of the game loop. Dispatching can consist of a direct call to a callback function or a data-driven delegation based on some input in the request. The key to this functionality is that the code to be executed is known a priori, and very few checks have to be made to determine which code to execute.

Events and Threads Are Not Mutually Exclusive

Using an event-based approach in a game server does not exclude using threads for part of the system, if appropriate. The game loop described above can just as easily reside within a multithreaded server, running in a dedicated *game thread*, while other threads handle network messaging, start-up and shutdown, and the like. The receipt of requests can be queued by the network thread and retrieved by the game thread for handling. Asynchronous calls made by the game loop can also be inserted into the request queue, whether or not other threads exist.

Python and Event-Based Programming

Event-based programming can be done in almost any language. This article uses Python for its implementation examples for the following reasons:

1. It has syntax and semantics that are easily understood.
2. It is dynamically typed, allowing the creation of sophisticated data structures without the added complexity of type restrictions.
3. Classes, modules, functions, and methods are all first-class objects, making it easy to implement callbacks and other event dispatching schemes.
4. Class, module, and instance attributes are addressable via a string-based name lookup. This adds flexibility when defining late-bound calls for implementing events.

Deferred Calls

Our first model of an event-based system is the *deferred call*. This is a fundamental idiom on which we base all subsequent implementations. A deferred call is a function or method call that takes the form of a request to be processed at some time in the future. In our event-based system, this means that the request will be handled in a future iteration of the game loop. The deferred call has six main elements:

1. The *target object* on which the call is to be made
2. The *call* itself
3. The *call's arguments*, which must satisfy the call's formal parameter list
4. The *time* in the future when the call should be executed
5. The *callback* that is to be called when the deferred call completes
6. The *callback's arguments*

Deferred Call Interface

Our deferred call implementation presents the following signature:

```
def Call(target, call, args, delay, cb, cbArgs):
    # deferred call implementation
```

The `target` parameter is an integer-based object id. We will use an object manager class to resolve the target. Since this call is asynchronous, by the time it executes, the target may have been destroyed by the game. If we used a reference to the target object instead of an id, we might introduce circular object references, which would prevent the proper clean-up of the object by Python's reference counting mechanism [Python01].

The `call` parameter is a string carrying the name of the method of the target we want to call. This makes use of Python's `getattr()` function to look up the method to be called by name. Since Python methods are first-class objects, they are also reference counted, and this approach avoids the circular object reference problem described above.

The `args` parameter is a *tuple* containing the actual parameters for the call, which must satisfy the call's formal parameter list. A tuple is a basic Python data type, which is essentially an immutable list.

The `delay` parameter is the minimum time in milliseconds to wait until making the deferred call. This value may be zero; if it is, the deferred call is queued immediately.

The `cb` parameter is a reference to a callback function or method to be called when the deferred call completes. This may be `None` (the Python `NULL` type) if notification is not desired. Here, it is acceptable to provide a reference, because the calling code knows its own life cycle, and we can assume it will not ask for notification if it will not be around to receive it.

The `cbArgs` parameter is another tuple containing the arguments for the callback. This may also be `None` if no callback is desired. If a callback is registered that takes no arguments, then we use an empty tuple, "`()`", to avoid having to test this value.

Deferred Call Implementation

We will implement this functionality in the module `deferred.py`. Our implementation must meet two key criteria:

1. Calls must be cached in some kind of collection for later retrieval.
2. Calls must be executed no earlier than their desired execution time, and then on a first-come, first-served basis with respect to other calls scheduled for that time.

Therefore, we need some kind of priority queue and a way to determine a call's priority based on its scheduled time. The latter is the more interesting, and it requires us to define a *callable object* that can be sorted by time. Below is a possible implementation.

```
import objMgr # object manager: maps ids to objects

class DeferredCall:
    def __init__(self, id, call, args, t, cb, cbArgs):
        self.targetId    = id
        self.call        = call
        self.args        = args
        self.time        = t
        self.callback    = cb
        self.cbArgs      = cbArgs

    def __cmp__(self, other):
        return cmp(self.time, other.time)
```

```
def __call__(self, objMgr):
    target = objMgr.GetObject(self.targetId)
    if target is not None:
        try:
            method = getattr(target, self.call)
        except AttributeError:
            print "No %s on %s" % (self.call, target)
            return

        apply(method, self.args) # make the call

        if self.callback is not None:
            # notify that call is complete
            apply(self.callback, self.cbArgs)
```

This class encapsulates the important attributes of our deferred request. We import the objMgr module to resolve the target object from its id. The __init__() constructor populates the object with the request data. Note that the self.time attribute contains an absolute time value derived from the delay parameter provided to the Call() function. This conversion is done to support sorting instances of DeferredCall in the priority queue. The __cmp__() method is a reserved Python hook that enables this sort [Python02], allowing a comparison based only on the time attributes of the compared objects. The __call__() method is another reserved Python hook that makes DeferredCall callable, just like a function or method. This method resolves the target object and the method to call on the target, makes the call, and executes the callback if one exists. In both executing the call and the callback, we use the Python apply() function [Python03], which allows us to pass the arguments to the call as a tuple in order to avoid concerning ourselves with the number of elements in the call's parameter list.

The implementation of the Call() function uses an instance of DeferredCall, as illustrated here:

```
import time
import bisect    # efficient list operations

# module-scoped list
deferredCalls = []

def Call(target, call, args, delay, cb, cbArgs):
    # schedule a call for later execution
    callTime = time.time() + float(delay) / 1000.0
    dCall = DeferredCall(target, call, args, callTime, cb, cbArgs)
    bisect.insert_right(deferredCalls, dCall)
```

This illustrates a module-based implementation, rather than a class-based one. This choice depends on our server's architectural goals and does not change the principle. The module declares the deferredCalls list, into which all deferred calls are

inserted and sorted by time. The `Call()` function converts the `delay` argument into an absolute time, creates a `DeferredCall` instance, and inserts it into the `deferred-Calls` list. The `insort_right()` function of Python's `bisect` module performs an efficient insertion sort that uses the `__cmp__()` method we defined on `DeferredCall`.

Now we implement the code that executes the deferred calls. The basic algorithm involves iterating over the `deferredCalls` list, executing each `DeferredCall` object that has a `time` attribute less than or equal to the current time. After the operation is complete, the `DeferredCall` object calls the callback if there is one. Because the list is sorted, we can break out of the loop at the first call that has a time later than the current time.

```
def ExecuteDeferredCalls():
    # run deferred method calls
    dCall = None
    now = time.time()
    while 1:
        dCall = deferredCalls.pop(0) # front of the list
        if dCall.time > now:
            # not time yet, put it back at front of the list
            deferredCalls.insert(0, dCall)
            break

        dCall() # execute the call, and any callbacks

    # now return how long in ms until next call
    next = None     # forever
    if dCall is not None:
        next = int((dCall.time - time.time()) * 1000.0)
        if next < 0:
            next = 0

    return next
```

The `ExecuteDeferredCalls()` function returns the number of milliseconds until the next deferred call is scheduled to execute. This can be used as a parameter to an asynchronous wait function, such as `select()`.

Making a Deferred Call

Making a deferred call is almost as straightforward as making a normal method call. The main difference is in how we identify the receiver and the method to be called. Also, we must determine whether or not to provide a callback method for notification.

```
import deferred

def DoSomething():
    objId = 42 # a parrot, Norwegian Blue
    intensity = 9
    sincerity = 0
```

```
deferred.Call(objId, 'WakeTheParrot',
    (intensity, sincerity), 100, Callback, (objId,))

def Callback(objId):
    print 'Parrot %d is pining for the fjords.' % objId
```

The example above shows us making a deferred call to object 42, which is a Norwegian Blue parrot, invoking the `WakeTheParrot` method 100 milliseconds in the future, with an `intensity` of nine and a `sincerity` of zero. When the operation completes, our callback will be called with the parrot's object id as an argument, printing, "`Parrot 42 is pining for the fjords.`"

Fitting Within the Main Loop

Refer to our original game loop pseudocode to get a sense of the role these functions play in our event-based system. The `WaitForRequests()` function blocks until it either receives a request from a client or times out on the delay until the next deferred call. The `ProcessRequests()` function calls `ExecuteDeferredCalls()`, which executes all the calls it can and returns the time until the next deferred call. If we let `Process-Requests()` return this time value to the main loop, we can modify our main loop pseudocode slightly as follows:

```
mainloop()
{
    waitTime = 0;
    while(game_is_running)
    {
        // wait for incoming requests
        WaitForRequests(waitTime);

        // handle requests
        waitTime = ProcessRequests();
    }
}
```

Deferred Call Implications

This is a simple and flexible approach to implementing an event-based system for a game server. Its advantages are that it is easy to understand and implement, and it can be used for any kind of asynchronous call. Yet, it also has some distinct limitations. The caller must know the identity of the receiver of the call. In the dynamic context of a game, this can be constraining. In a game, events cause actions to happen, and the set of actions initiated by a given event often changes when the game state changes. Using the deferred call model, we would have to use some kind of state machine to drive the specific calls to be made at any given time. This might lead to complex con-

ditional code that becomes hard to debug and maintain. Also, as new features are added that might need to react to a given event, the calling code must be modified in addition to adding the new code for the feature. Because deferred calls can be made from any point in the game code, we have no single point of access for changes or debugging errors.

Event Broadcasting

Our first enhancement to the deferred call model is to add a layer on top of it that implements a *broadcast* mechanism for game events. Instead of targeting each receiver directly, receivers register interest in a given event, and are called when that event is executed. This model adds some high-level abstractions: the *Game Event*, the *Event Broadcaster*, *Event Parameters*, and *Event Handlers*.

Game Event

A game event is really just an identifier for something interesting that occurs in the game. We implement it as a constant integer identifier that can be imported from a module by any code that needs it. The example below shows one suitable approach:

```
# gameevents.py

ACTION_ATTACK = 1
ACTION_PLACE_OBJECT = 2
ACTION_TAKE_OBJECT = 3
```

The values assigned to these constants have no meaning other than to uniquely identify the event. To use these events, code simply needs to import the module and refer to them by name, as in:

```
import gameevents

myEvent = gameevents.ACTION_ATTACK
```

Event Handlers

An event handler is any callable object, function, or method that is to be called when a specific event occurs. Any class or module can declare and implement an event handler.

Event Broadcaster

The event broadcaster is an abstraction whose job is to dispatch events to interested parties. The interested code *registers* an event handler with the EventBroadcaster class for a given event. When other code initiates an event, it *posts* the event with

EventBroadcaster, which makes a deferred call to a function that *dispatches* the event to all of the registered handlers. The following listing highlights the important points:

```
import deferred

class EventBroadcaster:
    def __init__(self, objId):
        self.id = objId
        self.handlers = {}

    def RegisterHandler(self, event, handlerRef):
        hList = self.handlers.get(event, [])
        if not hList:
            # handlers for new event
            self.handlers[event] = hList
        if handlerRef not in hList:
            # ensure only register once for a given event
            hList.append(handlerRef)

    def UnregisterHandler(self, event, handlerRef):
        hList = self.handlers[event]
        hList.remove(handlerRef)
        if len(hList) == 0:
            # remove unneeded entries
            del self.handlers[event]

    def PostGameEvent(self, event, delay, *args):
        deferred.Call(self.id, 'Dispatch',delay, args, None, None)

    def Dispatch(self, event, *args):
        handlerList = self.handlers.get(event, []):
        for handler in handlerList:
            apply(handler, args)
```

The EventBroadcaster is assigned an object id in its constructor so that it may be addressed as a targetable object by the deferred module. It is possible to have more than one EventBroadcaster if our game calls for it, but we must take care to manage the scope of each. The self.handlers attribute is a Python dictionary that maps events to lists of references to event handlers.

The RegisterHandler() method associates an event handler with an event by inserting it into a list in the self.handlers dictionary, using the event as a key. The list is used to allow more than one handler to register for the same event. The UnregisterHandler() method breaks the association between a given handler and an event by removing the handler from the list for that event.

The PostGameEvent() method schedules a deferred call on behalf of the event. This is little more than a wrapper around deferred.Call(). In all cases, the deferred call invokes the Dispatch() method of the EventBroadcaster, which identifies itself as the target by passing the self.id argument as the first parameter. In this case, we

provide the ability to delay the event using the `delay` parameter, just as we did when we used the deferred model directly.

Event Parameters

To preserve the power of our original deferred call model, our events should act like functions. In other words, they should accept parameters that enrich the meaning of the event. Referring to the `PostGameEvent()` method above, notice the last parameter, `*args`. The asterisk (*) symbol identifies this parameter as *a variable argument list* that allows the method to be called with any number of arguments in addition to the explicitly declared parameters. Python implements variable arguments as a tuple, allowing us to opaquely pass the `args` parameter to the event handler via the call chain initiated by `deferred.Call()`.

Each event could define a logical *signature*, so authors of event handlers can know what parameters to declare in the handler. This is important in order to avoid run-time errors associated with passing the wrong number of arguments to an asynchronous call. This signature may take the form of a comment associated with the event, as in:

```
# gameevents.py

ACTION_ATTACK = 1          # (attacker, defender, damage)
ACTION_PLACE_OBJECT = 2  # (actor, object, destination)
ACTION_TAKE_OBJECT = 3   # (actor, object, source)
```

A more robust approach might be to declare the signatures as tuples of strings, identifying the parameters associated with the event. When we register the handler, we could then use the Python `inspect` module [Python04] to compare the formal parameters of the event handler with the elements of the tuple.

Working with Broadcast Events

Now that we understand the implementation of the broadcasting scheme, we will demonstrate its use with a simple example. First, we declare one or more handlers for events of interest to us:

```
def HandleAttack(attacker, defender, damage):
    # a function-based handler
    print '%s attacked %s for %d damage.' % \
            (attacker, defender, damage)

class ObjectPlacementWatcher:
    # a class with method-based handlers

    def HandleTakeObject(actor, object, source):
        print 'Help! %s is taking my %s!' % \
                    (actor, object)
```

```
def HandlePlaceObject(actor, object, destination):
    print 'Thanks, %s, for the %s' % \
                    (actor, object)
```

Next, we register the event handlers with the `EventBroadcaster`, passing references to the functions or methods that implement the handlers.

```
import objMgr
import gameevents

# retrieve event broadcaster by id
eb = objMgr.GetObject(EVENT_BROADCASTER_ID)

# registration of function-based handler
eb.RegisterHandler(gameevents.ACTION_ATTACK,
                HandleAttack)

# registration of method-based handlers
watcher = ObjectPlacementWatcher()

eb.RegisterHandler(gameevents.ACTION_TAKE_OBJECT,
                watcher.HandleTakeObject)
eb.RegisterHandler(gameevents.ACTION_PLACE_OBJECT,
                watcher.HandlePlaceObject)
```

Now, when the events of interest are posted, our handlers will be called:

```
# somewhere else in the game
import objMgr
import gameevents

# retrieve event broadcaster by id
eb = objMgr.GetObject(EVENT_BROADCASTER_ID)

eb.PostGameEvent(gameevents.ACTION_ATTACK, 0,
                ATTACKER_ID, DEFENDER_ID, damage)
. . .

# at the very same time, elsewhere still. . .
eb.PostGameEvent(gameevents.ACTION_TAKE_OBJECT, 0,
                ACTOR_ID, SOMEOBJECT_ID, sourceLoc)
```

Each call to `PostGameEvent()` will initiate a *separate* asynchronous call via `deferred.Call()`. A zero value passed to the `delay` parameter will cause the calls to be executed as soon as possible. The event handlers will be invoked independently of each other, appearing as if they are executing at the same time.

Event Broadcasting Implications

The broadcast model adds power to our event-based system. In particular, we have decoupled the sender of the events from the receiver, allowing us to dynamically cre-

ate and break associations between events and handlers based on run-time conditions, but without needing a complex state machine or unwieldy conditional code. In addition, we have a single point of control through which all events travel, making it easy to add logging and debugging facilities as needed.

Yet, we still find limitations with this approach. Most notable is that our broadcaster invokes *all* registered event handlers every time a given event occurs. In a game, events are most interesting when they are *relevant* to a specific context. Consider the example of a secret portal through which only players wearing a specific amulet can pass. Using our current implementation, we could register a handler for the POR-TAL_ENTRY event. However, our handler would be called every time any portal posted this event, so it would have to check to see if the event came from the portal it cares about. In fact, most occurrences of the event are irrelevant for our purposes. If we have many portals in our game, but only one secret one, this approach is inefficient, resulting in many method calls that do nothing, just to support the seldom-used secret portal.

Precise Event Broadcasting

The final enhancement to our event-based system enables us to register event handlers with much greater precision. We can specify not only the events we care about, but also the context in which they are invoked as criteria for calling a handler. This minimizes the overhead of making unnecessary calls to handlers. The primary abstraction introduced in this model is the *game event key*.

Game Event Key

The game event key encapsulates information about an event that can be used as criteria for registering event handlers. These criteria are often values that would have been passed as event arguments in our basic broadcast model. For the sake of simplicity, it is best to identify common parameter types having similar semantics, then we can use these common parameter types to develop our keys.

For example, all events are initiated by some *source*, most often an object. In addition, most events relate to a specific *subject*, or the key point of interest in the event. Including the event itself, we now have three values with which to indicate interest in an event. This gives us the following possible combinations:

- By event alone
- By event and source
- By event and subject
- By event, source, and subject

While it is possible to include combinations that do not include the event, this does not seem useful for our purposes.

A powerful feature of Python is its dictionary data type, which allows the use of any immutable object as a key that maps to any other object. Simple examples of keys include integers and strings, but instances of user-defined classes can be keys as well, if they can be hashed to a unique value. We will use this feature to create a mapping of specific combinations of these criteria, encapsulated in an object, to a set of event handlers.

First, we declare a generic `GameEventKey` base class in the `gameeventkeys.py` module:

```
# gameeventkeys.py

class GameEventKey:
    # event key base class
    def __init__(self, event, src=None, subj=None):
        self.event = event
        self.src   = src
        self.subj  = subj

    def __eq__(self, other):
        # equality test
        return (self.event == other.event) and \
                   (self.src    == other.src)    and \
                   (self.subj   == other.subj)

    def __hash__(self):
        # hash function
        return hash((self.event, self.src, self.subj))

    def RegisterHandler(self, handlers, handlerRef):
        # this key maps to a dictionary of handlers
        hDict = handlers.get(self, {})
        if not hDict:
            handlers[self] = hDict
        hDict[handlerRef] = 1    # dictionary as a set

    def UnregisterHandler(self, handlers, handlerRef):
        # this key maps to a dictionary of handlers
        hDict = handlers[self]
        del hDict[handlerRef]
        if len(hDict) == 0:
            # remove unneeded key entries
            del handlers[self]

    def Lookup(self, handlers):
        # return the dict for this key, or an empty one
        return handlers.get(self, {})
```

This class acts as a hashable container for handler registration criteria. The __eq__() and __hash__() methods are Python hooks that enable us to specify how instances of GameEventKey are to be used as dictionary keys [Python02]. The normal comparison of two class instances in Python is implemented as a comparison of object *identity*; in other words, if two references point to the same instance, they are equal. However, we wish to consider two game event keys to be equal if they contain the same data, so we implement __eq__() to achieve this. Similarly, we implement __hash__(), based on the contents of the object, returning the hash of a tuple containing the class's attributes. Now, we can create one instance of this class to use as a key for inserting a value into a dictionary and use a completely different instance, having the same contents, to retrieve the value.

Note that we now implement RegisterHandler() and UnregisterHandler() in this class. It is possible that different event key implementations may follow different rules for registering handlers. We provide default implementations in the base class, permitting derived classes to re-implement them if desired, and likewise for handler lookup (now performed by Lookup()), which is used indirectly by the EventBroadcaster Dispatch() method. Instead of storing the handler references for a given event key in a list as in our nonkey model, we use a dictionary as if it were a set. This efficiently enforces unique handlers for a given key.

Event Key Derived Classes

To implement the various combinations of criteria that we want to use for registering event handlers, we derive from the base class:

```
class ByEvent(GameEventKey):
    def __init__(self, event):
        GameEventKey.__init__(self, event)

class ByEventAndSource(GameEventKey):
    def __init__(self, event, src):
        GameEventKey.__init__(self, event, src)

class ByEventAndSubject(GameEventKey):
    def __init__(self, event, subj):
        GameEventKey.__init__(self, event, None, subj)

class ByEventSourceAndSubject(GameEventKey):
    def __init__(self, event, src, subj):
        GameEventKey.__init__(self, event, src, subj)
```

These trivial classes give us a convenient and easily understood way of identifying the criteria by which we want to register our event handlers. Note that the ByEventSourceAndSubject class is essentially a re-implementation of the base class,

but this is purely coincidental. For the sake of consistency, we will never directly use the GameEventKey base class when registering for events.

Key-Based Event Broadcaster

The EventBroadcaster class evolves to accommodate our new paradigm. Where we previously used only events as keys into the self.handlers dictionary, we now use instances of GameEventKey. The relevant changes appear below:

```
import deferred
import gameeventkeys

class EventBroadcaster:
    def __init__(self, objId):
        self.id = objId
        self.handlers = {}

    def RegisterHandler(self, key, handlerRef):
        key.RegisterHandler(self.handlers, handlerRef)

    def UnregisterHandler(self, key, handlerRef):
        key.UnregisterHandler(self.handlers, handlerRef)

    def PostGameEvent(self, key, delay, *args):
        kArgs = (key,) + args
        deferred.Call(self.id, 'Dispatch',
                      delay, kArgs, None, None)

    def Dispatch(self, key, *args):
        handlerList = \
            gameeventkeys.GetHandlers(key, self.handlers)
        for handler in handlerList:
            apply(handler, (key,) + args)
```

Note how RegisterHandler() and UnregisterHandler()now delegate to the GameEventKey instance passed as the key parameter. The Dispatch() method similarly delegates the retrieval of handlers to the GetHandlers() utility function, using the key as the lookup criteria. The PostGameEvent() method changes only in that it accepts the key parameter, which is passed via the deferred call to Dispatch().

Registering Handlers with Game Event Keys

Registering and unregistering event handlers is now more precise. We can indicate that we want a handler to be called, not merely whenever a specific event occurs, but also stipulating which object is posted the event (the source) and what the event refers to (the subject). For example, our revised event handlers might take the form:

```
def HandleAttack(key, damage):
    # a function-based handler
```

```
            attacker = key.src
            defender = key.subj
            print '%s attacked %s for %d damage.' % \
                        (attacker, defender, damage)

    class ObjectPlacementWatcher:
        # a class with method-based handlers

        def HandleTakeObject(key, source):
            actor = key.src
            object = key.subj
            print 'Help! %s is taking my %s!' % \
                        (actor, object)

        def HandlePlaceObject(key, destination):
            actor = key.src
            object = key.subj
            print 'Thanks, %s, for the %s' % \
                        (actor, object)
```

Note how the key has replaced certain parameters from our earlier handler implementations. The data is still present, but it is now contained in the GameEventKey instance that is provided by the initiator of the event via the PostGameEvent() call.

Now we can register these handlers using more precise criteria. Here, we only want the HandleAttack() handler to be executed if an attacker (the source) having the id ATTACKER_ID initiates the attack. Similarly, we only care about object placement if the object being interacted with (the subject) has an id of SOMEOBJECT_ID.

```
    import objMgr
    from gameevents import *      # all event ids
    from gameeventkeys import *   # all event keys

    # retrieve event broadcaster by id
    eb = objMgr.GetObject(EVENT_BROADCASTER_ID)

    # register a function-based handler to fire when a
    # specific attacker attacks
    aKey = ByEventAndSource(ACTION_ATTACK, ATTACKER_ID)
    eb.RegisterHandler(aKey, HandleAttack)

    # register method-based handlers to fire when a
    # specific object is manipulated
    watcher = ObjectPlacementWatcher()

    tKey = ByEventAndSubject(ACTION_TAKE_OBJECT,
                             SOMEOBJECT_ID)
    eb.RegisterHandler(tKey, watcher.HandleTakeObject)

    pKey = ByEventAndSubject(ACTION_PLACE_OBJECT,
                             SOMEOBJECT_ID)
    eb.RegisterHandler(pKey, watcher.HandlePlaceObject)
```

Posting Game Events with Keys

Posting game events now requires creating an instance of the GameEventKey base class. We do this because we do not know which keys have been used to register event handlers, so we must provide all criteria of interest.

```
# somewhere else in the game
import objMgr
from gameevents import *      # all event ids
from gameeventkeys import *    # all event keys

# retrieve event broadcaster by id
eb = objMgr.GetObject(EVENT_BROADCASTER_ID)

aKey = GameEventKey(ACTION_ATTACK,
                    ATTACKER_ID, DEFENDER_ID)
eb.PostGameEvent(aKey, 0, damage)

. . .

# at the very same time, elsewhere still. . .
tKey = GameEventKey(ACTION_TAKE_OBJECT,
                    ACTOR_ID, SOMEOBJECT_ID)
eb.PostGameEvent(tKey, 0, sourceLoc)
```

Retrieving Event Handlers

One important detail remains: using the GameEventKey classes to retrieve the set of all handlers associated with a given event. Recall that we posted our events with a fully populated GameEventKey that contained all information about that specific invocation, including the event, the source, and the subject. We should expect to retrieve all handlers that are registered for any combination of these criteria. Yet, the key object passed in the call to PostGameEvent() generates a hash value that considers all criteria. To retrieve handlers that are registered using only a subset of the criteria, we must *coerce* the key we are given to each of the subtypes that represent the valid combinations we support, and we use the subtypes to retrieve the handlers.

This operation is handled by the gameeventkey module's GetHandlers() utility function, which, as we saw earlier, is called by the EventBroadcaster Dispatch() method:

```
def GetHandlers(key, handlers):
    # retrieve a list of handlers for all possible
    # combinations of key criteria
    hDict = {}
    hDict.update(ByEvent(key.event).Lookup(handlers))
    hDict.update(ByEventAndSource(key.event,
                        key.src).Lookup(handlers))
    hDict.update(ByEventAndSubject(key.event,
                        key.subj).Lookup(handlers))
```

```
hDict.update(ByEventSourceAndSubject(key.event,
                        key.src, key.subj).Lookup(handlers))

# since hDict is used as a set, the data we need
# is in the keys, not the values
return hDict.keys()    # list of handler references
```

This function creates an instance of each derived class of `GameEventKey` and uses the `Lookup()` method of each to search for handlers in the dictionary provided in the `handlers` parameter. The `Lookup()` method returns a dictionary of handler references, which we use as a set. This means that the interesting data is in the dictionary's keys rather than its values. The function accumulates the handler references in the temporary dictionary `hDict`, using the `update()` method to merge the data. Finally, we want to return a list of handler references, which we get by calling `hDict.keys()`.

This function illustrates another subtle point. It is possible that an event invoked with a specific key could cause the retrieval of the same handler more than once if that handler was registered using more than one key. For instance, we could register a handler for an event using the `ByEventAndSource` key, and again register it using the `ByEventAndSubject` key. If a given event were invoked having a source and subject that matched both of our registered keys, the handler would be found twice. Obviously, we do not want to execute the handler twice for the same event invocation, so we use the temporary dictionary, `hDict`, to ensure that we include it only once in the list returned by the `GetHandlers()` function.

Game Event Key Implications

The event key model allows us to fine-tune how handlers are registered for events. This gives us a great deal of control when compared to our previous two models. In addition, it is algorithmically more efficient than ordinary broadcasting, given a large number of event handlers. If we consider N registered handlers for a given event, the nonkey approach costs us an $O(1) + O(N)$ lookup, plus N method calls. By contrast, if we have N' registered handlers using a given event key, our cost is an $O(1) * M$ lookup, where M is the number of different `GameEventKey` subtypes plus N' method calls, where N' is almost guaranteed to be small with precise registration criteria. Since the number of event handlers registered for a given event (N) can be unbounded at run time, but the number of event key subtypes (M) will grow only when new functionality is needed, this is an efficient trade-off.

There are still some constraints to consider with this model, however. A game that has a large variety of events, with varying parameter types that do not lend themselves to common abstractions such as our *source* and *subject* key criteria, could suffer a proliferation of `GameEventKey` subclasses. This can be avoided by carefully defining the scope for events, much as we would for classes and methods.

Another point to consider is that we should take care in storing object references in the attributes of our event keys. Recalling the Python reference counting scheme, keys that are retained in the handler dictionary when they are registered may prevent some objects from being destroyed when expected. This is also true of event handlers that are declared as instance methods: holding a reference to such a method keeps the reference count on the instance, as well. These issues are easily managed with careful design policies, such as using native Python types as key attributes, rather than objects, and attention to the life cycle of objects in the game.

Conclusion

Event-based programming is an effective mechanism for simulating concurrency in a game server, without the complexity associated with threads. The dynamic nature of Python, with its weak data typing and high-level structures, makes it ideal for implementing an event-based system for an MMP game server. Deferred calls are a useful low-level implementation of events, but an event broadcasting approach provides the greater flexibility needed in a game. Adding the concept of event keys to a broadcasting model provides much finer control over event handling, resulting in a game system architecture that can meet most requirements for robust, dynamic gameplay.

References

[MSDN01] "Asynchronous Procedure Calls," Microsoft Platform SDK Documentation, available online at *http://www.msdn.microsoft.com/library/default.asp?url=/library/en-us/dllproc/base/asynchronous_procedure_calls.asp*.

[Ousterhout96] Ousterhout, John, "Why Threads Are A Bad Idea (for most purposes)," an Invited Talk at the 1996 USENIX Technical Conference, January 25, 1996, available online at *http://home.pacbell.net/ouster/threads.ppt*, 1996.

[Python01] van Rossum, Guido, "Objects, values and types," Python Reference Manual, available online at *http://www.python.org/doc/2.2.1/ref/objects.html#l2h-18*, April 10, 2002.

[Python02] van Rossum, Guido, "Basic customization," Python Reference Manual, available online at *http://www.python.org/doc/2.2.1/ref/customization.html*, April 10, 2002.

[Python03] van Rossum, Guido, "Built-in Functions," Python Library Reference, available online at *http://www.python.org/doc/2.2.1/lib/built-in-funcs.html*, April 10, 2002.

[Python04] van Rossum, Guido, "inspect—Inspect live objects," Python Library Reference, available online at *http://www.python.org/doc/2.2.1/lib/module-inspect.html*, April 10, 2002.

3.6

CONSIDERATIONS FOR MOVEMENT AND PHYSICS IN MMP GAMES

Jay Lee, NCsoft Corporation

jlee@ncaustin.com

The task of developing a Massively Multiplayer (MMP) game is a challenging endeavor. Thousands of simultaneous players expect to be able to move smoothly around a virtual world, interacting with other players, creatures, and objects in a believable manner. Adding to their expectations is the freedom that players have experienced when playing solo or small-scale, multiplayer games on their personal computers or consoles. These games are constantly pushing the envelope in terms of 'over-the-top' player movement, realistic physics, and the ability to literally reshape the landscape, usually though the destruction of terrain and various structures.

As MMP game developers, we are not immune to the lure of increasingly realistic environments and interactions. Each new MMP game that is announced usually attempts to push the envelope in at least one innovative and significant way to differentiate itself from the competition. However, the small percentage of MMP games that actually make it through a successful launch suggests that the added pressure of pushing the envelope can also play a part in a game's ultimate demise.

This article is designed to shed light on the various issues involved with the movement and physics systems in an MMP game. The intent is to understand these issues so that we as developers will be better positioned to deliver games that are sufficiently immersive, yet avoid the unexpected consequences associated with modeling these systems in a naive or overly ambitious manner.

Can We Get to Shipping the Game, Please?

The truth of the matter is that developers are almost always faced with the pressure to ship the game, and to do so in a timely, yet cost-effective manner. This will undoubtedly lead to many compromises in the underlying systems that support the game. It is no surprise that limits have to be placed on what these systems can do. Otherwise, the game would never be finished.

On the other hand, too many restrictions placed on gameplay erodes the suspension of disbelief. A player who feels too detached from the game becomes a primary candidate for an account cancellation. This is a scenario we certainly want to avoid.

An equally dangerous scenario is a lack of consensus among the development team on the compromises that are made. Perhaps the designers feel like the restrictions make the world feel dead, or that they cannot give the player a true sense of immersion through interaction. Or the world builders understand the restrictions that are placed on them, yet are constantly looking for ways to 'bend' the rules in order to create a more-interactive and visually interesting environment. While neither of these perspectives is wrong, they will erode the team's ability to ultimately deliver the product.

This calls for a balanced perspective: implement sufficient realism in movement and physics to continually engage, yet constrain enough to make it possible to implement the game in a timely and cost-effective manner. Getting every team member on the same page with regards to these systems is invaluable. It will lead to less overall stress, less rework or long-term maintenance headaches, and, hopefully, a perspective of creativity within the programmers' technology sandbox.

It's a War Out There

Development of movement and physics in an MMP game are, by definition, strongly influenced by a certain class of player, called the "rogue player" in this article. This class of player is willing to employ any means necessary in order to gain an upper hand within the game world. Whether attempting to move faster than the rules allow, or get to places they should not be, or exploit unanticipated object-environment interactions, we must account for these rogue players or face the possibility of anarchy reigning within our game.

The more successful our game becomes, the more likely it is a target for rogue players. These individuals far outnumber those on our in-house staff, and they are often just as talented, if not more so, than our own engineers. Worse yet, rogue players are somehow able to devote incredible amounts of time to their attempts to exploit our game code. Anytime a rogue player is successful in an exploit, all honest players are hurt. This in turn tempts previously honest players to try to regain an equal footing by using exploits themselves. When our support staff determines cheating has occurred, the player's account is banned, resulting in the loss of a paying customer. In the end, it is a vicious circle that can be significantly reduced with careful consideration of the decisions we make when implementing the game.

Therefore, every aspect of the design and development of movement and physics needs to be evaluated with the rogue player in mind. We have to look at the ways that someone with the time and ability to disassemble and patch the code, game resources,

and network packets at the client can use this information to cheat in our game. There is no question that this makes our already-challenging task more difficult than if players were just honest. Given the experience of games that are on the market, it would also be foolish to think that our game will somehow be spared from such attacks, or that we will somehow attract only honest players. We must be prepared to put up a line of defense—which leads logically into the next topic: the first and main line of defense against the rogue player.

The Server Is Always Right

The first technical issue to be considered in movement and physics is client autonomy. In today's MMP environment, there is an enormous amount of raw CPU and hardware-accelerated power available on each connected player's desktop. It certainly makes sense to leverage as much of this power as possible in our game. However, we have to draw the line when it comes to determining where a player may move, or how they may interact with the environment. It is up to the client's code to give the player the perception that they are in control; but ultimately, the server acts as the final arbitrator in these matters.

A game client can represent a player moving through the world smoothly by instantly responding to player move requests and checking these requests against the terrain and object representations in place on the client. A player requests to move forward, and the client code verifies that there are no obstacles to prevent the player from moving (e.g., terrain that cannot be passed or objects to collide with). With each rendered frame, this same verification is performed, and the player is brought to a halt if he collides with an obstruction. What if the player knowingly alters the code or world geometry on the client to provide access to parts of the world he should not be able to enter? The server must detect such violations and force an immediate correction in its representation of the game world, broadcasting that correction to every client that needs to know about it.

To illustrate: both the client and server have detailed representations of the game world, in this case a village that is populated with in-game player houses. As a player walks around the village, he would expect to be denied entry to a house unless he has a key to that house, something only the owner can provide. If the code on the server assumes that the only way a player will try to enter the house is by using a key, it leaves itself vulnerable to exploitation. Rogue players will attempt to bypass such a check by hacking the client so that their character is positioned within the house, simulating the end condition of a legal entry. We must decide whether or not a rogue player who successfully places his character inside another player's house can help himself to items in that house.

As soon as the server detects an illegal entry, it should at minimum correct that player's location to a known, valid location outside of the house. This location could

be the *last* valid location of the player outside the house, or it could be a known location like the doorstep of the house. Either way, as far as the server is concerned, when the player subsequently requests access to something inside the house, the request will be rejected, because the player is in fact outside of the house. In addition, every other player in the vicinity sees the player outside the house. To be honest, we do not care what it looks like on the offending player's hacked client. Additional safeguards against such exploit attempts might be to:

- Delay transmitting the contents of the house to a client until it is determined that the player entry was valid.
- Require storage of items in a home to be in an immobile lockbox, requiring its own key.
- Implement the act of entering a house in terms of transferring the player to a different zone, so the player cannot enter into it via movement alone.

In summary, the server is always right. It must have built-in correction mechanisms to defend against a wayward client. The server also has to be decisive in its simulation: every action processed for a player results in a well-known state. For example, a player that falls off a cliff to his death *instantaneously* moves to the bottom of the cliff and dies as far as the server is concerned. It is up to the client to provide the appropriate visual representation of arriving at the end state determined by the server.

The Cost of Movement

A general rule of thumb is that 70% of the bandwidth in an MMP game is related to movement. Since bandwidth represents a significant ongoing cost of an MMP, efforts made toward reducing this requirement result in significant dollars savings. In addition, a game that is more efficient in its data transmission broadens the base of potential customers who have hardware capable of running the game.

The client is capable of generating a movement message for the server, representing a new player location at least as fast as the frame rate at which it is running. Conservatively, this would represent 15 movement packets per second, since a frame rate of 15 frames per second is pushing the limits of what could be considered a responsive game. Assuming a conservative packet size of 20 bytes per movement packet, we would have 300 bytes of movement data per player per second. If our game has 20 players that are visible to a client at any given time, the data rate for simple movement has jumped to six kilobytes per second. This exceeds the theoretical limit of a 56k dial-up connection, and all we have achieved is getting player characters to move around like statues!

Clearly, we have to have a better approach for our game. We can start by reducing the frequency of movement-packet transmissions. Fifteen updates per second is sig-

nificantly more resolution than needed by the server to validate that the player is moving legally. The client can still generate the packets, but by implementing a concept called an *ephemeral channel*, only the most-current movement packet generated during an update cycle is actually sent to the server. This makes sense for transient information, such as movement data. The most-accurate reflection of the player's position is the most-recent packet generated by the client.

When the server receives the movement packet, it evaluates it in the context of the previous movement packet from that client. The server then validates the movement between the location in the last packet it received and the location in the current movement packet. To save CPU cycles, the server might only sample certain points between the two locations; and as long as all sample points and the ending location are valid, then the player is determined to have made a valid move. The detection of an invalid location results in a correction packet that is sent back to the originating client. The correction packet is sent as the actual move for other nearby clients.

It is extremely important when using a technique like this to ensure that the sample rate between the two locations is smaller than the smallest collision or trigger volume within the game. For example, if the sample rate between locations is at least once every 1.2 meters of distance traveled, then every wall, trap, teleport location, and so forth that a player can be blocked by or trigger must have a volume that is slightly larger than 1.2 square meters in order to ensure that the player cannot 'slip' through it. Figure 3.6.1 shows a player inadvertently slipping though an obstruction one

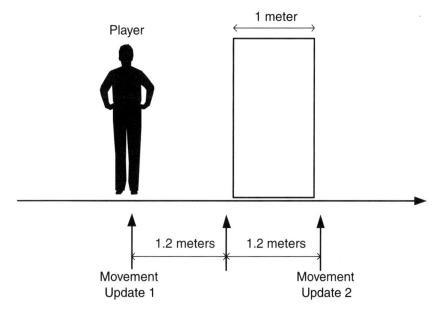

FIGURE 3.6.1 *A Player slips past an obstruction smaller than the sample rate*

meter wide, because the sample point between the two movement updates and the updates themselves are all valid locations.

Additionally, it is wise to place a distance cap on how far a player's character may travel between movement updates. We could allow some variance in apparent movement because of the inconsistency and latency associated with the Internet, and to lessen the impact of corrections. However, a hard cap ensures that a player does not exploit this to their advantage. For example, if the maximum movement rate (more on this later) of a player character is six meters per second, and we update the server four times per second, we might cap the movement between any two packets to two meters. Any movement beyond this is corrected back to the client. This should ensure sufficient play for Internet-related variance, but also ensure that the rogue player is not 'bouncing' around the world instantaneously with cleverly crafted rogue packets. To be effective, however, a cheat-detection mechanism must also be in place that records the history of player movement that violates the maximum character movement rate. This would pinpoint those players whose movement violations are statistically unacceptable, and we could monitor them at a more-detailed level (see Hack Detection).

Movement Rate

A game design that allows the player to utilize multiple rates of movement, such as running and walking, and to augment these movement rates through modifications by spells or enhancements certainly leads to a more interesting and immersive world. Player immersion can be further served by modeling the player character's ability to accelerate and attain a faster speed or decelerate for a slower speed, or to stop.

Under no circumstance should the client autonomously determine a player character's rate of movement. There are multiple anecdotes of players being able to influence their rate of movement in various online games by using hacks that speed up the rate of animation or frame rate of the game at the client.

Players will always want to reduce their 'dead' time, and will certainly desire to move at the fastest rate allowable. This is even truer in large, expansive worlds that have significant travel time associated with moving between locations.

Also, consider that the ability to enhance movement rates in the game leads to a wider margin of error that must be allowed for when validating a player's character movement. For example, in *Lineage* [LIN], a player can enhance his rate of movement by using a couple of easily accessible potions. In addition, a character can be polymorphed into a different creature with an enhanced movement rate. This combination of options leads to a large variance in movement rates, which are added to the fudge factor in place for network latency. Under such a scenario, players frequently

attempt to hack their client to gain speed advantages, and the larger allowable variance makes it harder to detect successful attempts.

A conservative approach might be to have two allowable movement rates in the world: moving fast and moving slow. The slower movement rate is used by players when they want fine control over their movement distances in tight environments, or when they are trying to accurately designate their destination and do not want to overrun it. The fast movement rate is used in every other case, and should be fast enough so that the player perceives sufficient progress in traveling quickly through the world. This keeps a player's movement variance to a known base value, plus the fudge factor. The code to validate that a player character is moving at an allowable rate becomes much simpler to implement, and thus less-vulnerable to exploitation due to bugs or oversights.

Variances in movement rates *can* be utilized by the nonplayer characters (NPCs) in the game, since the control over these resides exclusively at the server. The preferred approach is to tune NPC movement rates to a standard player character movement rate, as opposed to allowing the player to enhance his base movement rate.

Another consideration would be to scale down the size of the game world. Is there really a justification for a game's huge expanses of terrain or space that take significant periods of time to traverse? A player should have his down time between interesting events kept to a minimum. Scaling down the size of a world and increasing the relative density of interesting locales goes a long way toward alleviating the sense of vast emptiness, which exists in many current offerings. This can also provide additional development savings by removing the need for game mechanics that address the tedium of travel within a sprawling world.

Can I Get There from Here?

World Movement

It is significantly more difficult to constrain a player's movement within the game world if we assume that players have the freedom to go to any location not prohibited by an in-same mechanism.

This approach requires that the world builders adhere to a set of rules, such as "make the slope greater than 60° if you do not want the player to get there," or to place obstructions in the world that block off an area. As testers or players find ways to get to places that are intended to be off-limits, there is a constant battle to plug the holes that exist, and it may not be immediately obvious if the problem is truly fixed.

It would be markedly easier to start with the assumption that a player cannot go anywhere in the world. It is then up to the world builders to designate the movement-valid locations by cutting out a path where the player character may go. This is

significantly easier to verify, because it is very obvious when a player character cannot get to an intended location—they are stopped when they try to get there.

Teleportation

Teleportation is a very convenient game mechanic that is almost always employed in MMP games. For the player character, it is a useful tool for escaping danger or traveling quickly to other locations. Another application for teleportation is to free NPCs that are found to be stuck at the same location for an extended period of time. This can aid in dealing with trouble locations in the world—for example, where players lure creatures in order to immobilize them so they can attack with impunity.

Anytime a character is teleported, however, we are faced with the problem of determining a valid destination for the teleportation. If our game implements character-to-character collision (i.e., characters cannot overlap at a location), the problem becomes much more difficult to solve. It turns out that implementing an algorithm that reliably finds a valid location in an arbitrary three-dimensional world with both animate and inanimate objects is quite challenging and exploit-prone.

Even if teleportation were limited to well-defined locations, such as two teleportation devices, we still must determine where the character is placed on arrival. We can simplify the problem by marking arrival points at each teleport device as being accessible only to teleported characters traveling in a particular direction. This approach means that the only problem we are faced with is that all the valid arrival locations could be occupied at the time that a player attempts to teleport.

Unfortunately, this implementation of teleportation is quite limiting from a game feature standpoint and does not solve the problem of how a player character is brought into existence in the world when logging into the game. A world devoid of collisions between characters enables a more-robust implementation of teleportation. The worst that can happen is that characters will end up on top of each other. A player will usually adjust to this quite quickly and move away.

Translating Animations

A slight twist on the issue of teleportation is a player action that causes a character to have an ending location different from the starting location. The movement is typically not arbitrary: a custom animation is played that translates the character in one or more of the available three axes (i.e., x, y, or z). Examples include jumping, doing cartwheels, or some incredible martial-arts move. These are generally treated as special movement types that the server processes separately from regular movement. Because the translation information can be stripped out of the animation, the server is able to handle the movement request and process the translation appropriately in the context of its world representation. It can then resolve the new movement location with cer-

tainty, including determining if the intended translation is interrupted by an obstruction, such as a wall or a door.

Depending on the needs of our game, we determine whether or not to wait for server resolution before running the animation in order to provide the most-accurate representation, or if it is more important to feel responsive to the player at the risk of having to make a significant correction. Both these options appear more appropriate than the third option, which is to fail the request for action, based on the client determining it can not complete 'successfully.' For example, given an over-the-top martial-arts move that translates a character's position five meters forward, we may choose to wait for the server's round trip before running the animation that has the character coming to an abrupt stop at a closed door three meters ahead. Or we could play the animation and have the player character potentially sorting some distance into the door before the server indicates the correct end location. Both these options will feel better to the player than arbitrarily failing the move because the character cannot translate the five meters defined by the animation.

Collision Testing

Determining when in-game objects impede the movement of other objects is commonly known as *collision testing*. Collision testing is not a problem unique or more important to MMP games than it is to other genre titles. Most of the concepts presented here owe their origins to implementations in single-player or small-scale multiplayer games.

Collision testing can be computationally expensive, as the numbers of tests that must be performed grows geometrically with the increase in the number of candidate objects. A basic guideline for collision testing is to try to minimize the number of objects that must be collision-tested at any one time. If our game design happens to allow implementing a game world that is absent of collision altogether, without significant impact to player immersion, then we should rejoice and take advantage of it! Unfortunately, this is not often the case, so we will examine this issue in greater detail.

Collision Volumes

Collision testing is usually implemented by representing various world objects and characters as simple geometric volumes. Intersections between simple volumes, such as spheres, boxes, capsules and cylinders, are computationally simpler to determine than intersections between more-complex objects. Given the amount of collision-testing that must occur during a typical MMP game at run time, it makes sense to make such a compromise for the sake of performance.

However, there is no doubt that simple geometric volumes are likely to be poor approximations of the things that will appear in our game. But is this as much of an

issue as it initially appears? Take a tree, for example. What is the role of a tree in the context of a game? It is certainly used to populate the world and make it seem more lifelike. It may also additionally act as an obstruction to character movement, much like a tree would in the real world. If both a character and a forest of trees had collision representations that very closely approximated their physical appearances, navigation would likely be very frustrating for a player. As a player moves around the forest, he would find himself getting stuck on things like protruding branches and roots, or even leaves that catch the character's shoulder as he or she passes by. While more 'realistic' than a world with simple geometric volumes for collision, it certainly makes the game much less enjoyable for the player. We would be far better served by representing the tree as a simple cylinder that runs up the trunk, making it easier for a character to navigate. The character's head may occasionally intersect with leaves or branches, but the visual anomaly is much less noticeable to the player than unexpected interruptions to their movement.

A common technique can be utilized to improve collision efficiency and accuracy if it is warranted by our game world. We could build our collision volumes in terms of a simple geometric shape that serves as a coarse check. Should the coarse check determine that two objects collide, we could then do a finer check with the additional, finer-grained geometry that is in place. For example, if two spacecraft are flying around in space, they may be simply represented an enclosing sphere. Once it has been determined via the intersection of the two spheres that the craft *may* have collided, we can move to checking the individual smaller geometric volumes used to represent the various parts of the craft. This would not only determine whether a collision actually had or had not occurred, but it would pinpoint a more-detailed locale for that collision. This is something we can choose to take advantage of in terms of indicating damage location.

Character-Collision Volume

How then should a player character be represented from the perspective of collision? We would obviously choose one of the geometric primitives (e.g., sphere, cylinder, etc.) available in our engine. We should *not* attempt to completely envelope the character in our chosen shape. Doing so would lead to some of the same annoying anomalies that were alluded to earlier in the example of a collision with a tree. It turns out that situating a cylindrical collision volume to fit well with the player character's torso, extending no further down than the top of the knees and no further up than the character's shoulders, is well suited for games of this style. Characters are not likely to get stuck on objects that appear to be surmountable, such as a stairway, but they are obstructed by objects that should logically impede their progress. Figure 3.6.2 shows the suggested character-collision volume in relation to the collision volumes of other items that may show up in the world.

FIGURE 3.6.2 *Character-collision volume in relation to the collision volumes of other objects.*

Remember that the collision system needs to be functional and 'good enough' for our game while retaining the fun factor for the player. We should always be willing to trade occasional visual anomalies for the sake of keeping the player immersed in the game world. In creating world obstacles, we must ensure that the width and height of their collision volume is slightly larger than the largest legal distance a character is allowed to move, and that the height of the volume is taller than the lowest point of the character collision volume.

Character-to-Character Collision

It is really not debatable whether player characters should be obstructed by the inanimate obstructions we have intentionally placed in the world. What is in doubt is whether player characters should be obstructed by other characters—either player characters or NPCs such as AI-controlled creatures. Some factors in favor of implementing character-to-character collisions include:

- It makes the world feel more real; the player 'owns' the spot they occupy and has established 'personal space.'
- There are no visual anomalies associated with characters occupying the same space in the world, assuming avoidance code has been developed on both the client and server.
- It is simpler to implement; all collision presences are treated the same way.
- It makes it possible to deliver interesting game mechanics, where blocking is an integral part of the strategy (e.g., the castle sieges that occur in the game *Lineage*).

Some factors that favor avoiding character-to-character collision include:

- There is an overall reduction of CPU load related to collision; no character-to-character collisions need be performed at all.

- Arbitrary teleportation is simple to implement, since the target location only has to be a valid location for the character.
- Players are unable to use collision to grief other players (e.g., block the doorway of an NPC vendor's store).
- It avoids the need to implement surprisingly complex code to handle characters that arrive simultaneously at the same location (i.e., some sort of immersion jarring correction must be made as a 'winner' is determined).
- It avoids large spikes in collision-related CPU usage as player characters congregate in large groups.
- There is no need to develop sophisticated collision-avoidance code for AI-controlled NPCs.

Several currently available games choose to implement character collision with a 'shove' model. If a player character is in the way of another, it will cause one to shove the other out of the way. Unfortunately, it can be quite disconcerting for the player character receiving the shove, so it is worthwhile to first evaluate this model's appropriateness within the context of our game.

Scaling

A final point should be considered when it comes to character-collision volumes. If our game calls for supporting the resizing of character geometry to add variety and uniqueness to characters, then we must decide how this variation impacts their collision representation. If their collision representation stays the same, we can be sure that our collision code will probably work fine for all character size variations. On the other hand, we may be sacrificing an opportunity for unique game mechanics related to size variations that occur in the world.

Object Placement

A common way of increasing immersion in MMP game worlds is to allow the player to place items in the world, giving them the opportunity to leave their 'mark.' For example, if a player is able to acquire a home of their own in the game world, the opportunity to decorate that home with items is extremely compelling. However, letting a player arbitrarily place items in the world is also very problematic. Besides burdening the server with the overhead of having to track of all the items, arbitrary item placement can open up opportunities for rogue players. Consider the following possibilities:

- In a game where player-versus-player combat is allowed, a player drops many items in a small location so that another player entering that location is temporarily incapacitated as the packets describing each item flood his machine.
- Items placed in the game world can be put on top each other in creative ways to form walkways that enable access to areas that are normally off-limits.
- A player drops an item into the world and stands on the item; he then drags that item and drops it at another position in the world, illegally moving the character to a normally inaccessible location.
- Players agree to trade items by placing them on the ground, but a dishonest player grabs an item before the trade is complete and does not return the item.

Unfortunately, these scenarios are virtually endless. We should avoid arbitrary placement of objects in the shared areas of our game world if at all possible. Alternatives that might be considered include:

- Tag dropped items to the original owner for some period of time, after which it becomes available to others.
- Implement an aggressive decay scheme that destroys items after they are left unclaimed for a period of time.
- Abstract the dropped item(s) into some generic container that visually looks like a bag, which does not stack, and cannot be contained by another container.
- Designate predefined, acceptable placement locations within the world—for example, a public pedestal that may be decorated by the ruling faction with a single item of their choosing.
- Allow no placement of items in shared locations; instead, limit them to secured locations, such as players' houses.
- Implement NPCs that move around, picking up items that are dropped to the ground.
- Implement very-limited stacking of items with well-defined placement points; for example, pictures only hang on walls, or silverware can only be placed on tables.
- Place a cap on the amount of item-related information that gets transmitted in client updates, giving priority to those things that impact gameplay, such as creatures that pose a threat.

Each of these has various merits and down sides. However, we can be confident that none is a worse alternative than arbitrary object placement with all of its associated pitfalls.

Hack Detection

We will do well to assume that in spite of all our efforts to prevent it, the details of the contents of the data packets that travel between clients and the server will eventually be cracked. This is not to say that we should not try to encrypt and otherwise obfuscate their contents [Randall02]. Think of it as an additional line of defense that will delay the inevitable, perhaps for a long period of time. With this bought time, we should continue to shore up our game systems to help us detect and prevent exploitations by rogue players.

It goes without saying that the design and implementation of every game system needs to be evaluated in the context of how it might be exploited by rogue players. When evaluating design options, preference should be given to game mechanics that are either more difficult or impossible to exploit. For example, if our architecture requires that the game world simulation be split across multiple server machines, steer away from allowing any significant game-altering activity to occur in the transition across machine boundaries. This means that if items can be dropped on the ground, we should manufacture our world so that item-dropping is completed entirely within the confines of a single-server machine.

It will be invaluable to log all player activity that occurs on the server. We must take care not to bury ourselves in mountains of data or hamper game performance, but an asynchronous logging facility that sits on top of a commercial-grade database-management system will add a lot of ammunition to our exploit-detection efforts. Data mining can be performed in order to understand game trends and to detect attempts to duplicate valuable game items, gain access to typically inaccessible locations, or otherwise break the rules.

It would be extremely valuable to be able to use a disproportionate amount of hack-detection cycles to evaluate suspected rogue players in more detail. For example, if a player is determined to be pushing the boundaries of the allowable move distance on a consistent basis, this player becomes a suspect, and increased hack detection is turned on for him. The sample size for verifying his character's movement becomes smaller so that it is more accurate. The data that gets logged for this character may increase significantly as compared to a normal player, capturing details that are otherwise ignored, such as the exact location of the character when transactions that involved items occur. When the suspect player logs in, perhaps a notification message is sent to the support staff so they can monitor his activity in real time. All chat messages involving the player can be queried to look for certain tell-tale phrases that may indicate illegal activity. The opportunities are endless for actions that can be taken, all without the player's knowledge. However, the potential impact of successful rogue players warrants this level of scrutiny.

Conclusion

This article uncovers a lot of the basic issues we should consider when designing and implementing movement and physics in an MMP game. In doing so, we have seen that delivering these systems is a very challenging part of MMP game development. There are many options and potential solutions, yet each decision will have far-reaching consequences throughout the life of the game.

If we attempt to make these systems overly simplistic, we run the potential of alienating potential players or comparing unfavorably with our competition. On the other hand, being overly ambitious in this area could easily cost us our ability to ship the game. Worse, if we actually managed to ship in spite of bad decisions in this area, we can look forward to a miserable experience as we attempt to plug the unexpected issues that will keep cropping up as the game evolves.

Knowing the enemy plays a big part in being successful in battle. This article helps us know one of the enemies we will face when embarking on the journey that is MMP game development.

References

[LIN] Lineage Product Web site, *http://www.lineage.com*.

[Randall02] Randall, Justin, "Scaling Multiplayer Servers," *Game Programming Gems 3*, Charles River Media, 2002

CLIENT-SIDE DEVELOPMENT

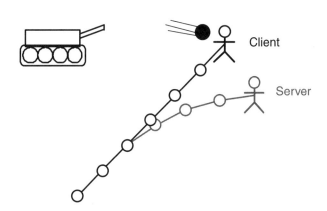

Client

Server

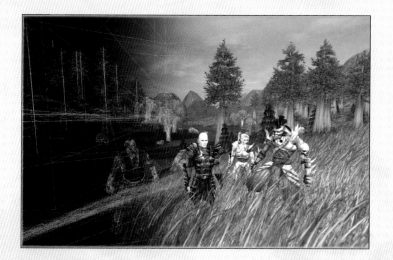

Plate 1 The large and expansive world of *Asheron's Call 2: Fallen Kings*. © 2002. Reprinted with permission from Turbine Entertainment Software.

Plate 2 Many gameplay features can be Tweaked at run-time like these options in *Asheron's Call 2: Fallen Kings*. © 2002. Reprinted with permission from Turbine Entertainment Software.

Plate 3 Seamless Servers can provide for smooth and fast transitions between areas. © 2002. Reprinted with permission from Turbine Entertainment Software.

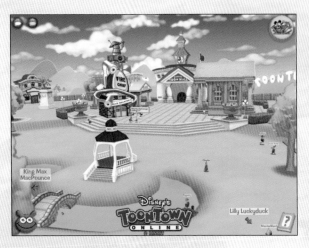

Plate 4 Wide view of the Toontown Central playground. Plate courtesy of Toontown Online. © 2002. Reprinted with permission from Walt Disney Company.

Plate 5 Toontown Character Creation and Customization is intuitive and user friendly. Plate courtesy of Toontown Online. © 2002. Reprinted with permission from Walt Disney Company.

Plate 6 Toontown's *Speedchat* feature makes in-game communication quick and safe from profanity. Plate courtesy of Toontown Online. © 2002. Reprinted with permission from Walt Disney Company.

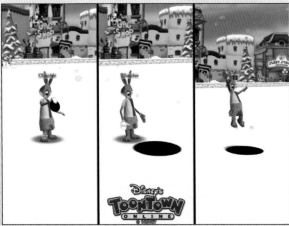

Plate 7 Teleportation in Toontown is performed with comical "portable holes." Plate courtesy of Toontown Online. © 2002. Reprinted with permission from Walt Disney Company.

(8) (9) (10)

Plates 8, 9, 10 Basic texture maps: (8) human skin texture (9) cloth texture (10) armor texture. Plates courtesy of Todd Hayes and Dale Homburg.

Plate 11 Basic texture maps can be layered together to customize the look of a character. Plate courtesy of Todd Hayes and Dale Homburg.

Plate 12 A large variety of looks can be generated from just a few texture layer combinations when used with Hueing of the textures. Plate courtesy of Todd Hayes and Dale Homburg.

Plate 13 Approaching an Earth-like planet and moon. The planet models are generated dynamically at run-time, and rendered using a spherical ROAM algorithm. When viewed from this distance, the planets are rendered using impostors to improve performance. Plate courtesy of Sean O'Neil. Reprinted with permission.

Plates 14,15,16 (14) View of an earth-like planet from orbit with a few impact craters. The planet's height map is generated at run-time using a fractal algorithm based on *fBm*. The planet's texture map reflects the height value at each vertex. The craters were added at run-time using a virtual quad-tree. **(15)** Close-up view of a moon with billions of impact craters. The craters are generated dynamically at run-time using a virtual quad-tree that requires no memory and runs in real-time. The crater shape can be modified to represent any shape you want to add to a terrain surface. **(16)** View of a Mars-like planet from orbit with a few impact craters. This one is very similar to the Earth-like planet except for its texture map, and the addition of more craters. Plates courtesy of Sean O'Neil. Reprinted with permission.

4.1

CLIENT-SIDE MOVEMENT PREDICTION

Mark Brockington, BioWare Corp.

markb@bioware.com

Users of Massively Multiplayer (MMP) games expect to be entertained by millions of objects inside the game you are designing, many of which move in autonomous fashion. Their perception of how the creatures move in the world affects how immersed in the game they become. Even a rare hiccup where a creature stutters into a new position becomes visibly jarring for users. Creatures that move through closed doors or through boxes remind the user that they are playing a game and are not actually engaged in a life-and-death struggle with the purple-jacketed, baseball bat-carrying thug.

This problem is not exclusive to MMP games; it is common to all networked multiplayer games. In this article, we are going to discuss algorithms that prevent the end user from seeing the problem.

Do I Need Good Movement Prediction?

Client-side movement prediction stems from two issues: the requirement for immediate user feedback and the variance of network packet latency. People want to see things happening immediately on their screens. When they click on the ground, step on the gas, or use the forward-movement button, they want to see their characters move. Players will not tolerate huge lags between their input and the result; they quickly tire when waiting for the result to be computed by the server and then rebroadcast to the client.

The need for immediate user feedback can be compensated for in numerous ways. An immediate audio cue signaling that the actor has received the order can mask the time delay as the command is being passed to the server [Svarovsky02]. We can also introduce command lag into the single-player portion of the game in order to reduce the expectation of immediate action in the multiplayer game. Unfortunately, astute users may still notice the delays.

Even if the users' expectations of immediate feedback can be properly dealt with, there are forces outside of your control that are working against you. Most multiplayer games attempt to enforce a constant rate of multiplayer updates to the various clients that are connected. Multiplayer gaming literature talks about update rates of 4 to 20 times a second. However, the Internet is a harsh network for gaming traffic. Some messages will be lost, and some packets will be rerouted through nonoptimal paths. This causes an extreme amount of variance in the time between location updates. Under poor network conditions, users will see actors hop from location to location. This is often referred to as *warping*.

This is not a domain for the application of the *Ostrich algorithm*; that is, you cannot bury your head in the sand and hope it does not happen. Action games such as *Half-Life*, *Battlefield 1942*, and *Unreal Tournament 2003* require accurate representations of your client and other clients' locations to provide a fun and nonfrustrating interface. Even games like *Neverwinter Nights*, *Total Annihilation*, and *Kohan: Immortal Sovereigns* require constant updates to prevent creatures and tanks from popping to new locations, making them more difficult to select in frantic combat situations.

In this article, we are going to talk about three separate techniques that will each help with the problem:

- Command-time synchronization
- Interpolation and extrapolation
- Reversible simulation

Command-Time Synchronization

Real-Time Strategy (RTS) games like *Netstorm* [Greer02] have to move objects to a specific position based on pathfinding requests. However, if each client moves their objects at the same speed, the objects on each client will get to the final location based on the latency of the move command from the server. Machines that are, on average, farther from the server will be further out of date than the server.

Thus, instead of sending "Move unit X such at that it will arrive at position P," we can also send the expected completion time: "Move unit X so that it will arrive at position P at time T in the future." If the time has been synchronized between the client and the server [Greer02], we can tweak the speed of the vehicle to reach the final point at the correct time.

This handles both of the issues discussed at the beginning of this article. A tank can be started at a slow speed on its path toward the final goal and anticipate being given the same movement by the server. Clients that receive the command later than others can move the tank at a slightly faster rate to reach the final destination at the correct time.

Figures 4.1.1–4.1.3 illustrate an example of command-time synchronization. The first client is controlling the tank and trying to move it 10 meters (each meter is represented by a hash line on the scale at the bottom of the figure). A tank can usually move at 10 meters per second. In Figure 4.1.1, we see the situation just after the tank has been ordered to move, and the client has decided to start moving the tank at a regular speed.

FIGURE 4.1.1 *Client1 has issued a 'move' command for the tank at a time of zero milliseconds.*

FIGURE 4.1.2 *After 200 milliseconds, the server receives a 'tank-movement' request and starts movement.*

FIGURE 4.1.3 *After another 200 milliseconds, each client receives the command, "tank must be at 10 meters at time 1,200 milliseconds."*

After 200 milliseconds have passed, the client is two meters closer to the target, and the server receives the movement command. The server verifies that the movement command is correct and starts the tank moving at the same 10-meters-per-second speed toward the final goal. Since the tank only moves at 10 meters per second, the server informs all of the clients that the tank must arrive at 10 meters at time 1,200 milliseconds.

After another 200 milliseconds, each of the clients receive the 'tank must be at 10 meters at time 1,200 milliseconds' command. Since the first client has already moved 4.0 meters toward the goal, it must travel the remaining 6.0 meters in 800 milliseconds, slowing its speed down to an average of 7.5 meters per second. The second client is completely unaware of the first client's movement command and is responsible for moving the tank 10 meters in 800 milliseconds. To reach the final goal, the second client must average 12.5 meters per second (m/s) for the tank.

It is important to note that when we tweaked the speeds, we mentioned average speeds. The jarring movement speed changes (e.g., from 10.0–7.5 meters per second) can easily be smoothed if the end movement is also slowed by an equivalent amount before the object reaches its final location. Furthermore, if the first client had an accurate representation of the latency, it could have predicted a 400-millisecond (ms) latency between the movement request and the response from the server, and moved the tank at 10 meters (m) over 1,200 ms, or 8.3 m/s.

Merging Waypoint Paths

Some games navigate based on a series of waypoints, such as in *Neverwinter Nights (NWN)*. For the purpose of pathfinding, *NWN* is a two-dimensional game. Creatures (objects that were allowed to move via pathfinding) move by keeping a list of two-dimensional waypoints to walk to. If a creature has no waypoints, it is not moving. Otherwise, a creature always faces and moves toward its first waypoint, deleting the waypoint when reached. Using this waypoint approach to movement allows us to transmit an initial list of waypoints at the start of movement and then not update the creature again until it has stopped moving.

In *NWN*, all movement requests are approved by the server, but we also allow a client to move in a straight line on its own behalf if it finds the line is clear. The server is responsible for issuing stop-movement commands when an object bumps into another object. The combination of these features causes the server's position and current path to occasionally differ from the client-object's position and current path. Inconsistencies between the server and the client must be resolved on the client.

To reduce the appearance of hopping, the server's updated position and path must be merged with the client's position and path. If we have c waypoints on the client's path and s waypoints on the server's path, there are $(c + 1) \times (s + 1)$ ways of

combining the two paths together via a single connection between the client's and server's waypoint lists, since the client's and server's initial positions must also be included as waypoints.

Figure 4.1.4 illustrates a server path with six waypoints and a client path with three waypoints. The eight gray lines represent the eight possible ways to merge the current client-server path that were attempted in *NWN*. If any of those eight paths were clear of static objects, we merge the waypoints together to create a new waypoint series. This allows us to get the client back on to the server's waypoint list in the minimum amount of time. After the waypoint lists are merged, the current server's waypoint list is measured in length and compared against the length of the client's waypoint list. The movement speeds of creatures in *NWN* were tweaked using command-time synchronization. In the case where all eight lines failed to generate a clear path, interpolation (which will be described in the next section) was used to push the object onto the server's path.

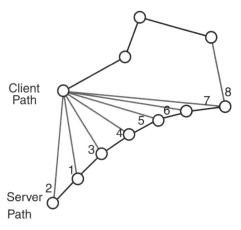

FIGURE 4.1.4 *Waypoint list-merging illustration from Neverwinter Nights.*

Why not use all pairs of client-to-server waypoints? When there is no possible way to merge the two paths, this example would force us to check 28 paths for static objects. In almost all cases when the algorithm failed to find a path in the eight paths shown, searching the remaining 20 paths did not yield a path and slowed down the rendering loop considerably.

Interpolation and Extrapolation

In the tank example given earlier, one assumption is that the first client was already moving along the correct path. In some cases, the path may have differed from the path selected by the server. For example, the 200-ms latency may have caused the

direct line between the start and end points to become permanently blocked, causing the tank to select a different path. In games centered on physics-based simulations (such as most first-person shooters), it is critical to place the client creatures at their correct locations so that targeting does not become a futile exercise.

The game *X-Wing vs. Tie Fighter* made the clients immediately jump ship to their proper locations [Lincroft99]. This did not seem bad when the latency was fairly small, but it could cause warping when the latency was quite high. Before the game shipped, a 'smoothing' algorithm was used to interpolate the previous prediction of the player's position and their new, current position. *Tribes* implemented the same interpolation technique over a period of 100 ms [Frohnmayer00].

Here is an example of how extrapolation and interpolation work. In Figure 4.1.5, we see two lines. The straight black line represents what the client knows about how the object is traveling. However, the gray line represents the turn that the object is actually making on the server. Each dot on the lines represents a small unit of time (in this example, 100 milliseconds per point). If we do not receive input from the server for 400 ms, the client uses *extrapolation* to render the object along the straight path. Extrapolation uses the last known position (or positions) and the velocity of the object to predict the future position/velocity of the object. The longer the server waits to update the client, the farther out of position the two objects will be.

FIGURE 4.1.5 *Server views and client extrapolation of object position.*

Figure 4.1.6 represents what would happen if the client receives input that the object is turning after 200 ms. The client is responsible for using *interpolation* to match the server's position and velocity. Interpolation uses a known position and velocity at a future point in time that the client must match within an interval of

FIGURE 4.1.6 *Client uses interpolation to match server position.*

time. In this example, the client executes a sharp turn so that the client's object will match the server object's position and velocity within 200 ms.

Interpolation works well when there is no visible impediment between the client and server positions. If the path is not clear (e.g., a stationary wall intersects the client's interpolated path), we always have the alternative of snapping the client to the server's view in order to put the object immediately on the right path.

The technique that we have described above is a linear interpolation technique [Olsen00]; we have used only one reference point to get the client-side creature back on track. For most games, this is sufficient. However, in 3D games like *Half-Life*, deathmatch players tend to bounce off of the ground like balls in attempts to make themselves harder to hit [Bernier01]. At any given moment in time, the player is either in the air or on the ground, ready to jump again. Based on our sampling approach, the player may seem to be floating in air. The approach in *Half-Life* is to use the last few update points to predict how the player is traveling through the world via a curve that encompasses all of the points. Instead of an object hovering above the ground to reach their next position, they correctly interpolate back to the ground and bounce like rubber balls.

In Figure 4.1.7, we see an example of a path followed by a hopping creature, with the z-direction on the vertical axis. The creature (represented by the gray line) leaps again as soon as it hits the ground. The circles represent the last three known client positions for the object, whereas the triangles represent the server's current location and the predicted locations 100 ms and 200 ms in the future. In this example, we will still use 200 ms to reach the proper server position, as in the example of linear interpolation from Figures 4.1.5 and 4.1.6. A linear interpolation technique would force the creature along the black line in Figure 4.1.7.

FIGURE 4.1.7 *Linear interpolation for a hopping creature.*

Figure 4.1.8 illustrates a *Catmull-Rom* spline that can be drawn between the first two predicted points on the server's new path and the last two points that the client knows about [Rabin00]. Using a higher-order spline would allow the interpolated path to get even closer to the impact point.

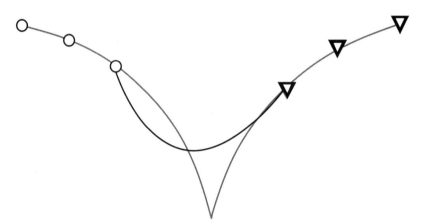

FIGURE 4.1.8 *Catmull-Rom spline interpolation for a hopping creature.*

Reversible Simulation for Aiming Lag

These approaches, by themselves, are not sufficient in the realm of first-person shooters. These games do not work on waypoints, so neither command-time synchronization nor waypoint merging are valid techniques. Interpolation, by itself, seems useful. However, a client experiencing a large lag will continually miss their target when the 'shoot' commands are sent to the server. The client may have lined up the player in his sights, and the player may have pulled the trigger at the right time, but in reality, the

target object was located in a different spot on the server. This will yield an extreme amount of frustration for end users who will claim that the shooting code is 'sloppy.'

Figure 4.1.9 illustrates the problem. The client is located in the tank and sees a soldier in its sights, and pulls the trigger. However, the server knows that the soldier has turned and taken a different path. When the shoot command goes to the server, no damage will be applied to the soldier.

So, how does one fix this problem? Let us take another example from Valve's *Half-Life* [Bernier01]. If the server could see the situation as it existed on the client at the time the shot was fired, the server would be able to determine correctly whether the person had been shot. The easiest way to do that is to actually have the client tell you that it hit the object. But you never want to be in a situation where you have a client telling the server that a person was actually hit; this is tantamount to telling the hackers to destroy your game service [Randall02]. Never trust the client!

In *Half-Life*, the core of the simulation can not only do forward simulations, but it can do reverse simulations, as well. The game code can go back through its history, using the same series of commands that it sent to the server that have been acknowledged, and compute the location of the client's objects at the time of the command. Once the hit/miss calculation has been made, the objects in question can be brought forward in time to their current time and locations. This requires a synchronized timer between the client and server in order to accurately compute the latency.

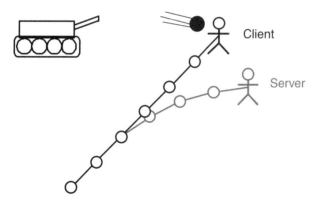

FIGURE 4.1.9 *Differing client and server views lead to missed shots.*

Using the example from Figure 4.1.9, the client last received a movement packet 400 milliseconds earlier. The client has not acknowledged any later commands. Thus, the server knows that it must go back to the time frame for the final acknowledged command for that client. This is illustrated by the curved arrow in Figure 4.1.10. Then, the server must extrapolate what would have happened on the client if no additional commands had come in (the diagonal arrow in Figure 4.1.10). Now the soldier

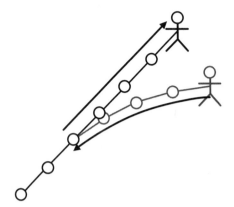

FIGURE 4.1.10 *Using reversible simulation to change from server to client view.*

is in the correct position as the client saw it, and the server can verify that the tank actually hit the soldier.

Conclusion

Depending on the genre of game that you are working on, client-side movement prediction can vary from 'a nice feature to have' to 'key and critical to the game's success.' We hope that the techniques discussed in this article, along with its accompanying references, will give you a greater understanding of what you will need to accomplish in your MMP and how far you should be taking this scheme.

References

[Bernier01] Bernier, Yahn, "Latency Compensation Methods in Client/Server In-game Protocol Design and Optimization," Game Developers Conference 2001 Proceedings, 2001: pp. 73–85.

[Bettner01] Bettner, Paul and Mark Terrano, "1500 Archers on a 28.8: Network Programming in Age of Empires and Beyond," Game Developers Conference 2001 Proceedings, 2001: pp. 789–803.

[Frohnmayer00] Frohnmayer, Mark and Tim Gift, "The TRIBES Networking Model or How to Make The Internet Rock for Multi-player Games," Game Developers Conference 2000 Proceedings, 2000: pp. 191–207.

[Greer02] Greer, Jim and Zachary Simpson, "Minimizing Latency in Real-Time Strategy Games," *Game Programming Gems 3*, Charles River Media, 2002.

[Lincroft99] Lincroft, Peter, "The Internet Sucks: What I Learned Coding X-Wing vs. TIE Fighter," Game Developers Conference 1999 Proceedings, 1999: pp. 621–629.

[Olsen00] Olsen, John, "Interpolation Methods," *Game Programming Gems*, Charles River Media, 2000.

[Rabin00] Rabin, Steve, "A* Aesthetic Optimizations," *Game Programming Gems*, Charles River Media, 2000.

[Randall02] Randall, Justin, "Scaling Multiplayer Servers," *Game Programming Gems 3*, Charles River Media, 2002.

[Svarovsky02] Svarovsky, Jan, "Real-Time Strategy Network Protocol," *Game Programming Gems 3*, Charles River Media, 2002.

4.2

KEEP IT SMOOTH: ASYNCHRONOUS CLIENTS AND TIME TRAVEL

Jay Patterson, Xbox Live™

jaypat@xbox.com

How many times have we seen previews for an episode of *Star Trek* where the *Enterprise* is destroyed in a spectacular explosion, and we assumed it was going to be another story about time travel and alternate realities? It is not likely the real ship would blow up like that, so it must happen in some other universe. You could also be confident that the ship's demise would be the result of some temporal anomaly. The writers of *Star Trek* knew that the relationship between time travel and alternate realities fit together in an approachable, common-sense sort of way.

The goal of this article is to use that simple relationship between time travel and alternate reality to help deal with the sometimes mind-bending topic when latency gets turned up, and when game clients do not wait to be told what happens next—and what players experience as a result of this latency. Refusing to wait is what essentially defines an 'asynchronous client.' The actual network model or protocol can vary, but if the client is able to keep moving when the network cannot keep up, it is considered asynchronous. In this type of game, each player exists to some extent in its own universe, so you need to stop thinking of your game as only creating a single reality.

A fundamental postulate of what follows is that to the extent you are able to take yourself out of the shared core and get out to where the game is really happening—on the player's screen—you will make a better game. The traditional approach centers on one game universe and makes concessions to multiplayerability by cleverly sharing its state. Shared experience requires agreed-upon perception; and most of the time, this is the more-practical perspective. The idea here is not to replace that point of view, but augment it with a deeper appreciation for the possibilities and limitations of each private world. Really getting out there to the client's point of view can be difficult, perhaps even uncomfortable, but thinking like a time traveler can make it easier.

Latency and bandwidth (the time it takes data to propagate and the amount of data that can be transferred over time) are the enemies of a smooth, consistent view of the game for all players. Your game will constantly battle these limitations, where time is a common element. A way to win that fight is to manipulate time to your advan-

tage. As events move over the network, your game is essentially moving through time. Being a time traveler means getting a feel for that flow.

Practical as well as philosophical suggestions regarding the passage and use of time will be presented in a manner that should be accessible to every member of a game development team. It is important that everyone making a multiplayer game for the Internet understand what they are up against if their game is to reach its full potential. Every team member should appreciate the implications of what they do in relation to what players will experience. This is vital for designers and programmers, but artists can also expand the possibilities of the game if they understand the fundamental limitations of networking,

Normally, AI and network programmers will be aware of what is happening 'on the wire' because they are the ones who drive the movement and use of game state. However, there are no perfect abstractions that shield everyone else. Optimal use of the Internet requires methods specific to what is happening in the game for any given player at any given moment. Designers must set priorities and be selective about when consistency among player worlds matter, and they have to be careful to give the programmers battles that can be won. Also, throughout production, tools must be used to continuously evaluate what happens to the game under real Internet conditions. This is especially true when participants are allowed to asynchronously run free, because the natural divergence of reality can manifest itself in unpredictable ways.

The Basic Shared-State Problem

Shared state is what puts the "multi" in multiplayer. If there is no interaction based on common goals in a common environment, it is not a multiplayer game. This interaction can be as simple as a virtual card table and deck of cards, or it can be as involved as an entire, simulated universe so real that players feel as if they are actually there. In any case, there will be shared data that must be the same for all players Also, because playing a game is not a passive activity, some of the data will change in unforeseen ways. It is the delivery of changes to that shared state that is the basic problem of any multiplayer game.

Dealing with this problem has an active history, and the variety of approaches is vast [Singhal99]. The military has done extensive research in the creation of *Distributed Virtual Environments* (DVE) as a training mechanism. Significant results of their work are *Distributed Interactive Simulation* (DIS), *Simulator Networking* (SIMNET), and *High-Level Architecture* (HLA). Each of these contributed new ideas to the problem of sharing state, though getting to the nuggets that are useful for multiplayer Internet games can be difficult. Part of the problem is that much of the literature completely ignores latency and bandwidth problems, assuming instead a fat and fast local network connection. Another aspect of military simulation research that needs to be filtered out for our needs is the

intense focus it places on standardization for the purposes of interoperability. However, searching the Internet for any of the above can lead to interesting reading.

Much of the state-propagation discussion focuses on throughput, or how much data can be moved. An excellent resource on this topic [Singhal99] frames it in the context of the 'throughput-consistency tradeoff.' However, there is not much made of the 'latency-consistency tradeoff' that is more to the purpose of this article. The reason for this is possibly that the throughput problem is much more technically solvable. Much can be done by programmers in areas such as network topology and messaging design to mitigate bandwidth limitations. This is not true when it comes to latency—which is also why so much has been said about getting the whole team involved in solving the problem. Technical tricks related to throughput and consistency are left to the reader to explore independently.

Dead Reckoning: Time Travelers Do It Better

As previously mentioned, one extremely useful topic that came out of military simulation research that is relevant to Internet games is *dead reckoning*. This is a form of client-side prediction that is used extensively in games that distribute positional data, such as first-person shooters. Once again, you will often see this discussed in terms of how less data can be sent, but it is equally valid to consider it as a way to compensate for latency. The full discussion of dead reckoning is a topic unto itself; but put simply, it means deciding what an object should be doing 'now' based on what it was doing 'before.' For instance, if it is time to move something, and a new position has not arrived yet—then guess. This guess is often based on where it was last, how fast it was moving, and (sometimes) how much it was accelerating the last time its position was known. A dead-reckoning model can contain historical information and allow for a wide variety of methods. Dead reckoning can be specifically tailored to individual types of entities.

Having time-stamp information on which to base predictions makes for much greater opportunity to keep things moving smoothly. Naturally, the ability to use velocity and acceleration information in a prediction algorithm implies some use of time, but that could be nothing more than local time elapsed since the last update. Marking state information with a shared simulation time allows better adjustment to the difference between what was actually happening compared to what was predicted. Basic dead reckoning is illustrated in Figure 4.2.1.

Notice that the movement to the corrected position involves a great deal of sudden discontinuity. Now look at what can be done if simulation time is used. Because of latency, the update of actual state could be in the past. The position at that time has already been guessed, so it is no good just popping to it. Instead, the new position is once again predicted based on the difference between the time of the update and the current simulation time. This is shown in Figure 4.2.2.

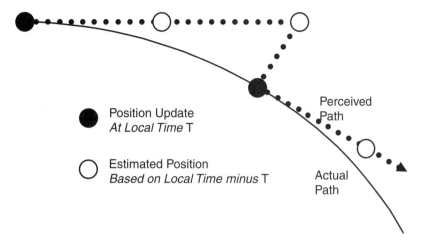

FIGURE 4.2.1 *Basic dead reckoning.*

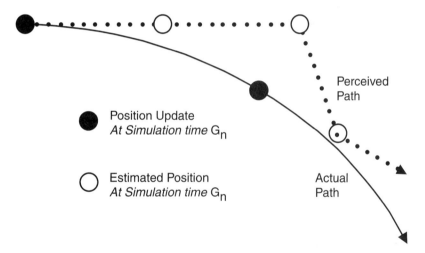

FIGURE 4.2.2 *Dead reckoning with time compensation.*

Another thing that can be done is to interpolate the old path with the newly pre-dicted path to achieve even greater smoothness [Fujimoto00]. Beware that interpola-tion could cause unacceptable drift from the true state. As you can see in Figure 4.2.2, even without interpolation, the displayed path does not get back on the actual path, and it will not until the object once again either moves in a straight line or stops. If being on the true path is of absolute importance, it may be necessary to pop there, or perhaps even roll back local simulation time to do so.

The tradeoffs that can be made between smoothness and accuracy when using dead reckoning have to be considered in terms of gameplay in order to be optimal.

Every object in the game does not have to play by the same rules. For instance, something that can change direction rapidly will be hard to predict; and because of this, a smooth rendering is more likely to be inaccurate. However, that might be okay if there is not a great need for the object to be consistently perceived by all players. Designers and programmers need to work together to make the best choices on a case-by-case basis to get the most out of dead reckoning.

Representing Simulation Time: Preparing the Way for Time Travel

When talking about time in a game (simulation time), we do not always mean real time—or "wall-clock time," as it is sometimes called. Games can have many time scales active at once. Like the scale on a map, a time scale is a ratio between what a player would measure on their watch compared to the virtual time passed in the game world. Sorting events or actions in a game by the time scales that govern them is a good first step toward more-active manipulation, because it destroys the notion that time is absolute. For example, arms and legs might animate in real time, bullets may fly in real time, but environmental effects (e.g., day, night, or resource regeneration) are likely to be accelerated, and economic or cultural developments would be faster still. Also, considering how each of these time scales could be used can help conceptually. For instance, in some cases a scale would need to progress continuously, but in other cases time could be advanced so that events are processed in big, discreet batches.

Regardless of the scale or how the clients choose to move through it, for our purposes there needs to be an agreed-upon, shared simulation time to which all participants synchronize. There are several well-established protocols for this. The primary factors that differentiate them are: some use a centralized authority, while some distribute authority; and some periodically broadcast, while others respond to requests [Fujimoto00]. The fundamental problem is the need to compensate for the unknown amount of time it takes to deliver the time values. An adequate and simple approach is to have one authoritative time source, make a bunch of requests to it, and then add one half of the average response time to the value it gives you. It can get much more complicated, but it does not need to be.

Although Internet latency is not necessarily the same in both directions, this technique is still effective. There is no risk of causal errors in the simulation logic as long as events are ordered using a time stamp generated in the same location.

Once all watches are synchronized, events and messages can be located in a global context that has many benefits. These include the improvements to dead reckoning described earlier and the ability to quickly determine current latency. The global-timing context also allows the proper ordering of events to be maintained. A good

example of why this is important comes from early military simulations where events were not time stamped and merely processed in the order received. This meant that when message delay varied, it was possible to see a weapon fire after its target was hit. Note, however, that having a global time to locate and order events does not mean that all clients are physically at the same time. Quite the contrary, participants may move through simulation time to suit their own purposes when compensating for problems created by latency. This could mean speeding up, slowing down, staying intentionally behind, or even going back to re-evaluate the events for a particular time based on new information. Global simulation time is a framework, not a mandate, for lockstep execution.

Simulation time should be completely separate from frame rate. Manipulation of 'when the client is' needs to be independent of the regular rhythm of 'view updates.' That does not mean that user input cannot occur at regular frame-rate intervals, or that the effect of some simulation will not be available for each new frame. In fact, because the goal is to keep things moving smoothly, we would like there to be new things to display each frame. What is implied is that 50 frames per second (fps) does not force each frame to plough through 20 milliseconds (ms) of simulation time. We want to reserve the right to play a bit with how much simulation is done each frame. This also means that object characteristics, such as animations, will need to be independent of simulation time so players are less likely to notice if the passage of simulation time becomes irregular. Support of irregular time intervals is not essential to all forms of latency compensation. Strictly speaking, the dead-reckoning example given earlier does not rely on this support, nor does the common practice of simply running each participant slightly in the past. However, keeping simulation time-independent of frame rate does allow for the greatest choice of approach. Furthermore, to achieve the greatest flexibility, object behavior calculations should be based on time deltas instead of fixed, discrete simulation ticks.

Manipulating Time Directly

One common way games use time is to have each client run simulation time slightly behind real time. This gives time for network messages to arrive before they are actually needed, but it also introduces a fixed delay to player interaction. However, this delay can be masked by sounds or animations that immediately acknowledge and initiate player actions, even though there will be some fixed delay before the shared world will be aware of it. One example of how handy this can be has to do with the problem of degenerative situations related to the aforementioned prediction smoothing. If the client simulation clock is targeting a time in the past, you should regularly know where a remote object is going before it actually gets there. This means you will be interpolating to a point in the object's future instead of extrapolating from a

known point in the past. There is no risk of drift, because the actual path is regularly touched. One way to expand on this practice would be to make the delay variable. During periods of increased latency or packet loss, the passage of simulation time on a client could be slowed to allow the messaging window to grow, and conversely sped back up to close up the delay when things get better. This would allow a minimal delay to be used most of the time, yet also handle the periodic disturbances that occur on the Internet.

Similar to having clients run behind is the use of an authoritative server that looks into the past to make decisions. The game *Half-Life* has used this method of latency compensation and serves as an excellent example of it put into practice [Brenier01]. Essentially, the server goes back in time to put what players did in the context of what they saw when they did it. Time stamping of commands makes this possible. The server can know the circumstances at that instant, because it runs the same modeling code and knows what it has told the client. This allows it, for example, to decide if a shot hit its target based on the recreation of what the player was seeing and aiming at when the shot was fired.

No matter how much prediction or fancy time manipulation is done, there is always the chance that the client will not have enough information to move forward in a meaningful way. When that happens, the game stops. The player is jarred out of their feeling of immersion and more than likely misses interesting things that are happening in the shared experience, such as being killed. Designers have to be aware of a risk/reward analysis that goes along with choosing gameplay. Game designers need to be informed of how likely a game will freeze or jump, and what can and cannot be done about it. For example, a sloth-racing game involves very little risk, which is good because the rewards are not so great, either. On the other hand, a platform jump is terribly risky due to hard-edge conditions that prediction can have a lot of trouble with, not to mention the tendency to rely on precisely timed twitch input, which is not going to feel right in the presence of too much lag-compensating delay. The game designer has to understand this and has to be able to ultimately come up with gameplay that works.

One way to make the designer's job easier is to allow the problem to be divided such that temporal tolerances can be object-specific and dynamic at run time. The best decisions about risk and optimization are made when the problem domain (the game) drives them.

The following technique does exactly that. It is taken from the time-management system of the *Run-Time Infrastructure* (RTI) of the military HLA simulation standard [DMSO02]. In a way, it is like the approach of running a client with a specified delay, as described earlier, but with much more potential.

RTI time management is concerned with things that are constrained by time and things that regulate time. It also controls the passage of time in that each participant

must ask to be able to advance its local clock. We are going to ignore that last part and focus on what it means to be constrained by, and to regulate time. To do so requires understanding these two important terms:

- *Lookahead*—The minimum granularity of events generated by those participants that are being regulating. In other words, a lookahead is the least possible delay between when an object state is changed and when the state can change again.
- *Lower-Bound Time Stamp* (LBTS)—The minimum time stamp a constrained participant can expect on a state change from the other participants that regulate it. In other words, it is the earliest the next update that a participant depends on could happen.

Figure 4.2.3 illustrates what these terms mean. There are four entities on it. One is only constrained, one is only regulating, one is both, and one is neither. Each is moving across a global simulation timeline with its current time marked by a dark circle. Both entities that are regulating have a shaded rectangle in front of them that represents their lookahead. A dashed vertical line represents the LBTS.

Imagine the lookahead as being an attribute that can be specified simply and experimented with for different objects in different situations. Then think of the LBTS as the barrier that the local simulation time should not cross if it does not want to potentially miss state updates. If you surmise that because the lookahead would be so small most of the time, the LBTS would not provide much of a window to work with, congratulations! You understand RTI time management. Remember, this is one of many networking tools that can be combined together. For example, with decent prediction, it is possible the lookahead could be stretched to the point where this approach would become useful in situations where it otherwise would not be of value. The LBTS could merely determine a client simulation time delay, or it could be a target that causes client time delay to stretch and shrink as if attached to it by a rubber band. However this method is used, key benefits will be derived from the way time sensitivity is rendered as granular and accessible.

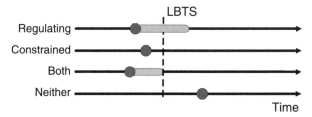

FIGURE 4.2.3 *RTI Time-management entity state diagram.*

Conclusion

Fully supporting, divergent client views of your game is a challenging undertaking. It is difficult to imagine what will happen when clients run freely and smoothly into the future. It is difficult to manage the greater burdens placed on nearly every member of the team. Doing so fundamentally requires that the following goals be held in high regard:

- Keep what clients see smooth. Being smooth is more important than being accurate. There may be many players, but each must feel as if it is all about them. Freezing or popping should be avoided above all else.
- Keep players aware and able to participate in what is happening to them. Being in control of their own world is more important than what they contribute to someone else's world.

Granted, the second point probably goes a bit beyond the scope of the discussion here, as well as opens whole other questions about security and contention for limited resources. Notice, however, that no specific mention is made of peer clients making global decisions as a practice favored over the use of some authoritative server. The intention of this article is to advocate a player perception that needs to be supported regardless of the underlying implementation. It is true that if a client can be trusted, it becomes much easier to make the client seem authoritative because, well, it is. Beware though; the history of trusted clients in Internet games is not good. However, security and trust are questions of degree, not absolutes. There is room for selective optimization specific to particular game situations and general audiences/platforms.

It is all about player perception. If you are going to let your clients be asynchronous, they need to be able to do meaningful things asynchronously, whether or not their client is the true authority. Figuring out what clients need to be able to decide for themselves involves some of the most-fundamental balancing decisions that designers need to make when dealing with asynchronous clients. What we allow players to do for themselves can be implicitly tied to what we allow other players to do to them. For example, consider the previously discussed lag compensation method used by *Half-Life*. In order to make the process of shooting other players seem more consistent, the designers of *Half-Life* had to accept that getting shot in return could be inconsistent. In a quick-respawn game like *Half-Life* where the penalty for dying is small and the real visceral fun comes from blasting everyone else, this was a wise decision; in an MMP where player death carries a much higher cost, it would not be.

Thinking about and building a game that bends time to its will is a process of exploration and discovery. It will be impossible to know how design, code, and assets respond to the rigors of Internet latency until they are put to the test. Use tools to simulate Internet conditions. Ensure those tools are used regularly by as many people

as possible right from the start. Ideally, anyone who runs the game to check their work should have access to two clients, with an Internet simulator between them. The more people that are able to see the game first hand and learn from the results of their decisions, the better the game will be. It is also important for the game engine to provide feedback concerning what is happening on the network in terms of current latencies and bandwidths, and for that feedback to be used to guide value decisions made by designers. There are no perfect abstractions that hide networking issues, but there are good ways to wrap them up for easier consumption.

Appreciation for the passage of time as events unfold is something that can be generally helpful to anyone who takes part in the creation of networked multiplayer games. Even in the era of broadband, there is no escaping the limitations of latency and bandwidth. Being a time traveler is more of a perspective than anything else. It is about putting yourself in the shoes of all your players at once and each individually at the same time. It is about understanding why programmers have no magic bullets to deal with all the limitations of Internet-related latency. Time is an enemy, and being a time traveler is knowing that enemy.

References

[Bernier01] Bernier, Yahn W., "Latency Compensating Methods in Client/Server In-game Protocol Design and Optimization," 2001 Game Developers Conference Proceedings, 2001.

[DMSO02] Defense Modeling and Simulation Office, *RTI 1.3-Next Generation Programmer's Guide Version 6*, September 4, 2002.

[Fujimoto00] Fujimoto, Richard M., *Parallel and Distributed Simulation Systems*, John Wiley & Sons, Inc., 2000.

[Singhal99] Singhal, Sandeep, et al., *Networked Virtual Environments*, Addison-Wesley, 1999.

4.3

PROCEDURAL WORLDS: AVOIDING THE DATA EXPLOSION

Sean O'Neil, Contract Developer for Maxis, Inc.

s_p_oneil@hotmail.com

ON THE CD

Source code from this article can be found on the companion CD-ROM.

As many in the industry already know, the detail level in games is growing at an incredible pace. Along with this growth has been an explosion in the amount of data required for a high-quality, professional game. To manage this data explosion, game development shops have come to rely heavily on procedural generation. Many shops purchase it in the form of third-party products. Some good examples are 3D Studio, Bryce, Lightwave, TerraGen, and MojoWorld. Others write their own procedural routines either as separate utilities or as plug-ins for third-party products. Some even generate data dynamically at run time.

ON THE CD

This article will explain run-time procedural data generation in game engines—more specifically, generating large game worlds dynamically at run-time. We will touch on a number of benefits and drawbacks of run-time generation, as well as some of the problems of scale encountered when working with large game worlds. A sample implementation with a working set of source code and executables is provided on the CD-ROM that accompanies this book.

The Benefits of Run-Time Generation

There are a number of benefits and drawbacks to run-time procedural generation. For online MMP games that require very large and detailed game worlds, the benefits weigh very well against the drawbacks. Even if run-time generation is not right for your project, the techniques explained in this article may still be useful in pregenerating large game worlds, and the code provided may be useful for quickly reviewing the output of procedural functions during the development cycle.

The key benefit of run-time procedural generation is data size. Using a single random seed and a good pseudo-random number generator, an entire universe can be

generated. As long as every player starts with the same seed and has the same routines, every player will see the same universe. The 1984 game *Elite* [Bell84] was a classic example of the effectiveness of run-time procedural generation. It was a graphical space combat/trading game that contained a virtually unlimited game universe, and its original platform ran on only 32K of RAM. A few books and articles have been published on those techniques [Lecky01].

While computer hardware has improved a lot since 1984, the same problems remain due to an ever-increasing amount of detail. If a large game world is needed that is incredibly detailed, all of that detail must be generated somehow, and it has to be either generated at run-time or pregenerated and stored somewhere. The other benefits of run-time generation revolve around the small data size. Online distribution becomes faster and cheaper, storage media requirements are reduced, the load time the user experiences for the game world is reduced, and (depending on how it is implemented) the amount of system memory used may be reduced.

For MMP games, size-related benefits could be great. Depending on how game world updates are distributed to the clients, new procedural scripts and procedure DLL updates (hopefully not as often) can be distributed instead of in the form of large data files. Terrain changes, static world object changes, new texture maps, and a number of other things can be generated automatically on each client. Of course, some texture maps will have to be drawn by hand, but today many texture maps are generated entirely using procedural routines in 3D Studio Max, and it is those textures that could be replaced with procedural scripts.

To give a quick example of just how much detail can be generated and how much space can be saved, let us use a full-size planet like Earth as an example. The Earth has an average radius of approximately 6,378 km. To model this, start with a 20-sided icosahedron and split each triangle into four triangles recursively (which gives a good approximation of a sphere). If we split recursively 20 times (20×4^{20}), we have approximately 22 trillion triangles, and each triangle edge would be about 0.3-km long. The space requirements for height maps, texture maps, bump maps, and so on are ludicrous, and the detail level is still pretty bad. To put things in perspective, no terrain detail would exist within any 900-m^2 patch of terrain. Imagine mountain peaks or entire hills just being chopped off. With run-time generation, we need only a single random seed to generate as much detail as we want.

The Drawbacks of Run-Time Generation

The most obvious drawback of run-time generation is performance. The more complex the procedural routine is, the more expensive it becomes to generate each height value in your game world. There are a number of techniques and algorithms that can be implemented to alleviate the cost of these algorithms, but the cost never goes away

completely. As a result, we must be careful when deciding what to generate at run time, what to pregenerate when loading a game level, what to pregenerate when applying an update, and what to pregenerate in-house.

Another drawback is the added complexity of the engine and the added development time that this implies. The procedural routines are not usually complex by themselves, but run-time generation of large game worlds requires dynamic Level-Of-Detail (LOD) routines, which can be very complex. The sample implementation in this article includes a simple and fast spherical algorithm based on Real-time Optimally Adapting Meshes (ROAM) [Duch97]. A description of the algorithm is provided in a later section of this article, and the sample implementation can be easily modified to work with 2D height maps. It can also be easily modified to handle pregenerated data, dynamically generated data, or a combination of the two.

Another problem with run-time procedural generation of data is that most procedural generation routines, like random-based fractal routines, are difficult to control. Many game designers are not comfortable with distributing random game worlds that cannot be tailored by designers or artists. This article will explain a few ways to compensate for this problem, but the problem may always exist to some extent. The easiest solution may be to pregenerate down to a certain level of detail, and then fill in the rest with dynamically generated data. A more-complex solution would involve writing more-configurable procedures with stored changes that can be applied on top of the dynamically generated data (e.g., add a crater here, add a volcano there, add a city over here).

Last but not least, it is worth noting that using dynamic LOD algorithms in multiplayer games causes some unique problems. Regardless of how terrain is generated, dynamic LOD algorithms display detail in a view-dependent fashion. Because each player in a multiplayer game is seeing the same world from a different viewpoint, each player may see a different set of triangles rendering the same piece of terrain. This can cause problems with visual artifacts, such as another player's feet floating above the ground or disappearing beneath the ground. It can also cause problems with how objects are rendered, and how collision detection is handled.

Handling these dynamic LOD problems for multiplayer games has been done in recent games, but much of it is beyond the scope of this article. Some good examples of multiplayer games using dynamic LOD algorithms are *Tread Marks* [McNally], and both versions of *Starseige: Tribes* [Sierra].

Classifying Terrain-Generation Algorithms

The number of unique procedural algorithms that exist for generating terrain is limited only by your imagination. However, some types of algorithms are more suited for run-time generation than others, some scale up to higher-detail levels better than oth-

ers, and some create more varied and realistic terrains than others. Of course, all algorithms must be repeatable in the sense that they must always generate the same terrain when given the same parameters. The algorithms that do not scale up well typically require a fixed-size mesh to be pregenerated. Let us call these algorithms "static algorithms" because they work with static meshes.

Consider the scale example of the Earth, mentioned above, and it is easy to see why static algorithms do not work well for run-time generation. The best procedural algorithm for run-time purposes provides a single function (let us call it "`GetHeight`" for now) to generate the correct height at any specific point on the map. Because a simple `GetHeight` method can also be implemented very easily for pregenerated height maps, this mechanism will also work for terrain that is not all-dynamically generated. Let us call these algorithms "dynamic algorithms" because they can dynamically generate the height value for any location required, which allows us to generate any portion of the terrain at any level of detail.

Static Algorithms

There are a variety of algorithms out there that are completely static. A mesh size is chosen, and operations are performed on the entire mesh. They are worth mentioning because they can be easier to control, and they work very well for pregenerating terrain down to a certain level of detail, and then are supplemented with a dynamic algorithm.

A good example of a static algorithm is the *fault line* algorithm [Elias]. This algorithm takes a fixed-size mesh and randomly divides it into two pieces. For 2D terrain, a random line is generated that divides a square. For 3D terrain, a random plane is generated that divides a sphere. The height values in the mesh are raised on one side of the fault and lowered on the other. After several thousand iterations of this, the terrain looks pretty good. The higher the number of iterations, the better it looks.

It is worth noting that this algorithm could be made dynamic by creating a `GetHeight` method that checks a list of thousands of fault lines at run time, but this would cause two problems. The first is that it would be exceedingly slow. The second is that, up close, the fault lines would be clearly visible as vertical discontinuities (or steps) in the terrain.

Subdivision Algorithms

The most basic subdivision algorithm that most people have read about is the plasma algorithm. The plasma algorithm starts with a 2D square or triangle and then recursively subdivides it, raising or lowering each new vertex in the mesh by a random amount. At each level, the maximum variance of new vertices is reduced by a certain factor. That factor controls how rough a surface is. Most implementations use a fixed

factor, which causes the terrain to be very monotonous; typically, all mountains and valleys look very similar. The method can be improved by varying the reduction factor by location, causing some parts of the terrain to be smoother than others.

Subdivision algorithms are essentially static algorithms. The points in each subdivision level must be generated in the same order each time to get the same mesh from the same random key; so at each level, the entire mesh must be generated. This forces the algorithm to be static. It is important to note that subdivision algorithms may be turned into pseudo-dynamic algorithms. Because triangle mesh subdivision usually implies splitting a triangle edge in the middle, it is not feasible to write a `GetHeight` function that quickly returns the exact height at any chosen point in the terrain (that would require an infinite depth of recursion in a subdivision tree).

However, it is possible to build a tree structure that mimics an adaptive mesh algorithm. For now, all we need to know about these algorithms is that they generally subdivide triangles in a fashion very similar to the terrain subdivision algorithms. The only problem is that in adaptive mesh algorithms, the order that triangles are subdivided depends on the camera path, and this will mess up the random generator's seed. The solution to this is to generate a new seed for each triangle. How the new seed is generated does not matter as long as the same triangle always gets the same seed, and as long as the root seed affects the generation. Keep this idea in mind, as it can be very powerful when applied in different ways.

Dynamic Algorithms

Most dynamic procedural algorithms used today are based on *Perlin noise* [Perlin99]. Perlin noise is so popular that 3D chipset manufacturers plan to implement it in video hardware. To put it simply, Perlin noise quickly generates smoothed random noise using a randomly generated table of numbers. A special lattice function is used to perturb the parameters passed to it so that it does not repeat, based on the size of its number table. Each entry in the table represents the resulting value at integer locations in the map, and linear interpolation is used to smoothly interpolate between those integer locations. Any number of dimensions can be passed to it, but each extra dimension increases the cost of linear interpolation exponentially.

The most well-known procedural algorithm for generating terrain based on Perlin noise is called *fractal Brownian motion* (fBm). Put simply, fBm is a weighted sum of calls to the Perlin noise function at different wavelengths (or positions in the lattice). See Equation 4.3.1 for a better idea. The variable p is the point on the map passed to the noise function. The variable n is called the "number of octaves" for the fBm routine, and in practice, it stops at a predefined value instead of going to infinity.

$$\sum_{n=0}^{\infty} \frac{1}{2^n} noise(2^n p) \tag{4.3.1}$$

Building on the basic fBm routine, Ken Musgrave has invented a concept that has been called a "multifractal" [Musg98]. Multifractals are essentially more-complex variations of the fBm theme. Some multifractal algorithms do a weighted product instead of a sum. Some include additive offsets and extra parameters. Kenton Musgrave is the main driving force behind MojoWorld, which is an excellent world-building program that combines his research with research from others in the field of fractal terrain generation.

Armed with a little bit of mathematical knowledge, we could play with variations of fBm as long as we like. Unfortunately, we could also spend a lot of time playing without coming up with anything interesting. Part of the problem with these fractal algorithms is that even small changes can have large, and in many cases undesirable, effects. It can take a while to get a good feel for how certain changes will affect the outcome, and even then surprises are common.

If this becomes a problem, keep in mind that any part of this procedure could be replaced or supplemented with a pregenerated map to gain more control over the outcome of the height map. Also keep in mind that it is not necessary to use a routine based on fBm at all. Any noise-based function will do. It would be easy enough to generate a set of fault lines and then generate terrain using a noise-based function that factors in proximity to the fault lines.

Altering Procedurally Generated Terrain

At some point, most designers will want to be able to manually alter procedurally generated terrain. The limits to creativity and feasibility become frustrating when trying to come up with mathematical routines to generate different terrain types and integrate them together in a realistic fashion. At some point, many would give up and want to do it by hand. Fortunately, there is a way to make alterations by hand and still fit them into a procedural world generated at run time. There is also a way to use static and pseudo-dynamic algorithms to alter a procedural world generated at run time to quickly add custom touches one could never achieve using noise-based functions and that would take too long to add by hand.

This article will use impact craters found on Earth's moon as an example. Any terrain feature could be handled in the same fashion, but craters are a good example because they are a common terrain feature found on every known solid planetary body, and any terrain generator could make use of them. Of course, the moon is peppered with craters of all sizes, ranging from those that look like all life had simultaneously been wiped out when they were formed, to tiny moon rock pits caused by dust particle impacts. To model the moon fairly well would require a great level of detail with billions or trillions of craters, and this section will work up to explaining how to do that. The sample code implements the dynamic algorithm, but not the static one.

Hand-Made Alterations

A designer wants to put a crater in a specific place on the map. He could be given an interface to define the point of impact and a radius, and with a single click, a crater could appear before his eyes. To tie this into the procedural generation, simply create a `GetHeight` method for the crater object. This method could pull height values from a set of height maps or implement a mathematical function. Every time a new vertex is created, first pass its location on the map to the main `GetHeight` method, then pass it to the crater's `GetHeight` method and offset the height from the main method.

Static Algorithm Alterations

A linked list of craters could be created and stored to disk as part of the game world. This increases the data size of the game world, but the number of hand-made alterations should remain relatively small. If a designer spends a lot of time adding thousands of craters by hand, something is wrong. That is what procedural algorithms are for, and it should not be very difficult to write a distribution function to generate a few thousand craters for his game world, which would be run at load time.

Of course, the run-time generation engine would come to a screeching halt if it had to check the location of thousands of craters for every new vertex. All that is needed to correct the problem is an optimized hit test for determining which craters to check for a certain location on the map. In the sample code provided with this article, a spherical planet is divided into six cube faces, and each cube face is treated as the root of a quad-tree. The craters would still be stored in a linked list, but pointers can be kept to them in the quad-tree based on each crater's location and radius. To get the height of a new vertex, the main `GetHeight` method would be called, and then the quad-tree would be traversed to determine which craters need to be checked.

Pseudo-Dynamic Algorithm Alterations

Now we get to the fun part—a real-time algorithm for adding billions, even trillions of craters to a procedural world using no memory and with no repeating pattern (not counting the limitations of the random number generator used and the size of the random seed). Think about the method explained above for making a subdivision algorithm pseudo-dynamic, and this solution may become obvious.

Take the crater quad-tree, make it a virtual tree (i.e., a tree that does not really exist in memory), and generate a new random seed for each node in the tree. At each node in the tree, randomly generate a few craters using the seed, and then go to the next level. Instead of using a real quad-tree with pointers and recursion, the `GetChild` method for the quad-tree can simply return the next random seed instead of the next pointer in the tree. The sample implementation provided with this article has three

parameters for the virtual crater tree: the level in the tree to start generating craters (or top level), the level in the tree to stop generating craters (or bottom level), and the number of craters per level.

A simple loop with some very simple code implements the virtual tree, and the only memory it requires, aside from the parameters, is the space for one tree node object, and that is allocated on the stack as a local variable inside the GetHeight method. With the bottom level set to 20, the game world will contain approximately 1.3 trillion craters; and while the engine runs a bit slower with craters than without, it is still real time. However, it is worth noting that too many craters will make the terrain very rough, requiring a lot more triangles to achieve the same level of detail.

```
float GetHeight(CVector vPosition)
{
    // First get the base height for vPosition
    float fHeight = GetBaseHeight(vPosition);

    // Then determine the face vPosition is in,
    // along with the x and y face coordinates
    float x, y;
    int nFace = GetCoordinates(vPosition, x, y);

    // Skip over the crater levels we don't want,
    // maintaining the proper child seed
    int nSeed = m_nCraterSeed + nFace;
    for(int i=0; i<m_nCraterTopLevel; i++)
        nSeed = GetChildSeed(nSeed, x, y);

    // Finally, loop to the bottom of the tree,
    // adding the height of the craters in each node
    CCraterMap node;
    for(; i <= m_nCraterBottomLevel; i++)
    {
        node.Init(nSeed, m_nCratersPerLevel);
        fHeight += node.GetOffset(x, y);
        nSeed = GetChildSeed(nSeed, x, y);
    }
}
```

TANSTAAFL and NEWYDIFR

It is time for the catch: "There ain't no such thing as a free lunch," or "Nothin's easy when you're doing it for real." The catch is that the pseudo-dynamic algorithm described above has some noticeable flaws in it. All of these flaws can be solved easily enough in the static algorithm, but like the previously described fractal algorithms, the dynamic algorithm is harder to control. As a result, all of these problems can be alleviated by combining the static and dynamic algorithms, using a real quad-tree for a fixed number of levels, then switching to the virtual tree. For the problems that can be fixed for the dynamic algorithm, the solution is too expensive.

The first problem is that craters can not cross the boundaries of the quad-tree cell they are in. This means that at high-level cell boundaries, there are very long lines of terrain with a conspicuous absence of craters. It will take players time to notice this one, but most players who explore a moon long enough will notice it. This one can be fixed easily in the static algorithm, as a crater that spans multiple quad-tree cells can just have pointers put into multiple cells.

The next problem is that the cells in the quad-tree are not perfectly square. Each face of the starting cube is projected onto a sphere, which causes distortion in the cells. This distortion is greatest at the corners of each face. To ensure that no craters cross a cell boundary, the sample code calculates the crater radius and distance from the crater in cell coordinates, which means that the crater shape is distorted right along with the cell. The cell boundary restriction does not exist in the static algorithm, so once again it is only a problem with the dynamic algorithm. It could be fixed in the dynamic algorithm by determining the projection of each cell and calculating the radius and distance to the crater in world coordinates, but this would incur a larger performance penalty.

Consider one more problem that deals with the interaction between craters and the existing terrain. The current sample implementation just adds all the height offsets, so overlapping craters have an additive effect on each other. This is very unrealistic. Due to the nature of impact craters, they have the potential to completely wipe out existing terrain. Newer large craters wipe out all older small craters within their radius, and older large craters will have parts of their crater walls obliterated, not added to, by newer small craters.

It is fairly quick and easy to randomly generate an age for each crater, and to sort the list of craters that affect a new vertex by age. This allows us to create some simple interaction logic. The trick in dealing with this problem involves finding the height of the terrain at the center of each crater in the list at the exact point in time that the crater was formed. This 'base height' for each crater is fairly expensive to calculate, as it requires a GetHeight call that adds in the effects of all craters older than the current crater. Since the base height of an old crater affects the base height of a young one, the base heights must be calculated in the proper order. All of this can be precalculated in the static algorithm, but it would be prohibitively expensive to call in the dynamic algorithm.

Rendering Procedural Terrain Efficiently

The spherical ROAM algorithm is merely one example of how to efficiently render procedural terrain. There are a number of other dynamic LOD algorithms being used today. Some good examples are [Duch97], [Hoppe91], [Lind96], [deBoer00], [Hakl], and [Hill01]. Regardless of the algorithm chosen, in our case it is important to make sure that it is optimized for run-time procedural generation.

The ROAM Algorithm

This article will only explain enough of the sample ROAM algorithm to give the reader a basic understanding of the concepts explained in this section. For a more-detailed explanation, see [ONeil2].

ROAM typically starts with a single square that consists of two right triangles. New vertices must be added at the center of the longest edge of a triangle, causing it to split into two smaller right triangles exactly half the size of its parent. Unless the split edge is at the edge of the map, it is shared by another triangle, which must also be split to avoid cracks in the mesh. When merging smaller triangles back together, similar logic must be implemented to avoid cracks. The spherical version starts with the six square faces of a cube, which are projected onto a sphere, and all triangle edges are shared (i.e., there is no edge to the map).

ROAM is typically implemented as a binary tree of triangles to maintain parent-child relationships. For each frame, a priority check is run to see which triangles need to be split or merged, and then all the resulting leaf nodes of the tree are rendered. The priority check involves calculating a view-dependent error metric and either splitting or merging to achieve a specific frame rate or triangle count, or by choosing a maximum error threshold and splitting or merging triangles that cross over that threshold. A simple view-dependent error metric is the amount of error in the triangle (or the amount a new vertex would move if it needs to be created) divided by the distance between the camera and the triangle (so that distant errors are weighed less heavily than close errors).

Note that most other dynamic LOD algorithms use similar view-based error metric and priority calculations, so many of the optimizations listed below apply to those algorithms as well.

Important Optimizations

The most important optimization that can be made for run-time procedural generation is to minimize the number of times the `GetHeight` method is called. Because the ROAM priority check requires the height value for the next potential vertex for each triangle, the first optimization is to generate that next height value and cache it in the triangle object. The cached value can be used to check the priority each frame, and if the triangle is split, the cached value is used for the new vertex, and `GetHeight` is called to calculate the next height values for the current triangle's children.

At this point, the `GetHeight` function is still being called twice as often as it should be when splitting. Because each child triangle will have a neighboring triangle that will share the new height value when the child is split, it is easy to check when each triangle is created to see if its neighbor has already calculated it.

The next place to look for optimization is in the merge routine. The `GetHeight` method should never be called when merging. Most ROAM implementations maintain a binary triangle tree, and the parent will still have its precalculated height value if it needs to be split again. In the sample implementation, the parents are not kept in a tree, but the algorithm knows which vertex it is removing, so the height is easily retrieved before the vertex is deleted.

At this point, it would be difficult to optimize the split and merge routines any further, so it is time to optimize the priority check that determines when to split and merge. This is an important optimization for any dynamic LOD routine, but it is even more important for run-time terrain generation. The first place to optimize is the calculation of the view-dependent priority. Start by lowering the priority of triangles outside the view frustum or view angle to zero, which will cause them to be merged if possible. For 2D terrain, triangles beyond the far clipping plane should be dropped. For 3D spherical terrain, triangles beyond the horizon distance should be dropped. It is also important to make sure the priority calculations are identical for the split and merge operations, or triangles may alternate between split and merge each frame, causing unnecessary extra calls to `GetHeight`.

If all the other optimizations are not enough, it is possible to throttle the number of split/merge operations that occur per frame for any given frame, which limits the number of calls to the `GetHeight` method. This is usually only an issue when the camera moves or turns really fast, which can cause a lot of terrain to need to be generated each frame to maintain the same detail level. Unfortunately, throttling the number of split/merge operations, or splitting/merging to a target frame rate or number of triangles requires sorting triangles by priority so that higher-priority triangles are split before lower-priority triangles.

If any of those throttling operations become a requirement, the bucket sort should be used to sort the triangles. It is $O(n)$, and since the code is already traversing the triangles to calculate priorities, it is very fast from a performance standpoint. Because the error metric equates to error/distance, and because projected size falls off linearly with distance from the viewpoint, the error metric can give a fairly accurate representation of the number of screen pixels the error equates to. So, just create an array of buckets and dump triangles into them using the approximate number of pixels of error as the index into the array. The triangles within each bucket will not need to be sorted because to the player, there is no visible difference between them.

```
void SortedROAMUpdate(CVector vCamera)
{
    float fPriority;
    int nPixels;
    for(every diamond)
    {
```

```
            fPriority = diamond.GetPriority(vCamera);
            nPixels = GetPixelOffset(fPriority);
            diamondbucket[nPixels].add(diamond);
        }
        for(every triangle)
        {
            fPriority = triangle.GetPriority(vCamera);
            nPixels = GetPixelOffset(fPriority);
            trianglebucket[nPixels].add(triangle);
        }

        // Merge all diamonds with less error than
        // max triangle error
        while(diamondbuckets.min < trianglebuckets.max )
            merge(diamondbuckets.min);

        // Split triangles up to desired count
        while(trianglecount < desiredcount)
        {
            if(exceeded max splits per frame)
                break;
            split(trianglebuckets.max)
        }
    }
}
```

Generating Texture Maps

A procedural game world is very nice, but it is no good at all without texture maps to make it look pretty. Unfortunately, this problem is very tough to solve adequately if the game world is too large for a single texture or a group of fixed-size textures.

A Simple Solution

The sample implementation uses a very cheap method of generating texture maps. Essentially, a very small 1D texture map is created whose elements map to a specific height in the terrain. The texture coordinate for each vertex is calculated based on the vertex height. In a previous incarnation, it used a 2D texture map with the second dimension used for latitude to make the planet snow-capped. To avoid sharp horizontal bands of color across the planet, the latitude was perturbed by a noise function to make the planet appear to have reasonable climate regions. On video cards that support multitexturing, a secondary noise-based detail texture is added to make the terrain appear less monotonous up close.

The sample implementation may seem fine initially, but it actually has some major flaws. The most difficult one to get around is the fact that the planet's color is essentially per-vertex color. So changing the level of detail produces a different picture. When triangles are split or merged, the terrain may pop a little, but the color may pop a lot. This is not a problem if the camera is very close to the surface; but

from orbit, entire islands can appear or disappear from one frame to the next. Even if that were not a problem, per-vertex coastline detail looks terrible. This is not a problem if the player has a monster machine and can crank the detail level up so high that per-vertex is close to the per-pixel level, but even with the amazing advances in CPU and GPU technology, we are still not there yet.

The sample implementation does have a temporary measure to alleviate the color-popping problem. This measure involves pregenerating a global texture map at a fixed resolution, using the same routine that calculates the texture coordinates. From orbit this looks great, but near the surface it looks terrible, so the code smoothly switches from the global texture to the detail texture. It looks better but is still not good enough for a high-quality game.

A More-Complex Solution

A few implementations have been explained, such as [Ulrich00], where a quad-tree (or similar subdivision structure) of textures is generated for dynamic meshes. When the triangle mesh splits too much in a particular node of the tree, the node is split, and new textures are dynamically generated. For performance reasons, these individual textures must be fairly small. To maximize parallel processing between the CPU and GPU, a separate thread may be used to generate new textures.

For vertex texture coordinates to be calculated properly and triangles to be rendered with the correct texture selected, the texture tree must be tied very closely to the adaptive mesh algorithm. It may be feasible to set texture coordinates based on the tree's position in the top-level square, and then calculate a texture transformation matrix for each node in the tree. This assumes, of course, that floating-point precision problems do not crop up (see "Problems of Scale in Large Game Worlds," below).

Collision Detection on Procedural Terrain

Now that we can efficiently render a game world that is generated dynamically at run time, how do we handle collision detection efficiently? The mesh keeps changing, so BSP trees and other pregenerated partitioning schemes fly right out the window. Worse yet, triangles outside of the camera's view frustum are given zero priority and merged down to nothing. What if a player backs into a crater wall or is looking up or to the side while falling? Many needed triangles will not even exist to perform accurate collision detection. A similar problem exists in multiplayer games; each player sees a different set of triangles.

The answer, of course, is to avoid doing triangle checks for collision detection. It is easy to just call `GetHeight` at an object's location as a quick spot check to determine if a collision has occurred. Even though the `GetHeight` function may be expensive, it is 100% precise, and it may actually be cheaper than polygon-intersection tests for

complex meshes. For objects above the surface, an initial bounding radius test could be done if desired. The bottom four corners of a bounding box may work better, as objects moving into a steep wall will not be detected until the point directly beneath the center of the object intersects the bounding radius. If the initial test indicates a potential collection, a more-thorough test would call GetHeight for a subset of vertices in the object's mesh.

For models moving on the surface, again, the bottom four corners of a bounding box could be determined, and the height at each point in the box could be checked for position and slope. A steep change in slope from one change to the next may indicate a steep wall and perhaps require a collision-detection check. In most cases, four calculations will not be needed for every frame. The bounding box for each frame will often overlap the bounding box from the previous frame, and corners of the new bounding box that fall within the old bounding box can be interpolated from the slope of the previous box. It may even be possible to just generate one new height value per frame, rotating the value that is chosen, or choosing the one that is closest to the direction of movement.

If the GetHeight function is just too expensive to call in this fashion, it may also be feasible to generate fixed-size mesh tiles around certain objects or areas. This would require more memory and would not be as accurate, but consider a game like *Dark Age of Camelot*. This game world may contain cities that have hundreds, perhaps even thousands of models moving around in them. It may also contain large areas of wilderness that have very few models in them. In this case, it may make sense to generate a mesh for the city and have some special code for ground-model interaction. In fact, it may even make sense to fix the city's terrain height at a specific level, and to just check against one fixed height level for the whole city.

Problems of Scale in Large Game Worlds

One serious problem with modeling and rendering a large game world deals with scale and precision. A 32-bit float has a maximum of 6 significant digits of accuracy, and a 64-bit double has a maximum of 15. If an acceptable amount of precision loss is one millimeter, floats start to lose accuracy at around 1,000 km, and doubles lose accuracy at around 1 trillion km.

Video Hardware/Driver Issues

Hardware-accelerated Z-buffers are typically 16, 24, or 32 bit. To drive that point home, when trying to display the entire Earth, which has a diameter of 12,756 km, from low orbit would lose precision at the centimeter level with a 32-bit Z-buffer. A smaller Z-buffer would be almost completely useless.

Trying to display the Earth from space will cause a loss of even greater precision. Displaying it from the moon's orbit, which is approximately 384,400 km from Earth, would make any Z-buffer almost completely useless for anything else. To make matters worse, even if we are willing to sacrifice Z-buffer precision, most video-card drivers break down when trying to render triangles more than 30,000–50,000 units away. The underlying cause is precision-loss in the floating-point operations used in the driver's (or the GPU's) matrix transformations.

Game World Modeling Issues

This loss of precision is not limited to the video card or drivers. It also applies to object positions and velocities. To model an entire solar system using floats (the radius of Pluto's orbit is close to 5 billion km), any attempt to change an object's position near Pluto's orbit will be rounded to the nearest 5,000 km along each axis. Depending on the Floating Point Unit (FPU), it may round down. This means a ship orbiting Pluto would have to be moving more than 5,000 km per frame (not per second) along a certain axis in order to move at all. The player would zip by Pluto so fast he would not even see it. Of course, these jumps of 5,000 km are axis-aligned, so objects that are moving fast enough will not move in the right direction.

Simple Solutions

All of these problems can be solved without a big hassles, but they can be serious problems if not anticipated or handled well. Double-precision operations are expensive and should be avoided where possible. However, if the game world is large enough, using doubles in one key place can solve a number of the issues mentioned; and that key place is the object position. With 15 digits of precision, a double will provide better precision at 1,000 times Pluto's orbit than a float will provide on the surface of an Earth-size planet with its center at the origin.

All other values can remain single-precision floats. The only double-precision operations needed are for changing an object's position and comparing its position to that of another object, all of which are add/subtract operations. Assuming there is a ship orbiting Pluto, once the position vector of the ship is subtracted from the position vector of Pluto, the doubles can be converted to floats, and floating-point operations can be used for everything else. In essence, once the distance and direction between objects has been determined correctly, it does not matter if a small percentage of precision is dropped.

Some of the matrix transformation issues can be solved by pretending that the camera is always at the origin when calculating the view matrix, then offsetting each model's position by the camera position when calculating the model matrix. This causes the precision loss at or near the camera to always be zero. Even though preci-

sion loss for distant planets may be huge, because the loss is always based on distance from the camera, it can never be enough to move the planet even one pixel.

A few simple steps can alleviate the distant-rendering and Z-buffer problems. Start by setting the far clipping plane to a reasonable distance, perhaps 1,000 km. Ignore small objects beyond this distance, as they will not be visible anyway. The large distant objects can be handled by sorting them in order of distance from the camera, disabling the Z-buffer, and rendering them from back to front. To avoid the driver rendering problems, distant objects can be scaled down in size and distance so that they are rendered at the same distance as the far clipping plane. Size drops off linearly with distance, so scaling an object by the same factor as its distance will not change the planet's screen size.

Unfortunately, that approach has two problems. The first is that it will only work well for convex objects because the Z-buffer is disabled, and concave objects will be rendered incorrectly without the Z-buffer enabled. This is not a problem for spherical planets rendered at a distance. The second problem is that, assuming a far clipping plane of 1,000 km, a planet with a radius of 6,378 km will always be rendered at the far clip plane with Z-buffering disabled. This is not the case if the distance is calculated as the distance to the surface of the planet (instead of the center); but in that case, a far clipping plane of 1,000 km will be too short to see the horizon of the planet in low orbit.

One potential solution is to take the nearest planet (the camera should never be this close to two planets simultaneously), and if it is within a certain distance, scale it down just enough so that its horizon distance matches the far clipping plane. There may be a better simple solution, but for now this seems sufficient.

Impostor Rendering

A more complex technique that can improve Z-buffer precision and rendering performance is impostor rendering. An impostor is a dynamically generated billboard. Complex objects are rendered to the back buffer or to a pixel buffer allocated in video memory. Then that buffer is copied into a texture, which is then used as a billboard to render that object for several frames. Like adaptive mesh algorithms, impostors use an error metric to determine when the impostor texture needs to be updated. To calculate this error metric, cache the vector between the object and the camera each time the impostor is updated. For each frame, compare this vector with the current vector between the object and the camera. If it has changed by more than a certain amount, the impostor needs to be updated.

Impostor rendering improves Z-buffer precision because each impostor gets its own view frustum, which means that each impostor gets its own near and far clipping planes. To optimize use of the texture resolution and Z-buffer precision, all six sides of the view frustum are fit as closely around the object as possible.

Other factors, such as changes in lighting, may also affect how often an impostor needs to be updated. Also, impostors can contain clusters of objects. The entire sky box of distant stars and planets can be rendered into six impostors, and reused for a very long time as long as the camera does not move between planets. If objects within these impostors move independently of each other, then that movement will also introduce error that requires the impostor to be updated.

Of course, impostors are not limited to rendering planets. As long as video memory is available, impostors can improve performance dramatically by reducing the number of triangles needed to render each frame. Detailed trees, or even entire forests can be rendered with impostors [Remolar02]. Volumetric rendering, which is very handy for clouds or fog, is often handled with impostors [Harris01]. City scenes, which can have a very large number of buildings, are also often rendered with impostors [Franc97]. The screen size of an impostor can be determined fairly easily, and smaller impostors can be put into smaller textures, which may allow a hierarchy of impostors to be created, having larger impostors built with smaller ones.

Unfortunately, there are a number of technical problems involved with using impostors. Impostors are partially transparent, so the video card must support destination alpha in the back buffer or separate pixel buffers so that the resulting alpha values will be copied correctly to the texture map. Also, impostors can eat up video memory very quickly if they are used too often. Fortunately, smaller textures can be used for distant impostors, and a texture cache implementation can limit the amount of video memory used by impostors.

On top of those issues, impostors have all the same problems that transparent billboards have. Transparent billboards must be sorted by distance and drawn from back to front with blending enabled, which may introduce performance problems. Plus, billboards are essentially flat, so if two billboards intersect each other, or if a normally rendered object intersects a billboard, the depth test will give incorrect results, and visual artifacts will occur. Billboards also do not look good when the camera is very close to them. For impostors, it is possible to switch to normal rendering when the camera gets too close.

Solving the billboard intersection problem is beyond the scope of this article. Planets are so few, so large, and so far apart that this problem is not really encountered. Please refer to [Harris01] for a good example of how to solve this problem.

Conclusion

Run-time procedural generation of game worlds is an exciting new possibility for managing the data explosion required by today's best games. It has some very strong benefits, especially for MMP games that distribute game assets online. As CPU power continues to outpace modem technology in speed (a lot of players still do not have

DSL or cable modems yet), it will become faster and more convenient for the player, as well as the game servers, to generate as many of these assets as possible on the client machine. Generation can take place at run time, load time, or once during an update. Even for offline distribution, no one likes to have to swap disks to install or play a game.

Some of the problems explained in this article may keep certain aspects of run-time procedural generation from being ready for high-quality game production. Fortunately, a lot of research is currently being done to solve these tough problems, and hardware capabilities are growing at a dizzying pace. Even if some of the ideas in this article are not feasible today, there is a good chance they will be feasible by the time a long development cycle is complete. The data explosion is more likely to accelerate than to slow down, and the same will apply to advances in procedural generation.

References

[Bell84] Bell, Ian, "The Elite Home Page," available online at *http://www.iancgbell.clara.net/elite/*, 1984.

[deBoer00] de Boer, William H., "Fast Terrain Rendering Using Geometrical MipMapping," available online at *http://www.flipcode.com/tutorials/geomipmaps.pdf*, 2000.

[Duch97] Duchaineau, Mark, "ROAMing Terrain: Real-time Optimally Adapting Meshes," available online at *http://www.llnl.gov/graphics/ROAM/*, 1997.

[Elias] Elias, Hugo, "Spherical Landscapes," available online at *http://freespace.virgin.net/hugo.elias/models/m_landsp.htm*.

[Franc97] Sillion, Francois, "Efficient Impostor Manipulation for Real-Time Visualization of Urban Scenery," available online at *http://www.cs.unc.edu/%7Eibr/other_pubs/Sillion_Impostor_Eurographics_97.pdf*, 1997.

[Hakl] Hakl, Henri, "Diamond Basics," available online at *http://www.cs.sun.ac.za/~henri/diamondbasic.html*.

[Harris01] Harris, Mark, "SkyWorks Cloud Rendering Engine," available online at *http://www.cs.unc.edu/%7Eharrism/SkyWorks/index.html*, 2001.

[Hill01] Hill, Dave, "Rendering Planets In Real Time," available online at *http://www.dgp.toronto.edu/~dh/research.html*, 2001.

[Hoppe91] Hoppe, Hugues, "Hugues Hoppe's Home Page," available online at http://www.research.microsoft.com/~hoppe/, 1991.

[Lecky01] Lecky-Thompson, Guy W., *Infinite Game Universe: Mathematical Techniques*, Charles River Media, 2001.

[Lind96] Lindstrom, Peter, "Real-Time, Continuous Level of Detail Rendering of Height Fields," available online at *http://www.cc.gatech.edu/gvu/people/peter.lindstrom/papers/siggraph96/*, 1996.

[McNally] McNally, Seumas, "Tread Marks—Battle Tank Combat and Racing," available online at *http://www.treadmarks.com/*.

[Musg98] Musgrave, F. Kenton, Texturing & Modeling: A Procedural Approach, AP Professional, 1998.

[ONeil00] O'Neil, Sean, "A Real-Time Procedural Universe," available online at *http://home.attbi.com/~s-p-oneil/*, 2000.

[ONeil1] O'Neil, Sean, "A Real-Time Procedural Universe, Part One: Generating Planetary Bodies," available online at *http://www.gamasutra.com/features/20010302/oneil_01.htm*, 2001.

[ONeil2] O'Neil, Sean, "A Real-Time Procedural Universe, Part Two: Rendering Planetary Bodies," available online at *http://www.gamasutra.com/features/20010810/oneil_01.htm*, 2001.

[ONeil3] O'Neil, Sean, "A Real-Time Procedural Universe, Part Three: Matters of Scale," available online at *http://www.gamasutra.com/features/20020712/oneil_02.htm*, 2002.

[Perlin99] Perlin, Ken, "Making Noise," available online at *http://www.noisemachine.com/talk1/*, 1999.

[Remolar02] Remolar, I., "Real-Time Tree Rendering," available online at *http://nuvol.uji.es/~ribelles/Investigacion/Papers/dlsi_01032002.pdf*, 2002.

[Sierra] Sierra, "Sierra: Tribes 2 - Team Combat on an Epic Scale," available online at *http://www.sierra.com/*.

[Ulrich00] Ulrich, Thatcher, "Quadtree tiling / unique full-surface texturing," available online at *http://www.tulrich.com/geekstuff/tiling/*, 2000.

[VTP97] The VTP Group, "Virtual Terrain Project," available online at *http://www.vterrain.org/*, 1997.

4.4

WRITING A FAST, EFFICIENT, FIXED-SIZE OBJECT ALLOCATOR

Tom Gambill, NCsoft Corporation

tgambill@ncaustin.com

Source code from this article is included on the companion CD-ROM.

In any sufficiently complex C++ program, especially today's large MMP games with continuous scrolling worlds, memory allocation over time can be one of the major performance bottlenecks. As the character walks across the world and objects come in and out of view, game data is continually loaded and unloaded from memory, almost certainly resulting in major memory fragmentation. As objects of different sizes are requested and freed from a common heap in different orders, allocations start to take longer and longer as more free blocks are generated by the spaces between allocated blocks. As this fragmentation occurs, the database that keeps all the blocks straight grows larger, contributing to the memory overhead of the game.

Fragmentation is by far the most significant problem with arbitrary-size block allocators like the heap. Because they are general purpose, they tend to be slower and less efficient than a custom allocator that is designed for a specific allocation pattern. Although there are many allocation patterns, this article focuses on one that is very common in C++, one in which all the blocks that are allocated out of a given pool of memory are the same size, commonly known as a *fixed-size block allocator*. This eliminates memory waste due to fragmentation because all blocks are the same size. Any new allocation fits in any slot in the pool, and finding an available slot is just a matter of passing out the next available pointer.

Memory Allocation in C++

The reason a fixed block allocator is so useful becomes clear when you look at what is likely the most common allocation in C++; allocating a new class object. How often have you written or encountered some form of the following line of code?

```
T* objectPtr = new T;
```

What if we could allocate each and every object of the same type in our programs from a different pool of memory? This would eliminate fragmentation completely! And as it turns out, we do not really need to do this for every class. Many of the objects we frequently allocate, like matrices, vectors, floats, ints, and so forth, are better served with *stack allocation*. This tends to reduce issues with memory cache coherency and pointer indirection, not to mention the overhead of allocating individual pools of object types that we may use only once. We need only implement fixed block allocators for certain commonly used objects that are allocated and freed repeatedly during the course of program execution. An example of this might be a class that represents an individual chunk of terrain in a large sprawling world.

There are a few things to keep in mind. We do not want to allocate too many of any certain object. If we do not use them, they waste memory. We also do not want to allocate too few, because then we will have to reallocate additional objects more often, taking us back to where we started. Also, a pool using these techniques cannot be freed until all the blocks in it have been released. This is all the more reason to carefully consider how many extra blocks to allocate initially.

A Simple Vector Allocator

An allocator generally consists of a store of objects to be allocated and some sort of database of to keep track of the store. We want the database to be small and efficient at both allocating and deallocating. Consider a store that is a continuous block of memory, some multiple of our object T in size, and an array or vector of T pointers with a pointer to each block in the pool. When a block is allocated, one of the pointers is returned, and an index into the next element in the pointer array is incremented. This sets up the pointer for the next allocation. If a block is released, the counter is decremented, and the pointer to the free block is put back in the pointer vector.

ON THE CD

Here is our very simple block-allocator class template which can be found on the companion CD-ROM.

```
template <class T, size_t numBlocks>
class SimpleAllocator
{
public:
    SimpleAllocator() : nextAllocation(0)
    {
        for (size_t i=0; i<numBlocks; ++i)
            pPointers[i] = &(pool[i]);
    }

    T* AllocateBlock()
    {
        return pPointers[nextAllocation ++];
    }
```

```
        void ReleaseBlock(T* pBlock)
        {
            if (pBlock)
                pPointers[- -nextAllocation] = pBlock;
        }

    private:
        T       pool[numBlocks];
        T*      pPointerArray[numBlocks];
        size_t nextAllocation;
    };
```

What happens when more objects are needed? We would need to allocate another block of T objects. This is relatively straightforward; we will just need to manage an array of pool vectors.

First we need to move the initialization out of the constructor and into the `Allo-cateBlock()` method. This will allow us to allocate new pool vectors as needed. Use STL vectors for the pools (hereafter called batches), and pointers can be made a bit cleaner by wrapping some of the details of managing the pointer arrays. Note that these hidden allocations happen on the heap and are not managed by our class. It is possible to write an allocator for vector<>, or write your own vector implementation for managing these arrays, but that is beyond the scope of this article. Now, each time an allocation occurs, we must check to see if there is another block available; and if not, we must allocate another batch of objects.

For this example, let us just allocate these batches on the application's heap; we will look at optimizing these allocations, as well, below. We must also grow the pointer array to match the number of new blocks that we have just allocated. Once that is done, we just loop through and set all the pointers as we did before. Except this time we add the new pointers onto the end of the vector, and we must clean up the allocated batches when the allocator object is destroyed. Here is our updated allocator class template.

```
    template <class T, size_t blocksPerBatch>
    class SimpleAllocator
    {
    public:
        SimpleAllocator() : nextAllocation(0) {}
        ~SimpleAllocator()
        {
            // Clean up the batches that we allocated
            size_t iNum = batches.size();
            for (size_t i=0; i<iNum; ++i)
            {
                byte* p = (byte*)batches[i];
                delete [] p;
            }
        }
```

```
T* AllocateBlock()
{
    if (nextAllocation >= pointers.size() )
    {
        // Allocate a new batch of blocks and pointers
        byte* pBatch =
            new byte[sizeof(T)* blocksPerBatch];
        batches.push_back(pBatch);

        pointers.resize(pointers.size()
            +iBlocksPerBatch);

        // fill or add the pointers for the new blocks
        size_t iNew = nextAllocation;
        for (size_t i=0; i<blocksPerBatch; ++i)
            pointers[iNew++] = &(pBatch[i]);
    }

    return pointers[nextAllocation++];
}
void ReleaseBlock(T* pBlock)
{
    if (pBlock)
        pPointerArray[- -nextAllocation] = pBlock;
}

typedef vector<byte*> BatchPtrVector;
typedef vector<T*>    ObjectPtrVector;

private:
    BatchPtrVector  batches;
    ObjectPtrVector pointers;
    size_t          nextAllocation;
};
```

Now we have an allocator that can allocate in constant time with just a size check and a counter increment as long as free blocks are available. This is true no matter how many blocks are allocated or how many free blocks have been used, and in any order. That is much better than the application heap, which gets increasingly slower as time passes. Releasing a block is just as fast and is also not dependant on the number of blocks available or allocated.

User-Friendly Allocator Template

To truly integrate our allocator into C++, we should use the standard operator new and delete methods, and ensure that the object's constructor and destructor are called. This way, the functionality of the allocator works without the caller having to do anything special. To do this, we will need to overload the new and delete operators on each class that we want to use this allocation template for. The prototypes look like this:

```
class T
{
public:
    // single allocation
    void* operator new(size_t s);
    void  operator delete(void* p);

    // array allocation
    void* operator new[](size_t s);
    void  operator delete[](void* p);
};
```

For this allocator, we will just use the single-instance forms of the operators. Using new and delete introduces a set of problems that are unpleasant to deal with in the context of this simple implementation. So we will avoid problems like tracking what ranges of blocks are allocated and dealing with a range of blocks when they are released.

To make one pool available to all objects of a class that uses our template, we will make the allocator a static member. This will require an external instantiation, but we can put that below the template code in the template header. An allocator static object will be instantiated for each class that uses the template, just like we want.

```
template <class T, size_t blocksPerBatch>
class BlockAllocator
{
    // new and delete operators here..

    struct BlockStore
    {
        // Our allocator implementation goes here..
    }
    static BlockStore s_Store;
};

// Instantiate the static allocator member for each type
template <class T, size_t blockSize>
    BlockAllocator<T, blocksPerBatch>::BlockStore
    BlockAllocator<T, blocksPerBatch>::s_Store;
```

Now, to use this template, just derive a class from it using that class's name as the first template parameter. Then, specify the initial number of blocks to allocate as the second parameter. Generally, it is a good idea to specify a number that is slightly larger than one half or one third the maximum number of objects that will be allocated at one time during the lifetime of your program. Of course, the actual number should be determined by common sense, the behavior of your program, and the objects that are being allocated. If you know that there will always be 100 objects of a particular

type, then just set the allocator to make 100 of those objects initially; but if the number can range from 50 to 100, you might start by specifying 60 or 120.

Expanding upon This Simple Allocator

One aspect of memory allocation that we have not covered yet is byte alignment. Most heap allocations, by default, are aligned on a DWORD, or four-byte boundary at best, depending on what the block you get back had been used for. This can be terrible for performance on a 32-bit machine that needs to work on 8 or 16 bytes at a time. On today's machines, nearly all allocations should be aligned on at least an eight-byte boundary for best performance. In some cases, 16-byte or 32-byte alignment is better, even at the expense of unused bytes, because of cache line size and vector processor units, like SIMD on the PC and AltiVec on the Mac. These processors work best when data is 16-byte aligned or higher. The following bit of code can be used to align any pointer to the next-higher boundary value.

```
size_t alignment = 16;  // 1, 2, 4, 8, 16, etc.
T* pAligned =
    (T*)(pOriginal + (alignment-1))&(~(alignment-1));
```

First, it takes the original pointer and adds one minus the desired alignment bytes. This ensures that the value is at least more than the final result. Then it performs a logical AND with the inverse of one minus the alignment value. This effectively masks out the low-order bits, leaving the desired aligned pointer.

This same technique can be used to round off class sizes to even multiples of the alignment value.

```
size_t aligned =
    (sizeof(T)+(alignment-1))&(~(alignment-1));
```

Both of these will be useful in aligning object allocations. This is our new AllocateBlock() method that makes use of both of the pieces of code above to align all batches to 16 bytes and all allocated blocks to the value of blockAlignment.

```
T* AllocateBlock()
{
    if (nextAllocation >= pointers.size() )
    {
        // Align the block size to blockAlignment
        static const size_t blockSize =
            (sizeof(T)+alignment-1)&(~alignment-1));

        // Allocate a new batch of blocks and pointers
        byte* pBatch =
            new byte[blockSize+blocksPerBatch+15];
        batches.push_back(pBatch);
```

```
            pointers.resize(pointers.size()+blocksPerBatch);

            // Align the new batch on a 16-byte boundary
            byte* pAligned = (byte*)(pBatch+(16-1))&(~(16-1));

            // fill or add the pointers for the new blocks
            size_t iNew = nextAllocation;
            for (size_t i=0; i<blocksPerBatch; ++i)
                pointers[iNew++] = &(pBatch[i]);
        }

        return pointers[nextAllocation++];
    }
```

Making `blockSize` a static `const` variable causes the value of it to be computed by the preprocessor and pasted into the code each time it is used. This can make the code faster. Also, the value for `alignment` can be passed in as a template parameter. This allows the instantiating class to specify the alignment of blocks on a per-class basis.

Reducing the Memory Overhead of the Allocator

One technique often used by page allocators, like operating or file systems, is to store the allocation database inside the unallocated blocks. We can employ this same technique to remove the need for the block pointer array by storing a pointer to each unallocated block in the first bytes of each block.

When a new batch is allocated, instead of creating an array of pointers to each block, we iterate through the store, treating it like a linked list. The first four bytes of each block now contain a pointer to the beginning of the next block. When we want to allocate a block, we return the first block in the list and store the pointer to the next block. When a block is released, we put the current next pointer in the beginning of the released block and set the next pointer to point to the released block. These are our new allocation methods:

```
    T* AllocateBlock()
    {
        //* Is there any room?
        if (!ppNextBlock || !*ppNextBlock)
        {
            // determine the aligned size of the blocks
            static const size_t blockSize =
            (sizeof(T)+blockAlignment-1)&(~(blockAlignment-1));
            // make a new batch
            byte *pBatch = new byte[blocksPerBatch*blockSize+15];
            batches.push_back(pBatch);
            //* Align the block on a 16-byte boundary
            byte* pAligned = (byte*)((uint)(pBatch+15)&(~15));
```

```
        // fill the pointers with the new blocks
        ppNextBlock = (byte**)pAligned;
        for (int i=0; i<blocksPerBatch-1; ++i)
        {
            *((uint*)(pAligned + i*blockSize)) =
                        (uint)(pAligned + (i+1)*blockSize);
        }
        *((uint*)(pAligned+(blocksPerBatch-1)*blockSize)) =
                (uint)0;
    }
    byte* pBlock = (byte*)ppNextBlock;
    ppNextBlock = (byte**)*ppNextBlock;
    return (T*)pBlock;
}

void ReleaseBlock(T* pBlock)
{
    if (pBlock)
    {
        *((uint*)pBlock) = (uint)ppNextBlock;
        ppNextBlock = (byte**)((byte*)pBlock);
    }
}
```

Conclusion

There are many ways to expand on this idea. As mentioned, a lower-level allocator can be added that allocates a large block of memory all at once from the heap. Now, when a block allocator needs a new batch of blocks, it uses a portion of this larger block that is already allocated. This would greatly decrease the time needed to allocate a new block when an allocator needs to grow, but it has the potential side effect of leaving large areas of system memory unused.

An implementation for the new and delete arrays can also be added to increase the speed and efficiency of these allocations. The most time-consuming part of this is finding a range of blocks that are available consecutively. You will want to allocate one more block than the number that is requested to store the number of blocks being allocated and any other data that you might need to describe the array allocation. When the array block is freed, use the information stored in the extra block to put the blocks back on the free list.

Do not be afraid to experiment. Using vector allocators like the ones discussed can be hundreds of times faster at allocating blocks than the default heap allocator. Use a performance analyzer or profiler to find the problem areas in your code. It is never ideal to have lots of allocations in critical code paths; but for those cases where it just cannot be avoided, a specialized allocator can often help.

4.5

TEXTURE-BASED 3D CHARACTER CUSTOMIZATION

Todd Hayes, NCsoft Corporation

thayes@ncaustin.com

A demo to accompany this chapter is found on the CD-ROM.

Given the social nature of massively multiplayer games, it is not surprising that players will attempt to mimic real-life social behaviors in these games. One of the most powerful examples of this is a player's desire to individualize their character in some way to make them stand out from the crowd. There is no better way to meet this need than to provide a mechanism for the player to customize their character's appearance. Taken from the player's perspective, the more options and variety allowed in this customization, the better. From the developer's point of view, more choices mean more art assets, more testing, and an overall increase in development time. Furthermore, all of these additional assets may cause performance issues, since there may be more meshes and textures to deal with at any point in time during gameplay. The challenge is to find a way to provide an acceptable level of customization for the player while minimizing development and performance impact.

ON THE CD

This article presents a method of implementing character customization that allows the performance impact and art-asset requirements to be well bounded while still providing a high level of customization. A demo that accompanies this article is included on the companion CD-ROM.

Types of Character Customization

A character's appearance is comprised of two components: texture and geometry (also known as a *mesh*). A character may be customized by modifying either the associated geometry or the texture, or both. Both methods have their good points and their bad points, and a programmer must consider all of the issues in the context of the game engine to choose the most appropriate method for the project.

Mesh Customization

Modifying the mesh of a character has the significant advantage of allowing changes to the character's silhouette. This is usually achieved by scaling the mesh or mixing and matching component geometry to build up the final character mesh. When scaling a mesh, it must be done carefully. Although it is possible to simply provide a scaling matrix to a character to change its size, this really only works when scaling the mesh uniformly along all axes. For instance, if this technique is used on a standard, proportioned mesh with a nonuniform scaling matrix to give the appearance of a tall, skinny character, side effects will be evident. For example, the character's arms will change length as they move; they would be longest when hanging at the character's side but shortest when positioned straight out, such as during a punch. Applying a nonuniform scale correctly requires additional work to scale various sections of the mesh in the appropriate directions and then to take a snapshot of the modified mesh to use as the character's mesh. Even if this problem is solved, there may still be a number of other issues that will affect the appearance of the mesh. The animation system needs to be able to deal with the new dimensions of the mesh. In addition, with any scaling, the mesh's normals will need to be transformed properly to avoid any artifacts in lighting or collision due to changes in length or nonuniform skewing.

Piecewise mesh-swapping is a technique that uses smaller component pieces or pieces from multiple meshes to build a character mesh. For example, in a fantasy game, an artist might create an entire mesh to represent a character wearing leather armor. Another mesh is created to represent a character in plate mail armor. The piecewise mesh-swapping technique makes it possible to generate a character mesh using components from each of these meshes so that some of a character's armor is leather and other parts are plate mail. Alternatively, these pieces can be stored as wholly separate meshes rather than being a part of a larger mesh, but the technique remains the same. This method avoids a number of the issues involved in scaling a mesh and allows for much more-dramatic silhouette changes. These additional benefits, however, come at a significant additional cost. While scaling starts with a single piece of geometry and simply applies a set of transforms to it to arrive at a final mesh, a mesh-swapping system requires new art assets to be generated for each piece that can be swapped. This demands the creation of more art assets and increases the number of separate meshes and textures that must be handled and rendered at run time. More important, a mesh-swapping scheme is very dependent upon the engine that it is built on. If a game engine offers characters that are composed of segmented meshes, then it likely needs to provide a mechanism that makes it much easier to swap out these segments during the game. If, however, the engine uses skinned or deforming meshes, then utilizing mesh-swapping becomes far more complicated. Skinned geometry will

need to be properly associated with the bones in the character's skeleton. If strict rules are not placed on art creation for such a system, then the geometry pieces may need to be 'stitched' together in order to avoid cracks and seams in the character mesh as it deforms. This stitching process incurs cost in both the development process and at run time. Art that is to be stitched must follow certain rules and limitations in order for the stitching to work properly. These rules are often difficult for the artist to comprehend and even more difficult to adhere to with the art tools that they use. Quality assurance becomes more difficult as well, since any combination of meshes in the stitching process could result in visual anomalies and must be tested.

Texture Customization

While not providing the silhouette alteration that mesh swapping brings, texture customization can give a character a far wider range of appearance with a much more predicable cost in terms of geometry and texture usage. Since a character's mesh must be texture mapped at the time the artist creates it, the number and type of textures required for the mesh is known at that time. No matter how much you modify the textures used by the mesh at run time, the actual size and memory usage of the texture will not change. Since it is straightforward to place restrictions on the size of these textures, this provides a controllable, fixed cost for the character, regardless of the level of customization. Because this method does not modify the mesh in anyway, the only feature that it requires from a rendering engine is the ability to modify textures in memory. It also allows the same mesh to be shared by multiple characters at a time, further reducing memory costs. By using alpha blending and other techniques to composite together multiple textures and regions of textures, a nearly unlimited number of unique textures can be generated for mapping onto characters. For instance, one small texture representing a guild or pledge symbol can be placed anywhere within a character's texture to provide a tattoo or patch representing their association. Eye color, hair color, and facial features can all be built up from small textures to provide an incredible array of diverse looks and styles.

Of the two customization techniques discussed, the texture-customization approach has the advantage in terms of a larger amount of variation, a bounded cost regardless of future customization options, and less dependency on engine features. For this reason, the rest of this article focuses on providing a more-detailed discussion of the texture-customization technique and its implementation. The discussion avoids specific implementation details that will be dependent upon the engine technology on which the system will be built. Instead, it focuses on the higher concepts involved, while pointing out essential technical requirements that the underlying engine must provide to the system.

Texture Composition Basics

There are a few basic features that the system must provide before texture customization can be supported. The engine upon which the texture customization system is built on must provide the ability to create and modify the texture that will be mapped onto the character at render time. It must also provide a method of rendering or copying all or part of a source texture into the composited character texture. At the very least, it should provide access to the pixel data contained in any textures used in the composition. This allows code to wholly replace any region in the destination texture with a region from the source texture. What constitutes a region of a texture that is valid to use in the texture composition process, and how it is defined, is up to the texture-customization system itself to specify. (The issues involved in this definition will be discussed later in this article.) While satisfying this requirement will make the system functional, in order to take full advantage of the flexibility of the texture-customization system, there are a couple of additional operations that should be supported during the compositing operation; it is highly desirable to have support for hueing and alpha blending.

Hueing allows a user to specify a color when requesting the compositing operation. This color is used to modulate the color of each pixel as it is drawn into the composite texture. By allowing the user to specify an arbitrary color at this time, a single art asset can be used to create a version of a texture in any color required. An artist could, for example, create a shirt texture in grayscale. By providing the color of the shirt at composite time rather than at art creation time, that single texture can be used for any one of over 16 million different shirt colors.

The ability to blend the source region into the destination region using an alpha channel embedded in the source texture will allow for a number of advanced effects. Instead of being limited to copying solid rectangular regions, the system will be able to render arbitrary shapes from the source texture into the composite texture by specifying a zero alpha value for the pixels that should not be drawn into the composite texture. Furthermore, these shapes do not have to completely replace the texture into which they are composited. If a pixel in the source texture has a nonopaque and nonzero alpha value, then it will not replace the pixel in the composite texture; it will blend with it. This concept is best illustrated by tattoos or body paint. First, a skin texture would be rendered into the composite texture. The source texture would be given an alpha value of 128, for example, in every pixel that represents the tattoo. When the tattoo texture is blended into the composite texture, it simply tints the skin texture that is already there, leaving musculature and other body features intact.

Figure 4.5.1 shows the sample textures involved in a compositing process to place a tattoo on a character's arm, broken into four stages:

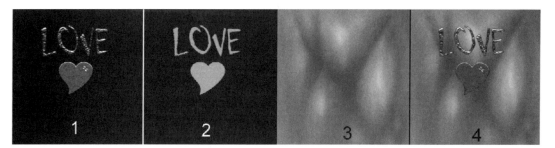

FIGURE 4.5.1 *Sample textures involved in a compositing process.*

1. The tattoo texture to be used.
2. The alpha channel for the tattoo texture. (Note that this is part of the tattoo texture. It is simply shown separately here for clarity. This example uses an alpha value of 195 to allow textures below it to partially show through.)
3. The portion of the skin texture representing the character's shoulder.
4. The final composite texture with the tattoo blended over the skin.

Combining these two features can result in a staggering variety of effects, such as sheer, see-through clothing, colored tattoos, dirt, and battle-scarring, among others. An additional feature of alpha-blend compositing is (as was implied in the previous example) the ability to do layering.

Layering

A system that only supports opaque copying from a source to a destination texture means that the compositing step would be very simple to perform. Only one source texture would be associated with a given region of the destination texture. The compositing process could simply step through each region and render into it from the appropriate source texture. The addition of alpha blending complicates the management of the compositing process significantly, since any number of source textures may have contributed to each region's appearance in the composite texture. This is where layering comes in. A *layer* is a way of associating a source texture with a set of regions that it should occupy in the composite texture. It can also hold additional parameters for the compositing process, such as color or opacity.

Layers are sorted bottom to top before the compositing process begins, using a priority system. In most cases, it is helpful to assign priorities to conceptual layers of clothing to make the layer relationships a little clearer. For a very simple example, priority zero might be associated with 'skin,' priority one associated with 'clothes,' and priority two tied to an 'armor' layer. Then at compositing time, skin would be composited first, followed by clothes, and finally armor, with the accompanying alpha

channels allowing each layer to show through the ones above it wherever they overlap. It is important to realize that you can have multiple layers with the same priority that use different textures. This would be useful in cases such as a shirts and pants that come from separate textures, but would both fall under the 'clothes' category. As long as the two layers do not contain overlapping regions, everything will composite fine. If, however, they overlap, then the behavior is undefined. The one is drawn last is the one drawn on top. Table 4.5.1 shows some additional example layers and priority assignments.

Since layers are responsible for determining which regions of the texture they use, there needs to be a mechanism for managing the definitions of these regions in a meaningful way. In order to deal with these regions without unnecessarily complicating the layer itself, we introduce the concepts of texture *templates* and *swatches*.

Table 4.5.1　Example Layers and Priority Assignments

Priority	Layer Name	Common Layer Contents
0	Skin	Base character skin
1	Body art	Tattoos, body paint, scars
2	Hair	Mustaches, beards, sideburns
3	Clothing	Shirts, pants, shoes, gloves
4	Over-clothing	Armor, vests, coats, jewelry
5	Emblem	Coat of arms, pledge or guild emblems

Texture Customization Templates and Swatches

The most important step in implementing a texture customization system is to determine how the final texture maps onto the character mesh. A proper mapping from texture to mesh can make or break a texture-customization scheme. Although most art-creation tools will allow artists to arbitrarily map any part of a texture to any point on the character's mesh, the customization system must be able to copy areas of a texture into the final, composite texture in a reliable and logical manner. To this end, it is necessary to define regions in a texture that map to conceptual areas of the character. For example, in order to be able to use a face from one texture in the composite texture, there must be a region that represents the face part of the texture in both the source and destination textures so that the system knows which part of the source texture to use and where to place it in the composite texture. The structure that defines these regions is known as a *texture template*, and the regions that it defines are referred to as *texture swatches*. Once a texture template is defined for a character, then any texture that follows its layout can be used to build the composite texture. Figure 4.5.2 shows a sample texture template.

				Right Upper Arm	Right Lower Arm	Right Hand	
Front Torso		Rear Torso					
				Left Upper Arm	Left Lower Arm	Left Hand	
Front Pelvis		Rear Pelvis					
Front Right Leg	Front Left Leg	Rear Left Leg	Rear Right Leg	Head Right Side	Face	Head Left Side	Head Back
Front Right Foot	Front Left Foot	Rear Left Foot	Rear Right Foot	◀ —	Neck	— ▶	

FIGURE 4.5.2 *Example texture template layout using common texture swatches.*

The texture template's only real purpose is to define the texture swatches. There are many ways to define such a template, but the one discussed here allows an artist to create a texture that is structured in such a way that it can be loaded and parsed to locate the swatches within it. Since this template texture will never actually be used for any purpose other than defining swatches, we can reserve certain colors to be used in it to define our swatch regions. It is best to do this in a way that allows the texture to be human readable as well as to be parsed by code. One method of doing this is to define a pair of easily recognizable colors as 'border colors.' For our example, pure purple (R:255, B:255, G:0) will be used as the border 'edge' color, and pure green (R:0, B:0, G:255) will be used as the border 'start,' or upper-left color. So, the upper-left pixel of each region's border will be pure green, and the edges of the region will be pure purple. In this way, our template parser can search until it finds a green pixel to start processing a border. Then the parser moves down and to the right one pixel. By scanning the texture to the right of this pixel and looking for a pure purple pixel, the parser can locate the right edge of the region's border. Similarly, it can find the bottom edge by scanning down from the pixel. Once these edges have all been found, the area that the swatch covers is the region defined by and including these border pixels (see Figure 4.5.3).

The swatches, themselves, are defined by and contain representations of the rectangular areas that they encompass in the texture template. Every swatch in the texture template is assigned an id that is unique within that template. Once the swatches

Border Start Color
(R:0 G:255 B:0)

Border Edge Color
(R:255 G:0 B:255)

FIGURE 4.5.3 *An example border definition describing an 8-pixel by 12-pixel swatch.*

are defined, layers can simply contain a list of the swatch ids that should be used to composite them into the destination texture.

Because the template defines the granularity allowed in composition textures, it should be tailored toward the specific requirements of the game for which it will be used. If a game only requires a certain level of customization, such as choosing a character's face, shirt, and pants, then it can probably get away with defining a few large swatches. If, as in our Figure 4.5.1 example, the game allows placing of tattoos in a user-specified location, it may need to provide a number of much smaller regions in its template to allow for each of the possible positions where the tattoo could be applied. One of the challenges in the latter case is that larger conceptual areas may be broken up into an unmanageable number of small swatches for the sake of flexibility. Perhaps a character's chest has to be broken down into top-left, top-center, or top-right areas to allow for tattoo placement, but when a shirt texture needs to be composited, all of these smaller swatches must be specified instead of a single chest swatch. Handling these logical collections of swatches can be made more manageable by using the concept of *swatch groups*.

Swatch Groups

Although they do not affect the underlying mechanics of texture customization, swatch groups provide a layer of abstraction that simplifies a user's interaction with the texture-customization system. By utilizing swatch groups, a character's texture template can be subdivided into a large number of swatches. This provides as little or as much granularity as needed for the composition process without increasing the amount of work required to specify which swatches should be used during composition. In the case of the facial area of the template, the full area could be extensively subdivided to allow for a finer granularity of customization for things such as eyes,

noses, mouths, tattoos, scars, or any other facial features. A swatch group could be created called "Face Group" that contains the ids of these smaller swatches. Using the swatch groups will isolate the user from the details of the template and allow changes or further subdivisions of the template without invalidating the user's associations. In the case of the Face Group, a user can still specify a single parameter when applying a layer to the entire face, but they have the freedom of specifying multiple, finer-grain swatches if they only want to apply the layer to part of the face. Figure 4.5.4 shows an example 'Face' swatch group and a possible subdivision of the original facial area to allow for fine-grain customization without complicating its use.

1. Right Forehead	13. Left Cheek
2. Left Forehead	14. Left Sideburn
3. Right-Outer Temple	15. Right-Lower Sideburn
4. Right-Inner Temple	16. Right-Lower Cheek
5. Right Eye	17. Right Mouth
6. Left Eye	18. Left Mouth
7. Left-Inner Temple	19. Left-Lower Cheek
8. Left-Outer Temple	20. Left-Lower Sideburn
9. Right Sideburn	21. Right Jaw
10. Right Cheek	22. Right Chin
11. Right Nose	23. Left Chin
12. Left Nose	24. Left Jaw

FIGURE 4.5.4 *Example 'Face' swatch group.*

Putting It All Together

Now that all of the components of the texture-customization system have been described, we will discuss how they all fit together. The following pseudo-code will illustrate a simple example implementation of the system. The first class that needs to be defined is the simple swatch definition:

```
class Swatch
{
    float left;
    float top;
    float right;
    float bottom;
}
```

The values that are stored in the swatch may be pixel coordinates or UV coordinates, stored as top-left/bottom-right coordinates, origin/width/height, or whatever

works best for the compositing engine. The important thing about the swatch is that it defines a rectangle in both the source and destination textures.

All of the swatches for a given template can be kept together and managed by the template class. This example implementation is an extremely simplified version that only keeps a vector of the swatches so that they can be retrieved by their id. In a real-world implementation, the template class would probably contain additional information about the texture that it was created from as well as functions to retrieve the region of a texture specified by a swatch, given the swatch's id. Such functionality is dependent upon the compositing engine's requirements for texture coordinates and is therefore excluded from our example.

```
class Template
{
    vector<Swatch> swatches;
}
```

Then a bigger piece of the system must be defined to use the swatches and templates—namely, the layer.

```
class Layer
{
    int priority;
    int opacity;
    color hue;
    Texture *pSourceTexture;
    list<int> swatchIDs;
}
```

The assignment of priorities is application-dependent. This example assumes that a priority of zero represents the bottom layer, with increasing priorities drawing on top. Opacity is typically stored as a number from zero to 255, where zero represents complete transparency and 255 represents complete opacity. Depending on the underlying engine, it may be desirable to embed the opacity value in the alpha channel of the hue member variable. Each layer must also have a reference to the texture that it will use during compositing as well as a list of the swatches that it will composite into, here represented by their ids.

The last remaining class to define is the workhorse of the system. A Character-Texture object keeps track of all layers that will be used to composite the final texture as well as the final texture itself. It also needs access to the template that defines the layout of the texture. Since the CharacterTexture class actually performs all of the work in the texture-customization system, it contains code in addition to its data members.

```
class CharacterTexture
{
    list<Layer> layers;
    Texture *pCompositeTexture;
    Template *pTemplate

    AddLayer(Layer *);
    RenderTexture();
}
```

The AddLayer() method is required to add a new layer to the system. It should ensure that the layers in the list are sorted by priority so that the compositing step can iterate once through the list and composite each layer into the final texture. Other helper methods and a little more symmetry, such as a RemoveLayer() method, would also be implemented here in a real system, but in our example are omitted to maintain simplicity.

Once all layers have been added, the RenderTexture() method is needed to perform the compositing work.

```
void RenderTexture()
{
    // Clear out the destination texture to
    // prepare it for a new compositing
    // operation.
    ClearComposite();

    // Iterate through each layer and composite it
    // into the final texture
    for each layer in layers
    {
        // To composite a layer, each swatch must
        // be used to render its region into the
        // final texture
        for each id in layer.swatchIDs
        {
            CompositeRegion( pTemplate->swatches[id],
                             layer.pSourceTexture,
                             pCompositeTexture,
                             layer.opacity,
                             layer.hue);
        }
    }
}
```

When the call to RenderTexture() has completed, each layer has been composited, back to front and using all of the specified alpha and color properties, into a final character texture that is ready to be rendered.

Further Enhancements to the System

There are many enhancements and optimizations that can be applied to the basic system outlined in this article. Most of them will depend heavily on the rendering engine that the system is built on. The `CharacterTexture::CompositeRegion()` method might be implemented in software by using multiple, optimized versions tailored to regions that are opaque or not hued, for instance. Alternatively, the method might take advantage of hardware rendering to do the compositing, cutting the cost of using alpha blending and hueing considerably.

This example system associated a single template with the entire process. A more-flexible system could allow separate templates for each layer as well as the final texture. Such an extension would allow for smaller textures to be composited into larger textures. For example, if a game allowed a small choice of skin tones but a large number of different facial features, a single-template system would require that the facial-feature textures be created at the same size as the whole-body textures, wasting a considerable amount of texture space. Being able to provide a smaller template that only contains swatches for the facial features, which the compositing system could then place into the larger, final texture based on the larger template, would recover that texture space.

A system that supports multitexturing of characters would further extend the given example. To implement such a system would require that the `CharacterTexture` class be given a list of composite textures instead of a single one. Each of these would serve as a texture for a specific multitexturing effect, such as a glow map or bump map. Likewise, each layer could optionally have multiple source textures that would be composited into the appropriate texture.

The rendering of certain swatches could be avoided entirely by implementing opaque flags for swatches or layers. During the compositing phase, the code could avoid rendering any swatches in a layer that were obscured by the same swatch in a higher layer that contained such a flag. Using such a flag could potentially avoid a large amount of overdraw in the compositing process.

Limitations of the System

One major feature of modern rendering engines does not coexist well with this texture-customization scheme: mip-mapping. The final texture used by the process is essentially composed of rectangular regions from disparate textures butted up against each other. Regions that are adjacent to each other in the texture may not map to adjacent areas of the character mesh. Since creating mip-maps of a texture involves averaging adjacent pixels, doing so at region boundaries of the texture will cause areas

of the mesh to receive texture data from nonadjacent areas of the mesh. In extreme cases, the effect may appear as if the texture was put through a blender before being applied to the character. If possible, mip-maps should not be generated for these composited textures. If this results in 'sparkling' of the texture or other unwanted side effects, other nontraditional techniques of generating the mip-maps should be investigated. One approach is to blend the entire texture to a single color, such as gray, in each successive mip-map to provide a more-natural loss of detail at a distance, or we might even introduce an alpha component to each level to allow the character to fade into the distance. Results may vary depending upon the game requirements, so experimentation is the key to arriving at an acceptable solution.

A similar problem arises when attempting to use the system with Level-of-Detail (LOD) meshes. Because of the discontinuous texture mapping, vertices may have to be duplicated at certain points in the mesh to allow the nonadjacent regions of the texture to appear to map to adjacent triangles of the mesh. If lowering the LOD of the mesh causes one of these paired vertices to be dropped from the mesh, then the mesh will appear to have inappropriate areas of the texture stretched across it. If the LOD meshes are created algorithmically, then this effect can be avoided by preventing any of the paired vertices from being dropped, effectively creating a hard seam that cannot be reduced and that preserves the noncontiguous mapping. Alternatively, if the LOD meshes are to be modified by hand, then a more-appropriate mapping of the texture to the new mesh can often be found.

Both of these side effects can be reduced by properly defining the relationship of the texture template to the mesh. The larger the number of adjacent areas of the texture that is mapped to adjacent areas of the mesh, the lower the number of rendering artifacts that will result. If the texture template is laid out as if a sheet of rubber had been wrapped around the mesh, the texture painted on it, and then allowed to snap back to its original rectangular shape, then the artifacts will be minimal. If, however, the texture appears to be a bunch of piece-meal, arbitrarily laid out disparate sections with no continuity, then the artifacts will be very noticeable.

Conclusion

The texture-compositing scheme for character customization is a versatile system that can easily be incorporated into most engines. Its ability to determine the exact cost of character customization and provide an extensive array of appearances from a small number of art assets makes it an attractive choice for platforms with fixed resources. Since the system is dependent upon a very small set of features from its underlying rendering engine, it can be implemented in the early stages of development, long before the more-advanced features of an engine are in place. Combine these features

with the fact that it can start out simple, evolve, and be used in conjunction with other customization techniques, and you have a system that can be used for everything from the foundation for early prototypes to the complete, long-term character-customization solution for your massively multiplayer game.

4.6

Unique Challenges of Console MMP Games

John M. Olsen, Microsoft Corporation

infix@xmission.com

Why would anyone want to create a Massively Multiplayer (MMP) game for a console? It turns out that many of the reasons are the same as for writing any game on a console instead of on some other platform, such as a PC. The biggest benefit is the uniform hardware, which leads to greatly simplified configuration testing.

Another thing to consider is that broadband Internet connections are becoming more and more common, and will continue on an upward trend for the foreseeable future. Internet connectivity is being either built in or added on to all the latest consoles, creating an audience that will, in many ways, be easier to profile, track, and market to than the general gaming population.

The MMP console market is in its infancy, and those who get into the market earliest with solid applications that deal with the unique issues of a console will have the opportunity to shape the market as it forms and grows. The tricky part will be to successfully address issues that are unique to console games.

Environment

The first difference to notice between game consoles and PCs is the location of the hardware. The simple fact of having a console in the living room rather than a PC in the home office puts it into more of a shared environment—a place where people gather and interact socially. This can be reflected in your design in multiple ways.

One common technique used on many console games is a split-screen mode. This can be used just as effectively on an MMP game as it can on the more-typical stand-alone games. Having between two and four people playing together on the same console reduces the complexity of a number of difficult problems, including communication, grouping, and commerce.

Another requirement for a console environment is to account for shorter play sessions. In many MMP games, it can take half an hour to connect, locate friends, decide

what to do, and get to the desired location. With a console, the pace must be picked up, making a half-hour play session long enough to be productive.

Login

Commercial MMP games require a login to verify that only paying users have access to the game. Since there is no keyboard included as standard equipment on any of the current consoles, you will want to do whatever you can to simplify the login process while retaining security.

One of the simplest approaches would be to remember user names so that the player does not have to enter a login name each time they connect. Once a user name has been entered with an on-screen virtual keyboard (or other text-input device), it would need to be saved to some sort of permanent storage on the console, such as a memory card or on hard disk.

Password entry could be done either as a series of button presses or as text entered the same way the user name was originally entered, most likely with a virtual keyboard. Both methods should be very familiar to console game users, so the choice depends on your design.

Resolution

A major difference between consoles and PCs is the range of resolutions available. PC games can take advantage of some very high resolutions, and often are able to switch resolutions on the fly as the game is running. For most PC games, screen resolution is very much under control of the user.

With consoles, the frame buffer is often fixed to NTSC or PAL resolutions. Some consoles are beginning to break the resolution barrier with support for higher-resolution HDTV modes, but your design must take into account the lowest denominator, which for current generation consoles is a 640 × 480 screen for NTSC or 640 × 512 for PAL. For handheld devices, this is restricted even further.

With this smaller amount of real estate, you will have to pay careful attention to how you present text to the user. Fonts and icons will need to be designed carefully to work even on a blurry television set, and the amount of text you can present at one time is limited. Although it may sound like a case of beating up on testers, be sure they have access to the worst televisions in the office. If they cannot read something, you get to fix it.

Note that using a split-screen mode will only aggravate the resolution problem. Using a two-way or four-way split-screen mode will put some severe restrictions on your ability to display text and even iconic information on-screen. This can be alleviated to some extent by combining sharable elements, such as radar maps and group rosters, so they are displayed only once instead of once per player.

Chat Channels

One of the mainstays of PC MMP games is chat between players. Chat is one of the primary things that help the players form a sense of community, as well as being a simple method for organizing groups and events of all sorts. Chat can be grouped into several categories, each of which fills a special need:

* One-on-one chat with individual friends.
* Organizing groups and gameplay with a small number of other players.
* Chat with widespread groups of friends or with guilds.
* Strategy and tactical chat for large-scale events.

So how do we meet each of these needs on a console? None of the base configurations of consoles on the market today include keyboards, which is how chat is done on most PC-based MMP games.

Voice is one possible answer, but one that requires a lot of careful consideration and planning. To handle all of the above uses would require the ability to switch voice input to be routed to just the desired channel, so you end up talking to only the group you intend. This means you need a mechanism to enable fast and easy switching to map your voice onto the proper channel.

Voice communication also becomes more problematic as more people join a chat session. Just like a crowd of people in a room, it is difficult to hear anything if everyone is talking at the same time. Text messages have this same problem, but not to as great an extent, since you can always scroll back through text messages. With voice, any lost message is lost for good.

Another thing to consider with voice is that you need the ability to individually filter out each of your incoming channels so you only hear the chat that is useful to you at the moment. Multiple voice chat channels can also cause much greater bandwidth requirements. The easiest ways to reduce bandwidth on the server are to either merge all channels into a single audio signal, allowing listening on one channel at a time, or to distribute the chat so it runs in a peer-to-peer fashion and does not pass through the server at all. Even when merged into a single channel, chat could easily double your anticipated bandwidth costs.

Voice also has some unique difficulties in that it cannot, in general, be filtered for content; it can only be switched on and off. The finest level of resolution available would be the ability to filter out particular players or channels, rather than use text filtering where you can easily filter individual words.

Communication between players can also happen via emotes, or a combination of visual gestures and short but static text messages. Many games on the market have hotkeys that can be used to trigger simple audio events, to issue commands, trade information between players, or to taunt victims.

Customized emotes would require some up-front time from the player, which could dissuade some players from using them. It would be important to have a default set of emotes that would be available with no set-up time.

Triggering emotes on a PC can be as easy as hitting a function key, but on a console there is no such thing as a row of function keys. Emotes need to be hooked up to run from the game control pad, meaning they require some additional time and effort for menu navigation and selection when compared to their PC counterparts.

Add-on text input devices are a convenient option where they exist for a console, because you suddenly have at your disposal either all or most of the capabilities that were lost due to not having a keyboard on the base console configuration. Navigating through a virtual on-screen keyboard for chat is simply unmanageable due to how long it takes to enter even a short message. The addition of some form of text input device makes regular text messages a real possibility, so you will want to take advantage of these devices if offered on the consoles for which you are making games.

Due to the restrictions of console development and the way they rely on specific libraries for user input, using an add-on text-input device would only be possible if a game has been designed to take advantage of it. This means that old titles will not suddenly become more usable with a new controller device, and use of the device must be planned for from the earliest phases of the design process.

You can also manage the difficulty of in-game chat by purposely designing the game to minimize the need for chat. Although not implemented on a console, *Toontown Online* is a good example of this (see Section 1.1, "*Toontown Online:* Building Massively Multiplayer Games for the Masses"). It uses greatly reduced chat capabilities when compared to the typical MMP game.

Targeting

Players need to choose targets for a variety of reasons. Targets are used for combat, for communication, for trade, for the forming of groups, and a host of other activities that will vary based on the game design.

Due to the many varied uses of targeting, it should be as simple as possible for the player to select another human player or a nonplayer character (NPC) within the game. Players of PC games will be used to the ease with which they can target something via the mouse or keyboard hotkeys, so it is important to keep the console equivalent simple to reduce frustration.

The difficulty comes in, as it has in several other areas, with the restrictions of the game controller, which must replace the functionality of the keyboard and mouse. So, exactly what functionality should you plan on migrating to a controller? One option is to use the controller to select targets the way you would with hotkeys, using a menu:

- Choose the next opponent from the list of possible targets.
- Choose the nearest opponent from the list of possible targets.
- Choose the weakest opponent that is within range.
- Choose the same opponent as the current target.
- Choose the next group member.

This list is by no means exhaustive, but it should give you a good idea of the things that will be required to build an interface that allows easy selection of targets. The list of things you want to implement may be too large to fit onto a controller, so it will be up to you to define those that will be the most useful to you based on your game design.

Another method that is used on many games is to make attacks automatically land on opponents within range. This is the typical the first-person-shooter mode of targeting. You hit what you aim at. This allows you to completely bypass the issue of target selection and simplify your game design. This implied targeting would significantly alter the way combat, trade, and other interactions work, so it is important to decide how you will be doing your targeting as early as possible.

Implied targeting has been used with great success in many console games, so it is a very familiar concept to gamers. It lends more of an action flavor to games, where the player takes a more-active part in physically aiming at and following targets.

Menus

Your design almost certainly includes the need for menus of one form or another, whether it is simply for a save-game menu, option and configuration screens, trade, inventory, or whatever other features your players will use. Menus are simply a way of hiding some of those choices within a tree of commands so they are not all available all the time. Consoles simply do not have enough buttons to give direct access to everything all the time.

The functionality of menus within a console game can strongly resemble PC game menus in many ways and could even be more extensive. This is because the functionality typically assigned to a mouse would likely be added to the menu system. A pause menu structure is common on consoles, so it makes a good starting point for the more-extensive menu system that is likely to be needed by a MMP console game. Console technical requirements typically give guidelines on how menu navigation should be done, and these guidelines can be used to impart a uniform feel to even a deep and complex menu system.

Even with the technical requirements of the console manufacturers, there is a lot of flexibility possible. In some cases, it may be good to switch rapidly between multiple menus or lists of items, as with the inventories of several players. Rather than

using the directional pad for the navigation as you might expect to see in that case, you can use the controller's shoulder buttons to speed the transition between submenus and still preserve the ability to use all four directions for navigation within a single menu or list. Those extra buttons are there to be used, so be sure to take advantage of them whenever it makes sense to do so.

One of the reasons you are likely to end up with a deep and complex menu system on a console MMP is that you will be adding menu options for things that a PC game would normally use a typed command. On a console, there is no ability to pop up a console window, enter a configuration command, and continue; so all those features that had been done in console windows on a PC will need to move into your menus.

One caution is in order here with menus: there is a temptation to flatten the menu system by grouping functions into multiple top-level menus that are triggered by different controller buttons. While this may work well for selected bits of functionality that are easy to isolate, such as weapon selection, it will be best in general to group most menu functions under a single top-level menu. That way you will preserve the rest of your controller buttons for other game functions.

Inventory Management and Trade

Some PC MMP games have an amazingly complex system of inventory management and trade between players and with NPCs. A console MMP will need to put all of this into a simplified package for it to be usable. This means that inventory management is yet another area that must be watched carefully from the earliest design phases to make sure you build something that is both simple and sufficient to meet the design needs of the game.

One example of an area that needs to be done differently is drag-and-drop inventory management. Since consoles have no mouse, and controlling a virtual pointer with a joystick can be troublesome at best, a replacement should be found. The simplest replacement for this functionality would be a system where you use a menu to navigate to an item, select it, and then navigate through the menus for a destination to drop it.

The functionality of picking and placing is the same as dragging and dropping, and is very similar to using a virtual pointer, but it is simpler for the player because of the discrete steps the menu navigation can take as it moves from one inventory slot to the next. It is much easier to put things where you mean to put them.

Areas to keep in mind for inventory management are the abilities to equip, store, trade, and use items. Each of these can be done with the methods described above by creating specific destinations for items. Equipping or using an item, for instance,

would be done by placing an item onto a character portrait. Putting something away could be done by placing an item in a pack or an empty inventory slot.

Trade is somewhat more complex and will vary greatly based on the game design, but is also mostly a matter of navigating the menus to move items between your inventory and that of another player or NPC.

Permanent Storage Space Issues

Some consoles have memory cards for storage, while others have either built-in or add-on hard disks. Other storage schemes exist, but these two types cover the current console systems. Each data-storage method has its own set of benefits and drawbacks.

Memory cards are great for mobility. It is very easy to toss a memory card in your pocket to go over to a friend's house. The size is sufficient for storing simple data, such as friend lists, preferred game servers, and other small sets of data. Server-side databases can benefit from this small amount of local storage by allowing the player to track some of their own data rather than keeping it all on the main game servers.

The down side of memory cards is that they cannot be used to store large amounts of data. This means that on a system with just memory cards, you will only be able to do very small client updates, such as small map updates or new characters. Even those updates will need to be limited so the player does not need to keep a stack of different memory cards depending on what add-ons they want to use. Any update to the client software will likely need to be done with an upgrade CD-ROM.

Consoles with a hard disk can take advantage of more features than systems that only have access to memory cards. With a hard disk, client software updates can be used to add very large chunks of new game content and even episodic content released on a regular schedule. Issues for managing and restricting the size of add-ons are quite a bit simpler. Even updates of the entire executable are possible, whether for security reasons or to add new features.

The down side to storing all this data on a hard disk is that the new data is no longer mobile and able to move with you to a friend's console. This may not be much of an issue, since all consoles with hard disks also have memory cards available to handle portable portions of the game data.

Another potential problem with using mass storage on the console to hold game updates is that you must force all users to have the same updates. You will need to design a way to keep all players up to date without causing new users, or those who take a game disk to their friend's house, to wait for hours as their system downloads files for the current version of the world.

If your target platform has an optional hard disk, you may be forced up front to decide whether you will require a hard disk or not use one at all. The middle ground

between those two decisions is a disaster waiting to happen, since you cannot take advantage of the hard disk in any way that prevents play with just a memory card.

Alternate Interfaces

When all is said and done, there may just be elements of your design that cannot be done on a console. But do not throw out those elements just because the console hardware will not support them. Your plans already likely include alternate interfaces for your player base, such as Web sites. In many cases, you can extend this portion of your project to cover the ground that cannot be implemented directly on the console.

Some features, such as voice chat or text messaging, could be added as external tools for the segment of your user base that has their computer and console next to each other. But the best thing to do may be to let your users, themselves, decide what is needed.

A sense of community among your players will grow as they build their own out-of-game presence with guild sites, organizations, hint sites, and a wide array of other related Web development. Encouraging your players in these areas will give you a more-stable player base as they develop a sense of belonging, and they will feel they are members of a community, rather than just game players.

One way to encourage the external community is to give them access to whatever in-game data you deem not to be a security/privacy risk, bandwidth hog, or proprietary knowledge. This could include information on what servers are active, what players are currently connected (with their permission), community broadcast messages, character and guild statistics (again, with player permission), and many other things that will depend upon your particular design.

Conclusion

MMP games have already begun to appear on consoles, and it is only a matter of time before consoles have a significant and lasting impact on the MMP market. But very early in the design phase, these games will need to be approached differently to allow for their console-specific lives.

Networking, voice, mass storage, and other devices will play a significant part in determining the success of console MMP games. It will be necessary for these hardware advances to be either built in or gain widespread acceptance as add-ons before a console MMP title can be a runaway success. Even given the difficulties associated with putting a MMP game onto a console, it is just a matter of time before this market segment is populated by several significant titles.

5

DATABASE
TECHNIQUES

5.1

RELATIONAL DATABASE MANAGEMENT SYSTEMS PRIMER

Jay Lee, NCsoft Corporation

jlee@ncaustin.com

A Relational Database Management System (RDBMS) is software designed to provide data storage, retrieval, and manipulation services via a standardized language called "Structured Query Language" (SQL). It is the de facto standard for data persistence in business applications throughout the corporate world. There are many commercial vendors providing RDBMS software to the market, such as [MSSQL], [ORACLE], [SYBASE], and [BORLAND], as well as viable open-source options such as [MYSQL] and [PGSQL].

This article is intended to be a primer on the basics of the RDBMS. It is presented as an aid to those with little or no background in this type of software. Hopefully, this will spark interest and further study in its application in MMP games. Additionally, this discussion on database management serves as a foundation for Section 5.2, "Leveraging Relational Database Management Systems to Data-Drive MMP Gameplay."

Tables

Data in a RDMBS is organized into units called "tables." Tables contain columns of various data types, and each entry in a table is called a "row."

The employee table shown in Table 5.1.1 has four columns, EmployeeId, FirstName, LastName and SSN. It has two rows in it, one for Jay Lee and another for John Doe.

Table 5.1.1 Employee Table

EmployeeId (PK)	FirstName	LastName	SSN
1	Jay	Lee	999-99-9999
2	John	Doe	888-88-8888

A table will usually have a primary key—a combination of one or more columns that uniquely identifies a single row in the table. This unique index, created as the key of the table, is typically the optimal method of accessing a single row from the table. In the employee table, the EmployeeId column serves as the primary key (designated as PK).

Querying and Relating Data

Using SQL, the row for Jay Lee can be retrieved with the following syntax. (Note that the format of SQL statements is flexible; spacing and line breaks are added for clarity.) This query will return the result shown in Table 5.1.2.

```
SELECT *
FROM Employee
WHERE EmployeeId = 1
```

Table 5.1.2 A Simple Query Result

EmployeeId	FirstName	LastName	SSN
1	Jay	Lee	999-99-9999

A table is generally created for every entity of interest in the domain for which a system is built to model. In an MMP game, for example, one might expect to find tables like the following: Player, Character, Spell, Monster, Treasure, Skill, Inventory, and Bank. The power of a relational system is in its ability to describe relationships between various tables or entities. Given the department table shown in Table 5.1.3, each employee can be assigned to the appropriate department by adding the primary key from the department table as a foreign key (FK) in the employee table in Table 5.1.4.

Table 5.1.3 Department Table

DepartmentId (PK)	DepartmentName
1	Programming
2	Finance

Table 5.1.4 Employee Table with DepartmentId as a Foreign Key

EmployeeId (PK)	FirstName	LastName	SSN	DepartmentId (FK)
1	Jay	Lee	999-99-9999	1
2	John	Doe	888-88-8888	2

This placement of DepartmentId formalizes the following rules:

- An employee can only be in a single department.
- The only valid departments that an employee can be assigned to are listed in the department table.

Furthermore, the *referential integrity* of the database containing these tables is maintained. A department can only be removed from the department table if there are no references to it on the employee table. This makes sense from a data-integrity perspective—an employee should be reassigned to a new department before the one he is in goes away.

This feature alone can provide huge benefits to MMP games, given the numerous complex relationships that must be captured and maintained in the game world. Many bugs are likely occur in MMP games because of the difficulty of manually maintaining referential integrity in game code.

The following SQL query answers the question, "What are the names of the employees in the programming department?":

```
SELECT FirstName, LastName
FROM Employee
WHERE DepartmentId = 1
```

An SQL query can involve more than a single table. By utilizing a common column with shared domains, we can perform a join operation between the tables in question. When referencing identically named columns in a join, SQL syntax requires qualification of the column by table name (or an associated mnemonic) to remove ambiguity.

For example, to generate a report of employees by department, one would write:

```
SELECT D.DepartmentName, E.FirstName, E.LastName
FROM Department D, Employee E
WHERE E.DepartmentId = D.DepartmentId
ORDER BY D.DepartmentName
```

SQL makes it incredibly simple to ask many varied questions about the data. Another powerful aspect of relational databases is their ability to store data in a manner that is decoupled from how it is going to be queried.

Relationship Types

Relationships come in three major flavors: *one to one*; *one to many*; and *many to many*. These are generally discovered by interviewing a domain expert (for MMP games, this would be a designer) and asking, for any two given entities A and B that are to be related, "For one A, how many B are there?" and "For one B, how many A are there?"

For example: given a student, how many courses can he take? Given a course, how many students can enroll in that course?

Tables 5.1.5 and 5.1.6, respectively, show the employee and company vehicle tables in a one-to-one relationship. In practice, these types of relationships tend to be rare. The example demonstrates a policy that an employee can only be assigned a single company vehicle, and a company vehicle can be assigned to only a single employee. Interestingly, in a one-to-one relationship, either of the primary keys can be selected to be the foreign key on the other table and still accurately portray the relationship. This example could be modified to have the EmployeeId as a foreign key on the company vehicle table and still be correct.

Table 5.1.5 Employee Table in One-to-One Relationship with Company Vehicle Table

EmployeeId (PK)	VehicleId (FK)
1	1
2	2

Table 5.1.6 Company Vehicle Table in One-to-One Relationship with Employee Table

VehicleId (PK)	Model	Year
1	BMW M1	2001
2	Chevrolet Malibu	2002

The department and employee tables in Tables 5.1.7 and 5.1.8 illustrate a one-to-many relationship. In this case, an employee belongs to a single department. A department, however, can contain multiple employees. In a one-to-many relationship, the foreign key must appear on the table where the entity has the 'one' side of the relationship. Since an employee can only belong to a single department, the DepartmentId must appear on the employee table. Placing the EmployeeId on the department table would limit each department to a single employee—clearly not what is desired.

Table 5.1.7 Department Table in One-to-Many Relationship with Employee Table

DepartmentId (PK)	DepartmentName
1	Programming
2	Finance

Table 5.1.8 Employee Table in Many-to-One Relationship with Department Table

EmployeeId (PK)	DepartmentId (FK)
1	1
2	2

The student, course, and student course tables shown in Tables 5.1.9, 5.1.10, and 5.1.11 demonstrate an example of a many-to-many relationship. In this case, a student can take multiple courses, and multiple students can take the same course. The main characteristic of a many-to-many relationship is that a third table is generated, utilizing the primary key of both tables in the relationship as foreign keys, and forming a compound primary key for any other columns placed on the resultant table.

Table 5.1.9 Student Table in Many-to-Many Relationship with Course Table

StudentId (PK)	StudentName
1	Jay Lee
2	John Doe

Table 5.1.10 Course Table in Many-to-Many Relationship with Student Table

CourseId (PK)	CourseName
1	Programming 101
2	Programming 102
3	Programming 204

Table 5.1.11 Student Course Table—Result of Relationship Between Student and Course

StudentId (PK, FK)	CourseId (PK, FK)
1	1
1	3
2	1
2	2

Attribution

Additional columns may be place in tables to further describe the key in the table. These columns are known as "attributes" and may be foreign keys from other tables, depending on the domain of the values in that column.

An example of an attribute from a previous table is the DepartmentId column in the employee table, which happens to be a foreign key because its valid values are taken from the primary key on the department table. Another example attribute for the employee table might be a column named "Gender," with the domain of valid values being "M" or "F." The domain does not justify an additional table, so it is not a foreign key. In the context of an MMP, one might find Character attribute columns like the following: ClassId, HitPointAmount, CurrentLevel, StrengthAmount, and DexterityAmount.

Normalization

The process of putting together the schema of a database—discovering all the desired entities, relating them appropriately, and adding desired attributes on each table to capture its essence—is a subject that has been widely discussed [Date] [SKS].

For this purpose, one needs simply to understand that there are a set of rules designed to determine the level at which the schema of a database adheres to certain desired characteristics. These characteristics are designed to make the database resistant to changes in the applications that use the data; they minimize redundant storage and handle the changes more gracefully. A schema that adheres to these rules is said to be "normalized" [Codd].

Due to performance considerations, it is rare in real-world applications that the entire schema of a database remains normalized. An experienced database administrator will take the desired 'logical' view of the schema and turn it into a 'physical' implementation that is designed to provide maximum performance for the most-frequently used query-access paths. These decisions are always weighed against the extra work required to maintain data that had been denormalized.

Manipulating Data

In addition to querying the database, SQL can be used to manipulate the data in tables. The language provides syntax to add, modify, and remove rows from tables. The following statement adds a single row into the department table.

```
INSERT
INTO DEPARTMENT
VALUES (3, 'Accounting')
```

This SQL statement removes each row from the employee table where the employee's id is greater than 12.

```
DELETE
FROM EMPLOYEE
WHERE EMPLOYEEID > 12
```

The following statement gives every employee a 10% raise.

```
UPDATE
EMPLOYEE
SET SALARY = SALARY * 1.1
```

Conclusion

A relational database management system is powerful software that does an excellent job of data persistence and manipulation services for industrial strength applications. Many MMP games are already taking advantage of this functionality to provide better service for their customers.

While there are many additional aspects to SQL and RDBMS in general, this primer should provide sufficient background from which to launch further study. Check out the Reference section below for additional material to use in getting up to speed with RDBMS. Also, check out Section 5.2, which discusses a practical application of RDMBS in MMP gameplay.

References

[BORLAND] Interbase product Web site, *http://www.borland.com/interbase/*.

[Codd] Codd, E. F., "Relational Completeness of Data Base Sublanguages," R. Rustin, ed., in "Database Systems," Prentice Hall and IBM Research Report RJ 987, 1972: pp. 65-98.

[DB2] IBM DB2 product Web site, *http://www-3.ibm.com/software/data/*.

[Date] Date, C. J., *An Introduction to Database Systems, 7th Ed.*, Addison-Wesley, 1999.

[MSSQL] Microsoft SQL Server product Web site, *http://www.microsoft.com/sql/default.asp*.

[MYSQL] MySQL Open Source Database, available online at *http://www.mysql.com/*.

[ORACLE] Oracle product Web site, *http://www.oracle.com/*.

[PGSQL] PostgreSQL Open Source Database, available online at *http://www.pgsql.com/*.

[SKS] Silberschatz, Korth and Sudarshan, *Database System Concepts, 4th Ed.*, McGraw-Hill, 2001, available online at *http://www.bell-labs.com/topic/books/db-book/*.

[SYBASE] Sybase product Web site, *http://www.sybase.com/*.

5.2

LEVERAGING RELATIONAL DATABASE MANAGEMENT SYSTEMS TO DATA DRIVE MMP GAMEPLAY

Jay Lee, NCsoft Corporation

jlee@ncaustin.com

Source code for this article is included on the book's CD-ROM.

Relational Database Management Systems (RDBMSs) have been the mainstay for data storage and retrieval in business applications within corporate America for around two decades. It is not surprising, then, that developers of Massively Multiplayer (MMP) games are increasingly looking to leverage this technology.

An MMP game has many of the same needs as other lines of business—billing, customer support, and account management being obvious examples. In addition, it would be natural to utilize a relational database to maintain player and game world states so that they persist across play sessions and server restarts, respectively.

The goal of this article is to explore the use of relational databases, beyond the obvious, with techniques that move them into the realm of gameplay to deliver data-driven game systems.

Before getting into the techniques, a case will be made for why reading and writing to the database in a synchronous fashion from game servers is a path fraught with peril. A workable approach will then be presented, and each of the subsequent techniques builds on this foundation to deliver robust data-driven game systems.

The examples and source on the CD-ROM are presented in Python [Python], an interpreted language, and use the Structured Query Language (SQL) syntax particular to Microsoft's RDBMS offering—Microsoft SQL Server [MSSQL]. However, there should be little difficulty in applying them to the language and RDMBS of your choice.

This author's article, "Relational Database Management Systems Primer" (see Section 5.1), contains prerequisite knowledge for this material. Review it first, if necessary.

The Obvious Approach—Why It Won't Fly

Over the years since RDBMSs have been in commercial use, their overall performance has increased dramatically. Faster hardware and significant improvements in

optimization techniques have allowed vendors to claim performance benchmarks that number in the many thousands of transactions per second [TPC] [MSTPC]. Given these performance numbers and the flexibility of the SQL language, it is a relatively trivial task to build logic into the game servers to read or write data in real time in order to reflect a consistent world state in the database. In theory this sounds great, since a well-designed MMP game should not have persistence requirements that come anywhere close to the performance that can be achieved by an RDMBS, right?

Well, not exactly. There are at least three compelling reasons why we would not want to simply purchase an RDBMS setup (software and hardware) and start implementing our persistent requirements in terms of real-time synchronous activity to the database.

The first reason is cost. Development costs for MMP games are already notoriously high. To attain the kind of performance being touted by vendors, a very heavy investment in multiprocessor hardware is required. Coupled with licensing costs related to commercial RDBMSs that license on a per-processor basis, we will quickly notice that our game's producer will not be happy about the kind of money needed to deploy and administer such a solution.

Assuming we were employed by one of the few organizations in the industry that is able to afford such an outlay, we would still face a daunting task. We all understand that benchmarks are used with great frequency by sales forces, but they do very little to help us predict how *our* game will perform in a live scenario with real-time synchronous activity to the database.

Thus, the second reason to avoid the party line in implementing an RDBMS solution for our MMP game: predicting the performance that we are likely to attain is an extremely tricky proposition at best. Furthermore, we will not be able to glean realistic measurements until very late in development when all the database activity is coded and in use. By that time, any significant changes in architecture become extremely expensive and are delay-prone. (See the first reason, above, for why 'more hardware' is a slippery slope to start down.)

The third reason why real-time activity to the database is folly is that a live MMP game cannot afford the types of hiccups that inevitably occur while waiting for transactions to complete. These dips in database responsiveness may be due to a naive database structure, unexpected database object contention, or sheer volume of activity. Regardless, they tend to occur at unexpected times and under scenarios that are extremely hard to reproduce, let alone debug and fix. It's just not an option to present a 'wait' cursor to the player in the middle of active gameplay while data is being written to the database.

A Workable Approach

Let's move on to discuss an approach that will allow us to gain the benefits of using a database while not impeding the overall performance of the game. This approach

should also allow us to be somewhat more modest in our investment in RDMBS-related hardware and software.

The quickest way to access data is to already have it resident in memory at time of use. The implication is that while all data to be used at run time is stored in the database, it is preloaded to avoid the impact of accessing the database when it is needed. For example, if all of the data that describes each weapon's effect in combat were stored in a set of tables, we would load this data into our game server at start-up time. Then when combat occurs in the game, we have the fastest access for retrieving the data for use in combat calculations. Later sections in this article will address how we might structure this data in memory.

A slight twist on this approach is 'just-in-time' caching of data, which is extremely useful for those cases when the data is typically not used until some specific event has occurred. The classic case in an MMP game would be for player-related data. Information about the player's items, quest logs, and so forth need not be in memory when the player is not in the game. But at the point that the player logs in, we have the opportunity to take some extra time building the cache of player data required, assuming we have an asynchronous method for retrieving data from the database.

Anytime we choose to cache data, we have to consider what to do when the data gets out of date with the version in the database. In some cases, the data in memory reflect changes that occurred during gameplay, and we need to reflect these changes back into the database. An example would be a character achieving the next experience level or acquiring an item. We should reflect this type of change as soon as possible. A delay of any significance means we risk losing game state should the game server crash unexpectedly. Commonly known as "warping," we need to balance this inconvenience to the player with the amount of workload placed on the database. A classic example would be that we would not write the player location to the database every time they moved. Instead, we might write the location to the database every five minutes, meaning that the player would lose five minutes of movement in the game under the worst-case scenario should the server crash.

Other changes to data occur in the database outside of the game. For example, suppose it is determined that the data values for an existing in-game item need to be modified because the current values cause an imbalance in gameplay. These updates can usually wait for the next maintenance window established for the game. The servers get brought down for a short period of time, updated as needed, and restarted. During the restart, the data caches get rebuilt, effectively bringing the game in sync with the database. Should a change made to the database be deemed sufficiently critical, we could choose to notify players of an unscheduled interruption and restart the servers to update the cached data. Of course, any effort we make to minimize server restart times will pay off during the (hopefully) infrequent occurrences.

Any deferred loading of data requires that some facility be in place for asynchronous access to the database. Asynchronous access is not built into an RDBMS. Instead, we have to architect this facility into our game servers. One approach would be to have a separate thread that performs data access running in our servers. The main game thread receives notifications from the data access thread when data has been retrieved and is available for use. The main thread is also able to push requests through to the data access thread in its processing cycle. A robust cross-thread communication facility would be required, as would be a database-access library that is multithread aware.

A simpler way to achieve this asynchronous facility is to build a separate database server application that the main game server talks through via network messages. When the game server needs to talk to the database, it sends a request in the form of a packet to the database server application and continues with other activity. When the game server receives an incoming message that is the response to its request, it spends some time processing the data before moving on to its other tasks in the game loop.

This same asynchronous facility would also be used to make updates to data stored in the database. When a player logs out, or at some other predefined interval, the data to be updated is sent to the database server application, which writes it to the database while the game server carries on. We should look for windows where a delay is likely to be acceptable to a player and use this time to mask database access time.

The RDMBS can also be leveraged to manage data for the client. However, the client should never query the database directly. Instead, for maximum access speed and minimum bandwidth impact, all client-side data should be accessed statically. That is, it is loaded at client start-up time into a structure expedient for access speed. This also suggests that client-side data managed in the database should be updated relatively infrequently. Typically, it will be updated via the patching mechanism we have in place for our game. The techniques that will be explained can be applied to client-side data as well, as long as the data is static enough to be sufficiently up to date via patching.

Retrieving Data

This article is not intended to detail how to access the data from the database. There are a myriad of solutions available, including libraries provided by the database vendors themselves that take advantage of their custom SQL extensions, Open Database Connectivity (ODBC) platform independent libraries, Microsoft's ActiveX Data Objects (ADO), and other third-party solutions. We should pick one that fits well within our overall server architecture, but favor one that makes it simple to map the data that has been retrieved into the data structures that are available in our programming language of choice.

We should also favor one that supports the use of stored procedures within the database itself. Stored procedures are constructs that contain the native SQL statements for a query and are reusable for any client of the database. They also have the added advantage of being precompiled in the database to boost performance, and their interface is generic enough that it becomes quite trivial to create a general-purpose facility from our server to achieve just about any query or manipulation. We should avoid writing embedded SQL statements in our code at all cost, as this is the moral equivalent of hard-coded, constant values in our code base.

Constant Modules

This first technique goes a long way to bridging the gap between data values in the database and the need to use that data in our code. It also allows us to maintain good coding practice by avoiding hard-coded values. Suppose we want to perform different actions based on the type of chat message that is received. We would normally write the following:

```
# chatprocessor.py
.
.
.
GLOBAL = 1      # defines of constant values to
RADIAL = 2      # maintain readable code
WHISPER = 3
.
.
.
if chat_type == GLOBAL:
    # do global chat stuff
elif chat_type == RADIAL:
    # do  radial chat stuff
elif chat_type == WHISPER:
    # do whisper stuff
```

Given the ChatType database table shown in Table 5.2.1: we can write the following code:

```
# chatprocessor.py

import chattype    # a generated constant module
```

Table 5.2.1　ChatType Table

ChatTypeId	ChatTypeDesc
1	Global
2	Radial
3	Whisper

```
if chat_type == chattype.GLOBAL:
    # do global chat stuff
elif chat_type == chattype.RADIAL:
    # do  radial chat stuff
elif chat_type == chattype.WHISPER:
    # do whisper stuff

# chattype.py this module is autogenerated from the database

GLOBAL = 1
RADIAL = 2
WHISPER = 3
```

Using Python, the constant module `chattype.py` can be made available by two methods. The first method is to have a process that generates it as a source file. This file is like any other source file, is managed through source control, and is imported by any code that needs to use it. This is extremely efficient as long as the update latency between data changes and source file generation is accounted for. The prime candidate for generated source files is the client, a topic discussed in more detail later.

The second method is to build the module dynamically at run time, which is possible due to Python's interpreted nature. At application start-up, the data is retrieved from the database, and the containing module is built from its content. The caveat here is that the code will need to delay any reference to the module until after the module has been built. This method is usually employed on the server side of the game, since we do not allow clients direct access to the database. The main benefit of this approach is that data changes are immediately reflected in the servers after a restart.

ON THE CD

Refer to `constantmodule.py` on the CD-ROM for details on how to generate constant modules from tables. An additional benefit of using constant modules is that symbols have been created that will be used by other parts of our code for doing lookups, a technique described in the next section.

Lookups

What are lookups? They are in-memory data structures populated from the contents of tables in the database. These structures are then utilized at run time to data drive various aspects of gameplay. For example, during combat processing, we could look up the `PercentToHit`, `DamageAmount`, and `BonusUndeadDamage` using the `WeaponId` of the weapon wielded by the attacker. Tweaking this aspect of combat processing in the future becomes as simple as updating the data values on the Weapon table. To illustrate, Table 5.2.2 shows a representation of the Weapon table in the database.

We run the data though code that generates the following module, creating a variable called "`lookup`"—that is, a dictionary with WeaponId as its key and having values that are a tuple of the remaining columns from the Weapon table.

Table 5.2.2 Weapon Table

WeaponId(PK)	PercentToHit	DamageAmount	BonusUndeadDamage
1	90	8	3
2	85	10	0

```
# weapon.py — a generated lookup structure

lookup =
{
    1 : (90, 8, 3),
    2 : (85, 10, 0)
}
```

The lookup can then be utilized in gameplay code like the following:

```
# combat logic example

import weapon

def Attack(attacker, defender):
    attackingWeapon = attacker.GetWieldedWeapon()
    stats = weapon.lookup[attackingWeapon.GetId()]
    percentToHit = stats[0]
    damageAmount = stats[1]
    undeadBonus  = stats[2]

    if _AttackSuccessful(percentToHit):
        totalDamage = damageAmount
        if defender.IsUndead():
            totalDamage += undeadBonus
        defender.TakeDamage(totalDamage)
```

This technique is the core of this article. It represents how we take data retrieved from the database and make it usable from within gameplay code in the most efficient manner possible.

A significant benefit to this approach is that we can maintain normalization of the database schema. Relational data is most flexible and immune to the addition of new content or changes in application implementation when it is kept normalized. We defer the queries of our data to periods in the game during which speed is not absolutely critical (i.e., outside the game loop). The most obvious of these windows are at the start-up phase of the game server or at player login.

When populating our lookup structures from the database, we massage the data from its normalized form into the optimal data structure for access. At this point, we are no longer concerned with how the data was organized in the database, only that we can access it at run time in the most efficient manner.

For example, if it's beneficial that the data is in sorted order when it is looked up, we use the built-in facilities of SQL to do the sorting. Perhaps some related data is organized into three different tables, but we would like to access it in a single lookup. We are free to join the three tables into a single result set that is then used to populate the lookup. If a particular set of data is going to be looked up in two different ways, we populate two lookup structures from the original data, again giving preference to speed of lookup over other considerations.

Python has some very nice built-in data structures that makes building lookups at run time fairly simple. As shown in the previous weapon.py code, we can use a dictionary to trivially build a lookup from WeaponId to its attributes. Because of the flexible data-handling capabilities of Python, we can take more-complex tables with composite keys and mixed data types and do the same thing.

Consider the following additional tables for handling weapons in the game. The EffectType table (Table 5.2.3) describes the available audio/visual effects we can apply to weapons in the client application during combat. The WeaponEffectType table (Table 5.2.4) describes the various effects to apply when the weapon is used, including specifying a DelayTime (in milliseconds) for when the effect is played after initiation of the attack and a ResourceName that represents the resource used to generate the effect.

We can generate a lookup like the following:

```
# weapon.py - generated lookups

weapon =
{
    1 : (90, 8, 3),
    2 : (85, 10, 0)
}
```

Table 5.2.3 EffectType Table

EffectTypeId	EffectTypeDesc
1	Particle effect
2	Weapon animation
3	Audio

Table 5.2.4 WeaponEffect Type

WeaponId(PK)	EffectTypeId(PK)	DelayTime	ResourceName
1	1	200	gamedata/particles/part01.ptl
1	1	2000	gamedata/particles/part02.ptl
1	2	200	gamedata/anim/weapon1.ani
1	3	100	gamedata/audio/swoosh.wav

```
weaponVisualEffect =
{
    (1, 1) : [(200, 'gamedata/particles/part01.ptl'),
              (2000, 'gamedata/particles/part02.ptl')
              ],
    (1, 2) : [(200, 'gamedata/anims/weapon1.ani')],
    (1, 3) : [(100, 'gamedata/audio/swoosh.wav')]
}
```

The variable `weaponVisualEffect` is also a dictionary, but its key is a tuple—we have to supply both the WeaponId and the EffectTypeId to retrieve the desired data. Also noteworthy is that code using this lookup has to handle the fact that the value side of this dictionary contains a list, since more than one effect of the same type may be applied to a weapon. Notice, too, that we now have two lookup structures in the same module. It makes sense to do this with related data sets, and we simply need to give each lookup its own unique name to achieve this.

ON THE CD

Refer to `lookup.py` on the CD-ROM for some utility functions designed to build various lookup structures. In summary, given a database schema for the game, we should be able to build a set of lookups that allows us to perform efficient run-time access in order to implement data-driven gameplay.

String Table

This next technique shows how a relational database can be leveraged to aid in one of the biggest issues in MMP development—how to minimize the amount of data being transmitted in network packets, thereby keeping bandwidth usage as low as possible. As an example, assume we would like to refer to game resources within our packets, to transmit a message that will tell client applications to play a sound file or animation, or to load a particular mesh. As these resources are produced, they are stored in some source-control location that maps to a file path accessible by the game, such as thegame/gamedata/audio/footsteps.wav.

At some point in the development process, it will become necessary to generate a lookup that will allow a numeric `id` to be substituted for the file path name; so, for example, we transmit the number 35 instead of the string "/gamedata/audio/foot-steps.wav" in the network packet.

In the client, we'd like to be able to execute the code as follows:

```
def ParseAudioPacket(packet):
    audioFileId = packet.GetId()
    audioFileName = stringtable.Lookup(audioFileId)
    Play(audioFileName)
```

We also want to support multiple logical string tables within our system, since there are many different groupings of ASCII strings in the context of MMP game

development. To that end, we'll introduce the StringType table (see Table 5.2.5). This allows us to keep like strings together in contexts where it matters—for example, when a designer is making entries in the database for spell casting and he needs to see the list of animations that are available.

Table 5.2.5 StringTableType Table

StringTableTypeId	StringTableTypeDesc
1	Animation
2	Mesh
3	Sound

We maintain all the ASCII strings in a single table in order to ensure there are no duplicate ids or string values. We do not care about what values get assigned to each string, only that they are unique. We can make StringId an auto-incrementing column and let the database do the bookkeeping of counting up each time a new string is added. The structure of the String table is shown in Table 5.2.6.

Table 5.2.6 String Table

StringId	StringValue	StringTableTypeId
35	/gamedata/audio/footsteps.wav	3
36	/gamedata/animation/fly.ani	1

Look at the file stringtable.py for the code on how the `stringtable` module works. The file stringscript.sql gives SQL code for recreating all the database objects required to implement this technique.

The String table then becomes a central repository for all ASCII strings within the game. Note that this does not include any data that will be displayed to the player. This type of data will need to be localized or made usable for the various languages supported in the game. (See "Localization" for a technique to handle data of that kind.)

An effective infrastructure can be built around the String table during product development. As new entries are created, they become available for project-wide use. They can be freely referenced in other tables without any concerns over data duplication or the effort required to generate the lookup by hand once all the assets are in place.

Getting Data Down to the Client

All of the techniques described here can and should be utilized to provide data access for the client-side application of the game. We want to prepopulate the client with all the data that we can in order to avoid having to transmit it. An assumption is being

made that this will not include any data that would be considered sensitive if revealed to players. Valid candidates under these criteria might be item description text, help text, string data, player status messages, and special effects parameters.

The trick becomes keeping this data up to date with the values that are being updated in the database. A simple approach is to provide a batch process that regenerates all the client data (Python modules with constants or lookup structures) and updating the source control system with the latest files containing the data. This batch process can be run on demand by developers as new updates occur. A development environment that has a process to automatically build the client distribution in place can easily integrate this batch process as an additional build step.

Localization

This final technique is designed to address another large issue with MMP games—that of localizing the game. Localized game text is strictly client-side only, and the server side of the game has little use for the data. On the other hand, storing localization data in an RDBMS makes excellent sense. It makes it infinitely more manageable for the localization staff than having it embedded in resource files, or worse, scattered in source code. Consider the following schema:

The Language table (Table 5.2.7) contains all the languages the game supports and is easy to extend. The LocalizedItem table (Table 5.2.8) contains an item for every bit of text in the game that must be translated. The LocalizedText table (Table 5.2.9) associates the Language and LocalizedItem tables to allow for the entry language-appropriate versions of each text item in the game. Note that the Translation column contains Unicode string data (designated by the leading "N"), meaning that it is a data type that uses multiple bytes to represent a single character.

Table 5.2.7 Language Table

LanguageId	LanguageName
1	English
2	French
3	Korean

Table 5.2.8 LocalizedItem Table

LocalizedItemId	LocalizedItemDesc
1	Welcome text
2	Button OK
3	Button cancel

Table 5.2.9 LocalizedText Table

LanguageId	LocalizedItemId	Translation
1	1	N'Welcome to the game, we are glad . . .'
1	2	N'OK'
1	3	N'Cancel'
2	2	N'Oui'
2	3	N'Non'

Since Unicode support is native to most RDBMSs, its an obvious step to take, especially given the huge popularity of MMP games in countries like South Korea and Taiwan, where the native languages require multibyte character support in order to display correctly. Taking this step goes a long way toward positioning a developer for growth in the worldwide market.

ON THE CD

By generating a set of lookups for each language, we could write localization-ready code as follows. Refer to the Python source file, localization.py, on the CD-ROM for details on how to create the lookups and constants necessary to achieve this.

```python
import localization
import localizeditem
import dialog              # some dialog class

def DisplayLoginDialog(locationX, locationY):
    dlg = dialog.Dialog(locationX, locationY)
    dlg.AddButton(localization.Lookup(localizeditem. \
        BUTTON_OK), _OnOK)
    dlg.AddButton(localization.Lookup[localizeditem. \
        BUTTON_CANCEL), _OnCancel)

def _OnOK():
    # handle OK button pressed

def _OnCancel():
    # handle Cancel button pressed
```

Conclusion

This article demonstrates that, with a few straightforward techniques, the power of an RDBMS can be leveraged in the gameplay systems of an MMP game. This allows the entire game to become truly data driven, which will prove extremely beneficial for a service that must be supported and evolved over a multiyear life span.

The methods of data retrieval/access presented also take an aggressive approach to minimizing the run-time impact of running on top of a database. This significantly reduces the likelihood that performance problems surface in the game because it

utilizes an RDBMS. This also allows us to keep our RDBMS hardware and software expenditures down to manageable levels.

In addition, this approach strives to consolidate data traditionally stored in configuration files or binary data files into a single, easy-to-access location. Because the database internally maintains referential integrity, there is a significant reduction in issues related to references going 'bad,' a common occurrence in complex software with a large development team, like an MMP game.

Once an MMP game sits on top of a database in this fashion, many new opportunities can be realized. An RDBMS is interoperable with many third-party tools for manipulation, reporting, and data mining. It becomes trivial to provide game data access to staff both inside and outside the game development team, and it can be leveraged to enhance the service via internal tools or player-accessible Web pages.

With data entry tools, artists and designers are able to update game content without having to become programmers. Since the game can be extended or tweaked using data entry, there is less developmental burden when doing maintenance and bug fixes—resulting in more time available to focus on improving the game and growing the customer base.

References

[Python] Python language Web site, *http://www.python.org*.

[MSSQL] Microsoft SQL Server product Web site,
 http://www.microsoft.com/sql/default.asp.

[MSTPC] Microsoft SQL Server TPC Benchmark Results, available online at
 http://www.microsoft.com/sql/evaluation/compare/benchmarks.asp.

[TPC] Transaction Processing Performance Council Web site, *http://www.tpc.org*.

5.3

DATA-DRIVEN SYSTEMS FOR MMP GAMES

Sean Riley, NCsoft Corporation

sriley@ncaustin.com

Data-driven systems are becoming a standard part of the game developer's toolbox. Games of all genres, from role-playing games to real-time strategy games and first-person shooters, use data-driven systems [Rabin00] to provide flexibility and extensibility during development, and to allow users to build 'mods' after the games ship. For Massively Multiplayer (MMP) games, though, 'shipping' is just the beginning. The developers and live team must deal with their own data-driven systems during the game's lifetime. This makes the need for powerful, yet stable data-driven systems even greater for MMP games than for single-player or smaller multiplayer games.

This article presents data-driven systems for MMP games from a variety of viewpoints. It begins with the benefits of using them and what they can be used for, then goes on to describe some of the implementation details of data sources and data-driven game architectures.

Benefits of Data-Driven Systems for MMP Games

From a technical viewpoint, some of the defining characteristics for MMP games are that they require a large amount of code, their code has a long life span (both for development and after release), and they require a large amount of content. These characteristics cause issues for developers that can be addressed by data-driven systems.

Lower Cost of Development

Data-driven systems can lower the cost of MMP game development in a number of ways by:

- Empowering more members of the development team early in the development process,
- Allowing game designers to get immediate feedback on their ideas, and
- Reducing the amount of code required.

Data-driven systems empower nonprogrammers by exposing data that they can manipulate without relying on programmers. This allows game designers and other

team members to have a hands-on role early in the process and feel closer to the implementation. This is a great advantage in that it expands the number of team members that can productive in tangible ways at an early stage.

Game designers are crafty individuals who thrive in environments where they can get immediate feedback on their ideas. Correspondingly, data-driven systems allow iterations of the game design to happen quickly. They allow designers and programmers to get feedback on their ideas and identify both good and bad portions of the technology/game design early in the process. This reduces the amount of code that needs to be reworked as the designers and programmers experiment with variations on the design and implementation.

Less code is needed when using data-driven systems. Repetitive sections of code can be *refactored* [Fowler99] into a single piece of code that is driven by data. This technique can be applied to many facets of the game, including the definition of classes, validations, the commands players can invoke, and the states that game objects can enter. Less code results in less time required for programmers, which in turn leads to lower development costs.

Lower Cost of Maintenance

Data-driven systems lower the cost of maintenance of MMP games by allowing changes to be made with less risk and more confidence, and because there is less code to maintain. The ability to make changes to the game purely through data is very powerful. Changes to data can be made with more confidence than changes to code. Although they are not entirely without risk, data changes are less likely to have unexpected consequences and require less testing. Data changes can be made without recompiling or (sometimes) even without shutting down servers. Using data-driven systems to make the game servers modifiable in real time can be extremely useful.

Bored players with too much time on their hands will stress every line of code in MMP games; the sad reality is that more code equals more bugs. In addition, the long lifetime of MMP games makes it inevitable that new programmers will join the development team and have to read and learn the existing code. Less code for these new programmers to understand means a shorter period before these new programmers are productive team members.

These factors mean that the more code there is, the higher the cost of maintenance. Data-driven systems reduce the amount of code and therefore reduce the cost of maintenance.

Faster Content Creation

Data-driven systems allow faster development by allowing content creation to be independent of game code, sometimes even before there is any game code. Unblock-

ing the content-creation pipeline early is essential for games where there is a large amount of content, and data-driven systems are a means of achieving this.

Content is quickly created at any time by establishing a buffer between the content-creation process and the source code. This also allows tools to be built to enhance the content-creation process—tools that are not dependent on game technology, but which are available to non-programmers, again allowing them to be productive team members at an early stage.

A content repository with a standard format for data-driven content can be added to independently of the game code. This allows production to continue when the build is broken or when a programmer is on vacation. Content can even be added before there is game code to support it. Using data-driven systems to separate the content-creation process from the development process allows for more-flexible scheduling of both disciplines. For MMP games, where there are large amounts of content and long development times, allowing content creation and coding to progress in parallel can increase the amount of time available for content creation.

Tools can be created, purchased, or downloaded that operate on the data repository independently of the game. This can be an advantage in the early stages of development when the game technology is immature or unstable and can increase the productivity of the game designers and world builders. These tools can also be valuable during the live phase of MMP games and when making expansion packs.

Summary

From the developer's perspective, data-driven systems lead to lower costs for developing, maintaining, and extending MMP games over time—factors that make publishers happy. From the player's perspective, data-driven systems lead to fewer bugs in MMP games and more content being available. This will motivate players to keep playing and paying their subscription fees.

Using Data-Driven Systems in MMP Games

The main area where data-driven systems are used in MMP games is in the broad area of defining the game rules. Most game rules in MMP games can be reduced down to defining the different types of objects and behaviors in the game. There will be code that implements the application of these rules, but most, if not all, of the rules can be driven by data that defines different types of game objects. Some examples of game objects that can be driven by data are:

- Creatures
- Weapons
- Equipment

- Spaceships
- Planets
- Types of terrain
- Character skills
- Character classes
- Character spells
- Inanimate world objects (e.g., trees, rocks, buildings)

As an example, consider the problem of creating thousands of types of monsters for a fantasy-based MMP. Without a data-driven architecture, the programmer would require some way to embed all the different types of monsters and all of their characteristics in the code, and then would have to recompile the code every time even the smallest change had to be made. The futility of doing this entirely in code quickly becomes apparent, especially when it must be extended to many other types of game objects, like weapons, armor, spells, and races.

Data-driven systems allow the game rules—the definition of the types of game objects—to be separated from the source code of the game and moved into a data source that can be managed in more appropriate ways.

Types of Data Sources

There are different media that can be used to store the data used for data-driven systems. Each type of data source has different characteristics and complexity. Following are descriptions of some of the ways that data for driving the systems of a MMP can be stored.

Text Files

In some ways, text files are the simplest data-source solution. They require the developer to write code to parse the text file to turn it into data, but are low in overhead and easy to manipulate. Managing large amounts of text files for data can become cumbersome, but tools such as spreadsheets can help.

Text files have no enforced internal integrity or structure. Any validation of syntax, structure, or relationships between rules must be handled completely by the code that the programmer writes. These issues are better handled by other data sources. The example in Table 5.3.1 shows tab-delimited text that could be exported from a spreadsheet program. It has data for different types of swords.

Table 5.3.1　Spreadsheet-Imported Sword Data

# Class	Name	Min	Max	Weight	Hands	Icon
CLongSword	Long sword	1	8	20	1	sword4.bmp
CTwoHandedSword	Two-handed sword	2	12	30	2	sword5.bmp

XML

XML (eXtensible Markup Language) is a standard language for defining data. It can be parsed by existing software libraries, which can alleviate the need to write a parser for reading data files, but it can be extremely verbose and leads to large data files when compared to other methods. XML data is also more difficult for humans to read than other data sources.

But XML is very flexible, which makes it good for representing unstructured or nonrelational data. The validation of syntax and structure of XML data can be handled by the libraries that perform the import and parsing.

A common complaint about XML as a data format is its lack of good tools. When using XML for driving game systems, developers often have to build custom tools to manipulate the game data and export it in XML format.

The following example shows XML data for defining different types of swords. Note that the attributes are not exactly the same for each type of sword. XML can allow different instances to have different attributes, providing great flexibility.

```
<\<>object name="LongSword">
    <property name="minDamage" value=1>
    <property name="maxDamage" value=8>
    <property name="weight"    value=20>
    <property name="hands"     value=1>
    <property name="icon"      value="sword4.bmp">
    <property name="damageMod" value=1>
</object>

<object name="2HandedSword">
    <property name="minDamage" value=2>
    <property name="maxDamage" value=12>
    <property name="weight"    value=30>
    <property name="hands"     value=2>
    <property name="icon"      value="sword5.bmp">
    <property name="hitMod"    value=2>
</object>
```

Scripting Languages

Scripting languages, such as Python or TCL, can be used as data sources. This can be extremely powerful if the game engine also uses the scripting language to store data, which completely eliminates the need for writing a data parser and makes integration with game systems easy. Similar to XML, scripting languages are also good for representing complex data. The choice of scripting languages for MMP games is a complex topic outside the scope of this article, but possible choices include Python, TCL, Lua, Java, or customized languages written by the developer.

Data stored in scripting languages is easily accessible for tools written by the developer, and it can even be manipulated by the scripting language with extremely

simple tools or a command-line interface. The example shows Python code for defining different types of swords. Note the variable-length list embedded in the data that represents the set of locations in which the weapon can be wielded. Storing this type of data in other types of data sources can be complex, requiring subtables or relationships between tables.

```
InitialSwordTypes = [
    ["longsword", 1,  8, 20, 1, "sword4.bmp", /&/
        [LEFTHAND, RIGHTHAND, 2HAND]],
    ["twohandedsword", 2, 12, 30, 2, "sword5.bmp", [2HAND]]
]
```

Relational Databases

Relational databases can be used as data sources, but they come with a unique set of advantages and disadvantages when compared to other, simpler techniques. Relational databases have standard interfaces, so tools that interact with them can be built with standard components. They are good at handling concurrent access from different sources, and they are easy to backup. They also allow queries and reports to be run on the data they contain, and they can scale up to handle very large amounts of data.

However, relational databases can be complex to install and maintain. In addition, developing for a relational database brings with it a number of issues, such as requiring vendor-specific code, libraries, and (sometimes) expensive licenses. Relational databases introduce limits on the data that can be stored and can lead to 'vendor lock-in' where the data and code that works with one vendor's database cannot be used with another vendor's product. Especially during the development of an MMP, the overhead of the schema evolution for the relational database to handle game rules can be expensive and time consuming, considering how volatile that data tends to be.

There are extremely mature and robust tools for viewing and manipulating data in relational databases, and even tools for defining and managing schemas and administration. However, these tools can be complex, expensive, and specific to particular database vendors, further contributing to vendor lock-in.

This example shows Structured Query Language (SQL) for creating a table to store different types of swords as well as inserting data into the created table.

```
CREATE TABLE swordtypes
(
    sword_id    int          PRIMARY KEY,
    name        varchar(32)  NOT NULL,
    mindamage   int          NOT NULL,
    maxdamage   int          NOT NULL,
    weight      int          NOT NULL,
    hands       int          NOT NULL,
    icon        varchar(32)  NOT NULL,
);
```

```
INSERT INTO swordtypes VALUES (1001, "longsword",1, 8, 20, 1,
"sword4.bmp");
INSERT INTO swordtypes VALUES (1002, "twohandedword", 2, 12, 30, 2,
"sword5.bmp");
```

The code to extract this data from the database and place it into a game is surprisingly complex, and can be platform/vendor specific. However, there are many libraries and toolkits available to aid in interfacing with relational databases.

Types of Data-Driven Game Architectures

In addition to MMP games, there are many types of game architectures that can be driven by data. This section describes three possible game architectures for using data-driven systems in MMP games:

- Generated classes
- Dynamic properties
- Category objects

Generated Classes

In this architecture, data is used to generate source code for each of the types of game objects that exist. The result is a programming language class for each type of game object.

The core implementation of this system is a module for generating class definitions from a set of data in the language your game is using. The build process then becomes a two-stage process of generating the class files from the data, then compiling the class files along with the regular source code. The class-generation step must happen *before* the compilation of the rest of the code base so that header files are available when the nongenerated code is compiled.

Driving this system from data involves loading data from an appropriate data source and generating source code for the classes to be used by the system.

The advantages of this approach include:

- Efficiency, as all data is at the class level, not the instance level.
- Efficiency, as there is no run-time lookup of game-rule data.
- Efficiency, as there is no loading time—all data is present as class attributes.
- Types of game objects can be identified by their programming-language class.
- Code is consistent, as it is generated by the same source.
- Attributes of every instance of an object of a type in one place can change.

The disadvantages are:

- A large amount of code (large memory image for executables).
- It is more complex to load only portions of the game rules, as it is compiled in.

- Compiling is a two-stage process.
- Code must be recompiled for even the smallest change.
- It is difficult to change at run time.
- Types of game objects can be only identified by their programming-language class.
- The generated code may not be humanly readable.

This example shows generated C++ header file code for different types of swords. Instances of these classes would all share the same static class data for their attributes.

```
class CLongSword : public CItem
{
    static const string    mLabel = "long sword";
    static const int       mMinDamage = 1;
    static const int       mMaxDamage = 6;
    static const int       mWeight = 20;
    static const int       mHands = 1;
    static const string    mIcon = "sword4.bmp"

    CLongSword(void);
    virtual ~CLongSword();
};

class CTwoHandedSword : public CItem
{
    static const string    mLabel = "2-handed sword";
    static const int       mMinDamage = 2;
    static const int       mMaxDamage = 12;
    static const int       mWeight = 30;
    static const int       mHands = 2;
    static const string    mIcon = "sword5.bmp"

    CTwoHandedSword(void);
    virtual ~CTwoHandedSword();
};
```

Dynamic Properties

In this architecture, game objects have a dynamic set of properties that are entirely driven by data. The types of game objects are completely separated from the programming language object model.

This system is implemented as a module; game objects have a dynamic set of attributes or properties, and each of these properties has a value. In this system, there is only one class at the programming-language level. The different types of game objects are just instances of this single class, with different properties. It is common to have a property called "type" or "class," which is used to identify the type of game objects. It is also common to have instances of the same 'type' that have the same properties, but this may or may not be enforced by the implementation.

Creating instances of different types of objects can be achieved by creating objects that are copies of known 'prototype' objects. These copies have properties that are the same as the properties of the template object. A primitive type of inheritance can also be achieved with this mechanism.

Driving the property system with data then involves loading data from an appropriate data source and creating game-object instances, and populating their properties.

The advantages of this approach include:

- A small number of classes (one!).
- High flexibility—every instance can be different.
- Dynamic construction of object types is allowed.
- Dynamic run-time modification of object attributes is allowed.

The disadvantages include:

- A large memory footprint—all instance data and no class data.
- There is high run-time overhead, as every property is in data.
- Because there are no real types, changing all instances of a type is complex.
- Objects of a type are not always the same and may not act consistently.
- It can be difficult to determine the type of game objects.
- It is complex dealing with properties of different base types (e.g., int, string, float).
- Load time is required to create all objects.

This example shows code for constructing sword prototype objects with properties that have different values. These prototype objects would then be used as bases to copy from when creating actual game instances of these types.

```
GameObject longswordTemplate = new GameObject();
longswordTemplate.addProperty("minDamage", 1);
longswordTemplate.addProperty("maxDamage", 8);
longswordTemplate.addProperty("weight", 20);
longswordTemplate.addProperty("hands", 1);
longswordTemplate.addProperty("icon", "sword4.bmp")

GameObject twohandedswordTemplate = new GameObject();
twohandedswordTemplate.addProperty("minDamage", 2);
twohandedswordTemplate.addProperty("maxDamage", 12);
twohandedswordTemplate.addProperty("weight", 30);
twohandedswordTemplate.addProperty("hands", 2);
twohandedswordTemplate.addProperty("icon", "sword5.bmp")
```

Note that the value of a property can be an integer or a string. This subtle feature can lead to significant implementation complexity.

Category Objects

In this architecture, classes are defined for broad categories of types of game objects, and variations of these objects are driven by data. There is an instance of a 'category object' for each type of game object and a set of 'category classes' for the broad categories of types of game objects. This is a compromise solution between the two previous implementations.

This system is implemented as a module with a hierarchy of category classes that represent broad categories of types of game objects with differing behavior or data requirements. These classes are written 'by hand' rather then being generated from code. "In parallel" is another hierarchy of category instance classes that represent game object instances of specific categories. For each category class there is a corresponding category instance class. Each category instance object has a category class attribute that holds the data specific to its category.

The advantages of this system include:

- A small number of classes—one per category instead of one per type of game object.
- Category classes can be created at run time.
- A small memory footprint—data is at the class level, not the instance level.
- The type of game objects can be identified by their category object.
- All instances of a category can be changed by changing the category object instance.

The disadvantages include:

- It requires a parallel class hierarchy for category types and instance types.
- Some data must be accessed from the category instance rather than the object instance.
- Load time is required to create category objects.

This example shows a category class for types of swords and the corresponding game object class for sword instances in C++:

```cpp
class CSwordCategory : CItemType
{
    CSwordCategory(string label,
            int minDamage,
            int maxDamage,
            int weight,
            int hands,
            string icon ) :
                mLabel(label),
                mMinDamage(minDamage),
                mMaxDamage(maxDamage),
                mWeight(weight),
                mHands(hands),
                mIcon(icon) {}
```

```
        virtual CSwordCategory();

        const string mLabel;
        const int     mMinDamage;
        const int     mMaxDamage;
        const int     mWeight;
        const int     mHands;
        const string mIcon;
};

class CSword : CItem
{
        CSword(category) : mCategory(category) {};
        Virtual ~CSword();

        const CSwordCategory &mCategory;
};

//Creating Category instance objects
CSwordCategory longsword = CSwordCategory(
"long sword",1,8,20,1,"sword4.bmp");
CSwordCategory twohandedsword = CSwordCategory(
"two handed sword",2,12,30,1,"sword5.bmp");

Here is the equivalent class in Python:
class SwordCategory(ItemCategory):
    def __init__(self, label, minDamage, maxDamage, weight, /&/
        hands, icon):
            self.label = label
            self.minDamage = minDamage
            self.maxDamage = maxDamage
            self.weight = weight
            self.hands = hands
            self.icon = icon

class Sword(Item):
    def __init__(self, category):
        self.category = category

longsword = SwordCategory("long sword",1,8,20,1, "sword4.bmp")
twohandedsword = SwordCategory("two handed sword",2,12,30,2,
"sword5.bmp")
```

Using the example Python code, these category class instances can be created from data. This example uses the Python `apply` keyword to construct a SwordCategory instance from each row of the example data:

```
InitialSwordTypes = [
    ["longsword", 1,  8, 20, 1, "sword4.bmp"],
    ["twohandedsword", 2, 12, 30, 2, "sword5.bmp"]
    ]
swordCategories = {}
for swordData in InitialSwordTypes:
    newSwordCategory = apply(SwordCategory, swordData)
    swordCategories[newSwordCategory.label] = newSwordCategory
```

Conclusion

The above architectures are generalizations that do not necessarily have to be used in isolation. It would be quite possible to combine these approaches or portions of them to build systems that meet specific requirements. Advanced combinations could include generated classes with dynamic properties, or multiple category objects being composed into more complex objects at run time and category classes being generated from data in addition to be populated with data.

With the different types of data sources, architectures, and variations available, developers have a wide variety of choices when implementing game systems for MMP games. Make your choices wisely, as you will have to live with them for the lifetime of your game.

References

[Fowler99] Fowler, Martin, *Refactoring: Improving the Design of Existing Code*, Addison-Wesley, 1999.

[Rabin00] Rabin, Steve, "The Magic of Data-Driven Design," *Game Programming Gems*, Charles River Media, 2000.

5.4

MANAGING GAME STATE DATA USING A DATABASE

Christian Lange, Origin Systems, Inc.

clange@origin.ea.com

Maintaining game state in a database can introduce some unique challenges. For those looking to dive into the Persistent State World (PSW) side of Massively Multiplayer (MMP) games, we present some helpful and practical tips to approaching this very broad area.

With MMP games appealing to such massive numbers of players, and with vast dynamic worlds growing larger and larger, it is very important to prepare for the mountains of data your game will generate. Your game may conceivably have hundreds of thousands of players and millions of game objects. Which of these objects need to be stored and how they will be persisted are just some of the initial questions that need to be answered. Properly managing these large volumes of data will require continuous planning during the course of development of your MMP game. This article will present a comparison overview of several common methods used when preparing to architect an MMP game database.

Schema Design

A database schema is an outline representation of tables and their relationships. The schema conceptually is a blueprint to follow for the creation of a database. Figure 5.4.1 is an example of a small database schema.

With this schema, the equivalent Data Definition Language (DDL) [Date95] would be used to generate the player table. The following code listing demonstrates the DDL used in Oracle [Ensor97] to generate the player table.

```
Create table player (
    Id              number not null,
    Name            varchar2(40) null,
    Hitpoints       number not null,
    Strength        number not null,
    Intelligence    number not null,
    Guild_id        number,
    Group_id        number,
    Constraint      r_player_guild foreign key (guild_id) references
guild(id),
```

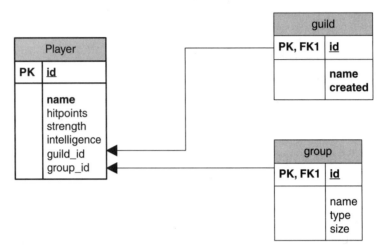

FIGURE 5.4.1 *Example database schema.*

```
    Constraint       r_player_group foreign key (goup_id) references
group(id)
                         )
```

This example represents a very small system. In MMP games, the size and complexity of a schema grows substantially. These large database systems demand careful attention to their design and implementation. Certain powerful database features may tempt developers to use them in inappropriate ways that can cause problems for the project later on. Here are several common pitfalls to avoid.

Indexing

Indexes provide a way for the database system to speed up data retrieval. They provide faster direct access to the records contained in a table. For example, indexes speed up the request to retrieve a player record where the player's id is equal to 100. Indexing also provides better sequential access to the data. For example: "retrieve all the players that have hit points greater then 50 and less then 100." One of the greatest benefits of indexing is its ability to retrieve a record based on multiple conditions. A multiple-condition retrieval would look something like this: "retrieve all the players that have hit points greater then 80, that belong to a guild, and who are not a member of a group." To take advantage of indexes, it is important to index the correct columns of the tables. The columns that are important to index are those that are used in the conditional portion of the retrieval request.

Indexing also has some negative impacts. They will slow down updates to the tables that contain those indexes. When an update occurs, the database system must modify the data in the table and modify all the corresponding indexes. If a player were to have fewer hit points, change groups, and leave a guild, the update would have to

change the relevant data then go and modify the index placed on hit points, groups, and guilds. It is more work for the database. Indexes can also result in slower retrievals if used improperly. In the multiple-condition example presented earlier, if only two of those conditions had been provided, it can result in a significantly slower retrieval. When an index consists of multiple columns, the retrieval request must provide conditions for all the columns in that index. Without all the conditions, the database system will have to look at all the records in the table. It can no longer use the index because the conditions are incomplete. Many database systems have the ability to create very powerful types of indexes. The database system does not, however, ensure that you place the right type of index on the correct type of data.

Normalization and Referential Constraints

Normalization is the practice of reducing the redundancy of data within a database schema. Referential constraints are used when the value of an id (e.g., the group id) must exist in the group table. Both concepts are presented here, since there is a close connection between the two. In the prior example, the player table contained a group id and guild id column. To ensure those two columns have correct data, there is a constraint placed on those columns that requires any id in the group or guild column of the player table to exist in the corresponding table. The group id used must exist in the group table; the guild id must exist in the guild table. Normalization can dramatically simplify the amount and complexity of the referential constraints required to contribute to data integrity. The guideline to normalization is to only have data in a table that is relevant to the key of that table. In the player table, there is no data there that belongs to any of the other tables, referential constraints excluded. Therefore, the player table does not include the name of the group or the creation date of the guild. This is important in simplifying updates, deletes, and inserts necessary to maintain the data.

When a database is not well normalized, several symptoms occur. The size of the tables, in terms of columns, may grow to be quite large. If data is being redundantly placed in one or more tables, those tables will grow in size. If the guild name and group size were not normalized, they might be placed in the player table, making the player table larger. Placing the data from the guild and group tables into the player table increases the amount of work to maintain that information. Every time the group size changes, the player table would also have to be updated to make sure the data is in sync. The referential constraint would make sure the group id is valid, but the application would have to make sure the size in both tables was the same. This is problematic and requires more database transactions to maintain the integrity of the data. Suddenly, the application is responsible for the integrity of the data and not the database system.

There are times, however, when too much normalization can lead to slower performance in terms of retrieval from the database. When data is normalized and the

retrieval requires data from many tables, the retrieval may be slower, since the data is not located in one place. The database system will perform a join of the tables, based on ids, to collect all the relevant information together. In the example with the player, group, and guild, the database system would join the guild and group tables to the player table based on their respective ids. Multiple table joins are slower then just retrieving the data from a single table. In this case, carefully denormalizing certain parts of the schema may be needed. Since normalization is usually beneficial, the act of denormalizing should only occur when high performance on a specific retrieval is required.

Data

Database systems offer a large amount of flexibility when it comes to actually putting data into the database. These data types vary greatly among database system providers; however, there are also many similarities as well. The following are some used and misused techniques that commonly arise when first working on an MMP game database.

BLOBS (Binary Large Objects)

Large binary objects can be anything. They can be in the form of a simple bitmap image or a binary representation of a player record. Think of it as writing the player data to a file in C++, using the binary mode. These BLOBS can be very easy to use: they are usually just one column in a table with all the data located in that single column. BLOBS allow the use of proprietary formats for the data contained within that BLOB. BLOBS, in some database systems, are often allowed to grow quite large. As the player data grows and more attributes are added, nothing would need to be changed in the database. The size of the BLOB would just grow to compensate.

BLOBS have several downsides to them. Referential constraints cannot be applied to BLOBS. This means that the integrity of the database is now in the hands of the application. It is the database system's job to maintain integrity, and BLOBS undermine that ability. BLOBS cannot be indexed; therefore, retrieval of BLOB data can be difficult. Retrieval will require the use of additional columns for indexing. The overwhelming downside for using BLOBS in an MMP game database is their inability to mine the data for review outside the game. On the one hand, you cannot make sure the data is valid; and on the other hand, you cannot even see what the data represents.

Database in a Database

This is a very tempting technique to use in an MMP game database. The concept is very similar to that of BLOBS, except a string may represent the data. This technique involves the practice of storing data that contains more than one piece of information in a single column. This practice is common, for example, when using a four-byte string in which the first byte is the color of the player's hair, the second byte is the

sword they are carrying, the third byte is the number of items in their inventory, and so on. This practice is very flexible; more information is packed into a smaller space without the need for additional columns to be added to the table.

The downside is that we take away the database's ability to maintain data integrity. Once again, with this practice, referential constraints cannot be applied. It is very difficult or even impossible to index such a column. There is no way for the database system to validate the internals of the string with its unique representations for each byte. It is as if a database exists within each column that uses this technique. This may be a tempting practice to use, but it places the data integrity in the hands of the application instead of where it belongs—in the database.

Multipurpose Columns

Defining multipurpose columns is a technique whereby a generic column is created to store one type of data for one record and another type of data for another record. An example of this might be to name a column something generic, like "data_slot1," and use it to store hit points in one record and the location of the object in another. It is a very flexible practice and reduces the number of columns needed in a table. It is easier to add new records for different types of objects, since they just reuse the existing table structure. This technique can also simplify access to the data, as the columns are always the same data type, and the number of columns does not change.

The downside to this practice is the database system's inability to apply referential constraints. If, for example, one record used that column for the group id, the database would not be able to verify the validity of the id. A constraint cannot be placed on that column (in this case containing the group id), because other records use that column for other things. Multipurpose columns are also difficult to index properly. The data in those columns may represent a large spectrum of unrelated values. It is still possible to index; however, the performance of such an index might not be predictable. This is another technique that places the integrity of the data within the application accessing the data and not the database system. The database system does not know what data belongs in that data_slot1 column as it changes from record to record. Only the application is aware of that information. This is also true when trying to review the data externally through customer support applications or report generators. It will not be clear that the number 89 in data_slot1 represents hit points, or magic resistance, or strength, and so on.

Additional Considerations

Up to now, the focus has been on very specific database system details. Another very important perspective to consider is the database system as a whole. There are some additional practices to be aware of that exist separately from the individual pieces of a

schema in a database system. Database systems can be impacted, with regards to performance, by several internal and external influences.

Performance

Performance has been mentioned in some of the previous sections, but not in the context of the overall database system. In regard to the schema design as a whole, huge tables, extensive joins, and no indexing are some of the most common outcomes of poor database planning. Massive tables having hundreds of columns are not usually managed well by database systems. The maintenance of such massive tables is very time consuming and makes it difficult to backup and recover the database in the event of a serious problem. Extensive table joins occur when, for example, a 10-table join is required to retrieve the desired information. This can create a massive hit on performance.

For performance-critical systems such as MMP games, it is wise to avoid table joins involving more then two or three tables. Be aware then even smaller joins can degrade performance if the system performs many of them with high frequency. Proper indexing is often overlooked. Indexing can greatly improve performance of queries in a database system. However, they can slow down other functions, such as inserting and updating records. It is a balancing act—too few indexes and queries can be slow; too many can greatly slow down inserts and updates. Which request to place a priority on is up to the individual application. Generally, MMP games perform mostly queries and updates. Additionally, deletes, which are typically required at some point in time, are best performed during maintenance and not during high activity. It is too expensive and too difficult to tune a database to optimize queries, updates, and deletes. A common technique to accomplish this is to only mark records for deletion, and then during regular downtime or maintenance, go through and actually delete those records. Deletes are very expensive. It is very beneficial to the overall performance of the database system to avoid them or at least delay them. Usage levels of a typical MMP increase and decrease in a predictable cycle throughout a given day or week. Off-peak times are great opportunities to perform database maintenance as well as deleting old records that need to be cleaned up.

Networks

Network bandwidth utilization is another key area of concern for large database applications. It is important to define what data to include in an update or query request.

Database systems can be very flexible, allowing an application to send or retrieve vast amounts of data. This openness to the database can be problematic. Not all of the attributes of an object need to be updated every time. If an object, such as a player character, moves forward a few steps, the application does not need to send the char-

acter's hit points, inventory, or orientation if these values have not changed since the last update. It would be prudent to determine if the application can break up those autonomous updates into smaller, more spread-out requests. The same is true for very large queries. Instead of one rather large request, see if the application can be modified to only request the data it absolutely requires. Then request the other needed data at a later time. This lowers bandwidth requirements and can help improve database system performance in general.

Transaction Loads

Transactions, such as queries, can cause a database system to work very hard as it sifts through millions of records created by a typical MMP game. These queries hit the database system especially hard if they do not take advantage of indexes. Without proper indexes, the database system may be required to scan every record that exists in the table. One cursory way to examine queries is to look at the conditions the query is imposing. In the previous example, a query was trying to get information about a player based on certain conditions: retrieve all the players that have hit points greater then 80 that belong to a guild and are not a member of a group. While looking at the conditions for the query, check to see of each of those conditions is indexed. There should be indexes on hit points, guild, and group, or quite possibly a single index that contains all three. If not, this query should be reviewed for possible performance issues. Every request made to a database system needs to be reviewed in this manner. Reducing the time each request will take reduces the overall transaction load of the database system.

Dynamic SQL

Another type of request that can greatly increase the transaction load and decrease performance on a database system is called a dynamic SQL [Date95] statement. This is an extremely powerful technique whereby an on-the-fly request, in the form of a string, is sent to the database system to be processed. Typically, the database system has no foreknowledge of this request. It is a run-time, dynamically generated request, as opposed to being a compile-time or database system-stored request. This means the request does not receive the advantages of the database system's ability to preparse, preoptimize, or precache the database request. When the database request is created at compile time or stored on the database system, it can be preanalyzed by the database system. The database is then aware of what it needs to do to get that request processed as quickly as possible. In the case of the dynamic request, the database has yet to analyze the request and determine the optimal way to fulfill that request. It is by far the slowest method of requesting action from the database. Carefully reconsider any requirements that indicate a need for this type of functionality. The potential for problems is high, and the performance impact can be severe.

Alternatives

MMP databases can grow to be quite enormous. Even when following all the recommended ways to handle and manage data, systems can still get overloaded and bogged down. This section addresses some additional options for the developer. It also presents some additional things to consider with regards to an MMP game database.

Data Caching

A data-caching system is external as well as different from the caching that already exists inside a database system. A data cache is an additional process placed in between the application and the database system (see Figure 5.4.2). All database requests would come through this data cache before potentially being passed on to the database. With this solution, all data that is requested is cached in memory in this new process. Any future requests for the same information are returned from the memory of this process instead of coming from the database system. This can dramatically reduce the load on the database system. Update requests are cached in reverse; the cached data is modified and the update to the database is sent later. Caching does introduce some of its own unique challenges; however, the performance gain can easily outweigh the additional work required to set up this data-caching process.

FIGURE 5.4.2 *A data-caching process.*

Architecture

In MMP game design, it is important to architect the flow of database requests in such a manner as to be able to control the occurrences of any request. This refers to the concept of letting the user of an MMP have the ability to directly impact the performance of the database. In other words, if the user can click a button that generates a request to the database every time, this can lead to serious problems. It practically lets the user perform a denial-of-service attack against the database. Think in terms of thousands of users, all able to press that button that keeps requesting data from the database. Those vast volumes of requests can easily keep the database completely occupied. In an MMP game system, there should not be a direct line between the user and the database. Some process or server in between should filter the requests or time-delays so that, for example, requests can be made only so often. The previously mentioned data-caching system could also help alleviate this particular condition.

Maintenance

As the database continues to grow, it will require maintenance on a regular basis. Log files and backups grow large, and indexes and data can become fragmented. Plan on bringing the database down periodically for a tune-up to keep it performing at its best. Performance will greatly decline over time if the database is not maintained correctly. If a lot of report generation or data mining are required, it may be appropriate to consider duplicating or replicating the database to another machine. This is important, since any additional request made to the database will impact performance. It is recommended to do that additional report generation against a copy of the database. This way the system will not notice reduced response times due to the additional load from reports, data mining, statistics gathering, and so forth.

Connectivity

An easily overlooked consideration is the connectivity to the database system. Database systems can often handle several connections simultaneously. A way to take advantage of this feature is to create a pool of connections to the database. Instead of only having one connection to the database from the game servers, create several. These can be managed in separate threads or as a pool of threads, each with their own database connection. The advantage is that as requests come in, they can be handed off to an available thread and handled immediately. With the proper balance of connections and threads, no request should ever have to wait to be able to communicate with the database. Clearly, the opposite happens if there is only one connection and one thread handling the communications to the database system. It should also be noted that this concept refers to static connections. These are connections that are established when the game servers start up, and they are not shut down until the game is shut down. Given the high transaction requirements of MMP game databases, it is not recommended to utilize dynamic connections. Dynamic connections are those made when a request is made, and are shut down when the request is completed. The opening and closing of a database connection can incur a lot of overhead and is typically a time-consuming operation. Since the database system directly impacts the performance of an MMP game (e.g., by waiting for data), a system architect may consider directly connecting the database machine with the game servers that are making the requests. This can isolate the database machine from outside network interference. It enables the system architects to optimize the bandwidth configuration between the game servers and the database.

Conclusion

There is no one golden solution to managing data for an MMP game. There are only proven strategies and practices to follow. Requirements for any given application are different, but the general guidelines presented here apply to all of them. The best way

to learn is to try the strategies presented here as well as experiment with the database system chosen. Learn that database system inside and out. Every one of them has different strengths and weaknesses. Learn to utilize them to your advantage. In programming, it is considered good form to not write anything too specific, but rather keep things generalized and interfaced. In database programming especially, for high-transaction systems like those found in MMP games, it is just the opposite. To really squeeze every drop of performance out, you will need to get under the covers and take advantage of everything the database system has to offer.

Use the techniques, strategies, and lessons presented in this article. They will give you a head start in any MMP game database endeavor you decide to undertake. The hope is that when the opportunity for one of these really tempting techniques comes up, you can look back at this article and understand the advantages and disadvantages of that technique. Granted, all of the pros and cons are not listed, but the ones that seem to pop up over and over again from one MMP database to another are presented in this article.

Managing game state data in a database really comes down to understanding what the requirements are, what must to be stored, how much will be stored, how to store it, and applying the appropriate strategies and techniques each step of the way.

References

[Date95] Date, C. J., *An Introduction to Database Systems*, Addison-Wesley, 1995.
[Ensor97] Ensor, Dave and Ian Stevenson, *Oracle Design*, O-Reilly, 1997.

GAME SYSTEMS

6.1

FROM RAW MATERIAL TO FINAL PRODUCT: LIFE IN A SOCIAL ECONOMY

Artie Rogers, Inevitable Entertainment

awrogers@texas.net

Crafting an object is the centerpiece of personal expression in any society. Creating items allows people to engage in a creative process and to gain tangible rewards for their efforts. Players of a Massively Multiplayer (MMP) game not only enjoy the same rewards from crafting as they would in real life, but the advantages of a robust crafting system extend beyond the personal satisfaction of creation and expression. It also provides an alternate avenue of achievement that serves to broaden the appeal of the MMP.

A crafting system also serves to lengthen the stay of players in the game by providing a legitimate playing style, other than combat. It gives rise to an entire community dedicated to the creation and distribution of those items. Furthermore, a crafting system designed with social development in mind can help cultivate a rich online *social economy*, which is defined as a closely knit community of crafters who rely on other players for further achievements. From learning how to craft an item to relying upon specialized experts when crafting the most difficult items, or trading and selling wares in the marketplace, a thorough crafting system designed with a reliance on cooperation is a significant contributor to the building of a strong online social community.

This article stresses a few main goals to consider when designing a crafting system. First is the importance of including chance in a crafting system, and how it can inject a 'slot machine' style of excitement into the process. When considering this point, keep in mind that it is better to reward the player for the result of a chance happening than to punish them. Exceeding the expectations of the player will make the introduction of chance a positive and enjoyable experience.

Next is the role that skill diversity has in encouraging the expansion and strength of a social economy. Designing ways to influence players to rely upon others when trying to accomplish the more-advanced tasks is an important part of this goal. These ideas create an interesting game system by adding some randomness to the crafting process, maximizing the reach of the social economy by increasing the diversity of

crafting experts that exist in the game as well as encouraging reliance on fellow players when trying to craft the best items.

This article traces the item-creation process from the harvesting of raw materials to the enhancing of newly crafted items. It explores some of the possible parameters of the materials and skills that might be considered when creating such a system. The article ends by briefly examining the role that crafting takes in other social systems, as well as a few thoughts on some of the more-common problems with crafting systems in general.

Harvesting and Treating Raw Materials

Harvesting raw material is the starting point for crafting an item. Designing a harvesting system with the goals of skill diversity and social reliance in mind is important in increasing access to the social economy to as many players as possible. There are several ways harvesting can be handled, and this article will briefly outline just one harvesting model.

Harvesting System

Harvesting takes place whenever a player collects raw material from the world. This could happen when a player chops a tree for wood, picks plants for food, or mines rock for ore. The main areas of discussion involve the *harvesting* action, which is the chopping, picking, or mining the material core (an object that represents the different game resources, such as wood, food or ore), and finally, the different qualities of the material core.

The harvesting action refers to the specific action that a character can perform that, if committed on a material core, will yield a certain amount of raw material. There are several possible player variables related to ability or skill that influence the result of harvesting:

- **Harvesting Precision:** Influences the *quality* of material a player would receive per harvesting attempt.
- **Harvesting Strength:** Influences the *quantity* of material a player would receive per harvesting attempt.
- **Harvesting Speed:** Influences the time invested in each harvesting attempt.

Providing the player the freedom to customize their character by dividing the harvesting skills into groups according to time it takes to harvest, quality of harvest, and quantity of harvest gives rise to several different classes of harvesting experts.

The material core is the in-game object that is the source of the raw material and will only yield that material when the proper action is committed by a player with the proper skill. The material core may or may not be visible to the player, depending on

that player's skill. The system will maintain a certain number of material core objects, each associated with a specific class of raw material. Each time a material core object is destroyed, the system will create a replacement. In this way, the designer can control where certain materials will be found and the rarity of those materials. There are several variables used for the material core:

- **Core Strength:** Represents the number of actions a material core could sustain before it is destroyed.
- **Core Quality:** Reflects the range of potential quality of material the material core would yield.
- **Core Depth:** Denotes the range of potential quantity of material the material core would yield per harvesting action.

The act of harvesting provides ample opportunity to expand the number of skill sets beyond those related to the basic act of collecting resources. Some skills are dedicated to the act of treating the raw material after it has been collected and before it is used to make an item. These treatment actions influence the final attributes of the crafted item by adjusting the quality of the raw material. Another advantageous skill set is in locating the best material core objects, which means finding the core with the highest yield of quality or quantity. When the system is created with social interaction in mind, there are plenty of opportunities to expand the role of the harvester in a crafting system beyond those mentioned.

The Chance or Joy of Exceeding Expectations

Chance is an important factor to introduce into each stage of the crafting process, beginning with harvesting. It is important that the player not be punished as a result of chance, such as harvesting something of a particularly low quality, but instead is rewarded by something better than what they expected. Exceeding the expected result of an action provides an enjoyable surprise for the player. There will always be some level of frustration linked to results that rely on chance. In order to help limit this frustration, establish a baseline response to a given harvesting or crafting action, one that the player will experience without fail once the action has been completed; then add bonus results to accompany the standard response. One bonus outcome of chance in harvesting is to allow the player to collect a material of a quality that may be outside their skill range—on occasion, the player will be pleased to find that they collected something that they should not have. Another possibility is to have the harvesting occasionally yield certain items that are completely unrelated to the desired materials, though the items have some value in the game. Introducing chance in harvesting allows the designer to create some unexpected and interesting surprises for the player, which makes the experience all the more enjoyable.

Time Invested vs. Material Yield and Risk vs. Reward

There is an internal balance between harvesting time invested versus material yield. The scale balances the value of the material versus the amount of time it takes to harvest it. The harvest time could be affected by what the player chooses to harvest and how they choose to harvest it. For example, the player could choose to harvest a cheaper kind of material because it takes less time to harvest. They will then have made the decision to receive more material in less time at the cost of the quality of material, linking the time investment to material type. In another example, the player might decide to harvest at a faster rate, which decreases material quality, rather than harvest more slowly and increase the material quality. The player will then have made the decision to harvest a certain material in a way that takes less time but yields a lower quality of material. Therefore, the time investment is linked to the harvesting method. Flexibility and an increase in the various ways a player can harvest material allows for a broader range of harvesting-related skills.

The role of harvesting being influenced by balancing risk versus reward will be discussed later in this article. Risk versus reward is a common notion when designing the adventuring portion of a typical MMP. It deals with the risk players assume versus the reward they gain for overcoming those risks. This is evidenced by stronger enemies typically yielding greater reward in the form of loot after they have been killed. Its importance is often overlooked with regards to harvesting; however, it can be useful in expanding the scope and effect of a social economy. For example, the harvester might require some assistance in gathering the most-valuable resources by traveling to the more-dangerous locations of the game world. The lure of the higher reward would urge them to seek protection from adventurers with greater experience so that they might survive this higher-risk activity. Keeping the risk-versus-reward dichotomy in mind when developing harvesting skills can strengthen the connection between harvesters and adventurers, thereby extending the reach of the social economy.

Harvesting Example

Consider this harvesting scenario that might play itself out under the rules of this harvesting system: a player is commissioned by an expert crafter to acquire high-quality ore that can only be found in a dangerous mountainous region. The player has the skill to mine the ore, but does not have the combat skills to survive the area and does not have the skill to quickly and reliably locate the material core that will yield the desired ore. He could locate the material core on his own, but considering the dangerous situation, it would be best to be able to locate the material core quickly, collect the needed ore, and leave. The player has also decided to use the light drill as opposed to the heavy drill, since time is of the essence, and will sacrifice a little quality for the sake of speed.

The player goes to the city to find the other players that he needs to help him. Using a 'Jobs Board' (a simple bulletin board that a player interfaces with to search for or post jobs in the center of any town) and by asking some friends, he is able to find a very capable group of players to escort him, and he finds a mining partner to spot the material core for him. Because he knows this group is of a very high level, he feels time is not so important; so he decides to take the heavy drill in order to obtain the highest-quality ore. The players who are in the miner's escort only require that they receive any non-ore items that the party might uncover during their quest. Because this is high-quality ore, and because the harvester will be using a high-quality tool, the chance that non-ore items be uncovered during the mining process is fairly high. Items such as gems or other precious minerals will undoubtedly be uncovered as the harvester is mining. The player does not care about these extra items, so he agrees to let his helpers keep anything they find, other than the ore he needs.

Finally, the player meets up with his business partners, and they set out for the dangerous cliffs of the heavily infested mountainous regions to retrieve the most-valuable ore in the land. They all will be richly rewarded in their own way if they can survive.

Summary of Harvesting

Harvesting of raw materials and the treatment of those raw materials is the starting point of the crafting process. By giving harvesting careful consideration, we expand the number of possible skill experts in the player base, add some interesting aspects to the harvesting act, and further encourage players of various gameplay backgrounds to work together in order to attain a high level of achievement. Once the raw materials have been collected, it is traded to the crafters in exchange for goods or services, and is transformed into usable items.

Group Crafting in a Social Economy

A well-designed crafting system yields many benefits. It not only serves to expand the player base and to lengthen the gameplay experience, but it also acts to strengthen and deepen social connections between players. Giving careful consideration to harvesting of materials, maintaining item demand, proper skill diversification, and extensive item recipes also serves to increase the depth of the gaming experience, and gives rise to an extensive social economy that is full of players exchanging items, goods, raw materials, and crafting services.

Crafting an Item

Crafting is the simple act by which a player performs an action on a set number of items or materials using a several different tools to create a single item. In order to

craft an item, the player must first acquire the skill needed to craft the desired item. The next step is to locate or discover the recipe for the item. The recipe for an item simply details the raw materials and items or tools the player needs to create the crafted product. It also lists the materials the player will need to use in case the crafting process falters. The recipe also serves as the key to unlock the ability to craft that item, so that even if the player knows what they need to craft the item, they will still need to possess the recipe in order to be allowed to craft the item. Making the recipes required and nontransferable gives the designer some control over the rate that recipes saturate the market: it becomes a system-controlled commodity.

The player needs to carefully consider the quality of the materials, items, and tools that they will use when creating the item, as the quality of the components will influence the attributes of the end product. Once the player has the recipe and has collected the items needed to craft the item, the player commits to the crafting act. The act takes a certain amount of time, based upon the skill of the player, and based upon the item being crafted. Once the item has been completed, the player may choose to sell the item as it is, or they may seek to enhance it, either by adding additional materials or items to the newly crafted object themselves or by finding a player with enhancing abilities to do it for them. In this way, a player can craft a wide variety of useful, as well as decorative objects.

Time Invested vs. Value of the Product

While in the case of harvesting the balance is between time invested versus material yield and quality, in crafting the balance is between time invested versus value of the product. Not only do the more-valuable items have a base crafting time tied to them, but there is also the time consideration concerning collecting up the needed materials and tools in order to fill the recipe for the item.

As in the real-world marketplace, rarity greatly influences the worth of an item, a fact that is more evident in online games, since the market is smaller and the effects of such variables are much more apparent. Some items that are more time consuming to create derive their value directly from their abilities and usefulness to the adventuring player. However, an item gains significant value purely based on its scarcity, even if the item is useless in terms of gameplay.

The amount of time required to craft an item is adjusted in a number of different ways. One way is to alter the availability of materials or tools needed to create the desired item. The system controls the amount of a specific raw material that is present in the world at any given time, thereby limiting the number of items that can be crafted at that time. Time is also adjusted by the design of the skill system. We can design the harvesting skills in such a way that requires players to achieve a certain amount of skill to be able to perform the needed harvesting action. For example, a particular item might require a high-quality wood to be harvested and treated before

it could be used to craft an item. If those skills are designed to be high-level, then it will take some time before a player could acquire the skills needed to harvest and treat the wood. In this way, the introduction of a certain item into the world can be delayed by requiring a player to attain this high-level skill before the item can be crafted. Some items require the combined effort of a number of high-level players working in conjunction to craft them. Adding a level of social complexity to the item creation can extend the time required to craft it, which again influences its value.

Roles of Material, Tool, and Item Components

There are three major categories of item components:

1. Tools
2. Raw Materials
3. Items

Each of these component groups influences the crafting process and the final product in different ways. The components have certain attributes, which vary according to material type. The quality of the material will be reflected by these attributes. The crafted items inherit those attributes, thereby influencing its final quality.

The first component to consider is *tools*. Tools are an interesting component not only because tools are crafted by other players, which ties another skill set into the social economy, but also because tools allow for unique variables to be introduced into the crafting process. Most commonly, the tool's quality affects the characteristics of an end product. With regard to the variables involved with the normal crafting process, certain tools shorten the crafting time. Other high-quality tools increase the base skill of the player when that tool is being used. The use of other tools introduces new attributes to the end product, which would not be present if a tool of a different quality were used.

The nature of tools also allows for the introduction of some unique crafting restrictions, such as limiting where or when an item can be made. For example, if a tool is too large to move from one location to another, the crafter must stay inside the workshop in order to craft the item. In another example, the recipe requires a certain raw material to craft the tool, and the movement of that raw material is restricted by weight or other in-game restriction. In this way, the tool is contained to a geographical region, which in turn restricts the crafting of that item to that region. Introducing tools into a crafting system influences the crafting process in some common and unique ways. It also serves to introduce a new class of crafter into the community.

The next component is *raw materials*. Raw materials have a set of core properties that influences the attributes of the final product. Within these core properties there is a baseline value that varies according to the quality of the materials. The quality of

the raw material filters down to the final product by either influencing the final attributes of the item or by introducing new characteristics to the item that might not otherwise have been present. The exact result would depend on the specific materials and item. Raw materials are the base component of item crafting and give the crafter some choice in terms of influencing the quality of their final product.

The final component to be discussed is the *item* component. For more advanced items, there is an item-component requirement. The item component functions much like raw materials in that it has a core set of attributes with some base values that fluctuate according to the quality of the item, and these values filter down and affect the quality and properties of the final product. This item is routinely one that is crafted outside the skill set of the final product, which helps to spread the need to rely upon other player crafters. For example, a certain player has the skill to create an engine, given the parts. Another player is an expert in creating an engine block, but does not have the skill to put it all together. Working independently, they create engines of approximately the same average quality. One engine is built in a superior fashion, but with normal parts. The other has superior parts, but average craftsmanship. When these players work together, they make a better engine. The main motivation for this item component requirement is to strengthen the reliance between skill groups, which in turn increases the strength of the social economy.

When building in the effects of chance, keep in mind the notion that a reward should be built into the system that varies with the outcome of player action instead of having punishment as the result of a chance happening. Attempt to exceed expectations and reward the player for a favorable turn of chance. The chance outcome, with regards to crafting, is crafting an item of better quality or crafting an item that inherits some new, unexpected property. While this is considered preferable to punitive, critical failures, where the material or items being crafted are lost, it is possible that a critical failure could be an opportunity to create some feeling of success by experiencing failure through some sort of creative outcome. For example, a player cook critically fails in preparing a special dish, and with that failure, the character takes on some special, funny characteristic, such as a bluish hue for a graphical MMP, or perhaps the player character would exhibit some other involuntary and (hopefully) humorous attribute that would pass after a certain time period. In general, it is best to maintain positive results when factoring chance into crafting.

Enhancing or Repairing the Newly Crafted Item

Another way to extend the crafting process is through postproduction enhancement or the repair of a crafted item. Players would perform both of these actions in the same way that they would craft an item. They simply combine a component with the item to be repaired or enhanced. If successful, that item would reflect the repair or

enhancement action. The ability to interact and treat the items once they have been crafted continues to widen the scope and range of the social economy.

Summary of Crafting

Paying attention to the potential social impact that a crafting system can provide gives the designer a chance to design the system to support the social organization that will sprout up around the collection and creation of items. Giving careful consideration to the entire spectrum of crafting-related activities, from the harvesting of materials to the repairing of existing items, broadens the scope of the system, thereby increasing the number of players impacted by the system. By maintaining item demand, establishing proper skill diversification, and creating an extensive list of item recipes, a robust crafting system increases the depth of the gameplay experience and encourages the development of an extensive social economy.

The Role of Crafting in a Social Economy

Crafting enriches the social significance of towns and broadens the appeal of any MMP. One of the goals of this article is to look at crafting as a way to expand and empower the social economy. The evidence of social economies can be seen in other MMP games by observing the volume of goods exchanged between players inside and outside of the game. This is true of a wide spectrum of games, from those that stress the importance of crafting and socializing to those that stress adventuring. Crafting is the life blood of a thriving online social economy, with players of all playing styles coming together to trade and discuss items, materials, and crafts.

This section explores the many ways in which this crafting model serves to enhance the importance of cooperation and teamwork in the social economy. It goes on to examine ways to link a robust crafting system into a reputation system, and how the reputation system assists a crafter's reputation. Finally, this section examines the role that maintaining demand has in keeping the social economy strong as the game ages.

Social Aspects of Crafting

This crafting system is specifically designed to require players to rely upon one another in order to craft the best quality items. This reliance on player cooperation is accomplished in several different ways. One method is to design the crafting system in such a way that it requires a wide variety of skill sets. Another method, which was touched upon, is the factoring in of risk versus reward and the reliance of the crafters upon the adventures.

It is important to consider the impact that a diverse number of player experts will have on the social economy. In addition to considering diversity, the system must also

be designed so that a single player may not be an expert in too many of these professions. It is important that during the course of crafting an item, the system touches upon several *mutually exclusive* skill sets.

In this crafting system, there are several different skill groups, including:

- Harvesting
- Tool crafting
- Item crafting
- Enhancement
- Repair

When a player expert wants to craft the best items of the best quality, they must contact several other player experts to collaborate on the crafting of the item. The cost of this collaboration could be goods or services, creating trade possibilities for the player experts in the community.

It is important to be careful with this idea, as forcing players to cooperate alienates players if taken too far. Players who wish to play alone are given the opportunity to access a majority of the gameplay systems through normal advancement and gameplay. They will be able to create a majority of the available items on their own without the help of another player. Cooperation is only reserved when attempting to craft items of high quality and a few items of exceptional quality.

Crafting, Items, and Reputation

This crafting system requires players be able to find the experts they need to create the desired item. There is also a need for the crafters to advertise their expertise in order to find players who will become their customers. Communication with the player base is important for the crafters so they can advertise their skills and their products. It is also useful for the crafter to have access to a list of information about their items, such as usage or numbers in existence. These points must be considered when constructing systems that may not directly influence the process of crafting an item, but which support and nurture the social aspect of crafting.

The most important need for the crafter is to create a method of communication for players to broadcast their goods and services to the interested public. There are a number of different ways to solve this problem, either inside of or outside of the game. One method is to construct a message board where crafters of a certain level could post messages advertising their expertise or their goods. Use two separate boards—one that advertises goods and services for sale and another where players can post requests for assistance—which is the 'Jobs Board' that was mentioned in the previous example. In-game, the boards automatically cull messages according to region, in addition to some simple filter options given to the reader, such as the general class

of item or the experience level of the advertising crafter. The requesting board also culls requests according to the skill level of the reader. The use of such filters keeps players from seeing requests for assistance that are outside of a given skill range. This message board also is mirrored on an external Web page for when players decide to browse for a potential business partner outside of the game. This provides players with a central location to give or receive assistance, and to find the player experts they need to complete their tasks.

Having access to certain metrics as they relate to objects a player has crafted is very useful. The ability to trace the history of an object and use that as evidence of the quality of the crafted object contributes positively to the reputation of that crafter. For example, when someone crafts a weapon that is used to deal the final blow in a large battle, the crafter who created that sword has access to that information and passes it on to the player base, giving his in-game shop some positive reputation. The crafter eventually builds a bank of information that is linked to their crafted items. Some example metrics include:

- Number of creatures killed, which could be sorted according to level, area, and rarity
- Number of total items in existence
- Average experience or skill level of the characters using the item
- Average reputation of the characters using the item
- Average sale price for the items as they begin to be resold
- Number of items created
- Quality of items created
- The resource harvested using an item

Reputation not only refers to the quality of items being crafted, but it can also refer to a character's reputation as measured by a *reputation system*. A reputation system measures character behavior, which results in a summary rating of that character as good or evil. Crafters may choose to access this information in the form of the average reputation rating of the characters that use their items if they wish to appeal to a market based on reputation. It is also possible for a designer to designate some items as inherently evil and other items as inherently good. The crafter could adjust their reputation by the items they choose to create. For example, creating thief tools or traps geared to injure players might negatively impact a crafter's personal reputation. In these ways, the crafting system ties into a game's reputation system to further enhance its role in the formation of the online community.

Communication and information are two staples in a thriving economy. Giving the crafters the tools they need is a great step in establishing a strong, long-lasting social economy.

The Importance of Maintaining Demand

Maintaining demand is an important detail that is often overlooked because of the frustration that it can conjure in the noncrafting player. However, it is crucial to preserve the entire range of demand for items. It is important to understand that crafters will craft a needed item according to the market demand until there is no longer enough demand to justify that the item's creation. Unless there is a healthy demand for all items during the lifetime of the game world, the demand will begin to push upward toward the harder-to-craft items. If this phenomenon is allowed to continue unchecked, then the newer crafters will not have the market to sustain their professions, because the market has been flooded by the efforts of previous crafters. It is very important to try to preserve the market for the newer crafters, otherwise that aspect of gameplay loses viability as the game matures.

There are two primary ways to preserve item demand. This first is by introducing decay into items, and the second is by causing a high degree of inventory turnover. The role of decay is fairly self-explanatory. Each item eventually disappears through normal wear and tear. If a player uses an item X number of times, that item will break. Having some repair routine present is useful to stem frustration and extend the life of the item; but even with repair, every item has a certain lifetime. In this way, decay helps to maintain some demand for all items that are used regularly.

Another method to maintain demand is by creating a system to ensure some level of inventory turnover. The specifics of the MMP dictate what is appropriate, but in an adventuring-based MMP, having a player lose some or all of their inventory when they die is an effective way of maintaining demand. Both of these methods are useful tools in the pursuit of preserving the market for crafters. It is vital to put systems in place to ensure that item demand is always present if crafting is to be a viable play option throughout the lifetime of the MMP.

Conclusion

Crafting is an important part of building a lasting online community. Its importance can be magnified by paying attention to the impact that skill diversity can have on increasing the scope of the social economy. By creating a robust harvesting system, the ties between the adventurous and the crafting players strengthen. By designing communication systems to empower crafters to look for and provide goods and services to the player base, the effect of the crafters' efforts are better observed and appreciated. By maintaining the demand for lower-skill items, the market for new crafters who enter the older, well-established community remains strong. By creating a deep, wide-ranging crafting system that encourages cooperation, the MMP reaps the benefits that can come from a vibrant and exciting social economy.

6.2

PLAYER HOUSING— MY HOUSE IS YOUR HOUSE

Paul D. Sage, NCsoft

psage@ncaustin.com

When we added landmass for player housing to *Ultima Online* (*UO*) in the spring of 2000 the response was overwhelming; people waited online for over 24 consecutive hours just for the chance to place a house in the world. This was not unexpected, but it did further emphasize the passion that was generated by *owning* a piece of property in *Britannia*. Still, in some Massively Multiplayer (MMP) games, housing has not taken off as a primary feature. Understanding what makes a housing system successful will, of course, directly depend upon the game being designed. In order to gain a better understanding of what makes housing really work, some misconceptions should be addressed concerning player motivations for housing.

One of the first and worst misconceptions is that players want to use a house as a place for privacy. This statement sounds correct, but it does not bear out as a good reason to put housing in a game. In stating that players have a need for privacy, we assume the statement means one of two things: the player wants to be alone, or the player wants a location to discuss things with others without fear of intrusion.

If the first assumption—that the player wishes to be alone—is correct, then the player could better address that need by either adventuring alone or not logging in to the game in the first place. While there may be some people that would want to enter a massively multiplayer environment to be alone, it is safe to bet on those people being in the minority.

The second assumption of wanting privacy with friends may be valid, but if the game has a robust chat system and enough landmarks for groups to use as gathering places, then this does not create a driving need for housing. With a private chat system, most groups can feel free to discuss whatever they like, wherever they like, without fear of intrusion. If there are ample landmarks in *safe* areas that the players can use as identified meeting places, groups can gather at these landmarks without the worry of interruption, making the meeting feel more palpable than a simple chat.

Privacy actually turned out to be one of the least-common goals in *Ultima Online* with regards to housing. In fact, once players were given the option to declare a house as *public* or *private*, many players chose the former. A private house meant that only a

character holding the key could enter the domicile, while a public house allowed anyone to enter. Once a system was put into place to allow items in a house to be *locked down*, meaning they could not be taken by anyone but the owner of the house, private homes became less and less used. At the time, *Ultima Online* did not have a robust chat system, and the only way to have a truly private conversation was to have a house that only you and your friends could enter. So why were public homes more popular, even if it meant sacrificing private conversations? The answer to this question is found in the following principles:

- Accomplishment
- Display of accomplishment
- Further ability for accumulation through vendors
- Good, old-fashioned gathering

A Path for Growth

There are very few experiences in any MMP that are more exhilarating than that of successfully placing a house in *Ultima Online*. One of the reasons for this is that housing in *UO* is a very difficult thing to purchase, not only because of cost, but also because of availability. Players have to save up money, often with other players, just to be able to afford their first house. Once a player is able to afford the deed for a house, actually placing that house is another challenge altogether. In the spring of 2000, available real estate in Britannia was extremely limited, making it very difficult to find the space for a house. This difficulty was often a source of great debate. Some felt that it was good to have a challenge that could not be easily achieved, while others felt that housing was vitally important to opening up other key features of the game, and that the lack of housing space was closing off a large portion of the game for many players. Whatever the case may have been, one thing was certainly true—placing a house in *Ultima Online* was a nonguaranteed reward; the uncertainty associated with placing a house was a major contributor to the elation of successfully doing so.

Once a player was fortunate enough to own a house, then their attention often turned to obtaining a better one. *Ultima Online* featured a clear path of upgrades for housing, which continued to challenge players to earn a bigger house. Of course, the larger houses were exponentially more difficult to obtain. Not only did they cost more money to purchase, but finding larger plots of land to hold them seemed a near-impossible task to most casual players. This gave rise to people spending outrageous amounts of in-game and real-world money to buy the smaller houses from the owners that were occupying valuable real estate. Players (often an entire guild) would buy three or more houses near each other and remove them from the land, clearing room for towers, keeps, or even castles. While this kind of challenge leads to a strong sense of pride and accomplishment, it is not an important achievement unless there are things to do in the house that are unique.

A Means of Commerce

When houses were first introduced into *Ultima Online*, they served as status symbols and gathering places, but little else. Because items could be freely taken from any home, most homes were not open to the public, with the exception of a few establishments that began inviting players to come and have an ale in their homes/businesses. Establishments like Kazola's on the Great Lakes shard and Golden on the Baja shard eventually became towns unto themselves, full of life that the original cities of *UO* could scarcely claim. These successes were hard-won, spurring players to request better tools to help them as they developed their budding communities. Seeing the potential in player-created towns and establishments, the development team turned a lot more of their time to giving the players some of the community tools they were requesting. This is when housing in *UO* started to develop a unique feature set that made them even more attractive to the player base.

Vendors were an addition that allowed players to share and trade goods while they were offline. As players accumulated more and more from their world adventures, they needed a place to sell their wares. It was very frustrating to try and sell them at the banks in *UO* because overcrowding was such a problem, as well as thievery. Even after thievery was removed from the game, many players felt uncomfortable selling goods in towns and became frustrated at having to stand in a crowd, shouting for hours, just trying to unload some goods. Without a global chat or auction channel, it was difficult to sell and buy things with other players. At the time, the trading feature of *Ultima Online* was even exploited and used to scam other players.

Vendors came into being as a way to solve these issues and perhaps increase traffic to players' homes. Vendors in *Ultima Online* were NPC salesmen of goods, which could be hired by players. Players would give goods to the vendor to sell, and the vendor would charge a modest price for continued employment. The vendor would stand happily at the home for as long as she or he was paid, and other players could browse the wares the vendors held. Vendors required the player to have a home, so this increased the desire for housing even more—and not just any housing, but housing in a high-traffic spot.

Location, Location, Location

So with the advent of vendors, real estate in *UO* became even more precious, and overcrowding took place. Of course, in hindsight it would have been better to have imposed restrictions early on in the game that set out rules for how houses could be placed. These restrictions came in later, but much of the landscape of *UO* had already been *littered* with houses, which left some players with feelings of claustrophobia. It was not uncommon while adventuring in the *wild* landscape to be literally blocked off by houses. The conclusion that might be drawn from this is that housing needs to be located in a separate district, away from the areas most traveled.

This, however, might not be the correct conclusion. Having such a district might hurt the commerce that was created by vendors. High-traffic areas, roads into and out of towns, roads to certain places, popular hunting spots, and so forth were always likely to bring more customers to a player's vendors. Separating out the districts would have made this more difficult, although travel spells that allow players to travel instantly to a location already existed, hurting this theory somewhat. Any traffic passing a house, though, was still likely to bring more customers than a house that never saw traffic.

Also, consider that the reward of placing a house in *UO* was akin to having a trophy or a *point of brag* that had to be seen by others. Trophies are really at their best when they are displayed where people can see them, meaning that having the biggest house in a housing district by itself would mean very little in terms of its visual impact on the other players. To many players of massively multiplayer games, accomplishment without admiration is a hollow thing.

The real understanding of what makes a housing system successful will directly depend on the design of the game. In a game with a robust auctioning system, buyers of goods could instantly be transported to the home where the goods were stored. Its location on the landscape would be largely irrelevant, and window shopping would also not be necessary. The *Anarchy Online* system of auctioning (despite requiring the player to be online when played) was a great example, actually showing the properties of the offered items in the auction channel itself. If more games move to this type of system or a more browser-like auction like that of eBay, then purchasing goods at houses may become a thing of the past. If the transaction were to require a visit to a house, housing would still play a big role, but the interior of the house might play a bigger part than the exterior.

Where Do I Put the Halberd According to Feng Shui?

If the interior of a player home is to be open to the community, then like all extensions of a player's personality in the community, the tools for interior home design will need to allow a player to express themselves. In *Ultima Online*, players are able to place items in their homes in almost limitless locations and arrangements, showcasing their creativity and design abilities.

This display of items eventually fostered a side-effect in *Ultima Online* known as the *rares* market. The rares market developed because a few very hard-to-get items, some requiring *exploit-like* behavior to garner, could be displayed in houses. Other players, intrigued by the unusual items, would go into homes with these rare items and question the owner. Huge sums of gold would eventually be offered for seemingly mundane items, all in the name of making a home or house truly unique. Seeing

everything in *Ultima Online* is a passion for some, but wanting to own everything that can be owned is akin to Shel Silverstein's *Hector*.

Because of the freedom afforded players in item placement, they were able to create amazing interiors, and even new items, in their homes. Players made grand pianos out of chessboards and dyed cloaks, fish tanks out of paper maps and other sundry bits, and decorative fountains out of cotton. Walking into a player house came to be a bit like walking onto the set of *Junk Yard Wars* . . . few of the materials were used for their originally intended purposes, but somehow it all managed to work.

Some of the open rules, however, came back to hurt the game. Because there was no limit to the amount of items that a house could hold, houses quickly filled up with hoarded junk that the players did not need (although in all fairness, the game did encourage hoarding, since players lost items on death). Limits had to be placed on items in houses retroactively, prompting the development team to devise an ingenious solution of giving players tickets, like those found in local pizza arcades for playing SkeeBall, in return for deleting their extra and unneeded items. The inventive plan made a very difficult process easier from a community standpoint, but it is advised to set limits when housing is first designed, and save yourself the heartache of having to do it later. People do not like to give up items.

Lessons Learned

The *Ultima Online* experience demonstrates the strength of the housing feature; it accomplished so many good things, design-wise, for massively multiplayer games:

1. It serves as a social gathering place.
2. It represents the player's growth.
3. It is a point of brag or a trophy.
4. It is a way to further customize the world and make an impact bigger than one avatar can make alone.

Housing in *UO* involves a good deal more systems than the ones discussed here, but the most relevant points can be illustrated by looking at the systems in this article. The four points above represent a success story, and rather than trying to add more points, it is perhaps more important to discuss how to apply these points to future games.

When trying to make houses social gathering places, the situation that sparks the gathering must be unique to the design of housing. If the feature is replicated anywhere else, the impact of this motivation for housing will falter in the design. Try to think of what makes players gather or group together, and perhaps save those features for housing if it is right to do so. Each game will likely be unique in the way it encourages social interaction, but the goal is the same: forming social ties. Social ties are the

ones that bind players to your game; fun is the catalyst that gets them there. Commerce is an excellent reason to visit the house of another person. It is a needs-based system that will naturally occur in any game that incorporates trade. Being able to browse for goods easily is important, but instinct says that too much convenience sometimes destroys the flavor of food.

Having a path of growth that is not always assured for every player is dangerous; and yet for the players who achieve the end goal, few things are more rewarding. Still, it is not advised to put an end goal with so many features out of reach of players in a game. *UO* continues, as of this writing, to ensure that all players are able to earn a house. What is not guaranteed is what size house a player can own, and therein lies the challenge and the reward for the player. Housing should have a challenging path of growth with a commensurate reward for the player.

For many players, that reward manifests itself in the ability to show off their accomplishments. Housing provides an excellent way to make player rewards and achievements visible and long lasting. One of the critical features of MMP games is to give players a reason to converse. A player might ask, "What were you doing when you got your house?" or "Wow! That is one big magic sword. Where did you get that from?" So many designers spend so much time trying to create stories that could be better spent on trying to create points of brag. Players often care about fiction and back story as much as your average U.S. citizen concerns themselves with the very interesting political system of Canada. Points of brag give players a reason to create their own stories, and this bragging is far more important than any developer-created fiction because it directly involves the player.

Finally, one of the ultimate goals of players in MMP games is a way to have a meaningful impact on their world. Giving the player the ability to run a shop, open a tavern, or just have an imposing castle is an incredible way to allow them to fully impact the world around them.

Conclusion

The future of houses in MMP games is open to a great deal of exploration on the part of designers. Not all MMP games will need houses, nor will houses be appropriate in every game. Still, there are many avenues left unexplored. Homes could become a portal to a unique adventure created by the player, or maybe the home becomes the adventure itself. More tools may become available in future games to allow housing to really become a part of player-run towns that boast their own political systems and rules. Houses could become more Lego-like in construction, with players able to piece together houses in the ways they desire. What can be done is as unlimited as the imagination of the people sitting down to create the housing system.

6.3

SOCIAL GAME SYSTEMS: CULTIVATING PLAYER SOCIALIZATION AND PROVIDING ALTERNATE ROUTES TO GAME REWARDS

Patricia Pizer, MMP Design Specialist

ppizer@earthlink.net

There is no question that human beings are social animals. Throughout history, we have formed different types of communities based upon our commonalities, with proximity and mutual survival as key motivators. We formed villages that worked under certain norms in order to optimize survival for its members. Since then, we have formed communities around numerous common aims. We have geographical groups (from households to nations), religious organizations, academic groups, clubs, and so on.

In the 'era of the Net,' this portion of the Information Age, we find ourselves increasingly making social connections in virtual space. Current advertisements for what is probably the most mainstream ISP (remember all the diskettes that came in your mail box and in your cereal box?) depict a grandmother talking about how easy e-mail is to use. It seems that interaction in the virtual world is filling a gap caused by the breakup of more-traditional communities as people become increasingly mobile and move all over the country, and, indeed, the world.

Massively multiplayer online games are currently the most technically advanced, publicly accessible virtual spaces and are replacing traditional interactions for people planet-wide. These 'games' represent the latest evolutionary step for the human community. How are we, as game developers, influencing, nurturing, and shaping the social experience in cyberspace?

What Are Social Game Systems?

A game system is an underlying basic way the game *works*, as opposed to the content of the game. For instance, a 'spell' is a gameplay element or content, whereas 'magic' is a game system. Even though this concept *sounds* simple, many people, including

many game developers, do not understand the distinction between the two. Once a game system is in place, the particulars—the *content*—can be changed and manipulated fairly easily. The underlying game system, however, is difficult to alter, as it is an integral part of the game's foundation.

At their simplest level, *social game systems* are those game systems that support, enable, encourage, reward, or punish different social behaviors. Unfortunately, real-life social systems are more complicated than that. In traditional human societies (whether it is a nation or the Girl Scouts), there are many aspects to socialization. The *Oxford English Dictionary* defines *socialization* as:

> "The process of forming associations or of adapting oneself to them; esp. the process where by an individual acquires the modifications of behavior and the values necessary for the stability of the social group of which he is or becomes a member." [OED89]

Using this definition, we can explore the different roles of socialization in a game world.

Induct New Members into the Society

Social systems help to induct new members into the society. The act of smoothly integrating a new member of a virtual world is critical to a successful society and community in that world. New members need to be taught the particular knowledge of the world. One of the commonly used methods is the implementation of a 'training' period.

In *Asheron's Call* (*AC*), for example, players enter the world directly in front of the *Training Hall*. Walking through the hall and reading the messages on the stiles along the very obvious route of progression provides players with a quick overview of how the game works. Another game that does this admirably is *ToonTown*, which was developed ostensibly as a children's game, and the design required careful induction into the game world. Players are immediately informed by the game of what they need to do, and they are provided with introductory tasks to practice necessary skills. The game *Earth & Beyond* also attempts to address this problem, though the effectiveness of that system (as of this writing) remains to be seen.

When logging in to a MMP for the first time (assuming you have not actually read the manual, which is usually a safe assumption), a player might have the guidance of a real-world friend regarding what to do in the space, how to navigate the user interface, and how to interact with other players in the space. Players who do not, however, have friends to guide them need a game system to train them. However, these examples all illustrate existing systems of 'game' induction, but not 'social' induction. A similar initiation of a member into the social conventions of the world is essential.

For instance, having logged in to a 'role-playing' server, players can reasonably be expected to act as though they really are the characters in the world they have entered.

If it is a medieval fantasy game, get your "Good Morrow!" ready to greet other players. It does, of course, go far beyond this most simplistic level; players who are role playing do not usually publicly discuss problems from their real, mundane lives. If the setting is futuristic, the mundane world is again set aside in favor of discussing blasters, spaceships, aliens, or whatever is applicable to the setting.

Ideally, the properly designed game helps the player to learn and apply the social expectations defined by the world. Just as it was the first time you stepped into a library as a child and learned that libraries are quiet places where you try not to disturb others, starting out in a new 'world' involves learning the inductive rules of that world.

Enable Player Communication and Connection

The social game system most utilized in current MMP games is *chat*. If you have played any of the popular graphical MMP games, you have seen and used a chat system. Chat enables players (to the degree that the system allows it) to interact publicly, privately, in close quarters, as a group, and across the world. In most current examples of established MMP games, chat is the *only* social game system in the game. After all, it enables players to talk, does it not? Is not socializing about talking to one another? No, it is, in fact, more complex than that.

Support and Promote Cooperative Play

A number of the current games have introduced systems to support and promote cooperative play. Mechanisms such as experience-sharing are perfect examples of this. *EverQuest* (*EQ*) and *Dark Age of Camelot* (*DAoC*) have developed their player classes in such a way as to essentially require players to work cooperatively at higher levels of play. The ability to create 'solo classes' actually cuts into this goal. *Asheron's Call* provides character development that not only allows, but also fosters solo play, even in much higher levels. Playing an MMP game without interacting with other players in the game world is a waste of network bandwidth. One might as well play a single-player game.

An MMP game is based on players interacting as they would in any other cooperative/polite social organization. The lack of involvement or investment in the society you join encourages negative or sociopathic behaviors; a sociopath is averse to society or companionship, an individual opposed to the principles on which society is constituted, and who is devoid of or antagonistic to normal social instincts and practices. If you are not attached to the world or do not have anything personally to lose, why play by the culture's rules?

A major social system goal that has yet to be effectively solved in the MMP field is that of actively rewarding positive social play and discouraging antisocial or even

sociopathic behaviors. While it has been touched upon in systems like the *Ultima Online* reputation system, this area remains wide open and essential to the establishment of social norms and guidelines for behaviors in this nascent virtual community.

Foster a Sense of Belonging

A good social game system helps to foster a sense of belonging in the world, a basic human need. See *Maslow's hierarchy of needs* for clarification of the other basic needs [Maslow68]. Being part of a group is the third step in Maslow's hierarchy of needs; it includes belonging, association, acceptance by others, and giving/receiving friendship and love. A supportive social system to accomplish these goals might be as simple as a guild system paired with effective chat utilities. A sophisticated system, however, will take this further, as we will explore later.

Small World Networks

Finally, in considering social game systems, we should examine the effects of 'small world' networks and player organization. Small world networks provide maps of how connected nodes relate to one another—or, in this case, how players relate to one another. One of the theorems of small world networks shows the premise behind the phenomenon of 'six degrees of separation,' which states that from any person to any other person on the planet, there are six or fewer steps or 'hops' [Milgram67].

For example, if your best friend's cousin lives next door to Robert Redford, you are three steps from Robert Redford. This phenomenon is well illustrated in a Web site game called "Six degrees of Kevin Bacon" [Reynolds99]. The game was invented by three Pennsylvania college students, Craig Fass, Brian Turtle, and Mike Ginelli. Utilizing this phenomenon, we can create player organization systems that encourage the 'connectedness' of a virtual world. By providing stronger social systems, you can even lower the number of steps, further increasing the connectedness of your players.

Why Do We Want to Socialize Players?

The current business model for virtually all commercially successful MMP games is a monthly subscription model. To be successful in this model, we must provide players with reasons to keep coming back and playing the game. The notion that players feel compelled to return may be referred to as 'stickiness' [Gladwell]. By increasing stickiness, player retention is increased, and the user base remains stable and profitable.

Create Self-Sustaining Communities

No one will argue that virtual worlds are cheap or easy to maintain. The ongoing costs associated with customer support, ongoing game-content creation, community

management, bandwidth, servers, and so forth mount up quickly. The more we can do as developers to create worlds that are self-sustaining, that move and grow independently of developer input, the lower the costs of the long-term life of the game. This handy 'business' reason aside, virtual worlds need to continue to keep the community happy. Residents of virtual spaces develop strong connections to that world and will be hurt, angry, confused, saddened, and disenfranchised when 'their' world goes away. Worlds that change in ways that make players unhappy will cause player migration to other games.

Reduce "Sociopathic" Play

Players who engage in sociopathic behaviors (to varying degrees) are generally referred to as 'griefers.' The moniker comes from the grief that these particular individuals cause to other players in the space. Griefing behaviors range from talking to other players in an annoying fashion, to blocking the progress of others by actively stepping in their way repeatedly, unacceptable language, or repeatedly killing a particular player.

These sorts of behaviors have a negative effect on the other members of the community that may be as simple as annoyance and as dramatic as driving someone to act against the griefer in real life. While only about three percent of your players fall into this category, they can still wreak havoc within your world. This statistic was quoted in a 2002 Game Developers Conference roundtable session [GDC02]. Unfortunately, the data suggests that the recidivism rate is 99.7%. Think about that for a moment. A person who creates trouble and angst for other players *once* is almost guaranteed to act in this (or another) antisocial way again, despite warnings or punishment.

The effects upon the community are apparent. Your Customer Support Representatives (CSRs) spend a considerable portion of their time dealing with complaints about grief players. *Asheron's Call* figures estimate that around 40% of CSR time is spent dealing with griefer issues, 20% on bugs, and the rest of the time on answering questions. This time could be spent far more constructively helping players who have technical difficulties or who have run afoul of bugs in your game. This is not, by any means, an easy problem to solve. However, solving it will lead to far better worlds and more-solid communities, making it a critical social issue.

Increase Player Equity

Player 'equity' is the degree of investment any given player has in a world. Imagine a person who just started playing a game and found out (after developing their first character for a few levels) that all of the people they know play on a different server. The equity in the character is still low, and the player is likely to abandon the first character and create a new one where there are friends to play with. On the other

hand, a person might realize after a fair amount of investment (such as elevating a character to the tenth level) that the character is fatally flawed due to an early choice the player made. Once there is emotional involvement with the character (generated through time, shared experiences, etc.) it becomes difficult to desert that character in spite of the flaw. The character has become 'sticky.'

Similarly, a person who has become actively involved in the social workings of a virtual world has greater investment and loyalty to that particular world. When *DAoC* was released, *EQ* initially suffered a noticeable reduction in active players. There were a number of similarities between the games, and some players found they liked *DAoC* better and convinced their friends to follow them to the new world. After a few months, *EQ* got a number of those players back; while some players had found the new game wanting in some way, many simply could not give up their equity in the *EQ* universe. Effectively, these players were homesick.

Create Richer Worlds

Of course, one obvious way to increase player equity in a world is to create greater breadth and depth to the world that you build. Breadth in this case refers to implementing more game systems and social systems in particular. Depth refers to richer experiences available to residents of your world. Better AI, more-intricate quests, and larger geographical areas are all aspects of increased depth of the player experience. Having complex social systems in place can increase a world's depth and breadth simultaneously.

It Is Not Just a Game

Perhaps the most important reason to build social systems to reward players for positive social behavior is that these worlds are not simply 'games.' Throughout this section, we refer to players and game systems; the reality, however, is that virtual worlds extend beyond what we have traditionally thought of as games. These services play host to almost the entire range of traditional human interactions. They are a new medium for communication between people; and, in much the same way we found was true of the telephone, they are important in their own right. No one can credibly argue the telephone is simply a novel toy. Many dismiss this notion readily, armed with such remarks as, "But it's not real, it's virtual." Anyone who has launched a successful MMP game, as well as devotees of said games, knows this is simply not true.

Take, for example, individuals who discover undeveloped skills and talents in the game world. Players who become leaders may not have had the opportunity to do so in real life in a safe setting, which the game world provides, increasing the experience level and confidence of that player to use those skills in real life. A terrific example of a player's real-world skills being affected by play comes from *EverQuest*; a player was, in real life, terrified of swimming. In the game, the player fell into a body of water and

drowned. Finding that this occurrence did not have the terrible consequences the player feared, he began to swim in the game. He was eventually able to get over his fear enough that he learned to swim in real life.

People fall in love in these worlds. Virtual romances can destroy real-world marriages or lead to real-world marriages. Some players become so engrossed in their virtual lives that their jobs and relationships suffer. These are societies that compete with and complement reality, and therefore, must be taken seriously.

Current Social Systems

Virtually every MMP game on the market sports some kind of social system. At the very least they have a chat function that enables players to communicate with one another. There are, however, several communication systems that bear examination. Let us begin with the most basic: chat.

Chat

Every successful game on the market currently has some sort of chat system. These range widely in flexibility, but all provide essentially the same functionality. Some games are utilizing voice chat, which has both benefits and drawbacks. Depending on the voice client used, the experience can be either more immersive or can completely break role-playing immersion. In a hyper-realistic setting, a player's natural voice makes their avatar more identifiable and creates better empathy that enriches the human connection experience. On the other hand, for players who engage in cross-gender play, this can completely shatter the immersion.

There are several established and common features in existing game systems. For instance, most games use text to convey player messages to each another. Players type what they want to say into a text box, and it is broadcast to the world around them. Generally, the game provides 'channels' to discriminate who receives any given message. Frequently implemented using a tab-based interface, players click on the tab that corresponds to the channel they want to use for a message, type into the text box and press their 'enter' key to transmit the message. In this way, people can send a message to a particular player, a particular group, or everyone within earshot.

Furthermore, most games provide 'emotes,' text and graphical cues to other players. For instance, players can 'wave' to one another in *Asheron's Call*. You might see a character dancing in *Dark Age of Camelot*. This functionality supports another method of communicating with other players, even nonverbally. The next generation of games are planning on incorporating voice, allowing players to actually talk to one another.

Hierarchical Structures

One current hierarchical structure used in the *Dark Age of Camelot* is the guild system. Guilds are formed with a minimal number of members who register the guild name.

Members may then continue to invest in the guild to buy their own crest, which can be worn on cloaks or shields. Aside from a private chat channel and the ability to quickly find other players to adventure with, the guild system offers little else. For the record, most of the top MMP games have some sort of guild system.

The allegiance/monarchy system in *Asheron's Call* is another good example of a hierarchical social system that is currently being used. Through the allegiance system, a player may become the patron of another player who then becomes a vassal. The person at the top of the pyramid is the monarch. In this particular system, experience points rewarded for in-game actions roll upward, providing experience to a patron through the experience gained by his or her vassal, and so on up the line to the monarch. Therefore, a monarch who has a great number of vassals will continually get a stream of experience, even if the monarch is not actively playing.

Some have referred to this as the pyramid scheme. While the system does encourage players to seek vassals, it does not necessarily enforce or reward patrons to aid their vassals, especially novice players. If, for instance, a patron got a reward for getting things to a vassal, the relationship would not be so one-sided. While most patrons do assist their vassals to some degree, many patrons and monarchs simply sit back and watch the experience points roll in. As in any other historical monarchy, the vassals at the bottom of the pyramid simply bear the weight of those above them without gaining significant assistance.

Reputation

According to the *Oxford English Dictionary*, reputation is defined as:

> "The common or general estimate of a person with respect to character or other qualities; the relative estimation or esteem in which a person or thing is held."

Reputation is an aggregate set of impressions one creates among others through actions and words. It is fame; it is infamy.

A reputation system provides players a means to evaluate and rate other players. Just as one accumulates a reputation in real life, people in virtual worlds can as well. For instance, if one person cheats another in a deal, the victim might take the time to make an entry of some kind pertaining to the offender's reputation.

Ultima Online, the prototypical graphical MMP, utilizes a reputation system to help players identify other players in a positive or negative light. Similarly, the reputation system utilized by eBay allows participants to evaluate one another so that other participants can make an educated decision about working with a particular individual. If a seller has a bad reputation, future buyers will not buy/sell from them.

Unfortunately, this kind of system can be undermined if not very carefully constructed; a player can easily manipulate the system to acquire an underserved reputation. So while this sort of system is quite susceptible to abuse, a carefully constructed

and tested reputation system immune to manipulation can aid players in choosing whether or not to play with a particular person. There will always be players who revel in negative press, but the majority of players will find others of their own type and, therefore, have a more enjoyable play experience.

Bartle Types

In 1990, Richard Bartle published an article on the ways players approach Multiuser Dungeons (MUDS), the text-based predecessors of today's MMP games [Bartle90]. He defined a taxonomy of player motivations that has proven to be extremely helpful in understanding and creating MMP games. This seminal work introduced us to four player types: *explorers*, *achievers*, *killers*, and *socializers*.

Let us look at a quick overview of these definitions. Explorers like to learn about the world. They map it, they test the physics of it, and they find new territory as soon as it is introduced to the game world. Achievers create game-related goals for themselves and pursue those goals. These players primarily accumulate loot and seek status. Killers impose upon other players and monsters, seeking to demonstrate their superiority against others. Ordinarily, this applies to Player Killing (PK) game systems. In situations where other players cannot be killed, killers manifest themselves by griefing or finding ways to bother other players. Finally, socializers interact with other players; in other words, they socialize.

While all players have indices on each of Bartle's four player styles, we can safely assume the social index for all players is greater than zero. Even players labeled as pure killers are usually interacting with other players, boasting of their exploits, taunting players, and otherwise utilizing the game's communication systems to 'connect' with other players. In other words, any game system that enables players to interact can be thought of as a social system.

Matching Services

The chat system as used in the game *Dark Age of Camelot*, in combination with the guild system, appears to be very sophisticated and encouraging of group play. The game also uses a matching system (a way to select out a narrow range of players from the population to fill a particular need) to help players seek out and join up with other players. For instance, if the group lacks a healer, the group might look for a cleric or friar. A paladin who logs on alone and knows no one in the game currently online may look for a party that is seeking a fighter; they can look by player class and location to find someone nearby. A special advantage of the system is that players who find themselves in need of resurrection may search for a nearby healer to come to their aid.

This system is currently the best in class for MMP matching services. Of course, this elegant social system encourages players to group together to play, generating a

shared experience. Indeed, it helps players meet other players that may share a routine online playing time. Initially, it appeared that the system would aid players in creating groups of people they might play with and interact with on a regular basis. We can further analyze this in the next section.

Innovative Ways to Reward Social Play

To quote the renowned MMP designer, Raph Koster [Koster02], "We're doing a crappy job of rewarding people who are social builders." Let us start by taking existing social systems to the next level.

Evolve Current Social Game Systems

Virtually every social game system being used today could use improvement. In some cases, it is merely a case of improving the user interface to make the system easier to use. Indeed, the development of individually configurable interfaces would greatly improve a number of problems in the current systems. In all fairness, most of the games being played have utilized patches, monthly downloads, or extension packs to implement this sort of improvement. By following suggestions from player feedback, developers can finely polish their game systems.

The *DAoC* matching system has a significant weakness. There is no way in the current system to discriminate among the other players. For instance, take a group that is tactical and strategic in its planning. It does not run into a fight without giving thought to the condition of the other members at the time as well as the peril inherent in a situation. The group, however, finds itself in need of a fighter. After using the matching system, they locate a paladin who is nearby and of an appropriate level, who is also looking for a group.

Once the group is in battle, they may find that this player prefers to simply proceed at will and take great risks in stark contrast to the group's typical risk-managing approach. Unfortunately, they do not discover this until the new player has gotten the entire party in trouble. Similarly, players who like fast-paced action will be frustrated when waiting for a player who insists on healing and preparing before entering a new battle. Additionally, there will always be grief players who want to join with other groups simply for the sake of getting them in trouble. This weakness leads to 'one-offs' in grouping rather than establishing regular player groups.

By one-offs, we are referring to a one-time situation that requires a certain amount of investment of time and effort. The group must learn about the individual, perhaps to its detriment. If a good connection is made, those players will continue to play together over time and reinforce the social network, adding new links to it. But these one-offs require the same effort and time, and do not result in further connections between the players involved.

To significantly improve this service, we can take a lesson from the ever-popular online dating services. Participants fill out questionnaires, which can help the system select others who are a 'good fit.' By optimizing the grouping of players, we can weave a stronger, tighter social network, as explained above in reference to 'six degrees of separation.'

How can we improve upon chat? The most basic thing missing from current chat systems is a way to keep multiple conversations going; we have facilitated so much communication that it often intrudes on the game experience. We could add a number of novel features to existing systems. E-mail, for instance, could nicely complement traditional chat functions. Message posting, an essential facet of MMP communities, could be hooked into a chat system. With WAP (Wireless Application Protocol) messaging, cellular phones add another dimension to the basic communication functions available to a player. Perhaps we could create a rebirth of the telegram!

The point here is, of course, that there are already many real-world communication channels that we can take advantage of with minimal design and implementation. But there are some important caveats to this idea. Controlling the use of obscenity becomes difficult. Players must have some kind of 'ignore list' available to them in any of these chat extensions so that they may block undesirable contact. Think about those communication channels we have available in real life and see how they can be applied to virtual worlds.

The further development of other conventional game systems provides numerous opportunities for us as developers. How can trade skills be extended into games in ways that make them more central to the social workings of those worlds? How can we utilize reputation to improve social systems? How do we grow guild/allegiance systems to encourage players to socialize and strengthen their ties to the world and its community?

Small tweaks to established social systems can make the system considerably more effective, transforming it into an extremely useful tool rather then a simple safety net. In short, analyze the game systems that are already in play. Play the games. Find out what works and what does not. How do similar systems differ? What makes some more successful than others? The best way to improve our game-making skills is to learn from what has gone before. Utilize good systems and improve on them.

Increase Community Ties

In his book, *The Tipping Point*, Malcolm Gladwell defines what he calls "The Law of the Few" [Gladwell]. This concept describes how a few members of society, through their unique social skills, help to connect people and spread the word. 'Connectors' are people who have a way with getting to know large numbers of people. In any online world, there are connectors who actively hook up other members of the com-

munity. If, as developers, we worked at ways to identify connectors and reward them, we could use them to help create and strengthen social networks; after all, they run most of the fan Web sites! Data mining, for instance, is a resource available to us as developers that can help us to analyze, manipulate, and improve the communities in our worlds. Think about ways to use the player data you collect to identify certain play types.

Develop Parallels to Real-World Social Systems

In the above section, "Why Do We Want to Socialize Players?", we briefly looked at the relationship between the virtual and the real worlds. Player gatherings are filled with people who have genuine friendships. Guilds that had been established as early as 1995 still work as a group and play together using the advantage membership affords them to network and using the social links group membership provides. There have been many cases of players dying in real life, only to have their virtual communities participate in memorial activities of all sorts, as well as erecting in-game memorials. Funds have been raised in the real world to help out a guild member who'd had a terrible accident and was unable to pay the ensuing medical costs.

The lesson to be learned from these emergent behaviors is simple: utilize the social systems that people use in real life and apply them to the game world. Provide the means by which a character can advance through 'support roles' or service provision. In *Asheron's Call*, a group of players used the cooking system to start a catering service. The service would 'cater' your in-game functions, such as guild meetings and weddings.

Aside from using the system in ways that the developers never intended, this is a perfect example of how players take matters into their own hands to create social systems. After all, do your virtual guests really need virtual ale? No, but it does lend a more immersive feel to an in-game function. It enriches the experience. Similarly, we have seen players spend considerable time creating color-coordinated outfits (down to the shoes) so that they have appropriate attire to attend in-game weddings. If players can come up with these ideas, shouldn't we? Any emergent behavior in the world indicates a need within the game that is not being met (almost always among the socializers who are ill-served by most MMP games).

Define New Behavioral Norms and Etiquette

Once you have built a world, you can decide what social norms and etiquette will be observed in that world. The most common dictate currently enforced is that of naming conventions. Designers and programmers have tried all kinds of way to keep players from giving themselves offensive, bigoted, or obscene character names. At first, it was a simple checklist of obscenities. Unfortunately, it became a game for players to

'outsmart' the system and devise unique spellings or word play to get around the rules. Hence, more rules were put in place.

While this example refers to a game rule that, in turn, refers to social norms, the general idea is sound. Other examples include such things as not filling (or spamming) the common channel(s) with repeated requests or demands. Seeing "SEEKING SWORD OF GREATNESS. MSG L33THAX0R WITH REPLIES" scrolling 20 times up the screen is quite annoying and is frowned upon. While some systems allow player User Interface (UI) personalization to exclude these sorts of messages, it is still problematic.

Again, providing rewards to players who enact acceptable social behavior adds incentive. Tracking players who help to encourage players to conform to or actually enforce social norms established in the culture of a given world provides us with a method to reward said players. How can we track such things? How do we want to reward them? A thorny question, to be sure, but a very pertinent one.

Rites of Passage

Dark Age of Camelot has an interesting notion that *The Sims Online* Executive Producer Gordon Walton coined as a *rite of passage* [GDC02]. While a player must choose a broad category of character class, the player does not have to choose a specialization area until the character has reached level five. Similarly, once a character reaches level 10, they may choose a last name for their character. This is a simple, clear, and visible sign of the character's accomplishment; you can tell by looking at the character that they have achieved at least the tenth level. It is a sign of status that is readily identifiable by all other players. While the selection of a specialization area is a simplistic rite of passage that may or may not be outwardly visible, the acquisition of a last name is a rite of passage that is easily recognized by all. By designing in similar rites of passage—those milestones that a player is consciously involved in achieving— the involvement of the player in the world is increased, as is their equity in the character and the society at large.

New Economies

In most existing games (and most of those on the horizon), economies revolve around wealth. Wealth may be comprised of currency, loot, and trade. Currency is the obvious economic basis; currencies in these economies have, however, traditionally been extremely difficult to maintain and balance. In many popular MMP games, currency has suffered hyperinflation comparable to a wheelbarrow filled with pre-WWII Deutsche marks buying a mere loaf of bread. We all know how to get loot, right? Go kill monsters, fulfill quests, or find a benefactor. Trade-skill systems allow players to create goods and barter with other players.

These are three well-established economic systems. What else can be used as currency? Economists refer to many different types of commodities. Commodities are, essentially, units of utility. A dollar bill is an extremely common commodity. Time can be one. Space qualifies. Any commodity, be it physical or conceptual, can be used as the basis for an economy. Referring back to reputation systems, a player's reputation can become a powerful commodity. Let us continue to look for new commodities to help drive multiple economies in-game.

Mentoring

One way to reward social play could be to institute an apprentice/mentor system. Let's note that while *DAoC*, for instance, has an 'apprentice' system, it is administrated by NPCs in the world, rather than actual people. Apprenticing could serve as a part of socializing new players by providing guidance from more-experienced players. The apprenticeship process could have certain rites of passage built into it as well.

Socializing

By examining people's play styles, we find that Bartle's definitions of player motivations can be further broken down when it comes to socializers. There are many different kinds of socializers. At the simplest level, socializers use the communication tools in the virtual world. They talk. They hang out in public places and interact with passersby. They can be found in pubs and bardic circles, sharing stories.

There are, however, players who socialize in nontraditional ways. The *AC* caterers referred to above invented a way of interacting with other players by providing a service. Other players assist people in trouble, donate items and currency to players in need, or explain world particulars that other players are unacquainted with. These players often put communicating above the active pursuit of experience as rewarded by the world in question.

The challenge to developers then becomes a question of acknowledging players who are primarily motivated by social matters. After all, these people tie our communities together. They actively tout systems in the game for other players to learn about. They convince other people to come and join the world you have created. We need to consider ways to reward our social players for making our worlds richer, stronger, and more interesting places than they were at launch.

Conclusion

Strong social systems empower players to enact increased socialized play. It is apparent from experience that your players will use all supportive game systems. Thus, by providing players with a trade system, some will fervently pursue becoming masters of their trade (and will collect the wealth that comes from it). If you put fishing in your

game, people will fish in your world. Any game system you place into an MMP will find its way into the hearts of some players. By providing strong game systems that support the social guidelines and culture in your world, players find themselves acting more social. By empowering players to drive social change in the world, they will do it. If you build it, they will come; it is that simple.

As players actively engage in these social activities, we need to recognize, reward, and acknowledge their efforts. Social systems that result in constructive emergent behavior will promote creativity in your world; players who establish positive, inventive play styles should be rewarded. What kind of message do we send by recognizing only their efforts at killing monsters and other players? It seems clear that rewarding these behaviors encourages these behaviors. We want to ensure that positive behaviors grow in popularity. They make our worlds better places to visit and play in.

Finally, we all strive to create great games. Great games provide rich, deep experiences. The power of large communities to interact and to grow, to learn from one another, and to invent new ways of using our tools all help make our worlds more interesting. These connections between people are essential to support any other kinds of sticky systems that are designed to keep players coming back. Shared experiences are compelling experiences. Any methods we provide to help our world members share their experiences brings the world together.

References

[Bartle90] Bartle, R. A., "Hearts, Clubs, Diamonds, Spades: Players Who Suit MUDs," *Comms Plus!*, October/November 1990, available online at *http://www.mud.co.uk/richard/hcds.htm*.

[Koster02] Koster, Raph, Patricia Pizer, Gordon Walton, et al., "Are Massively-Multiplayer Games Blazing a New Trail for Humanity?" Game Developers Conference, 2002.

[Gladwell] Gladwell, Malcolm, *The Tipping Point*, Little, Brown and Company, 2000.

[Maslow68] Maslow, Abraham H., *Toward a Psychology of Being*, D. Van Nostrand Company, 1968.

[Milgram67] Milgram, Stanley, "The Small World Problem," *Psychology Today*, 1967.

[OED89] *Oxford English Dictionary*, *Second Edition*, Oxford University Press, 1989.

[Reynolds99] Reynolds, Patrick, *The Oracle of Bacon at Virginia*, available online at *http://www.cs.virginia.edu/oracle/*.

6.4

DESIGNING A FLEXIBLE GUILD CREATION AND MANAGEMENT COMMAND SET

John M. Olsen, Microsoft Corporation

infix@xmission.com

Player organizations (simply referred to as guilds in this article) play a huge part in many of the Massively Multiplayer (MMP) games that exist today. The social aspects of the game are often a major driving force that brings in new players who desire to play with other people. Giving the players a way to organize themselves into guilds enhances the social aspects of the game. Designing a new MMP game without guilds would mean having to field a flood of complaints from users who have become used to guilds and other long-term organizations in other games.

The purpose of this article is to go through a top-down design process that can be used to help you discover the features your users will need and to create a framework on which new features can be added later with little risk to the stability of the game. A significant portion of this article is devoted to communication due to its importance in building a feeling of community among your players.

The guild command set described here will be entirely text-based, since nearly all MMP games are played with a keyboard available. A small leap in design will take you to menu trees that are console-friendly or mouse-enabled by replacing each of the key words with a menu selection and by choosing players from lists rather than by name.

To organize all the guild commands, they will be preceded with the word "guild" for parsing purposes. The scope of this article does not include the command parser itself, due to space limitations.

Within this article, the following format will be used to describe the text commands: commands should be case-insensitive to avoid frustrating your players. An exception is made for parameters that are used as newly assigned names, where the case will be used as supplied by the player. (An example of preserving case would be when specifying the name of a guild.) Required parameters will be shown between less-than and greater-than brackets (<>). Optional parameters will be specified within square brackets ([]). Where a parameter can be repeated, it will have a "+" appended.

```
[Optional parameter]
<Required parameter>
[Parameter repeated zero or more times]+
<Parameter repeated one or more times>+
```

Creation

The first thing your players will need is the ability to create a guild. All that is required to form a guild is an initial membership list and a guild name. We will assume that the player issuing the command wants to also be in the guild, even if they do not specify their own name.

```
guild create <guild name> [user name]+
```

When entered by a player, it would look like this:

```
guild create "Hamster Crew" Bill Bob Fred
```

A guild could be created with just the person issuing the command, but having a requirement for a minimum number of initial members is useful for filtering out troublemakers. An additional consideration is that of requiring the guild to begin under a temporary name and adding the request to a queue that will be processed by game staff, rather than creating the guild on the spot. Your staff would then approve the guild name before it was displayed in-game. This will considerably reduce prank guild creation.

Also, players change over time, and what was once a fully appropriate name may not apply any longer. It could also be that your staff has rejected a guild name, and the player forming the guild needs to choose a better name. Giving certain members of a guild the ability to change the guild name is a much simpler option than that of creating a new guild and managing the migration of the members. The next section will discuss methods to keep this rename command from being a hotbed of abuse by disgruntled guild members.

```
guild rename <new guild name>
```

The same name-approval mechanism should be used for the guild-rename command, keeping players from displaying an inappropriate guild name. Since players only belong to one guild at a time, and only an authorized member can rename the guild, the source guild name is not required. On the other hand, an administrator version of this command would require both the old and new guild names.

Leadership

Now that you have a way to create a guild, you need a way to determine who is a guild leader. By default you can make the one forming the guild the Guild Master, and all others become general members. For convenience in sorting and specifying how the

ranks fit in with each other, a numeric value can be used where the Guild Master is zero and the Member is 100.

For many, this two-rank system is not expressive enough, so there needs to be a way to create ranks within the guild. This requires not only a name for the new rank, but a way to specify how it fits into the other ranks. Some other maintenance functions are also necessary for ranks, so the list expands to include the ability to assign a rank to a particular player, to be used for promotions or demotions. The rank delete command will not work when applied to the Guild Master rank, since a guild really needs to have that rank and a person in it at all times.

```
guild rank new <rank name> <rank number>
guild rank delete <rank name>
guild rank list [guild name]
guild rank rename <old rank name> <new rank name >
guild rank assign <player> <rank name>
```

Once you have your guild created and the ranks defined and named, you should assign some duties and abilities to those ranks. The Guild Master rank (or whatever it is renamed to) will contain all permissions and abilities. Many things can fit into this category of duties, depending on your game design. To maintain our syntax, this will be a guild command relating to rank, and will adjust the duties for the rank, so it would be specified like this:

```
guild rank duties add <duty> <name of rank>
guild rank duties remove <duty> <name of rank>
```

A typical list of duties and abilities would likely include being able to invite new members, remove old members, and to control whether that rank is allowed to display their guild affiliation (ShowTag) and guild rank (ShowRank). The last item is useful if you build a probationary rank prior to becoming a full guild member. The new member would be able to take part in things like guild chat channels, but would need to be promoted to a new rank to become a full member.

The following duties are used in the commands shown above. Some are attributes for a rank, and some are commands that can be issued by someone who has been assigned a rank that allows that command. The duties that have not been described yet will be covered in later sections.

```
Area
Bank
CreateChat
Crest
Invite
EditRank
HideRank
HideTag
```

```
Merge
Motd
Remove
Rename
ShowRank
ShowTag
SeeMembers
```

Identification

Sometimes it is good to have more than just a name associated with a guild. The concept of heraldry and family crests has been around for centuries, and can make a wonderful addition to the feel of the game. Some games have already begun incorporating a heraldic guild symbol feature, such as *Dark Age of Camelot*. A simple heraldic symbol can be created by starting with a background, or *ordinary*, as shown in Figure 6.4.1, consisting of two different colors or patterns.

FIGURE 6.4.1 *Examples of historically used ordinaries.*

On top of this is placed a foreground symbol, called a *charge*, as shown in Figure 6.4.2. There are many ordinaries and charges that could be added while still keeping a fairly authentic feel.

In typical European heraldry, you are limited to a rather short list of colors. These are argent (silver or white), or (gold or yellow), sable (black), gules (red), azure (blue), vert (green), purpure (purple), tenne (tawny orange), and sanguine (reddish purple). Some additional furs can be added, including ermine, vair, and potent, which are actually patterns combining argent and another color, rather than being pure colors. This is a good starting point for the list of colors you offer for use on the ordinary chosen by the player.

FIGURE 6.4.2 *Examples of possible foreground symbols, or charges.*

To avoid problems with replicating actual national flags or potentially racist symbolism, you should consider using purely imaginary charges derived from your game, and check the possible combinations carefully to filter out any combinations that may be objectionable.

Once you have decided on the possible options for a crest, you need a command to assign one to a guild. Since the player is likely to want to experiment first, we will include a preview mode that should be available to all users.

```
guild crest preview <ordinary> <color1> <color2> <symbol>
guild crest create <ordinary> <color1> <color2> <symbol>
guild crest remove
```

As you can see in Figure 6.4.3, the combinations can work out to be fairly interesting and easily distinguishable.

One nice thing about a component-based system such as this is the large number of possible combinations. Once you combine an ordinary, two choices of color, and a charge, you are well into the thousands of combinations, even with the short set of components and colors listed here. Should that range prove to be too small for you,

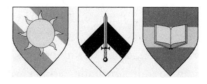

FIGURE 6.4.3 *Some sample crests using components from Figures 6.4.1 and 6.4.2.*

there are many more things that can be done. The edges of the ordinaries can have patterns applied to them (zigzag lines, scallops, crenellations, etc.), more colors can be added, and many more ordinaries, and charges can be added. There are also historically proper options for combining multiple charges or entire crests onto a single combined crest. A simple Web search for the term "heraldry" will give you plenty of information on how to extend this simple example.

Guild Maintenance

Guilds need members. This means your players need a way to add new people to the guild. It is also an unfortunate necessity that your players will need a way to remove unwanted members, and players will need a way to remove themselves from a guild. The remove command with no parameters is meant to remove just the player issuing the command. The other commands, adding and removing other players, are to be used by Guild Leaders who have been granted that duty. Players with the ability to invite others should get a pop-up warning of some sort before deleting themselves from the guild roster.

```
guild invite <player>+
guild remove [player]*
```

When a player receives an invitation to join a guild, they should not automatically become a member. First, they need to not be associated with another guild; and second, they need to explicitly join the guild. If they only have one outstanding guild invitation, the name of the guild is optional.

```
guild join [guild name]
```

Once they become a member, they should be automatically assigned to the lowest available rank. An alternate way of doing the same thing is to present the player with a dialog asking them if they want to join, rather than making them type in the join command. You want to make it as easy as possible for your players to keep them from thinking the command set is cumbersome to use.

Players often want to see the membership roster in the guild and which of their guild members are currently online. Both of the commands shown below are enabled for all players, so the default settings for the initial ranks will allow both of these commands. Listing the members of guilds, other than the player's own, can be done by specifying the optional guild name. The behavior of these commands can be altered with the rank setting for SeeMembers, which can limit who sees the guild membership list. The nonguild population should use the SeeMembers setting for the lowest guild rank, making it a simple matter to hide guild membership from those outside the guild.

```
guild members [guild name]
guild online [guild name]
```

At times, two guilds will discover that they have many mutual interests and will want to join into one combined guild. When a `guild merge` command is issued, it must be accepted by all of the highest-rank officers of the guilds being merged. In case something bad happens, the merge can be cancelled. Merging guilds should be a fairly uncommon event, but having it as an option will greatly simplify life for the players when it is needed.

```
guild merge create <new guild name> <guild name>+
guild merge accept
guild merge cancel
```

This command will preserve the crest and rankings of the guild issuing the merge command. Due to the likelihood of having radically different ranking systems between guilds, it is up to the leaders of the guild issuing the merge command to promote players into the new guild rankings as appropriate.

Property

Guilds are great for communicating with other players who have common interests, but they can do so much more than just aid in communication. Take the ownership of in-game assets, for instance. In games where there is no concept of guild-owned property, guild equipment sharing requires a series of questionable tactics, such as mule characters and password sharing, which often violate the game's End-User Licensing Agreement (EULA).

The fact that players often resort to such tactics is a great indicator that a problem needs to be addressed. A first step toward addressing the problem is to allow for a guild bank where coin and items can be stored. This does not necessarily need to be an actual location; here is a set of commands that can be used to transfer funds and items into and out of this virtual guild account:

```
guild bank donate <quantity> <item>
guild bank disburse <player> <quantity> <item>
```

This gives us the ability to give money or items to the guild bank account, and the ability to withdraw from the guild bank and give it to a player. One important feature players will want is the ability to see what has been happening to the guild funds, so a report command is needed that will display all recent transactions. If there is an easy way to track the transfer of items and funds, there is less likelihood of abuse. It is up to the players, however, to only give the ability to disburse guild items to trust-

worthy players. The donate command is open to all members, while all the remaining bank commands are restricted, based on rank settings.

```
guild bank report
```

Now that there is a place to store funds, how do you gather funds? Players will likely not remember to always contribute to the bank in a fair and regular manner, so some guilds may wish to implement fees for joining and monthly membership fees.

```
guild bank fee join <coin count>
guild bank fee membership <coin count>
```

Players can be automatically reminded by the system when their membership fees are due each month, but the guild leadership needs a way to see a list of where each member stands on their membership dues. This command would display all guild members and their current standing on dues.

```
guild bank fee report
```

Private Areas

Should your game design allow for guild halls, you can add the ability to restrict access to certain areas based on guild membership or rank. As an example, a guild may claim a guild hall within a city, and then allow only members into the hall. The hall may have a council room that could be further restricted to only allow members of certain ranks to enter.

```
guild area add <rank>
guild area remove <rank>
guild area list
```

To use these commands, the player would need to go to a particular area owned by that guild. Once at the proper location, the commands issued would apply to that area. The list command describes the properties of the current area, including which ranks are allowed to be there.

Communication

One of the main reasons for the existence of guilds is so friends can communicate with each other more easily. A long format that fits into our existing scheme would be to have a guild command to enable saying something to the guild, like this:

guild say <message>

This is, of course, cumbersome and contrary to the idea of quick and easy communication, so you should consider abbreviating this command, as has been done in nearly every MMP game that has such an option. Whatever you do to make this com-

mand easier, work it into the game in a way that makes it behave sensibly when combined with other long-term and short-term chat channels, such as for the current group of your player, any friends lists, or chat with people occupying the same geographic area.

Another item to consider for guilds is the idea of 'raids' or other large-scale events where many players gather to do something together. Quite often, some of the participants will not be guild members, and not all guild members will be at the event. This makes it cumbersome to use the normal guild channel for communication, so the creation of new chat channels becomes critical for wide-scale communication. This command is not part of the actual guild commands, but it is included here because it is very useful to guild communication and sets some groundwork for additional guild commands.

To create a channel, you need only a name and password. Optionally, you could limit the list to particular guilds.

```
chat create <chat list name> [password]
chat restrict <chat list name> <guild name>+
chat delete <chat list name>
```

Players would then join or leave lists as they desire. Membership in a list should persist as long as the list exists, even while not connected. The join and leave commands can be used by a player to control their own membership, and an invite command can bring others into the list.

```
chat join <chat list name> [password]
chat leave <chat list name>
chat invite <chat list name> <player>+
```

Depending on your design, it may be best to leave it to the player to join a list rather than to allow massive invites in order to avoid grief tactics where one player continually bombards others with join commands.

There is an issue of ownership involved with chat channels. Each channel is owned by the person who created it, but you need to handle the case of that person leaving the game. As a default, you can simply assign ownership to whomever has been in the channel the longest whenever no owner is present. This may not be the desired behavior, so a command to assign ownership comes in handy. There is no reason a list can not have multiple owners, so the command set turns into this:

```
chat owner add <chat list name> <player>+
chat owner remove <chat list name> <player>+
```

There is also the issue of removing troublesome members. This would be done by the chat owners. Any owner can remove anyone, including another owner. A more

forceful measure can be taken to keep people from rejoining the chat channel by banning them.

```
chat remove <player>+
chat ban <player>+
```

These chat channels typically need to be removed from the system when the last member of the channel leaves the game. This could be overridden by the owner to make a chat channel persist for longer periods of time (a day, for instance) without anyone being connected to it.

```
chat persist <chat list name>
```

Another thing players will want to do is to see the settings on the chat groups they are in. When a parameter is used to specify a particular list, it should describe just that one list. The command with no parameter should describe all lists of which the player is already a member. This information should include a list of members and owners, and whether they are currently connected.

```
chat list [chat list name]*
```

Now that players have chat lists running, they may want to open them up for public use or restrict them to be private. This can be done by adding three more chat commands. The first two change the status of a chat channel, and the third lists all public chat channels. This could potentially be a very long list, so you may want to allow wild card searches. The fourth command is to describe the purpose of the chat channel, which would be shown when someone issues the `chat lists` command.

```
chat public <chat list name>
chat private <chat list name>
chat lists [search pattern]
chat describe <chat list name> <description>
```

With the huge number of possible channels a player can belong to, one more command can be invaluable in controlling the amount of text received. The player should be able to mute a channel without leaving it, making it easy to rejoin without having to go through passwords and ownership changes. The need for this command could be reduced or eliminated by allowing the player to redirect channels to particular windows, as has been done in *EverQuest*.

```
chat mute <chat list name>
chat unmute <chat list name>
```

Now that the groundwork has been laid for nonguild chat groups, it can be incorporated into the guild layout. It may be that guild officers will want a permanent chat group of their own, for instance. These chat groups should remain active full time,

even if no players are currently connected to the game to use that channel. Rather than assigning membership and ownership based on player names, membership can easily be done based on rank, so there is no need for the commands used to join and leave chat channels.

```
guild chat create <chat list name> <rank>+
guild chat delete <chat list name>
guild chat owner add <chat list name> <rank>
guild chat owner delete <chat list name> <rank>
guild chat list [chat list name]*
guild chat mute <chat list name>
guild chat unmute <chat list name>
```

Your user interface will need to have some capabilities built in to make it easy to say things to a particular chat list and to monitor messages from each of the lists a player has joined. This is a key point that you should spend a great deal of time on to make sure it is very easy for your players to configure and use.

The initial guild say command described in this section would use a default guild chat channel that is automatically created for each guild, and it would contain all guild members. Guild lists need no owner and cannot be modified, since membership is based on guild rank.

One last item on guild communication is the ability to have a message area where guild leaders can post a message that is shown to all members. This is based on the UNIX motd command, which stands for 'message of the day.' This is a message that is shown to users each time they log in to the system. This message should persist through any downtime of the game servers.

```
guild motd [message]
```

If no message is specified, or if the user does not have permission to alter the message, the current message should be displayed.

Conclusion

The guild command set shown in this article is not final by any means, but it outlines a progression that can be used to first identify a need and then build a command set that fills that need for the players while still fitting into the existing scheme of commands. It is flexible enough to meet the needs of most of your user base with their differing play styles and desires for structure, or lack thereof.

When you come upon new commands that would be useful or get requests from your user base, the groundwork is already there to insert the new functionality. One of your primary goals with guild commands should be to give the players all of the tools they need to organize and manage themselves, thus reducing the need for cus-

tomer support. Whenever the players can handle an issue on their own, your costs go down.

A flexible and extensible guild command set gives your users the power to organize and communicate more easily with each other. Communication is one of the main reasons people play any MMP game, so you should do whatever you can to encourage it. This ease of communication will translate into happier players, which will in turn lead to a more stable player base and fewer lost customers over time. Keeping customers and making them happy will go a long way toward making your game a success in what is quickly becoming a crowded market place.

6.5

BUILDING A REPUTATION SYSTEM: HATRED, FORGIVENESS, AND SURRENDER IN *NEVERWINTER NIGHTS*

Mark Brockington, BioWare Corp.

markb@bioware.com

The designers and programmers for *Neverwinter Nights* (*NWN*), a multiplayer *Dungeons and Dragons* type role-playing game for IBM PC-compatible machines, had grandiose goals when it came to the AI engine. When we first hypothesized how NPCs would react to other creatures, we tried to come up with a small, easy-to-understand system that we could implement early on in the project and never have to revisit.

In this article, we will discuss the evolution of our reputation system into the subsystem that throbs deep inside the bowels of *NWN* today. The article will cover four topics in the chronological order that they were addressed: friendship and hatred, forgiveness, surrender, and player-versus-player settings.

An Implementation of Friendship and Hatred

Back in 1999, we had our first discussions on the reputation system. The designers said "We want a reputation system to tell the NPCs which creatures we like and which creatures we hate." This did not seem like a particularly difficult task.

At the time, *Ultima Online* had dramatically revamped its original reputation system to include karma, fame, criminals, and murderers [Grond98]. Nearly all of BioWare was playing *EverQuest* obsessively, and we saw how reputation changes were marked in the game each time you killed a creature. For example, you gained in-faction standing with town guards by killing marauders, but the marauders did not enjoy being butchered by the PCs. Eventually, they learned that you were a menace to their tribe, and they would become aggressive and attack you on sight. The marauders could be quite docile toward those PCs who had not decided to wage war on them. In fact, if your PC assisted the marauder's friends by completing quests or killing their enemies, they might turn out to be very friendly toward you and give you further quests.

For our purposes, it was difficult to see how the *EverQuest* system was actually implemented. Your chat window included statements such as "Your faction standing with Marauders got worse," but it did not tell you by how much. The lack of information did not stop us from attempting to duplicate the system and adapt it to our own needs.

As in *EverQuest*, we required that each of the NPCs in the world belong to a faction. This would allow us to describe how members of each faction would respond to one another. For example, how does the 'monster' faction respond to the 'guard' faction? One would expect both of them to attack each other on sight. A 'commoner' might help a fellow commoner against injustice and tyranny if they were in a fight for their lives. What if a monster was attacking a 'bandit?' One might expect that another bandit may not care that someone in his faction was being attacked, and the bystander bandit may view the entire contest with neutrality until something attacked him.

This yielded a range of possible reactions spanning from friendship to neutrality to hatred. We placed the range of reactions on a scale from 100 (a true friend) to zero (a hated enemy). In *NWN*, the designers decided that 90 and above would be a friendly reaction, while 10 or below would represent hatred.

When all possible faction-to-faction reactions are considered, this yields a reputation table similar to the one given in Table 6.5.1. The source group is specified by the rows, and the target faction is specified by the columns. The first thing to note is that the table is not necessarily symmetric. The Monster faction hates everyone except for other Monsters, but the Bandit faction views Monsters with neutrality. Another important note is that members of a faction need not necessarily love other members of their own faction. For example, a Bandit is neutral to other Bandits.

EverQuest allowed the base reactions to evolve over time, so we thought we should do the same. Overt hostile events, such as killing friends of a faction, would decrease the player's standing on the scale. Other events, such as donating money to a church or finishing a quest, could help to improve your faction standing within certain groups. Our original design specification contained three different hostile actions (attacking, killing, and stealing). How these hostile events automatically modified faction reputations was stored in a database table called "HostileEvents," which the designers could tweak without programmer intervention.

Table 6.5.1 A Sample Global Reputation Table

	Monster	Bandit	Guard	Commoner
Monster	100	0	0	0
Bandit	50	50	0	0
Guard	0	0	100	100
Commoner	0	0	100	80

Once we had this system in place, we envisioned how quickly a thief would fall into ill repute within the society. The designers did not want a person who committed a murder in the middle of a busy street to be treated the same as someone who committed a murder in a dark alleyway where no one was watching. At the core of the issue was whether there was anyone else to witness the action.

We introduced additional columns into the HostileEvents database table, which represented different adjustments based on whether the event was witnessed by other creatures. Depending on whether the witness was a friend, neutral, or hostile to the victim, it affected the standing adjustment for both the victim's faction and the witness' faction. A sample of this table is given in Table 6.5.2.

For an extended example, let us say that a Bandit kills a Monster in plain view of a Guard. The Monster faction is the victim, and the Guard faction is the witness. The Monster and Guard have no love for one another, so we examine the entries under Kill/Hostile Victim and Kill/Hostile Witness in Table 6.5.2. According to the table, the Monster faction standing with respect to Bandits should go down by five points. The Guard faction standing with respect to the Bandits is not modified at all, because the Guards already hate the Monsters and view what the Bandit did as a good thing. If the Guard actually liked Monsters, we would instead use the Kill/Friendly Victim and Kill/Friendly Witness entries. The Monster faction's standing versus Bandits would go down by 45 points, and the Guard faction's standing versus Bandits would go down by 25 points, as we assume that the Guard witness will tell all of his friends (as well as all of his Monster friends) about the dastardly deed perpetrated by the Bandit. Furthermore, the dramatic increase in the adjustment may also lead to the Guard jumping into the fight and attacking the Bandit.

Note that these reputation adjustments were instantaneous. This allowed witnesses to become immediately hostile. We did not assume a proper witness-to-witness communication model based on event knowledge [Alt2002]. A plan was made at one point to introduce a delay of the additional reputation adjustment due to the presence of a victim's friend witnessing the event. The delay could simulate the communication delay in the spread of information to other members of the faction and also allow a thief character to silence all witnesses to a hostile event. However, it caused numerous issues and was removed.

Table 6.5.2 A Sample Hostile Events Table

Witness Faction	None	Friendly Victim	Friendly Witness	Neutral Victim	Neutral Witness	Hostile Victim	Hostile Witness
Attack	-2	-12	-6	-4	-2	-2	0
Kill	-5	-45	-25	-15	-5	-5	0
Steal	-1	-5	-3	-2	0	-1	0

It is also important to notice that in Table 6.5.2, there is no way for you to automatically improve your relations to a hostile witness via hostile actions. If you wanted to implement the maxim "the enemy of my enemy is my friend," you could place a positive number in the Kill Hostile Witness entry.

Player Character Reputations

We have described how NPCs react to one another, but we still have not introduced PCs into the equation. Unlike the system described above, NPC reactions to PCs can vary dramatically. The PCs have free will and can do many things to change how groups react to them. Guards may like PCs at the start of an adventure. If a single PC starts killing Guards, one would expect that this information would be spread among the remaining Guards, and they would eventually decide to exterminate the PC in question. Under no circumstance should a single player who is killing Guards affect all PCs' reputation standings with the Guards. Allowing this would make it possible for an errant player to ruin another player's game experience.

To introduce PCs into the system, we added a single column to the table to indicate how each faction views PCs when the PC has no previous reputation in the world. Table 6.5.3 shows a revised global reputation table with PCs included. Note that if we had to redo this system today, we probably would have included columns for all of the playable PC races instead of just one column for all PCs. This would allow the designer to implement inter-racial relationships, such as an animosity between elven PCs and dwarven NPCs.

When a PC joins a game, they have a copy of the column placed on the PCFactionTable array inside their character record. As the PC reacts to and interacts with the various factions within the game, the table changes to indicate how the NPCs view that PC.

How does a PC view other NPCs or PCs? In general, players do not like to be told how their PC is supposed to react to someone. However, for informational purposes, some people do like to know who their friends are and who currently hates them. Thus, whenever a PC tries to determine whether they like a given NPC, we reverse the question and ask whether the NPC likes the PC. Clearly, this does not

Table 6.5.3 Example of Complete Global Reputation Table in *Neverwinter Nights*

	PC	Monster	Bandit	Guard	Commoner
Monster	0	100	0	0	0
Bandit	0	50	50	0	0
Guard	95	0	0	100	100
Commoner	75	0	0	100	80

work when two PCs are involved, and we are going to avoid this question until we discuss player-versus-player settings by saying that all PCs view other PCs neutrally.

In the code below, the Object::GetReputation() function returns how a given object views another object (represented by oTarget).

```
// GlobalReputationTable stores Table 3.
int GlobalReputationTable[NUM_FACTIONS][NUM_FACTIONS];

int Object::GetReputation(object oTarget)
{
    if (GetIsPC() == TRUE)
    {
        if (oTarget->GetIsPC() == TRUE)
        {
            // All PCs are neutral to all other PCs.
            return AI_REPUTATION_NEUTRAL;
        }
        else
        {
            // How a PC feels about an NPC is
            // the same as how the NPC feels
            // about the PC.
            return oTarget->GetReputation(self);
        }
    }
    else
    {
        if (oTarget->GetIsPC() == TRUE)
        {
            return oTarget->PCFactionTable[self->faction];
        }
        else
        {
            return GlobalReputationTable[self->faction][o->faction];
        }
    }
}
```

Forgiveness

The designers realized quickly that this system was fraught with danger. If you place multiple creatures in the Guard faction, adjusting the faction reputation for one Guard to attack you will make all of them attack the PC. What they wanted was the ability to only have one Guard come after the player, but a very small (but permanent) effect for all Guards against that one PC. Eventually, the hostile guard would forget what happened and go back to the regular (slightly lowered) faction standing.

This brought up the idea of *personal reputations*. In *NWN*, the game engine would store a reputation adjustment on the guard that was attacked about the PC that attacked it. Figure 6.5.1 shows a graph with a typical reaction to a guard being attacked in *NWN*. The dashed line represents how guards viewed the PC before the attack.

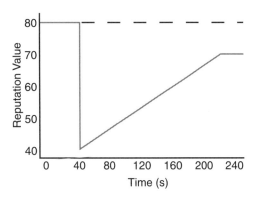

FIGURE 6.5.1 *How a personal reputation adjustment affects reputation over time.*

When we first implemented the system, we insisted that the personal reputation adjustments would eventually have to decay and disappear (they could not have an infinite time frame). This was necessary because we were worried about the resource usage associated with storing thousands of object-to-object interactions inside the save game and the game engine. In *NWN*, these personal reputation hits decayed and deleted themselves within 180 seconds.

Note that there is a small permanent drop in the guard's standing with the PC who attacked a guard. This prevents a PC from killing a guard, running away, waiting for three minutes, and then *ad nauseum* blowing up all of the guards in the game. To the end user, this can be explained, as many 'accidental' attacks on a faction add up to a clear pattern of hatred, and the guards will then attempt to execute the PC on sight.

The personal reputation system sits over the pseudo-code set out in the previous section and adjusts the values passed out of the GetReputation() call. The GetFinal-Reputation() function is found below.

```
float DECAY_TIME = 180.0f;

int Object::EvaluatePersonalReputation(object oTarget)
{
    int nPersonalReputation = 0;
    CPersonalReputationEntry *pEntry;
    PEntry = FirstPersonalReputationEntry(oTarget);
    while (pEntry != NULL)
    {
        int nTimeRemaining = nTimeExpiry - GetCurrentTime();
        if (nTimeRemaining > 0)
        {
            float fRemainRatio = nTimeRemaining / DECAY_TIME;
            nPersonalReputation += pEntry->Adjust * fRemainRatio;
        }
        pEntry = NextPersonalReputationEntry(oTarget);
```

```
        }
    }

    int Object::GetFinalReputation(object oTarget)
    {
        int nReputation = GetReputation(oTarget);
        if (HasPersonalReputation(oTarget) == TRUE)
        {
            nReputation += EvaluatePersonalReputation(oTarget);
        }
        return nReputation;
    }
```

When we finally got our first chapter of *NWN* up and running in the game engine, many people started playing it. Within 15 minutes, someone decided to emulate a grief player and started slaughtering people with a battle axe. Eventually, he was hunted down and killed by guards. However, when the PC finally got resurrected, he discovered an angry mob of NPCs waiting for him in the temple because he had upset their factions in his bloodlust rampage. The player was butchered mercilessly about five times by the commoners before the tester finally came down to the designer's office and commented, "I think there's a problem with the reputation system."

The designers wanted a system in which one could reset the factions for the PC after the PC perished. This allowed for the ultimate level of forgiveness from the game mechanics. Fortunately, this was a simple task, since the game mechanics did not allow the PC column in the global reputation table to be modified. When the PC died, the scripting command reset its reputation table to the PC column in the global reputation table and removed all currently active personal reputation values from the people who were nearby when the PC died.

The PC column in the global reputation table was not allowed to change, but all other columns were allowed to change. This led to problems. Our QA staff watched with horror as pleasant deer decided to go into a homicidal rampage against all monsters in the game. It seemed that the reputation adjustments of one orc who had killed a deer in a completely different area was enough to put the deer in attack mode, attacking all hostile faction members in the game. A bug in the encounter system that allowed NPCs to trigger encounters meant that deer would continually spawn in, rush headlong at the group of orcs, and get slaughtered by the axe-wielding orcs. Depending on how the encounter was set up, it may have an infinite number of deer in it, and eventually the deer would win through attrition. This makes for an interesting AI life scenario, but it spoiled the designer's plans for an epic orc battle against the PCs. The PC entered the area to find the ground littered with deer corpses and orc body bags.

For most factions, the designers did not want the NPC-to-NPC global reputations to change automatically. Our solution was to flag each faction as "global" or

"nonglobal." If the faction was global in scope, changes to that row in the global reputation table could be made. If the faction was not global, only the personal reputations for the instances of the creatures from that faction took place. This allowed the attacked deer and the deer that witnessed the attack to retaliate against the orc, but it prevented the other deer in the module from turning into raving lunatics.

Surrender

Surrender is a common plot device in role-playing games where one is supposed to hear the enemy's information before they are freed or killed by the player. To implement surrender, we must counteract the automatic personal reputation adjustments that have accrued during the previous moments of the battle. At first, some ad-hoc adjustments via the scripting language seemed successful. Subplots were rewritten to implement surrender in many places.

As we approached release, QA reported most of the surrender plots as broken. The first problem was that a surrendering hostile creature would go back to being hostile after 180 seconds, after the personal reputation adjustment had decayed. The second problem was that the designers could not know how many personal reputation adjustments they needed to apply to guarantee momentary friendship. Ultimately, surrender was very difficult to implement without additional programmer assistance in the reputation system.

The programmers started by providing scripting functions to clear out all personal reputation adjustments, but the system still was not working. The personal reputation adjustments that they applied would take too long to decay or would last for too long when the PC decided that the person had to die anyway; so the surrendering NPC would sit there and take it on the chin. The solution was to provide the functionality for nondecaying permanent personal reputation adjustments inside the game engine via `SetIsTemporaryFriend/Enemy()`, two scripting commands. A new version of `EvaluatePersonalReputation()` that implements nondecaying reputation entries is given below.

```
float DECAY_TIME = 180.0f;

int Object::EvaluatePersonalReputation(object oTarget)
{
    int nPersonalReputation = 0;
    CPersonalReputationEntry *pEntry;
    pEntry = FirstPersonalReputationEntry(oTarget);
    while (pEntry != NULL)
    {
        if (pEntry->Decays() == FALSE)
        {
            nPersonalReputation += pEntry->Adjust;
        }
        else
```

```
        {
            int nTimeRemaining = nTimeExpiry - GetCurrentTime();
            if (nTimeRemaining > 0)
            {
                float fRemainRatio = nTimeRemaining / DECAY_TIME;
                nPersonalReputation += pEntry->Adjust * fRemainRatio;
            }
        }
    }
    pEntry = NextPersonalReputationEntry(oTarget);
}
    }
}
```

Player versus Player Settings

One of the major components of *Dungeons & Dragons* is to have henchmen, summoned creatures, or familiars to assist in your fights. For the purposes of our reputation system, henchmen and summoned creatures always use their master's reputation, and a master and henchmen are always friends while they are allied together.

There are three types of areas in *Neverwinter Nights*: no player versus player, party-based player versus player, and full player versus player. Hostile actions (such as attacking with swords, casting hostile spells, and pick-pocketing) are forbidden between all PCs and their party members when in a no player-versus-player area. Hostile actions are allowed in the party-based player-versus-player area if the players are not part of the same party. In full player versus player, even members of your own party (such as your henchmen or other PCs) could be damaged by your spells.

In games such as *Diablo II* and *NWN*, whether you hate another player is expressed on a player-versus-player panel. Although the decision to like or hate a player has little effect on the game as far as the PCs were concerned, it meant a great deal to the PC's henchmen, since they are not under direct control of the PC. If a PC hated another PC and they were in a player-versus-player area that allowed hostile actions, the PC's henchmen would immediately attack the other PC and their henchmen on sight. The method GetFullReputation() contains the information on how we deal with the like/hate relationships for PCs and henchmen.

```
int Object::GetFullReputation(object oTarget)
{
    // Henchmen do not have reputations of their own.
    if (GetMaster() != NULL)
    {
        return GetMaster()->GetFullReputation(oTarget);
    }
    // To see if we like the henchman, examine the master.
    if (oTarget->GetMaster() != NULL)
    {
        return GetFullReputation(oTarget->GetMaster());
    }
```

```
        // We are always friends of ourselves.
        if (oTarget == self) { return 100; }

        // Do we need to use the player-versus-player tables?
        // If not, use the NPC calculations.
        if (GetIsPC() == FALSE || oTarget->GetIsPC() == FALSE)
        {
            return GetFullReputation(oTarget);
        }

        // At this point, both self and oTarget are player chars.
        //
        int nPVPSetting = GetAreaPVPSetting();
        bool bInSameParty = (GetInParty(oTarget) == TRUE);
        bool bPCLiked = GetPCLiked();

        // GetPCtoPCReputation lookup, see which of the 12 possible
        // values applies, and sets the reputation based on the table.
        nReputation = GetPCtoPCReputation(nPVPSetting, bInSameParty,
    bPCLiked);

        return nReputation;
    }
```

Conclusion

We have presented our many and various attempts to build a satisfactory reputation system for *Neverwinter Nights*. We believe the system is relatively simple to understand, and it was easy for both our designers and end users to code the automatic behaviors they wanted their NPCs to exhibit. The system is also relatively easy to explain to the end users. Most of the reputation system (aside from the player-versus-player panel) can be implemented in an MMP without modification.

Building a reputation system is a complicated undertaking. *The Sims Online* has a team of three programmers whose sole job it is to implement an interpersonal reputation system for their ambitious title. *Ultima Online* went through numerous revisions before finally arriving at their current system. The description of our system inside *Neverwinter Nights* may make a reputation system seem simple, but do not underestimate the effort required. If this is your responsibility on your next project, stick this book under your producer's nose and get him or her to double the time estimate for the reputation system.

References

[Alt02] Alt, Greg and Kristin King, "A Dynamic Reputation System Based on Event Knowledge," *AI Game Programming Wisdom*, Charles River Media, 2002.

[Grond98] Grond, G. M. and Bob Hanson, "Ultima Online Reputation System FAQ," Origin Systems, 1998, available online at *http://www.uo.com/*.

6.6

CITY-STATE GOVERNMENTS—THEIR ROLES IN ONLINE COMMUNITIES

Artie Rogers, Inevitable Entertainment

awrogers@texas.net

When designing systems that enable an MMP to provide a long-lasting and strong community for its player base, it is important to turn to the tenets of a real-world society to learn what brings people together and makes them a part of a community. By observing the successes of actual societies and governments, we are able to pick out specific characteristics that are applicable to designing the basic framework for an online government. A few important ideals of a real-world democracy easily serve as a solid base for an online government. These ideals include: the ability to create a body of laws; the ability to tax the citizenry; the ability to use the resources gathered through taxation to provide protection and benefits for the citizenry; and the ability of citizens to vote for their leaders. These tenets of a strong democracy are also the tenets of a strong online government.

Creating a robust system of online government is an important step toward solving some problems that are common to MMP games. The online government serves to stabilize the player base by giving the casual player a better feeling of belonging to a larger, in-game community, and it gives the veteran players avenues to affect some change in their gaming environment. This online form of government is more than a loosely linked alliance based on race or location, and it is more than a *metaguild*, which would allow guilds to ally with other guilds and work toward common goals. It is a true political system that will set laws, conquer lands, experience political drama and overthrow, and will serve to cultivate a strong sense of community.

Player killers are a common problem in open-ended, persistent state worlds. One of the main reasons that player killers present such a problem is that few games empower the player base to protect themselves against player killers. A community that is able to effectively protect itself from outside threats is also able to grow closer relationships with fellow community members as they work together to overcome adversity. The two main problems with combating player killers are lack of reward for those that attempt to control them and a lack of tools to control them efficiently. Our online government is designed with this problem in mind. The solution is to generate

some automatic monetary bounty on the heads of the player killers and provide the more-involved citizens with the tools needed to limit the impact of player killers. With proper earning potential and tools, controlling player killers becomes a viable in-game profession for the *bounty hunter*. The bounty hunter profession, itself, is detailed later in this article.

This article details an example design for an in-game form of government by tracing the three basic levels of involvement a player can occupy within the government. It begins with the casual player, who is new to the game, and outlines how the government will provide them with an immediate identification with a group. It goes on to describe the role the player takes on in the government, including the ability to vote. It continues by describing example positions within the government, such as the bounty hunter. Finally, this article details the duties, powers, and responsibilities of the *mayor* and what a player must do to become mayor.

Life as a Citizen

A democratic *city-state* form of government is the strongest model for a proposed online system of government. The city-state is linked to not only a metropolitan area, where people can congregate to socialize or trade goods, but it also encompasses the surrounding lands where players harvest raw resources or go adventuring. This city-state system is a political and social system that allows the players to have some impact on their immediate playing environment, and it provides in-game direction for its citizens.

A new player's life in an MMP that has a strong form of online government begins by selecting their citizenship. Problems that plague the new player's experience are generally due to their feeling disoriented and apart from the action that surrounds them. Players, especially those who are playing their first MMP, are often confused by the open-ended quality of the game. They lack the direction that they would normally receive from a single-player game. They often feel self-conscious about and detached from those playing around them. By granting the player citizenship in the city-state government, the player becomes part of the larger online community from the moment they log in to the game, which will provide them with some feeling of belonging and inclusion in the in-game group. The city-state government also provides the player with some direction, as there will always be tasks that need to be completed. Citizens of the city-state enjoy the social advantages of inclusion and direction, regardless of their level of involvement, from the most casual citizen to the most active online politician.

As is true when designing any online game system, it is important to consider some limitations and rules in order to keep the city-state citizenship societies from becoming too fluid, or to keep it from opening up to abusive players. Abusive players will seek to misuse the freedoms a developer might give the player base in order to

serve their own goals. Abusive players may also seek to use these freedoms to disrupt the governmental system, from elections to the bounty-hunter operations, just as a way to exercise their presence in the game, without any personal in-game benefit. Various solutions to these problems will be discussed. Apart from these issues, the life of a new player starts with choosing citizenship.

Citizenship

Basic individual citizenship is the foundation of any government. There are a number of aspects of citizenship that are important to consider when creating an online government; these include: the process of establishing citizenship, the steps an existing player takes to change citizenship, and some of the problems and solutions to abuse of citizenship.

New players are granted citizenship when they log in for the first time. Specific citizenship is determined according to where they decide to begin their game. At character creation, the players have an opportunity to review some simple metrics about each city-state before they make their choice. Some example metrics include:

- Total city-state wealth
- Total population
- Regions occupied
- Quests completed
- Mean reputation for the citizenry

The exact categories will change depending on the genre of MMP. This information will provide the player with the knowledge to make an informed choice of citizenship. If the player is not interested in choosing and wants the game to choose for them, then the game will automatically distribute the player base evenly across the existing city-state governments. The player has the option of coming in as a nomad and then making their choice once they are in the game. However, the player is encouraged to choose a citizenship at character creation.

For a player to become a citizen of another city-state, they first have to renounce their current citizenship status and assume a nomad status. The player is given some time to consider their choice. During that time, they will retain all the current benefits of their citizenship. Once the time period has passed, then they will become a nomad. It is important to give some time for consideration, as regaining citizenship is a difficult and costly process; so the player needs to be certain that it is something they want to do. Once a player who is a nomad decides they wish to become a part of another city-state, they must find a sponsor for citizenship. The sponsor must be a current citizen of the city-state that they wish to become a citizen of. Once they have received sponsorship, then the player can petition for citizenship. This process takes time and has a moderate in-game cost, which can be set by the mayor. The cost could

be simply an amount of in-game currency, or it could be a certain amount of raw resources. The mayor would be able to set the entry cost according to the needs of the city-state. After the waiting period has passed and the player has paid the cost, then the player receives the full benefit of citizenship.

There are a number of reasons to prevent societies from becoming too fluid by making the process of shifting citizenship difficult and limiting citizenship by account. By subtly discouraging citizenship changes, we provide the player time to gain a sense of loyalty to their city-state, which will occur over time as the player becomes more familiar with their surroundings. In addition to the limitations and restrictions in switching citizenship that were discussed earlier, it is also important that citizenship be limited by account. Some abuse issues that could be impeded by limiting citizenship per account and restricting the change of citizenship include interference in government elections and city-state operations. In attempts to distort the voting system, abusive players may create 'dummy' characters in order to skew elections in favor of their own candidate or to be purely disruptive. Creating these dummy character for the sole purpose of casting votes serves to dilute the votes of the honest players who would not abuse the freedom associated with character-based voting and citizenship. If players were able to have multiple citizenships per account, abusive players might seek to sabotage the attempts of bounty hunters to control player killers. They may accomplish this by creating dummy bounty hunters who, under the guise of loyalty to the city-state, would work contrary to the efforts of the honest bounty hunters, and could work in support of a player-killer group. One solution to problems related to character-based voting and character-based citizenship would be to have the account gain the citizenship, which then extends to the characters of that account. Voting rights accompany a player's paid account, and not the player's character. This requirement is in place so that if a player wants to amass more votes for themselves, then there will be a real-world cost attached to it—they will have to open a new paid account per vote. In making citizenship something valuable and difficult to change, some of the abuse issues that arise from an online government system are resolved.

Potential Benefits of Citizenship

There are a number of tangible gameplay benefits that accompany city-state citizenship. These benefits range from receiving protection from players and the environment, to enjoying character-ability bonuses, to taking part in city-state-related activities and quests. These benefits are not only for players who are actively involved, but they also appeal to the players who have no interest in city-state politics.

Some benefits of citizenship are linked both to the core characteristics of the city-state the core characteristics of the region that the city-state occupies. Some city-states are oriented more toward certain skills or abilities, so their members gain bonuses in

those skills or abilities. For example, if a city-state is magically inclined, all the active citizenry have a bonus to magic skills; or if the city-state is combat-oriented, their citizens receive a combat bonus. These character benefits are also linked to area expansion. Once a city-state occupies a certain map region, then the citizenry reaps the ability or skill bonuses linked to that region. Regional benefits are also enjoyed in the simple terms of granting access to premium harvesting, hunting, or adventuring areas that are only available to the citizens of the occupying city-state. By linking some benefits to the region, players of that city-state are encouraged to congregate in that area, thereby furthering strong community ties between citizens.

Some additional benefits of citizenship are linked to casual involvement in the workings of the government. The city-state issues quests that serve the interests of the city-state and that grant experience for the completion of those quests. These random quests are related to the slaying of certain NPCs, gathering of material, or exploring of a region. All these quests are generated to fulfill some goal of the city-state, such as clearing a harvesting area of troublesome NPCs, gathering material for building construction, or exploring a neighboring region that may be worthy of occupation. By completing quests given by the city-state, the player is working for the benefit of their community; their adventuring gains a better sense of purpose.

Summary of Citizenship

There are numerous benefits that a city-state system brings to the player base. The city-state system plays a large role in introducing a new player into the game. The new player immediately becomes a part of a larger social group. Through the granting of quests, the new player is given the opportunity and motivation to help the government work toward specific in-game goals by completing these quests. Having the ability to vote and being involved in the workings of the city-state gives the new player a feeling of acceptance and provides in-game direction by giving them goals to work toward that have discernable, wide-ranging in-game impact. The social benefits of inclusion and acceptance that are granted by the city-state are always evident. While the city-state-specific character benefits (which change as the city-state expands and contracts), the existence of the city-state government is kept in the mind of the player because their fortunes are influenced by the success of their city-state. The city-state design uses the ideas of providing protection and benefits, and of granting its citizenry the ability to vote to deliver these gameplay benefits to the player.

Becoming Involved in the City-State

A robust system of online government provides ample opportunity for players to become involved if they so chose. One of the most fundamental ways to keep the citizenry involved in the workings of government is by allowing them to vote for their

leaders. Even the most casual and disinterested player has the time to cast a vote when they log in. There are a multitude of different levels of involvement from which a player chooses—from helping introduce new players to the game to taking a more-active part, like taking an appointed position within the city-state. Examples of positions that might fit into a medieval setting include:

- *Regents* who sit on a council representing player created cities
- *Sages* who are granted unique abilities based on the core city-state tendencies, and who are crucial in city-state expansion
- *Bounty hunters* who control player killers and help clear NPC enemies when a citizen needs assistance

The presence of an online government also gives a developer the opportunity to craft an alternative advancement path centered upon the level of involvement the player takes in the government. This level of involvement could range from voting to holding the office of mayor.

Voting

Voting is the most fundamental way a person becomes involved in a democratic form of government. This truth holds for the city-state system of online government. Every player who is a city-state citizen has the opportunity to vote for their leaders. The player is presented with the voting ballot at log-in time. They then choose to vote or to exit the ballot and continue into the game. The player has access to simple metrics on each candidate as well as a prepared statement that the candidates submit to the system. Because of the hurdles one would have to take to become a candidate, the opportunity for abuse of the statement system is limited. However, by employing a limited number of candidates, a simple profanity filter, candidate account information, and perhaps some administrator review, the opportunity for abuse is limited; and if it happens, then there would be some consequences. The specific metrics include a detail listing of the candidate's attributes, such as in-game achievements, reputation, and land ownership. The election winner is determined by a simple majority, and the results are broadcasted both in-game and on a Web page. The act of voting provides the citizenry some feeling of involvement and power over the direction of their government, with a minimal amount of individual effort.

To prevent problems with abusive players interfering with the voting process, it is important to take steps to stabilize the voting pool. As mentioned earlier, restrictions on citizenship help nullify the effect of players who seek to skew voting results by slowing down population shifts. If we do not want to impede players from changing citizenships, then here are some alternative restrictions to consider: restrict voting privileges according to time, as a citizen achieves similar protection from potential election abuses; and establish a solution at the citizenship level, instead of placing

restrictions upon the act of voting itself. This solves the voting problem and allows all the citizens to vote, which is crucial.

Example Government Occupation: Bounty Hunter

A very important benefit of the city-state government is that it provides protection from player killers and other environmental hazards. This benefit is delivered by creating a system-supported position that gives the players the tools and rewards to even the playing field with the player killers by making player-killer control a viable profession. The bounty hunter is just such a profession. This section will detail the steps a player takes to become a bounty hunter, as well as explain their duties and how they carry out these duties. Finally, we will discuss the rewards and tools that bounty hunters use to achieve their goals.

Primarily, the bounty hunter is a player-filled position; if there are few players willing to become bounty hunters, then NPCs occupy the role. For the sake of discussion, this article will center on the player bounty hunter.

Bounty hunters are appointed by the mayor. The player must have a predetermined character level, or they must have achieved some predetermined tasks. They also must have been a citizen of that city-state for a certain time period if they wish to become a bounty hunter. A material cost accompanies the petition for a bounty-hunter position. The petition process is achieved through an in-game bulletin board that allows for enforcement of the requirements of the position. The mayor has the option to further restrict access to the boards either by time or by total messages. Once the player meets the cost requirement, then they must post their petition for a bounty-hunter position. Once the player has met the citizen, level, and cost requirements, the petition goes to the mayor for consideration of appointment. The mayor has access to character and account metrics in order to get a better idea of the applicant, such as age of the account, various in-game achievements, and perhaps some privileged intelligence on antisocial behavior through player/administrative notes. Once all information is reviewed, then the mayor could grant the position to the player if he so chooses.

The bounty hunter's primary role, as mentioned earlier, is to protect the citizenry. A majority of this protection comes in the form of protection from the game environment. One of the problems associated with having bounty hunters help players in the wild is the problem of linking the player to the bounty hunter. It is important to establish that link so that the player receives assistance in a timely fashion. These problems are addressed in a couple of different ways. One way to link the bounty hunter and the citizen is by allowing the player to page a bounty hunter in time of need. The player calls upon the bounty hunter for assistance, and then the bounty hunter responds by teleporting to the player. In order to prevent abuse, a cost to the player would be associated with the page.

Another method to encourage the bounty hunters to disperse over a wide range of wilderness is to encourage patrolling of the wilderness by setting up dynamic way points throughout the hunting or harvesting areas. The bounty hunter navigates to each way point and receives a reward when they collect that way point. In this way, the bounty hunters are encouraged to patrol areas of the game map that might not be challenging, or which they might not visit under normal circumstances.

Player killers are the other threat to the citizens of a city-state. The bounty hunter is counted upon to protect the citizenry from the player killers. The system gives appointed bounty hunters a variety of exclusive in-game tools to locate, track, and eliminate enemies of the city-state; these could be player killers or members of rival city-states. These tools include a system to easily communicate and travel to other bounty hunters and citizens. Another tool provides bounty hunters with a system to identify and track the player killers. Bounty hunters are also given the ability to banish a noncitizen, player-killing character from the city-state for a certain time period. The player would have to meet certain criteria to be banished. The criteria are set by the mayor and involve character information based on things like reputation, guild association, and player kills.

A problem with protecting the citizenry is that it is not a lucrative online occupation; in essence, most players want to do what benefits their character. They want to help their fellow citizens, but not at the cost of their own character's future. On the other hand, being a player killer is a very lucrative position, since they hunt the weaker players, and players most often carry more valuable items than creatures. The city-state solves this problem of compensation imbalance by allowing the mayor the ability to grant monetary rewards to the bounty hunters in exchange for player service, kills (the exact reward is influenced by the player's reputation or number of kills), and for patrolling (the reward is determined according to the difficulty of the region). The bounty hunter spends their time providing for the city-state and is richly rewarded for their efforts.

The bounty hunters are also counted upon to go into service when the city-state seeks to expand its borders by taking over a region. Border expansion is a higher-level game in which a mayor could choose to participate as the leader of a city-state. Bounty hunters are called into service by the mayor to help lead a region takeover. A certain number of bounty hunters are required to capture a region.

Of course, there are safeguards to ensure that the good bounty hunters are rewarded and the poor bounty hunters are removed. Bounty-hunter tools are easily tracked by the system, so abusers are easy to identify. Some players may seek to be appointed bounty hunters so that they might enjoy the benefits of the prestige of the position and the tools that go along with it, without actually fulfilling the role of the position. It is important that all the powers of the bounty hunters can be tracked so that the mayor can find those players who abuse the powers. One tool to measure

bounty hunter quality is to enable the paging player the ability to rate the bounty hunter. Another tool gives the mayor the ability to measure certain metrics and track bounty hunter activity. Some example metrics include:

- Reviewed pages
- Number of pages ignored
- Number of enemies of the city-state killed
- Number of way points collected
- Number of calls for help answered

Certain safeguards are needed any time there is a position of perceived prestige that does not have built-in turnover. With a combination of tools and rewards, the bounty hunter is an attractive position for those players who wish to help control the various hazards that plague the more-peaceful characters within the citizenry, and who want to help continue the expansion and success of their government and leader.

Summary of City-State Involvement

Allowing the player to voluntarily increase their level of involvement in the city-state government gives them the opportunity to feel like an integral part of the community. Voting is a basic and important stepping stone toward greater involvement. It allows every player some role in the direction of their government. The player may continue to escalate their involvement in the government by gaining an appointment to a government position, such as bounty hunter. Providing the player some outlet for their desire to help the community builds upon the feeling of social inclusion and acceptance, as well as continuing to provide in-game direction. It presents a viable, alternative in-game profession by equipping and rewarding the players who wish to better their community. Giving the players the incentive, structure, and opportunity to help improve their social environment is crucial when attempting to cultivate and strengthen the social ties that are the life blood of any MMP.

Defining the Political Process

The central position of the city-state government system is the mayor. This portion of the article goes into the procedure a player follows to be nominated for the position of mayor, and the election that takes place for the citizenry to pick their mayor. We will go on to explain the process the player base uses to remove a leader. Finally, we will touch upon a list of the powers and responsibilities of the mayor.

Becoming a Mayor

In order for a player to be considered for a nomination for mayor, he must meet certain criteria, such as having an account of a certain age and/or being the citizen of a

given city-state for a certain time period. Once he fits the most basic of qualifications, then the second step is to gain citizen support. The player does this by having a number of players pledge their support to the potential candidate. The number of pledges needed is a sliding percentage of the population, which fluctuates up or down as the city-state population rises and falls. Also, a cost is linked to pledging support, which gives the citizen reason to carefully consider their pledge. Some possible costs could be an actual in-game fee of currency or resources. It is also possible that a single player has a limited number of pledges per time period, or that each pledge has a certain value that diminishes according to how many that player has given out over a time period. These steps are necessary, or else the player would have little reason to consider the act of granting a pledge. Depending on the specifics of the MMP, other optional requirements can be added, such as requiring the candidate to have been a leader of a guild of a certain size for a certain time period, having a certain reputation, or possessing a certain skill or level. As soon as the player meets all the requirements, then their name is added to the ballot.

When the player's name is added to the ballot, they are given the option to accept the terms of the nomination. These terms include an in-game cost as well as revealing the history of their account to the voting populace. For example, the person might be required to donate a certain amount of in-game currency in proportion to the city-state population or size of the treasury. It is important that the cost remain somewhat prohibitive to ensure that the player is serious about their pursuit; so that cost has to float according to in-game inflation. The agreement does not reveal any real-world information, but it does give some simple information about the nominee by revealing the activity of the characters on the account and the general tendencies of the account holder. Once the player accepts the terms of the nomination, then they choose whether or not to submit a statement. The purpose of the statement is to sway the voters to choose them over their opponents by explaining their plans for the city-state once they become mayor. Once they complete and submit their statement, then the candidate is ready for election.

Elections are held at a predetermined time period, every month for example. City-state elections are staggered across the month to avoid problems with too many people trying to vote at the same time. It is important to disperse election dates simply to avoid overtaxing the game servers on Election Day. Additionally, the shifting of power can be an anxious period for the members of a community, so limiting the amount of changes and chaos related to a shift in power is important with regards to the anxiety level within the player base. Once a player has been elected to mayor, he immediately inherits the powers and duties of mayor. The number of terms a player can serve as mayor is limited. There are different ways to enforce the limits, either by the number of terms served in a row, such as no more than three in a row, or number of terms served over a certain time period, such as no more than three terms per year.

If the city-state citizens feel a particular mayor is not to their liking, then they can vote to usurp that mayor. As opposed to coups in real life, this is not a test of physical strength, but it is a test of citizen solidarity. If a certain percentage of the citizenry vote for his ouster, then the mayor will automatically be removed. A system-operated mayor would operate the city-state in his stead until the next election cycle. The system takes control of the city-state because it is important that the election schedule remains intact in order to ensure the mayor is properly elected by the citizens, and because it is important that a player does not gain some advantage from the election occurring at an unusual time. The system-operated mayor would be in place at the game's beginning as well as during times when no mayor is available, and it would simply work according to certain defaults. The game can measure certain criteria for the acceptance of applications to government positions. The system-run mayor is based on an average configuration of the past player mayors so that the city-state would not be so shocked by the loss of a player mayor. Therefore, the average tax rate, bounty payment, laws enforced, and so forth would be maintained until a new player mayor can be appointed. It is very important to take steps to restrict the usurping of power within the citizenry. Some level of governmental stability must be preserved to insulate it against a flood of take-over attempts by abusers. There are a number of different ways this is accomplished. Two methods would be to attach a cost to usurping the mayor and to restrict usurping actions to land-owning citizens within the city-state. Such restrictions are needed to prevent frivolous overthrow attempts by citizens who may not have a real interest in the well being of the city-state.

If the player feels as if they no longer want to be mayor, then they have the option to immediately resign. A player can also automatically lose their mayoral position if they do not log in enough times, or if they do not have enough account activity during their term. Again, a system-operated mayor would hold the position until the next election cycle.

Serving as Mayor

Once a player becomes mayor, then they take over the wide array of powers and responsibilities that go along with being mayor. The first such power is that the mayor is able to designate the laws for the city-state. The mayor is also able to determine the tax rate for goods sold by citizens within the borders of the city-state. The mayor is responsible for distributing the money collected to pay for various government positions or city improvements. The mayor is also responsible for designating bounty hunters and all other nonelected governmental positions.

The most important duty of the mayor is to designate laws for their city-state. The mayor chooses the laws to enforce from a predetermined list of laws, all of these actions are easily tracked by the system. Some of the laws that the mayor will choose from include:

- Attacks against a citizen
- Attacks upon any player within the city-state limits
- Restricting city-state benefits according to reputation of a certain level

There are also laws restricting the selling or crafting of particular goods and the practice of particular skills within certain skill sets. The specific laws would be dictated by the genre of the MMP, but most important factor is that the actions must be easily tracked by the system. The mayor simply toggles the laws between an active and inactive state. As always, it is necessary to instill safeguards against excessive law changes by restricting the number of times the laws could be changed and by designating that law changes only take place, for example, once per week. Designating laws for the city-state is the one of the most powerful tools at the mayor's disposal; the mayor could conceivably transform a law-abiding community into an unruly outlaw town.

The next couple of duties are somewhat linked. The mayor has the ability to set a sales tax on goods sold within the boundaries of the city-state, as well as redistribute that money to various outlets as the mayor sees fit. The mayor is only able to set the sales tax rate within predetermined limits. This money is diverted to a central fund that is unavailable to the mayor directly. The mayor does have the ability to divert this money to various destinations according to the needs of the city-state. As an example, they could use the money to pay for bounty hunters by increasing the amount of money paid out for the killing of outlaws or enemies of the city-state. As another example, the mayor could use the money to buy an improvement to one of their cities, such as placing a bank in a player-run city within the city-state boundaries. Being able to set the tax rate and spend the money on things that could benefit the citizens of the city-state is one of the larger responsibilities of the mayor.

Another important duty of the mayor is the appointment of players to nonelected positions within the government. The mayor is able to designate the number of available slots for each position within the governmental system. The size of the city-state fund restricts the number of positions a mayor can attempt to fill, since each position costs the city-state a certain amount. The mayor is in charge of filling those slots if he or she chooses. The mayor is also responsible for controlling the quality of the players in these positions, and the mayor has the ability to not only appoint players to the positions but to also remove those players who are unable to perform the duties asked of them.

The mayor is the top ranking player representative in the city-state government. Their ability to tax the citizenry, appoint players to government positions, buy permanent improvement to cities within their city-state, and set the laws that are monitored and enforced makes the player who has become mayor one of the most famous and influential players within the city-state.

Conclusion

Borrowing from the lessons provided by observing real-world governments and societies can enable a developer to design a good system of online government. A strong system of government can go a long way toward dampening several of the problems present when creating an open-ended, persistent world game. It helps to control the problem of player killers by providing a system to deliver tools and rewards to those players who are interested in combating player killers. It provides direction and social inclusion that greatly improves the first experiences of a new player by immediately granting them citizenship and all the benefits that go along with it. It provides an alternative advancement path through the ranks of government for the veteran players by establishing different positions of involvement that build upon each other. It also provides an interesting backdrop that sets the stage for large-scale political warfare and area expansion exploits, providing material for compelling elder games. In the end, a solid system for online government provides a strong framework for the solutions to many of the problems of online societies.

APPENDIX

ABOUT THE CD-ROM

The CD-ROM that accompanies this book contains material that supports many of the articles. Be sure to read the file ReadMe.doc for important details. Here are some of the things that are included:

Demos

The CD-ROM includes several demos in Shockwave to support the ideas and concepts presented in select articles. These demos can be run from a Web browser, provided you download the latest Shockwave plug-in, which is freely available online at *http://www.shockwave.com*. Demos are provided for the following articles:

- Section 2.7: Parallel-State Machines for Believable Characters
- Section 4.5: Texture-Based 3D Character Customization

Source Code

Source code is provided in either C++ or Python to support the following articles:

- Section 2.3: Creating a 'Safe Sandbox' for Game Scripting
- Section 2.5: Using the Twisted Framework for MMP Service Integration
- Section 3.5: Precise Game Event Broadcasting with Python
- Section 4.3: Procedural Worlds: Avoiding the Data Explosion
- Section 4.4: Writing a Fast, Efficient, Fixed-Size Object Allocator
- Section 5.2: Leveraging Relational Database Management Systems to Data-Drive MMP Gameplay

Color Images

High-resolution versions of some of the color plates are also provided on the CD-ROM.

System Requirements

Intel Pentium-Series, AMD Athlon, or new processor recommended. Windows 95/98/ME/XP with at least 32MB RAM for C++ demos. Linux and Mac OS are supported for cross-platform Python and Shockwave demos. 3D graphics card and DirectX 8 or higher recommended for Graphics demos.

INDEX